THOMAS CHAMBERS

American Marine and Landscape Painter, 1808–1869

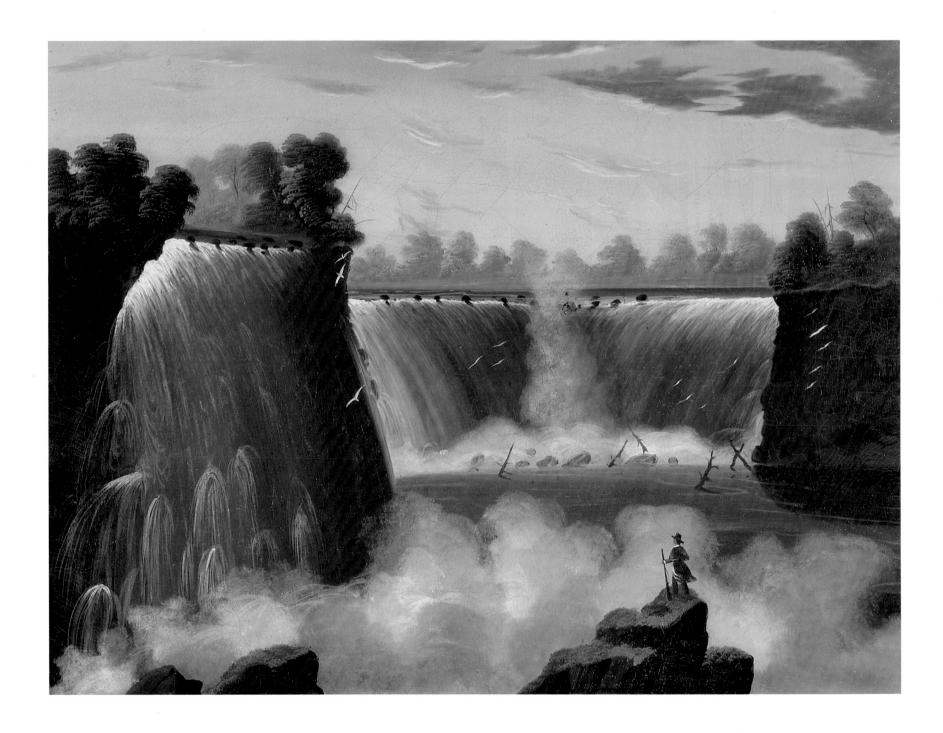

THOMAS CHAMBERS

American Marine and Landscape Painter, 1808–1869

Kathleen A. Foster

PHILADELPHIA MUSEUM OF ART

Published on the occasion of the exhibition *Thomas Chambers: American Marine and Landscape Painter, 1808–1869.*

Philadelphia Museum of Art
September 27 to December 28, 2008

The Hyde Collection, Glens Falls, New York
February 8 to April 19, 2009

American Folk Art Museum, New York
September 29, 2009, to March 7, 2010

Indiana University Art Museum, Bloomington
March 26 to May 30, 2010

The exhibition was organized by the Philadelphia Museum of Art and its Center for American Art, in association with the Indiana University Art Museum, Bloomington, and made possible by a generous gift from Mr. and Mrs. William C. Buck. Additional support was provided by the Morton C. Bradley, Jr., Fund at Indiana University.

The catalogue was supported by the Davenport Family Foundation.

Exhibitions in the Berman and Stieglitz Galleries in 2008, including *Thomas Chambers,* were made possible by RBC Wealth Management.

RBC — RBC Wealth Management

Front cover: Thomas Chambers. *Boston Harbor*, c. 1843–45 (fig. 2-8)
Half-title page: Thomas Chambers' signature on his U.S. naturalization papers, November 7, 1838
Frontispiece and back cover: Thomas Chambers. *Niagara Falls from the American Side*, c. 1843–52 (fig. 3-8)
Page xi: Thomas Chambers' signature on the verso of *Ships in a Choppy Sea*, c. 1834 (fig. 1-5)

Produced by the Publishing Department
Philadelphia Museum of Art
Sherry Babbitt, Director of Publishing
2525 Pennsylvania Avenue
Philadelphia, PA 19130 USA
www.philamuseum.org

Edited by Mary Cason
Index by Jennifer Vanim
Production by Richard Bonk
Designed by Dean Bornstein
Printed and bound by CS Graphics, Singapore

Text and compilation © 2008 Philadelphia Museum of Art

ISBN 978-0-87633-204-7 (PMA cloth)
ISBN 978-0-87633-205-4 (PMA paper)
ISBN 978-0-300-14105-4 (Yale cloth)

NOTES TO THE READER
Works that will travel to all exhibition venues are indicated by *. Works that will be on view only at the Philadelphia Museum of Art are indicated by †.

Spelling and punctuation for all works of art follow the conventions specified by the lenders and sources of photography.

LENDERS
We give special thanks to the Indiana University Art Museum for the many loans from the Morton and Marie Bradley Memorial Collection that form the core of the exhibition.

We are grateful as well to the following lenders:
Ann Abram and Steve Novak
Albany Institute of History & Art, Albany, New York
The Art Institute of Chicago
Dr. Howard P. Diamond
Fenimore Art Museum, Cooperstown, New York
The family of J. Welles Henderson
Susanne and Ralph Katz
The Lilly Library, Indiana University, Bloomington
The Metropolitan Museum of Art, New York
Nahant Public Library, Nahant, Massachusetts
National Gallery of Art, Washington, D.C.
Smithsonian American Art Museum, Washington, D.C.
Wadsworth Atheneum Museum of Art, Hartford, Connecticut

PHOTOGRAPHY AND ILLUSTRATION CREDITS
Art Resource, New York: fig. 1-13; Gavin Ashworth: fig. 5-4; Michael Cavanagh and Kevin Montague: figs. 1-9, 2-1, 2-9, 3-3–5, 3-8–9, 3-15, 3-19–25, 3-28–30, 3-33–34, 3-36, 4-1, 4-7, 4-17, 4-21–25, 4-28–30, 5-5–6, c-2, c4–6; courtesy Louis J. Dianni: Appendix; Brian Garvey: figs. c-1, c-3; T. M. Gonzalez for Toledo Museum of Art: fig. 1-6; Robert Hashimoto: fig. 2-13; J. Troy Hooper: fig. 2-11; Melville McLean: fig. 4-11; © 2007 The Metropolitan Museum of Art, New York: figs. 1-1, 3-14; Eric Mitchell: fig. 4-2; Board of Trustees, National Gallery of Art, Washington, D.C.: figs. 1-10, 2-3, 2-5, 2-8, 3-13, 3-26, 5-2; William Jedlick papers, New York State Historical Association, Cooperstown: fig. 4-27; Andrea Nuñez: fig. 1-5; Richard Walker: fig. 3-1; Graydon Wood: figs. 1-5, 1-7, 4-2, 4-4–6, 4-9, 4-12, 4-16, 4-26, 5-3; Zinman: fig. 2-4

CONTENTS

FOREWORD

The two lives of Thomas Chambers present an opportunity to reconsider American art and taste across two centuries. His first life—still almost impenetrably obscure—from his birth in England to his death in the third quarter of the nineteenth century, encompassed more than three decades of work as a prolific marine, landscape, and "fancy" painter in the United States between 1832 and about 1866. From Chambers' art, and from scraps of information about his life, we catch a glimpse of an enterprising imagination and a burgeoning new audience for American art around 1840. In his second life, begun with his re-emergence in 1942 at an exhibition at the Macbeth Gallery in New York as *T. Chambers, First American Modern*, he was reinvented as a folk original. Although at that point almost nothing was known about his biography, Chambers was embraced as "the American Rousseau," an artist intuitively commanding the rhythmic, abstract sensibility that seemed—to many viewers—the national birthright. Yet remarkably, despite the celebrity of his work in the mid-twentieth century, his subsequent popularity with collectors and museums, and the distinctive personality of his art, no major gathering of Chambers' paintings has been undertaken since 1942, and no extended scholarly investigation has advanced the pioneering research of Nina Fletcher Little, published in 1948, and that of Howard Merritt, in 1956. It is rare to find a nineteenth-century American artist so widely recognized today, and yet so understudied. At last, two hundred years after his birth, the moment both to investigate his work and to weigh the significance of his recovery in the modern period has arrived. In the light of provocative new research and analysis by Kathleen A. Foster, the Museum's Robert L. McNeil, Jr., Senior Curator of American Art, it seems that neither delineation of his identities—as a "folk" artist or as a precursor of the moderns—has been adequately subtle.

The mystery of Chambers first provoked Dr. Foster during her tenure as curator of Western art after 1800 at the Indiana University Art Museum in Bloomington. In the 1990s, the arrival of twenty-nine paintings by Chambers among the hundreds of gifts to Indiana University from Morton C. Bradley, Jr., inspired her curiosity, and plans were laid that we were delighted to carry over to Philadelphia when she was appointed to head our new Center for American Art in 2002. She appends her thanks in her own acknowledgments, but we warmly second her gratitude to her former colleagues, particularly the director of the Indiana University Art Museum, Dr. Adelheid M. Gealt, who supported Dr. Foster's initial planning and the concept of the present traveling exhibition, which will triumphantly conclude in Bloomington. Fittingly, the Morton C. Bradley, Jr., Fund at Indiana University has underwritten the early research for the catalogue. We are grateful for the many loans from the Morton and Marie Bradley Memorial Collection that form the foundation of the exhibition, as well as the expert photography undertaken for the catalogue, and for the conservation expertise supplied by Margaret K. Contompasis, the Gayle W. and Beverly Doster Conservator of Paintings at the Indiana University Art Museum, who has contributed an enlightening essay on Chambers' techniques and materials to this book.

Building upon the new survey of Chambers' work found in the Bradley collection, Dr. Foster has added a select number of important examples of his painting from other public and private collections, and we are most grateful for the generosity of the lenders contributing to this landmark gathering. In particular, we are delighted by the large group of paintings from the Edgar William and Bernice Chrysler Garbisch Collection at the National Gallery of Art, which are reunited in this project with paintings given by the Garbisches to the Metropolitan Museum of Art and the Philadelphia Museum of Art. Seeking Thomas Chambers' place in mid-nineteenth-century American art, it has been a pleasure to draw upon the American collections at the Philadelphia Museum of Art, including splendid recent gifts and promised gifts from Robert L. McNeil, Jr., Charlene Sussel, and the family of the late J. Welles Henderson.

We are profoundly grateful to the Davenport Family Foundation for its support of the catalogue, which renews a welcome partnership with the Philadelphia Museum of Art and makes a fresh demonstration of the Davenport family's ongoing commitment to scholarship in American art. The Museum's Publishing Department, headed by Sherry Babbitt, oversaw the editing and production of the catalogue with its legendary energy and high standards; special thanks go to Mary Cason,

Richard Bonk, and the designer, Dean Bornstein, who worked to capture the flavor of Chambers' era as well as the sensibility of the artist's modern admirers.

In Philadelphia, the exhibition was made possible by a gift from Mr. and Mrs. William C. Buck, who have been extraordinarily generous in their support of American art throughout the Museum. Research and program support have also been underwritten by income from the endowment of the Center for American Art at the Philadelphia Museum of Art, created by the philanthropic vision of Robert L. McNeil, Jr., who perpetually deserves our last and best thanks.

Anne d'Harnoncourt
The George D. Widener Director and
Chief Executive Officer
May 2008

ACKNOWLEDGMENTS

My adventure with Thomas Chambers began in the 1990s at the Indiana University Art Museum, where the gifts of Morton C. Bradley, Jr., were gradually transforming the nineteenth-century American collections. As the curator of Western art after 1800, I was happily awash in an increasing tide of donations, which included twenty-nine works by the mysterious Thomas Chambers. Discovering that very little had been written about him, I proposed an exhibition based on this new trove of paintings. Launched informally in 1992, my research has been episodic until recently, and I have accrued many debts, from many quarters, over many years. My first thanks go to my initial and most enthusiastic supporter, Mr. Bradley, a brilliant man who always twinkled with delight when he talked about Chambers, sharing stories of acquisition and conservation during many happy afternoons at his home in Arlington, Massachusetts. I regret that he is not here to share this work.

I am also grateful to many colleagues at Indiana University, particularly Nan Esseck Brewer, my co-author on the early catalogue of the Bradley collection, and a series of graduate assistants who helped with the initial research: Karen Pierce, Karen York, and Jenny McComas. I received assistance then, as well as more recently on this catalogue and exhibition, from Jenny and from Linda Baden, Anita Bracalente, Brian Garvey, Heidi Gealt, Diane Pelrine, and the Indiana University Art Museum's fine photographers, Michael Cavanagh and Kevin Montague. Most importantly, I have relied on the museum's paintings conservator, Margaret K. Contompasis, for her many conversations and observations, which I convinced her to compose into the essay included in this book. In addition to her close examination of the paintings, she prepared Indiana's works and their frames for photography and travel.

Professor Howard S. Merritt of the University of Rochester still reigns as the senior expert on Chambers, based on his cornerstone study of 1956, and he was generous and encouraging when approached. Newer scholarship, drawing on the important collection of Chambers' work at the National Gallery of Art in Washington, D.C., has come from Deborah Chotner, who graciously shared her research files and welcomed my questions. Thanks also go to other colleagues at the National Gallery, Franklin Kelly and Nancy Anderson, who supported generous loans for the exhibition. Stacy Hollander, at the American Folk Art Museum, New York, likewise shared insights and bibliography, and lobbied to bring the exhibition to her museum. Other curators at key institutions were similarly helpful, including Brian T. Allen at the Addison Gallery of American Art, Phillips Academy, Andover; Tammis K. Groft, Mary Alice Mackay, and Norman Rice at the Albany Institute of History & Art; Erica Hirschler, Carol Troyen, and Karen Quinn at the Museum of Fine Arts, Boston; Tara Cederholm, Diana Gaston, and Anne M. Donaghy at the Fidelity Corporate Art Collection, Boston; Christine B. Podmaniczky and Audrey Lewis at the Brandywine River Museum, Chadds Ford; Paul D'Ambrosio, Michelle Murdock, Kathleen D. Stocking, and Shelley L. Stocking at the Fenimore Art Museum, Cooperstown; Elizabeth Matson and Wayne Wright at the library of the New York State Historical Association, Cooperstown; William Rudolph at the Dallas Museum of Art, who led me to the archives and libraries of New Orleans, where I was assisted by Wayne Everard, John Fowler, Nathanael Heller, Barbara Rust, and Sally Stassi; Jacqueline De Groff and Debbie Rebuck for the Dietrich American Foundation, Chester Springs; Maud Ayson, Dorothy Chen-Courtin, and Mike Volmar at the Fruitlands Museum, Harvard; Kevin Avery, Carrie Rebora Barratt, and Barbara Weinberg at the Metropolitan Museum of Art, New York; Andrea Henderson Fahnestock at the Museum of the City of New York; Craig Bruns at the Independence Seaport Museum, Philadelphia; Marjorie Searle at the Memorial Art Gallery of the University of Rochester; Daniel Finamore at the Peabody Essex Museum, Salem; Elizabeth Broun, Eleanor Jones Harvey, Virginia Mecklenburg, and William Truettner at the Smithsonian American Art Museum, Washington, D.C.; Barbara Luck at Colonial Williamsburg; and Elizabeth Kornhauser—a long-time Chambers fan—at the Wadsworth Atheneum, Hartford. Joan Johnson, as my roving field deputy, deserves special credit for spotting pictures and introducing me to many collectors. Other scholars, conservators, and friends who have shared advice, bibliography, photographs, or moral support have included Bill Bolger, Alexis Boylan, Beverly Brannan, Terry Carbone, Tom Denenberg, Linda Ferber,

Sarena Fletcher, Henry Glassie, Michael D. Hall, James Hamm, Lee Haring, Bernie Herman, Mike Heslip, William Jedlick, Dan Kushel, Kenneth Myers, Barry and Missy Pearson, Tony Pizzo, Darrel Sewell, Ted Stebbins, John Vlach, Marc and Fronia Simpson, and John Wilmerding.

Like many art historians, I am indebted to the beleaguered librarians at the New York Public Library, the New-York Historical Society, the Frick Art Reference Library, the Boston Public Library, the Free Library of Philadelphia, and the University of Pennsylvania. Similarly, I am grateful for help from overworked staff at municipal archives in New York, Boston, Albany, Washington, D.C., and London. More particularly, I would like to thank Daniel A. deStefano at the Nahant Public Library, who went out of his way to accommodate my visit as well as my request to borrow the library's prized painting. Help also came from Sandy Vermeychuk at the Swarthmore College Library; Jeanne Gamble at the archives of Historic New England, Boston; Jim Green at the Library Company of Philadelphia; Daniel Traister at the Rare Book Room of the University of Pennsylvania Library, Philadelphia; Francis P. O'Neill at the Maryland Historical Society, Baltimore; and, closest to home, the resourceful librarians at the Philadelphia Museum of Art, led by Danial Elliott and including Lilah Mittelstaedt Knox, Jesse Trbovich, Evan Towle, and Ryan McNally.

The research begun in museums and libraries soon led farther afield, first to the dealers and collectors that Bradley mentioned as fellow Chambers fans, beginning with Dana and Peter Tillou. Dana generously sent his file of photographs, and Peter—now aided by his son Jeffrey—has unfailingly come up with a new painting or reports of others every year. Roderic Blackburn likewise shared photographs of the many Chambers paintings he has encountered in the Hudson Valley. Similar help was gratefully received from Eric and Katherine W. Baumgartner, Joan R. Brownstein, Louis J. Dianni, Nancy Druckman, Howard and Melinda Godel, Stuart P. Feld, Martha Fleischman, Roger Howlett, Frank Moran, Kenneth M. Newman, Marjorie Riordan, David Schorsch, and Bill and Terry Vose, who opened their files and made connections to collectors.

These collectors have, like Bradley, demonstrated the grass roots appeal of Chambers' work, and I have learned a lot from both the owners and their paintings. Special thanks to Susanne and Ralph Katz and to Dr. Howard P. Diamond, for hours of good company. Likewise, Emmy Cadwalader Bunker, Colleen Cagle, Mike and Lucy Danziger, Curt C. Deininger, Josef and Karen Fischer, Elise Patterson Gelpi, Margaret C. Godwin, Peter and Barbara Goodman, Hannah and the late

J. Welles Henderson, Harold Kokinos, Paul Kossey, Lex and Lynn Lindsey, Peter and Carolyn Lynch, Martin Maloy, Bob and Mia Matthews, Maureen Murphy, Ann Abram and Steve Novak, John Painter, Bill and Sharon Palmer, Barry and Linda Priest, Costa Sakellariou, George and Zahava Schillinger, and Harry and Betty Waldman all gave friendly assistance.

Pursuing helpful leads from Alan Russett, the biographer of George Chambers, I headed for Whitby with my daughter, Ellen Adair, in 2001. I was assisted there by Barbara Cowie, Anne Deniers, Graham Pickles, Sylvia Hutchinson, and Jacqueline Price. In Bath, I was welcomed by my friend James Ayres and assisted by the staff of the American Museum in Britain, Anne Armitage, Sandra Barghini, and Susan Elsdon. Over the Internet came advice from Anne and Paul Bayliss and from D. J. Salmon.

In 2002, before leaving Indiana, I enjoyed a visiting fellowship at the Smithsonian American Art Museum, where I was welcomed by curators and librarians, and at the Archives of American Art, where I enjoyed access to the incomparable files of Colonel Merl M. Moore, Jr. Similarly, a Whitney Fellowship at the Metropolitan Museum of Art gave me a chance to use the library and research files of the Department of American Paintings and Sculpture, and I remain grateful for the collegial support of the entire staff.

Moving to Philadelphia, I found new colleagues and students at the University of Pennsylvania, many of whom attended colloquia I presented in the Department of the History of Art and in conjunction with the McNeil Center for Early American Studies while my research was under way; particular thanks to David Brownlee, Sharon Ann Holt, Michael Leja, John McCoubrey, Gwendolyn Dubois Shaw, and Mike Zuckerman.

At the Philadelphia Museum of Art, first thanks go to my inspirational director, Anne d'Harnoncourt, who liked Chambers' snap and encouraged the development of the exhibition. Her death, just as this publication neared completion, has been a blow to the entire museum staff, who will miss her guiding hand as curator, director, and friend. In an institution where curatorial collaboration is a way of life and "folk art" finds many supporters, I thank many colleagues for their help and conversation, including David Barquist, Carlos Basualdo, Alice Beamesderfer, Dilys Blum, Donna Corbin, Kristina Haugland, John Ittmann, Norman Keyes, Alexandra Kirtley, Shelley Langdale, Audrey Lewis, Terry Lignelli, Mark Mitchell, Ann Percy, Debbie Rebuck, Joseph Rishel, Innis Shoemaker, Marla Shoemaker, Carol Soltis, Michael Taylor, Mark Tucker, and Jennifer Zwilling. Gabriela Hernandez

Lepe, Carol Ha, and Adrienne Gennett all kept the American Art Department running; Katie Rieder, the Barra Fellow for 2007–8, shouldered many tasks for the catalogue, and a succession of summer fellows lent a hand, including Lillian Fish, Ellery Foutch, Edwin Harvey, Catherine Holochvost, Ned Puchner, and Rachel Wadsworth. Huge debts of gratitude are owed to Suzanne Wells and Zoe Kahr for special exhibition supervision; to registrar Mary Grace Wahl; and to the superb installations staff at the Museum, particularly the exhibition design team led by Jack Schlecter and Andy Slavinskas. Most of all, the indefatigable, fastidious, and (all things considered) remarkably good-tempered team in the Publishing Department deserves special thanks, particularly Sherry Babbitt, Rich Bonk, and Mary Cason;

I am also grateful for many helpful copyediting suggestions from Kathleen Luhrs and Katherine Reilly, and a handsome book design from Dean Bornstein, who put up with my meddling.

Lastly, love and thanks to my mother, Isabella Chappell, who gave me the gene for historical research and introduced me to the world of on-line genealogical resources, and to my daughter, Ellen Adair, who will call from faraway cities to tell me she has found a Chambers in the local museum.

Kathleen A. Foster
The Robert L. McNeil, Jr. Curator of American Art
Philadelphia, June 2008

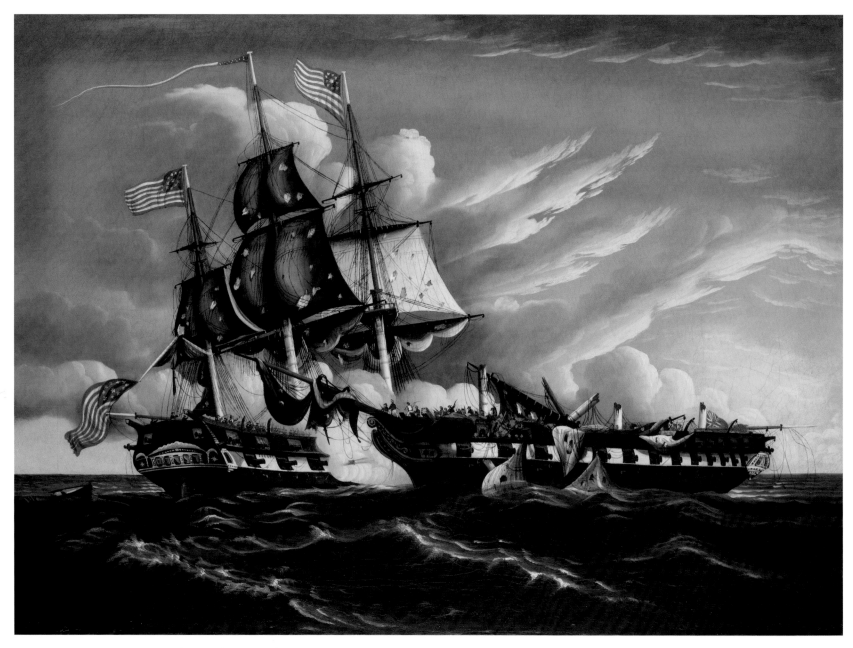

*FIG. 1-1 Thomas Chambers. *The "Constitution" and the "Guerrière,"* c. 1840–50. Oil on canvas, 24¾ x 31¼ inches (62.9 x 79.4 cm).
The Metropolitan Museum of Art, New York. Gift of Edgar William and Bernice Chrysler Garbisch, 1962, 62.256.5

WHO WAS T. CHAMBERS?

THE artist Thomas Chambers arrived in the United States from England at some point before March 1, 1832, the day he appeared at the courthouse in New Orleans to sign a Declaration of Intention to apply for American citizenship. After this date, he left only a faint trace in American city directories and census rolls in New York, Boston, Baltimore, and Albany until 1866, when he disappeared, leaving behind hundreds of remarkable landscape and marine paintings as a perplexing legacy. The distinctiveness of his style as a painter, matched inversely by the vagueness of his biography, has made him a tantalizing figure, at once one of the most widely collected American "folk" landscape painters and yet one of the least studied and understood. For almost fifty years, the same few facts have supported appreciation of his work as a "pioneer landscape painter," while the question posed at the moment of his rediscovery in the mid-twentieth century continues to ring: "Who was T. Chambers?"[1]

Obscure in his own lifetime and utterly forgotten in the late nineteenth century, Chambers was recovered by the art dealers Albert Duveen and Norman Hirschl, who found a signed painting, *The "Constitution" and the "Guerrière"* (fig. 1-1), that helped identify a small group of related works gathered from country sales and antiques dealers in the late 1930s. In November 1942, they brought eighteen paintings before the public at the Macbeth Gallery in New York. The title of their show, *T. Chambers, Active 1820–1840: First American Modern,* conveyed the strength of his appeal in the twentieth century as well as how little was known about his identity at the time. Praised for his boldness and spontaneity, his national subject matter, and his sense of design, Chambers was welcomed as "an authentic American artist" and a "pioneering modern." By 1956, numerous American museums and folk art collectors had acquired his work. They needed no dossier on the artist to be impressed; indeed, his mystery had its own allure. But the question had been posed—who *was* T. Chambers?—and the search for answers began.

Two curious scholars took up the challenge. First, the intrepid Nina Fletcher Little gathered and published, between 1948 and 1950, the few facts that still comprise the backbone of information about the artist's life. About fifty paintings had by then emerged, all united by a characteristic "brilliance of palette" and "rhythmic" decorative composition. Theories abounded: that he was African American; that he painted in Europe and never came to the United States; that he worked entirely in the studio, basing his paintings on printed sources; and that he never existed. Dispelling some of these so-called myths, Little surveyed the New York city directories and found "Thomas Chambers" listed as a landscape painter at 80 Anthony Street in 1834. She traced him to various addresses, sometimes as a marine painter, until 1840, when he disappeared from the listings in New York (see Chronology).[2] She found him again in 1843 in Boston, where he remained for nine years, listed as an artist (but not among "people of colour"). In 1951, betrayed by misleading census information, she announced that Chambers was also a portrait painter, born in London in 1815, who emigrated to the United States in 1832, followed two years later by his wife, Harriet, also born in London.[3]

Little lost track of Chambers after 1851, although she knew of a painting dated a year later. The mystery was taken up by a young assistant professor at the University of Rochester, Howard S. Merritt, who kept bumping into Chambers' work in upstate New York. In 1956, Merritt published an eleven-page article that has remained, with one addition (by Merritt himself), the basic biographical, iconographic, and stylistic analysis of the artist's life and work, cited and recited by every subsequent scholar.[4] The known corpus of paintings attributed to Chambers had now grown to about sixty-five, and a few official documents bearing his name had at last been discovered.

Merritt found Chambers listed in Albany from 1851 to 1856, always as "artist," and then in New York city directories in 1858. He disappeared for another

two years and then emerged again in New York in 1861, where he was listed at different addresses until the directory of 1866–67.[5] Valiant searches in New York, Brooklyn, Boston, and fifteen county courthouses in New York State uncovered no report of Chambers' demise, but Merritt did find the record of the death of the fifty-five-year-old Harriet Shellard Chambers from consumption on July 28, 1864, in St. Luke's Hospital, New York, and her subsequent burial in Brooklyn's Green-Wood Cemetery. Using the Albany address, Merritt located Chambers in the New York State census of 1855, which noted that Thomas, a naturalized citizen, had lived in the United States for twenty-three years; Harriet had emigrated twenty-one years earlier; both had come from London. These facts confirmed Chambers' birth in 1808 and his arrival in the United States in 1832.[6] Subsequently, Merritt found the naturalization papers filed in New York on November 7, 1838, which confirmed the date of his Declaration of Intention in New Orleans, six years earlier.[7] From this scholarly spadework emerged a foundation of dates and residences outlining unknown origins in England about 1808, activity in the United States from 1832 to about 1866, and then mystery.

The English Context: Whitby and London, 1808–32

Merritt found no trace of Chambers in London schools or exhibition venues, but he suggested that the artist might have had experience in scene painting, like the English marine painter George Chambers (1803–1840), whom he characterized as "no relation."[8] However, a new look at George Chambers, offered by the recent biography by Alan Russett, opens up a promising new perspective into Thomas Chambers' life and work. George Chambers was born in the port of Whitby, in Yorkshire, the son of an impoverished sailor; his mother took in washing and rented lodgings while raising eight children, five of whom grew to adulthood. Pulled out of school to work loading coal at the age of eight, the diminutive George went to sea on a lumber ship at the age of ten. But George showed a talent for painting and decorating the ship's gear, and eventually he won release from his indentures to take up an apprenticeship to a painter. In 1825, at the age of twenty-two, he went to London, where he made a hit painting ship portraits and harbor views for Whitby sea captains. About 1830, after a stint of panorama painting, he began to work as a theatrical scene painter, a profession he pursued with great success until the acceptance of his marine paintings at the exhibitions of the Royal Academy, the Society of British Artists, and the British Institution promised a brighter future. In a breath-taking turn of events in 1831, he was taken up by Vice Admiral Mark Kerr, who introduced him to King William and Queen Adelaide, who both ordered paintings. In the last five years of his life, he was elected to the Old Water-Colour Society, given the opportunity to travel to the Continent, and awarded major battle painting commissions for Greenwich Hospital. As his first biographer, John Watkins, noted in 1837, George Chambers was rescued "by his genius" from "the lowest grade of humanity" and raised to "the highest eminence."[9] Sadly, he did not live to enjoy such heights for long: Chronic illness brought an early death in 1840, at the age of thirty-seven.

George Chambers' life provides a contour that neatly outlines the biographical void of Thomas Chambers, offering an explanation for his style, his attitudes, and the lower-class muteness of the historical record. Russett's biography gives a glimpse of the extended Chambers family, particularly George's son, George junior (1829–1900?), who also became a painter and wandered the world, but whose work disappeared from mention in exhibitions after 1862, just when he was most successful.[10] Russett notes, too, the roster of George Chambers' siblings listed in the family Bible, including an older brother John (born 1800), who apparently became a master mariner, and a younger brother, William (born 1815), who also went to sea but then, like George, "turned marine-painter."[11] In the middle is a Thomas Chambers, born in 1808, five years after George and seven years before William.[12] No mention of Thomas is made in extant letters, or in John Watkins' memoirs of George Chambers, published in 1837 and 1841. Who was this Thomas Chambers of Whitby?

Tellingly, no Thomas Chambers has been traced in Whitby between 1832 and 1866, and no paintings by him have been discovered in England. My own expedition to Whitby yielded, however, a forlorn entry in the record of interments at the Larpool Cemetery: Thomas Chambers, artist, resident of the workhouse, age sixty-one, November 24, 1869.[13] From these two brief entries—merely records of birth and death—a life for Thomas Chambers can be sketched hypothetically, featuring a boyhood in Whitby in a family of sailors and marine painters, an apprenticeship in London in the circle of George Chambers, emigration to the United States, and then a return to Whitby at the end of his life. This story is founded on scant documentation, but the supporting evidence in the paintings confirms the fitness of this new biography. Earlier scholars have speculated on a background for Chambers in sign or coach painting, akin to the decorative painting on buckets that George Chambers first essayed as a boy.[14] There is a boldness and cartoonlike energy in Thomas' work that suggested to Merritt a brush with theatrical scene painting or

FIG. 1-2. Frank Meadow Sutcliffe (English, 1853–1941). *The Dock End*, 1880. Photograph. Copyright The Sutcliffe Gallery, Whitby

panorama painting—two related professions linked in the work of George Chambers. Also George and Thomas share the same repertory of marine painting, from ship portraits and harbor views to the epic scale of naval battle scenes, the marine artist's grand history painting. That Thomas' style differed, and that his subjects ranged into landscape, seems obvious, although he stood apart from all his contemporaries, not just his brother. That these differences might be, in part, a response to his personality and his American experience deserves investigation.

So let us adopt this beginning narrative, admitting its frailty, and assume the English marine painter George Chambers was Thomas Chambers' older brother. We would have then, for Thomas, a childhood of work and poverty in the bustling seaport of Whitby, known in this era for coal and lumber transport, whaling, and shipbuilding. Seen through the lens of its most famous artist from the later Victorian period, the photographer Frank Sutcliffe (fig. 1-2), the picturesqueness of the town emerges, with its ruined abbey looming above steep and narrow streets along the River Esk. The large Chambers family, packed into a tenement just steps from the harbor in one of the famous courts, or "yards," opening off Church Street,

must have known the darker, grubbier side of the town.[15] His parents, both illiterate, struggled to educate their children by turns. Growing up, Thomas saw his two older brothers alternate days in school because the family could not afford the weekly penny tuition for both. George left school permanently to go to work at the age of eight, and then to sea at ten, on his uncle's lumber keel. His health would be blighted by the hardships of this childhood, and his truncated education would remain a source of embarrassment for the rest of his life. Doubtlessly, Thomas suffered the same afflictions of working-class poverty. However, George was released from his indentures at the age of eighteen to return to Whitby to work for a "house and ship" painter. He spent his spare time copying prints and bookplates, sketching from nature, and taking lessons from a local drawing master. He began to make pictures of whaling scenes on millboard, and won the patronage of a local doctor. Between the ages of eighteen and twenty-two, his ambitions and his horizons expanded. George completed his new apprenticeship, and declaring in 1825 that he was "sick and tired of Whitby," he left for London and the promise of a gentler and more affluent lifestyle.[16]

Perhaps the teenage Thomas was still in Whitby in the early 1820s to witness his older brother's amazing escape from the grind of the merchant marine. Probably, he was already working on his uncle's boat if not apprenticed in some trade. But he suddenly had two career models in the family, and it is not hard to imagine his interest in George's path, even if others in Whitby, as his biographers record, were incredulous or disapproving.[17] This route must have been tantalizing for Thomas, and after his mother's death in 1824 and his father's death three years later, there was little to keep him at home. Evidently, he followed his brother—and his older married sister—to London. In 1855, when the New York State census taker knocked on his door in Albany, he said he was "from" London.

While at home in Whitby, Thomas might have learned from George's example, cobbling together an art education by copying from prints and books, borrowed overnight from the local bookseller. Surviving sketchbook pages, with rows of small generic figures suited to the staffage of a painting, show George learning to draw from W. H. Pyne's *Etchings of Rustic Figures, for the Embellishment of Landscape*, of 1815. The recurrence of similar figures in Thomas' work, usually fishermen, hunters, or strollers admiring the view, often dotted with a touch of red, implies the same strategy, maybe even the use of the same sources.[18]

In London, Thomas would have been drawn to the riverside district of Wapping, "the Whitby of London," where the north country seamen gathered at a few

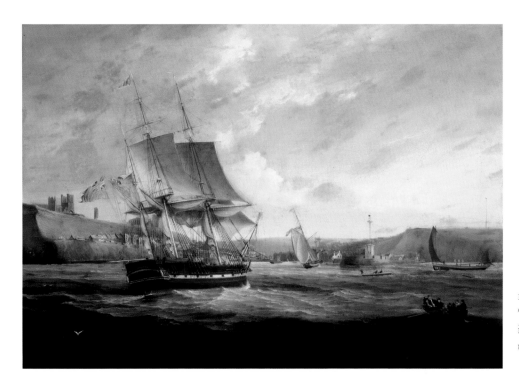

FIG. 1-3 George Chambers (English, 1803–1840). *The "Phoenix" and "Camden" Running into Whitby Harbor*, 1825. Oil on canvas, 25 x 36 inches (63.5 x 91.4 cm). Private collection. Photograph courtesy Christie's Images Ltd. (1991)

favored public houses. At one of these, the Waterman's Arms, George Chambers found his first London patrons, and Thomas could have followed his brother into these same circles of sea captains, shipowners, and sailors.[19] The work that George was producing at this time provided a model for his younger brother: His celebrated early painting *The "Phoenix" and "Camden" Running into Whitby Harbor* (fig. 1-3), made from memory in London for the owner of the two vessels depicted, has the overall size and compositional strategy of Thomas' harbor views of New York and Boston painted fifteen or twenty years later (see, for example, figs. 1-12, 2-5, 2-8). George would become a more fluid, inventive, and atmospheric painter in the next decade, but already his work showed a naturalism and delicacy that his brother would rarely achieve in his marines. Still, the pictorial devices—a dark, almost black foreground, fluffy clouds with patches of open blue sky, diagonal ocher shadows on the sails, silhouetted birds, rippling flags—will all find an echo in Thomas' work. George, still a student of the English marine tradition at this point, was himself adopting the conventions of the genre from others, and Thomas surely could have learned such mannerisms from many other sources. But he had a ready and talented compiler of marine painting techniques and strategies at hand in his own brother, and he seems to have paid some attention at exactly the point when George was mastering the basics. Thomas departed for the United States before George developed a more complex and sophisticated style in the 1830s, but even considering an early work like *The "Phoenix" and "Camden,"* it is clear that George had much to teach that Thomas never absorbed. Apparently, Thomas was a quick study, not a patient student—of his brother or of any other painter.

Nothing is known about Thomas in this period; he could have been earning a living in many ways. His name never appears in London directories, but this is not unusual; his better-known, gainfully employed brother was not listed either, until 1832.[20] Evidently restless, as his American sequence of residences tells us, he may also have lived several places before emigrating. But he probably knew his brother's enterprises, and it is at least possible that he followed George's career path, step by step.[21] Perhaps his brother found him a place on the crew of unnamed assistants working for fellow Yorkshireman Thomas Horner, preparing the sensational cyclorama in London housed in the Colosseum built in Regent's Park from 1824 to 1826.

Horner's many sketches of the view from the lantern of St. Paul's Cathedral were enlarged by the chief of the painting team, Edmund Thomas Parris, and the design was transferred by Parris and his crew to the interior surface of a huge cylinder of canvas shaped something like a gigantic cooling tower. Said to be "the largest oil painting the world had ever seen," over 24,000 square feet in size, the project must have needed many hands.[22] George joined the enterprise in 1827, contributing his painting skills as well as his seaman's nimbleness aloft, working on the murals while suspended in a "cradle" high above the floor. Rumors of debt and mismanaged funds led to the flight of the financial backers to the United States early in 1829, and Horner himself soon joined them. George, however, remained as the project regrouped and opened, half-finished, to the public in 1829. Spectators climbed a central tower to inspect the view with binoculars, while the painters continued to add the finishing touches from their dangling platforms. For a time the most stylish spectacle in London, the panorama employed a much-diminished crew until the end of that year, when it was finally completed.[23]

George probably left the Colosseum project in the spring of 1829, and by 1830 he was working as a scenery painter at the Pavilion Theatre in London, where the skills of a panorama artist or a sea painter would have been much in demand. The frantic pace of work in this business, combined with the increase of private commissions that he much preferred, inspired George to hire assistants, perhaps even including his younger brother, who would later show a flair for broad and speedy painting. Although praised and given top billing for his designs, George withdrew entirely from the field after only a year, yearning to be free to work on canvases destined for the Royal Academy or the British Institution exhibitions. Others had done the same thing: Clarkson Stanfield and David Roberts, true celebrities in scenic painting at this moment, likewise parlayed their success into more prestigious careers painting easel pictures. In this golden age of spectacle, theaters vied for audiences, and the demand for novelty required large teams of painters, fabricators, and special-effects wizards. Blurring the distinctions between panorama painting (and its numerous variants), theatrical staging, and blockbuster exhibition canvases, Stanfield excelled across all three genres. For young Thomas Chambers, even the most conventional components of this kind of painting seem to have had an impact: The broad handling and romantic effects of scene painting, with its inevitable flanking groups of trees, shorthand descriptions of foliage and texture, rustic cottages, and distant prospects, all seem to infuse his work. At the very least, we can imagine him as an enthusiastic spectator of such popular entertainments. However, for an entry-level job seeker, scene painting was an apprentice-bound profession, dominated by family dynasties, guild traditions, and bare-knuckle competition, so it is likely that—if he arrived as an outsider in this field—his opportunities for work were marginal, unglamorous, and low paying. Like his brother, Thomas seems to have yearned to be a fine artist free of these onerous, low-prestige jobs conducted under the direction of others.[24] Ambitious, like many emigrants to the United States, he wanted to make his own way unencumbered, to be his own boss. Opportunistic, like generations of English artists, he might have been fleeing daunting competition—and, in his case, the shadow of a successful older brother—and hoping for better chances in the New World.

New Orleans, c. 1832–c. 1834

When Thomas Chambers signed his naturalization papers in New York in 1838, he presented a receipt documenting the earlier filing, in New Orleans on March 1, 1832, of his Declaration of Intention to become a United States citizen. The obscurity of his arrival—most likely through the port of New Orleans shortly before this date, but possibly elsewhere, or earlier—typifies the frustrating pattern of evidence for Chambers' entire life: documents missing or unrecorded, information lost.[25] In the New Orleans city directory for 1834, "T. Chambers, painter," appears at 98 Poydras Street, in a burgeoning new residential and commercial district that would come to be known as the American quarter, south of Canal Street and the Vieux Carré.[26] Merritt, who discovered this listing, also found a reference (now lost) to an exhibition of paintings by Chambers in New Orleans in 1833. No works known to have been painted in this period survive. The absence of art galleries, auction houses, and organized exhibition venues for artists in New Orleans in this decade makes tracking his activity difficult, although the tremendous energy of the port must have offered opportunities for a ship painter. New Orleans was a large and cosmopolitan city, with many resident artists in this period and a regular round of visiting portrait painters. The portraitist John Wesley Jarvis, another peripatetic Yorkshire emigrant, visited New Orleans in the winter of 1833–34 after several lucrative trips in earlier years. In a grumpy letter to William Dunlap in the spring of 1834, he remarked on the mud, complained about the lack of housing fit to receive his sitters, and concluded that "New Orleans is more disagreeable than ever."[27] Many artists and residents fled in the feverish summer months, and perhaps one summer was enough to make a Yorkshire native head north to cooler climates.

New York, c. 1833–c. 1840

Chambers arrived in New York in time to have his name listed in a city directory published in July 1834. He described himself as a landscape painter, residing at 80 Anthony (now Worth) Street, at the southwest corner of its intersection with Broadway, about four blocks north of City Hall.[28] His building would have backed on the parklike surroundings of the old New York Hospital, which dominated the entire block on Broadway between Anthony and Duane streets. His wife, Harriet, arrived from England about 1834, and to complicate matters, a William Chambers appears about this time, too, listed as an artist and portrait painter living on Hudson and then Greenwich Street in New York directories from 1836 to 1838.[29]

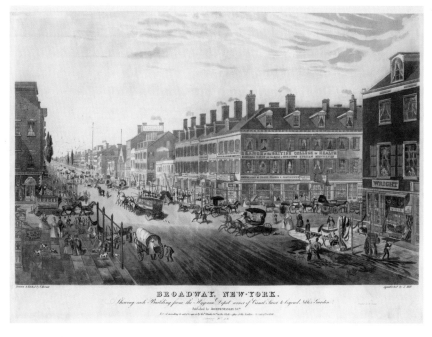

FIG. 1-4 John Hill (born England, died United States, 1770–1850) and Thomas Horner (born England, died United States, 1785–1844). *Broadway, New-York. Shewing each building from the Hygeian Depot corner of Canal Street to Beyond Niblo's Garden*, 1836. Hand-colored etching, 17¹¹⁄₁₆ x 27³⁄₁₆ inches (45 x 69.3 cm). The New York Public Library; Astor, Lenox and Tilden Foundations. I. N. Phelps Stokes Collection, Miriam and Ira D. Wallach Division of Art, Prints and Photographs

In 1837, Thomas Chambers moved a dozen blocks uptown, to 213 Greene Street, just south of Washington Square, close to the edge of the built city. Two years later, the household moved back down to 48 Vesey Street, opposite the tip of City Hall Park and midway between the wharves and the elegant new Astor Hotel.[30] Although not listed in the 1840 city directory, Chambers was still in New York, but at a previously undiscovered address revealed by the federal census that year. With his wife and three children, he had moved due east and probably a bit down-market, to 15 Catherine Street, near the intersection of East Broadway, just below Chatham Square.[31]

Such restlessness was not unusual for New Yorkers in this period, but it does tell us that Chambers was not professionally settled or prosperous enough to own a home. The community of artists in New York, including architects, engravers, scenic painters, and the large group of portrait and miniature painters, lived in various neighborhoods, though most, like Chambers, stayed close to the bustling artery of Broadway, with its chain of picture framers, art supply stores, book and print sellers, and auction rooms that all served as commercial art galleries. Few of Chambers' addresses, however, seem to have been close to other artists. Perhaps his nearest artist neighbor at his first address was Asher B. Durand, who lived on Duane Street, on the other side of the hospital, while his residence on Vesey Street was two doors away from that of Henry Inman and Daniel Huntington, but he was never far from the major public exhibition sites near City Hall Park.

Little work by Chambers from his first years in New York has been located, so it is difficult to know how he supported himself and a growing family. It is tempting to connect him to Thomas Horner, the guiding genius of the London Colosseum, residing in New York after 1829 and scrambling with various print projects and new schemes for a panorama of Manhattan from Brooklyn (fig. 1-4).[32] As in England, panoramania ran wild in the United States in this period, when Horner's cyclorama of London and Stanfield's gigantic canvases toured many American cities. Chambers could have found employment in this field or in New York's equally booming show business, which supported eight theaters in the city, some of them new and opulent.

Not long after arriving in New York, Chambers exhibited a watercolor of a marine subject at the seventh annual fair of the American Institute of the City of New York, which took place at Niblo's Garden on Broadway in the fall of 1834. Happily, he won a prize: a "Second Premium" that brought a cash award and a diploma from the institute.[33] This entry, perhaps *Ships in a Choppy Sea* (fig. 1-5),

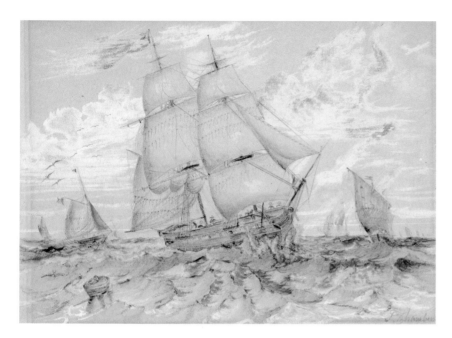

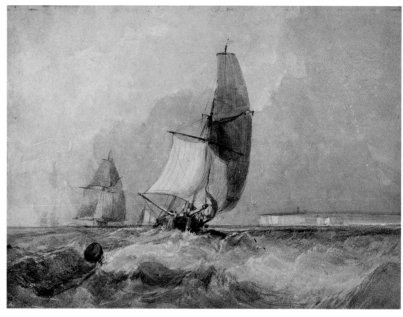

*FIG. 1-5 Thomas Chambers. *Ships in a Choppy Sea*, c. 1834. Graphite with opaque water-color heightening and touches of transparent glaze on wove paper, 7½ x 10⁵⁄₁₆ inches (19.1 x 26.2 cm). Philadelphia Museum of Art. Purchased with funds contributed by Mr. and Mrs. M. Todd Cooke in memory of H. Richard Dietrich, Jr., 2007-158-1

FIG. 1-6 George Chambers (English, 1803–1840). *North Foreland*, 1833 or 1835. Watercolor, pen and ink, and surface scraping on paper; 6½ x 8⅞ inches (16.5 x 22.5 cm). Toledo Museum of Art, Toledo, Ohio, 1953.95

is unique and tantalizing, as it represents the only time Chambers is known to have shown his work in an institutionally organized exhibition, his only known prize, and the only time he appears as a watercolorist. The surviving watercolor *Ships in a Choppy Sea,* signed "by T. Chambers" on the front and "T. Chambers" on the back in a familiar hand, provides a useful early benchmark for his style and technique.[34] Immediately, this wash and pencil drawing establishes a connection to the main-stream of English marine painting of the 1830s and the suaver academic manner of his brother (see, for example, George Chambers' *North Foreland* [fig. 1-6]) or the more celebrated fellow scene painter turned academic marine artist, Stanfield. Although it is unremarkable in the larger context of marine watercolor painting of this period, the proficiency and variety of brushwork seen in *Ships in a Choppy Sea* suggest that Chambers had training and experience in this medium. The small figures lining the rail of the ship have the doll-like quality that is found in his oils of a few years later, such as *Ship in a Storm* (see fig. 2-1) and *Storm-Tossed Frigate* (see

fig. 2-3), but the look of this watercolor is thoroughly academic and mainstream. The uniqueness of this work opens many questions: Did he make others, now lost? Why didn't he exhibit at the fair again?

Perhaps, like his brother, he had higher ambitions. The art exhibitions orga-nized by the two related (and frequently confused) organizations, the older Ameri-can Institute (with fairs running from 1828 to the end of the century) and the Mechanics' Institute of the City of New York (which held only five fairs in the late 1830s), offered a logical opportunity for a newly arrived artist. These fairs joined education, commerce, entertainment, and civic boosterism in a complex mix aimed at stimulating and improving the "useful arts" in the United States and bringing new talent to light. Under this very large umbrella was gathered everything from technology and manufacturing to new or borderline fine art mediums, such as pho-tography, printmaking, transparencies, window-shade painting, needlework, callig-raphy, and shellwork. The exhibitions welcomed an eclectic range of artists, too,

showing a particular penchant for amateurs, youngsters, crossover practitioners, and the self-taught. Many artists—such as William Sidney Mount, in 1830, Jasper Cropsey, in 1837, and William Ranney, in 1838—were encouraged by their first success at these fairs. Artists might prefer the more sedate and focused artistic ambiance of the young National Academy of Design's exhibitions, but crossover participation was common. In the early 1830s, the divisions between fine art and applied art that would rise after mid-century were conscientiously paved over. Relations between the institutions were especially collegial while the academy was headed by the painter-inventor Samuel F. B. Morse, who warmly supported the mission of these institutes and served on the fine arts jury the year Chambers won his premium; many artists, particularly printmakers, exhibited in both places.[35]

Notwithstanding the attraction of the premiums, the huge popular audience, and the high-minded hopes for the "mechanics" supporting American arts and industries, Chambers does not seem to have exhibited at one of these fairs again. It is not hard to understand why. The fairs were visually muddled and dominated by the work of amateurs and students; Niblo's Garden, an arena for all kinds of popular entertainment, was lively, but hardly dignified. Typically, painters submitted work once or twice—showing solidarity, seeking exposure, or trolling for prizes—before graduating to more focused, prestigious, and hopefully lucrative arenas. James Pringle, another English immigrant, showed his marines steadily at the National Academy of Design and the Apollo Association after his arrival in New York in 1832, exhibiting only once at the American Institute, in 1838, when he won a diploma for a "large and spirited" view, *The Departure of the Steamship "Great Western."* After showing a landscape in oils at the American Institute in 1830, the younger English-born John William Hill captured in 1834 the "First Premium" (alongside Chambers' second) in landscape and marine painting, with his "spirited sea piece, in water colour." Already an associate of the National Academy, Hill exhibited there for the rest of his career, but at no other known institutes' fairs.[36]

Chambers never moved on to the other venues, such as the National Academy or the Apollo Association, which opens up further questions. Numerous examples of success by British immigrant artists of very modest backgrounds (such as Thomas Cole, Thomas Sully, or Thomas Moran) prove that it was not impossible to overcome constraints of class and education to rise in the arts from such fields as printmaking or coach painting to academic glory. Closer to home, Chambers' brother offered a splendid example of determined upward mobility. Absence from the usual artists' groups may hint at a shy, graceless, eccentric, or antisocial person-

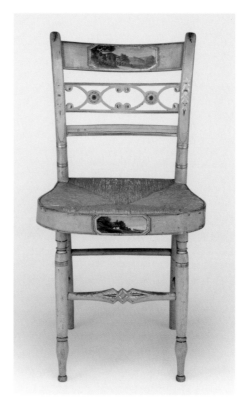

†FIG. 1-7 *Side chair*, 1815–25. American, artist/maker unknown, made in New York. Beech, hickory, and possibly other hardwoods, with rush seat and painted and gilded decoration; 33½ x 17⅞ x 21 inches (85.1 x 45.4 x 53.3 cm). Philadelphia Museum of Art. Bequest of Anne Hinchman, 1952-82-9

ality, and a wide range of possible attitudes that we can return to consider once we have taken a harder look at Thomas Chambers' work and his career path.

The complexity of his professional life, and a sense of his patchwork training and myriad income sources, emerges in a brief four-line advertisement that Chambers placed in Horace Greeley's new weekly paper, the *New-Yorker*, beginning in the issue of March 28, 1835:

> T. CHAMBERS, Marine and Landscape Painter.—A great variety of Cabinet Pictures constantly on hand. Fancy Painting of every description done to order. Old paintings cleaned and varnished. 333 Broadway, entrance 80 Anthony St.[37]

This medley of offerings tells us how Chambers earned his living and implies a body of work from about 1835—on signs and furniture, for interiors, or as an independent painter of cabinet pictures—now unattributed, scattered, or lost. Cabinet pictures, defined as small, finely finished paintings for display in domestic spaces,

could encompass a variety of genre subjects, still lifes, and landscapes in the mode of the seventeenth-century Dutch little masters. "Fancy painting" was a much larger term, embracing the imaginary and delightful (that is, fanciful) subjects of the cabinet-picture sort, as well as exuberantly decorative work of many kinds, including graining and marbling.

Chambers' self-description as a marine, landscape, and fancy painter introduces his versatility and ambition at the age of twenty-eight, close to the high-water moment of the optimistic and spirited "fancy" taste in American art and interiors. Following the practice of the English-born Francis Guy, who painted landscape vignettes on furniture and composed cabinet paintings and fancy pieces in the first two decades of the century, many painters worked across these genres, producing pictures entitled "A Fancy" or "Fantasy" as parlor ornaments, or decorating doors and chairbacks with cheerful imagery (fig. 1-7).[38] The intersection of this taste in painting and interior design is captured with zest in the work of Joseph H. Davis, who depicted the Demeritt family of Farmington, New Hampshire, in a setting that includes a wildly energetic floorcloth, brightly painted and grained furniture, and a bucolic river landscape painting, very much in the Chambers mode (fig. 1-8).[39] A model for Chambers, with a similar repertory of subjects, would have been the older immigrant marine painter Thomas Birch of Philadelphia, who also embellished looking glasses, decorated furniture and clocks, and cleaned and repaired paintings.[40] Such a range of activity places Chambers exactly where the visual qualities of his paintings tell us he worked: across the gap between the makers of pictures and the decorative painters who, like his brother, began with ornamenting ships' chests and buckets before graduating to ship portraits and marines.

The earliest example of his work in oils, *Cutting Out of His B.M.S. "Hermione"* (see fig. 2-2), dated just a year after Chambers' debut at the American Institute, must represent the kind of cabinet picture available from his workplace. The unusual subject and the detailed calligraphic inscription on the back likewise suggest work done to order. Modeled on a twenty-year-old aquatint by the English marine artist Thomas Whitcombe, it is the first extant example of a long series of paintings that Chambers, like many decorative painters, freely improvised from print sources. With no claims to observation from nature, fancy painting, by definition, was based on invention and fantasy, and its premises of spontaneity, emotion, and entertainment drove Chambers' methods as an artist from this moment forward.

The improvement in Chambers' skill and his sense of enterprise as a marine artist can be read in a painting inspired the following year by one of the most

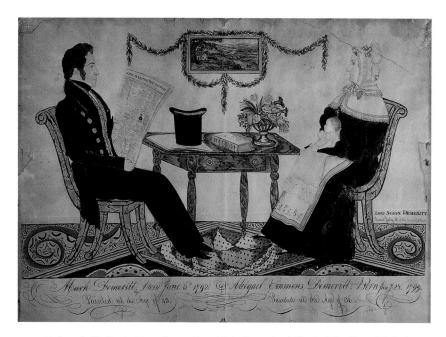

FIG. 1-8 Joseph H. Davis (American, 1811–1865). *Portrait of Mark, Abigail, and Lois Susan Demeritt*, 1835. Watercolor, ink, and graphite on paper; 12 x 16⅛ inches (30.5 x 41 cm). Currier Museum of Art, Manchester, N.H. Museum Purchase: Gift of the Friends, 1977.53

famous shipwrecks of the era: the loss of the ship *Bristol* and seventy-seven lives off Long Island, on November 21, 1836. Accounts of the disaster that filled the press were compounded by the even more horrifying fate of the barque *Mexico*, wrecked nearby a few weeks later, bringing the dismal total that winter to almost two hundred deaths. The fortitude of the *Bristol*'s captain and the cowardice of the *Mexico*'s, the greed of the scavengers who picked over the corpses on the beach, the inattentiveness of the harbor pilot boats, and the pathos of the Irish and English immigrants trapped on both of these ships captured the imaginations of journalists and entrepreneurs. On Broadway, Henry and W. J. Hanington lost no time producing a "beautiful" illuminated diorama of the fate of the *Mexico* within a week of its loss; the Bowery Theatre staged a melodrama, *The Wreck of the "Bristol"*; and the *New York Sun* published three editions of a sixteen-page pamphlet recapitulating the awful details of both calamities. Illustrated with generic woodcuts, the *Sun*'s text assured readers that an artist had been dispatched to the site for more authentic details.[41] Indeed, a week later, Nathaniel Currier rushed into print a litho-

*FIG. 1-9 Thomas Chambers. *Rockaway Beach, New York, with the Wreck of the Ship "Bristol,"* c. 1837–40. Oil on canvas, 21¾ x 30⅜ inches (55.2 x 77.2 cm). Indiana University Art Museum, Bloomington. Morton and Marie Bradley Memorial Collection, 98.44

graph, *Dreadful Wreck of the "Mexico" on Hempstead Beach*, "drawn on the spot by H. Sewel," an artist who also worked for the Haningtons. Showing a similar feeling for news and the popular appetite for disaster stories, both James Pringle and Gabriel Augustus Ludlow composed views of the *Bristol* for the National Academy's annual show, which opened on April 21.[42]

Probably at the same time, to capitalize on this interest, Thomas Chambers produced "from the original sketch taken on the spot, three days after the dreadful catastrophe," a painting described as "Rockaway Beach, New York, with the wreck of the ship Bristol, Where Upwards of 60 Passengers Were Drowned, in 1837." This long title, with its supplementary gloss and mistaken date, appeared in the checklist of an auction sale in 1845 in Newport of Chambers' work, probably referring to a painting much like his *Rockaway Beach* (fig. 1-9), which emerged with a similar title. Notably, the descriptive title dodges saying whether the painter and the sketcher were the same artist; perhaps Chambers worked from a print or drawing similar to the Sewel lithograph, embellished with generic romantic motifs, such as the ancient hulk at the left and the pensive watcher on the beach at the right.[43] If the painting demonstrates a degree of artistic license—certainly a hallmark of Chambers' style—his combination of effects reveals an idiosyncratic sensibility. Alert to topical subject matter, and with the practical outlook of a mariner, he includes the workaday salvage of the ship by the wreckers who have pulled alongside. Chambers nonetheless frames his image within a romantic structure in which a bystander contemplates, under sunny skies, the aftermath of the most recent episode in a timeless cycle of tragedy and recovery.[44]

Such a view of Rockaway and the *Bristol* might have been among the marine paintings on the block just a few months after the wreck, when the auctioneer Aaron Levy announced in the *New-York Evening Post* a sale on April 22, 1837: "A choice collection of Modern Paintings, together with a number of fine old pictures will be offered for sale at the Arcade Baths, Chambers street, on SATURDAY EVENING at half past 7 o'clock. Among them is a number of sea pieces by Mr. Chambers, particularly 85, 86, 87 and 88, taken from Captain Marryatt's p[i]rate."[45] This auction sale, the evening after the opening of the spring exhibition of the National Academy of Design a few blocks away, tells us how Chambers was marketing his work, and demonstrates again his sense of timely subject matter. His subjects from *The Pirate* seized upon one of the most recent tales from the phenomenally popular English writer of sea stories, Captain Frederick Marryat, who was "not a little lionized" upon his arrival in New York on May 4, 1837, when he came to greet his American admirers and do battle with the pirates who had been publishing his work illegally in the United States.[46] Although no painting known today has been conclusively identified with the subjects sold in the Levy auction of 1837 or the later Newport auction of 1845, certain marine battles and storm-tossed ships, such as *Ship in a Storm* (see fig. 2-1) and *Storm-Tossed Frigate* (see fig. 2-3), may illustrate Chambers' efforts in this literary genre. Similar compositions were part of the bread and butter of every marine painter, but Chambers was unique in American painting in opportunistically connecting these conventional subjects to the latest literary best sellers by Marryat and James Fenimore Cooper.

Tellingly, the rest of the material in the Levy sale included, "if not in all cases the undoubted originals, at least the best copies of old masters, which the most fastidious connoisseurs would be glad to possess." The catalogue of this sale has not survived, although the auctioneer Aaron Levy was remembered as a "humbug, with his 'old master paintings.'"[47] The mix of modern work credited to Chambers and copies of venerable European paintings creates an interesting marketplace with a new set of questions: Was Chambers organizing with Levy's hired assistance the entire sale, or was he just a consignor? Was he responsible for any of the copies?

Chambers may have used the funds from the auction sale to leave the country, because "Thomas Chambers, artist, age 25," appears on the manifest of the packet ship *Sheffield*, returning to New York from Liverpool on December 23, 1837. On the list of ten passengers, most of whom are identified as simply "gent" or "lady," the name appears between that of an American printer, Murdock McPherson (age thirty), and a British "picture restorer," George Noble (age twenty-five), perhaps a colleague.[48] The reasons for this trip remain unknown: Both of Chambers' parents were dead, but he had three siblings still alive in England, including his brother George, who was in Whitby that summer and then in new lodgings in London, busy preparing work for the annual exhibitions.[49]

A year later, as the impact of the panic of 1837 began to settle on the American economy, Chambers appeared at the courthouse on November 7, 1838, to sign his naturalization papers. Joseph Britton, a grocer who lived next door to the artist on Greene Street, testified that he had "behaved himself as a man of good moral character," fit to support the "good order and happiness" of the Constitution of the United States. Chambers produced the receipt from his Declaration of Intention in New Orleans in 1832, and signed the application with two flourishes of the pen—*Thos Chambers*—endorsing the only known document that survives to the present day with his handwriting (see half-title page). Like the signature on the back

*FIG. 1-10 Thomas Chambers. *Threatening Sky, Bay of New York*, c. 1835–50. Oil on canvas, 18⅛ x 24¼ inches (46 x 61.5 cm). National Gallery of Art, Washington, D.C. Gift of Edgar William and Bernice Chrysler Garbisch, 1973.67.2

FIG. 1-11 Thomas Chambers. *Baltimore Schooner "Chesapeake" Passing Bodkin Light House in a Brisk Breeze, the United States Ship "Delaware" R*[illegible] *in the Distance*, c. 1843–45. Oil on canvas, 21⅜ x 30¼ inches (54.3 x 76.8 cm). Private collection

of *Ships in a Choppy Sea* (see page xi), it is a confident, even flamboyant signature, suggesting not just literacy, but panache.

Chambers' listings in the New York directories were unbroken by this possible return to England, but his designation changed in 1838, when he announced himself as a "marine painter." Perhaps renewed contact with his brother encouraged him to specialize, or maybe he was bolstered by the reception of marine work in the Levy sale. He remained in New York, according to the city directories, through 1840, perhaps producing the first of his harbor views (such as fig. 1-10).

Baltimore, c. 1841–c. 1842

The death of his brother George Chambers, in October 1840, might have drawn Chambers back to England again; his location is unknown until 1842, when his name appears, listed as a marine painter, in the Baltimore city directory. This previously unknown stay in Baltimore, at "Conway Street east of L[ittle] Green," did not

last long, as his listing disappears the following year.[50] Perhaps from this residency, midway between two branches of the Patapsco and not far from the city dock, came the idea to paint the newly recommissioned American ship of the line, the *Delaware*, at anchor in Chesapeake Bay opposite Windmill Point and Bodkin Light, at the base of the Severn River (fig. 1-11).[51] Three years later, a pair of "handsome marine views" would appear in Chambers' auction sale: "Annapolis Roads, with the U. S. Ship Delaware, 74 Guns, at Anchor, Com. Morris, Commander, from the original sketch taken in 1841," and its companion, "Bodkin light house and Point Chesapeake Bay, near Baltimore city."[52]

Boston, c. 1843–c. 1851

Chambers probably left Baltimore in 1842, arriving in Boston in time to list his name (as artist) in the city directory of 1843. He settled into a house at 21 Brighton Street until after the publication of the 1851 directory, launching the longest unbroken residency in the same city, and under the same roof, of his entire career. Merritt proposed that he moved to take advantage of the vacuum created by the departure of the English-born marine painter Robert Salmon, and certainly his residence suited a prospecting marine painter.[53] On the wharf overlooking the river, looking north to Lechmere Point and Bunker Hill, this address must have resembled the working waterside district of Chambers' youth in Whitby. Close by the Canal Bridge (now the Charles River Dam) and two railway depots (now consolidated as North Station), his neighborhood was surely noisy and dirty; presumably, the rent was low. Certainly it was not an address shared by Boston's principal artists, who tended to cluster on higher ground, around Tremont and Washington streets, closer to the State House and the Common. Nor was it near the enclave of the ship painters, all gathered on Commercial Street on the opposite side of the city, close to the largest wharves.[54] The census of 1850 records his nearest neighbors: several carpenters, a ship chandler, glass stainer-painter, shoe dealer, tailor, coppersmith, blacksmith, and other manual laborers, mostly native born; apart from the "carver" Levi Cushing, he was the only "artist" on the street.[55]

Chambers' distance from the city's art community can be measured again in the surviving records of the city's two important annual art exhibitions in this period, organized by the Boston Athenaeum and the Boston Art Association (hereafter BAA). The Athenaeum's displays, begun in 1827 with a commitment to the city's artists, had altered by 1840 to emphasize European and old master paintings lent by

local collectors, contemporary New York artists, and an ever-smaller percentage of local exhibitors. The BAA, formed to rectify this trend, gathered their first exhibition in 1842, just as Chambers moved to town. Held in Chester Harding's studio on School Street, these shows continued to champion contemporary art for the next decade. It is not surprising that Chambers found no place at the Athenaeum, just as he made no appearance at the National Academy of Design in New York. More interesting is his absence from the BAA's shows, at least according to the three surviving catalogues from 1843 to 1845. The roster of sixty-five exhibitors and members of the inaugural exhibition offers a census of the relatively small Boston fine art community during his residency in the city. Most of them were listed in the Boston business directories as portrait or figure painters, like Harding, and they were likely to exhibit at the Athenaeum occasionally. The smaller corps of landscape painters (mixed into the portrait section in the business directory), including Alvan Fisher, Samuel Gerry, Thomas Doughty, and an occasional visiting New Yorker such as Cole, stood to gain both more space and status in this new venture, although these men were also welcome at the Athenaeum. More telling is the habit of the few marine painters: The well-established Fitz Henry Lane exhibited steadily at both venues; the newly arrived Clement Drew showed only at the BAA; and the two other marine painters listed in the city business directories in this decade, William Marsh and J.W.A. Scott, appeared at neither.[56] This pattern reminds us that even the newer, more liberal and comprehensive BAA hardly embraced the entire population of local artists. Listed in the business directories alongside the portrait and marine painters were twice as many house, sign, coach, ornamental, and fancy painters, who may have produced the occasional picture but never exhibited at either exhibition. William Matthew Prior, a prolific portrait painter who seems to have identified with this majority, submitted one portrait to the Athenaeum in 1831 from Maine, but never exhibited there again—or at the BAA—after settling in East Boston in 1841. Like Prior, Chambers seems to have negotiated a place between the two populations of painters, learning from Lane and Doughty but seeking different neighbors and a different audience.

The Newport Auction, 1845

Perhaps his distance from the Tremont Street crowd was made longer by an itinerant existence, as Chambers sought patrons and exhibition opportunities on the road. Although the notion of an artist peddling paintings from town to town is a cherished but seldom documented staple of folk art histories, a rare piece of oral history hints at such sales trips out of Boston for Chambers. A small landscape, found in an old house in Duxbury, south of Boston, was said to have been "acquired in 1840 in exchange for bales of hay for Chambers' horse."[57] On July 11, 1845, Chambers was even farther out of town, bringing his work to the public in an auction sale in the Masonic Hall in Newport. The broadside that documents this sale (see Appendix) headlines the work of "London and New-York artists," including Chambers, who evidently felt that his residence in Boston was either temporary or not worth touting. The list of works sold that day, "never before seen in the U. States," revolutionizes our sense of Chambers' repertory in the mid-1840s and his transition from marine painting to landscape in this decade.

All of the seven paintings in the Newport sale credited to "Mr. Chambers of New York" were marine subjects, including shipping in the harbors of New York, Boston, and Cork, Ireland. The three views of New York included a pair of paintings featuring the Liverpool packet ship *George Washington* inbound and outbound (akin to figs. 1-10 and 2-5), and the steamship *Great Western*, leaving Sandy Hook (perhaps related to fig. 2-10). As a complement to the New York packets, he also presented "Boston Bay and Harbor, with a quarter view of the U. S. Ship Ohio, 74 guns, at anchor; the Royal Mail Steamer Hibernia, leaving port for Liverpool,—a splendid original picture" (such as figs. 1-12 and 2-8). In addition to these five harbor views, Chambers took credit for two marine battle scenes from the War of 1812, "The U.S. frigate Constitution's last broadside to the British frigate Guerriere" (like known *Constitution* subjects figs. 2-14 and 2-16), and, "decidedly the noblest painting in the collection," "The U. S. Frigate United States, capturing the British Frigate Macedonian" (relating to two known views of this battle, figs. 1-13 and 2-18), both subjects taken from James Fenimore Cooper's recent *History of the Navy*. This body of marine paintings, which will be studied more closely in Chapter Two, creates a core of work defining Chambers' style and his interests about 1845, as well as his primary artistic identity.

More confusing are the related marine subjects in the Newport sale listed without any attributed artist, such as the scenes from Cooper's *The Red Rover* and Marryat's *The Pirate*, uncredited but suspiciously reminiscent of the titles in Chambers' New York auction of 1837. Also anonymous were additional views of New York harbor, Long Island, with the wreck of the *Bristol* (as in fig. 1-9), Annapolis roads (perhaps akin to fig. 1-11), and "Nahant, from Lynn Beach, the Royal Mail steam ship Britannia, running in for Boston" (suggesting fig. 2-11), all paintings that

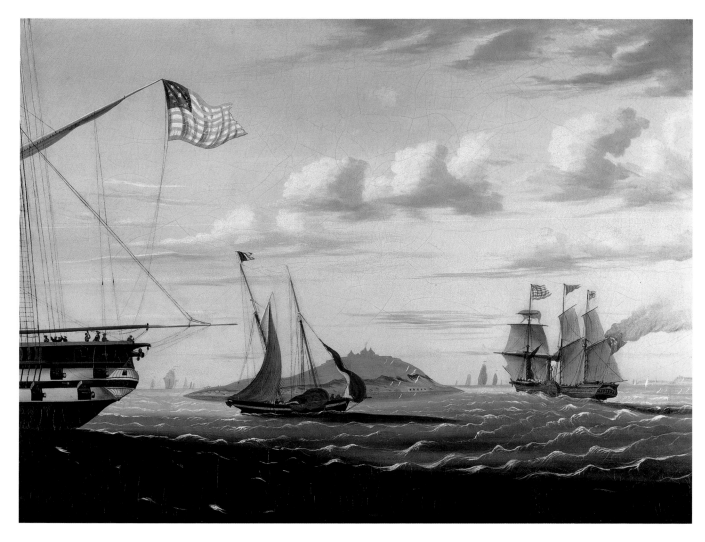

FIG. 1-12 Thomas Chambers. *Boston Harbor*, c. 1843–45. Oil on canvas, 22¼ x 30⅛ inches (56.5 x 76.5 cm). Addison Gallery of American Art, Phillips Academy, Andover, Mass. Museum purchase, 1959.13

clearly relate to the first group of works credited to Chambers in the sale as well as to extant paintings attributed to him today. Looking further down the list of the sixty-six paintings sold in Newport that day, a striking number can be tied to subjects now linked to Chambers, although these paintings—of Niagara Falls, West Point, Washington's Virginia birthplace, Italy, and Scotland—are sometimes anonymously listed in the broadside, or given to other painters, such as "Mr. Corbin of London," "Mr. Nesbit, of London," "Roberts," and "J. Miller," all of them obscure.

Just as the entries in this sale can suggest the original titles of certain familiar Chambers subjects, these same listings open a host of new questions about Chambers and his circle, investigated more closely in Chapters Two and Three.

The correlation of items sold in the Newport auction with known works—often extant in multiple versions—also introduces Chambers' method of favorite or successful images, perhaps his own compositions but more often subjects borrowed from print sources, such as the landscape views of William H. Bartlett.

These repeated, undated versions make it hard to determine which paintings may have been the ones sold in Newport, when he began to paint a given subject, and how long it remained in his repertory. The only signed and dated painting from the Boston period, The "Constitution" in New York Harbor of 1847 (see fig. 2-7), confirms the currency of his New York views five years after he left Manhattan.[58] However, the auction listing allows us to say with certainty that he—or his studio—was producing this set of landscape and marine paintings by 1845.

Albany, 1851–c. 1857

Chambers moved to Albany, New York, by May 1851, in time to get a listing in *Hoffman's Albany Directory, and City Register*, where he was recorded as an artist at 387 Lydius (now Madison) Street. His address, between Dove and Lark streets, was in the newer part of town, on the southwestern edge of the city, away from the river. At the same address that year lived one George Chambers, a clerk, who subsequently disappeared from the Albany directories; maybe this was a relative from England, or a son—perhaps the boy recorded in the census of 1840, now old enough to work, and evidently old enough to leave home the next year. In the 1852 directory, Chambers' address is further north, at 343 State Street, between Swan and Dove, just two blocks west of the capitol. His home was a two-story brick house, next door to a woodshop, in a bustling district of hotels serving visiting merchants, politicians, and tourists. He remained there at least until 1857, the last year he is listed in the Albany directory, and he must have been at this address in the city's Ninth Ward when he was recorded by the New York State census of 1855. This survey noted with reassuring preciseness the presence of the artist Thomas Chambers, age forty-seven, and Harriet Chambers, forty-six, both from London, along with Sarah Wright, age nineteen, a domestic servant who had arrived from England three years earlier.[59] From this profile, as well as the value of the house ($2,500), Merritt concluded that Chambers was prosperous in Albany, but closer study of the census and tax records shows that he was a renter, not an owner, of this property. In this light, Sarah Wright could well have been a lodger. His neighbors, in any event, were mostly other immigrants, German, Irish, and Dutch, renting quarters in this new commercial district.

Albany, proud to call itself in 1845 the "oldest city in the United States," had grown to a population of about fifty thousand by the time Chambers arrived. The city also hosted a flood of transients each year, including citizens interacting with the state government, vacationers in search of picturesque scenery, businessmen and merchants using Albany's nexus of canal, turnpike, rail, and river corridors, and thousands of westward-bound immigrants.[60] Amidst the bustle of politics and commerce, the cultural life of the city was blooming: Jenny Lind sang in Albany in 1851; Emerson lectured there the year before; a gleaming new cathedral was dedicated in 1852; and a prestigious observatory opened in 1856. The city's artists also had reason to cheer, as new rooms opened on State Street in December 1851 for the Young Men's Association, which became heir in 1854 to the collections and exhibitions of the defunct Albany Gallery of Fine Arts.[61]

Prone to lose its most ambitious artists to New York City, Albany held few landscape painters for long, but Chambers arrived to witness the emergence of the two Hart brothers, both born in Scotland. William and James M. Hart came to the United States in 1831 as children, and both were apprenticed to coach and sign painters. William toured as an itinerant portrait painter before returning to open a studio in Albany in 1847 and begin teaching at the Albany Academy. The following year his brother James announced himself in the Albany city directory as a "landscape painter." Both brothers spent time in Europe around 1850, but returned in 1852 to Albany before departing for New York, William in 1853, followed by James in 1856. Like many native and immigrant painters, the Harts put their sign-painting tradition behind them after a tour of Europe, which focused their professional identity as academic painters. Their work in this early period shows some of the flatness and clean color of ornamental painting but fundamentally aspires to the dainty and atmospheric style of their Hudson River School models, particularly Asher B. Durand.[62]

Chambers' style was well established by this time, and he seems to have responded little to the work of the Harts or other painters who exhibited in Albany in this period. As in New York and Boston, he evidently never showed his work in the genteel arenas of the Young Men's Association or the Albany Academy, nor is he mentioned in the accounts of Albany artists given in the gossip columns of the *Crayon*. His only dated painting from the Albany period sought different territory, asserting command of a genre pursued by no resident artist—historical marine painting. *Capture of H.B.M. Frigate "Macedonian" by U.S. Frigate "United States"* (fig. 1-13), signed "T. Chambers/ 1853," is one of the artist's largest paintings, clearly involving special effort and a special occasion. Merritt speculated that it "was done as a pictorial show piece for Chambers' Albany establishment," or as a "commemorative commission," reflecting the news given in the *Albany Evening Journal* of July

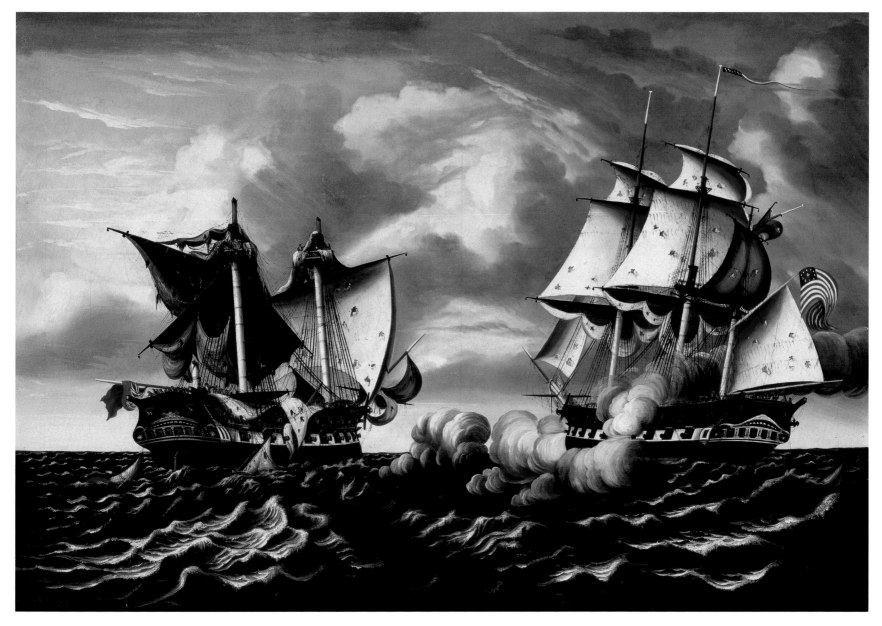

*FIG. 1-13 Thomas Chambers. *Capture of H.B.M. Frigate "Macedonian" by U.S. Frigate "United States," October 25, 1812,* 1852 or 1853. Oil on canvas, 34⅞ x 50¼ inches (88.6 x 127.6 cm). Smithsonian American Art Museum, Washington, D.C. Gift of Sheldon and Caroline Keck in honor of Elizabeth Broun, 1992.18

2, 1852: "The famous *Macedonian* is no longer a frigate. She has been cut down and rebuilt at the Brooklyn Navy Yard as a corvette, and is to be named the *Raleigh*."[63]

Within months, the Navy Yard was also hosting the most famous veteran of the War of 1812, the *Constitution*, now the flagship of a squadron preparing for departure to Africa.[64] The refitting of both ships coincided with the fortieth-anniversary celebrations of the war, still warm in the memory of old New Yorkers. Recollections of the capture of the *Macedonian*, the first prize ship taken by the United States Navy and brought in triumph to New York in December 1812, offered an occasion to forget contemporary discord and relish the past humiliation of the greatest navy in the world by the tiny upstart American fleet. Their exploits were remembered in Albany on February 3, 1853, when a hundred "survivors of the campaign of 1812 arrived from New York," and joined by "38 Albany comrades," paraded in the street, accompanied by "Republican artillery." The following day, the governor addressed the entire group of veterans at the capitol.[65] It is not hard to imagine that one of the Albany survivors, perhaps from the crew of the *United States*, now sixty-odd years old and a commercial success, commissioned Chambers' painting to remember their glory days and mark this reunion.

Chambers' reasons for moving to Albany can only be conjectured. Perhaps, if his business of landscape painting needed new pastures, farther from the more sophisticated market of New York, Chambers felt that Albany, with its mix of commerce and tourism, would make a good base for his marketing of Hudson River views. The pattern of discovery of Chambers' work in the twentieth century, across upstate New York from Rochester and Syracuse to Lake George and down the Hudson River Valley, inspired early theories about his itinerant sales in the countryside, and Albany may have been his winter studio. Following the practice of his Newport auction, he is said to have held an auction sale at a hotel in Albany in the mid-1850s.[66] This sale, or something quite like it, inspired a mocking letter in 1855 to the New York art journal the *Crayon*, but Chambers was never mentioned.[67]

New York Again, 1858–66

Chambers was back in *Trow's New York City Directory*, published in May 1858, listed as an artist at 148 Spring Street, west of Wooster. He disappeared from the directory in 1859 and 1860, but emerged next door at 150 Spring Street in 1861. This gap in the listings may suggest that he was on the move again, although he seems to have been living at the same address in June 1860 when the federal census taker came around. This census interview, more detailed than earlier records, notes two children (Samuel and Margaret) in the household and several other families in the building. Housed on the top floor, above a milliner and fancy store run by four Irish women, the Chamberses were the poorest of the five families in this building, with even fewer assets ($500) than Wallace Wallace, an obscure poet who lived with his family on the floor below. Apart from Wallace, no other artists lived under this roof, although an inscription on the back of Chambers' *View o[n] the Rhine* (collection Joan Brownstein) grandly asserts a studio of "European artists" at this location.[68]

In this last New York period, Chambers' life must have been darkened by the illness of his wife, Harriet, who died of consumption at St. Luke's Hospital on July 28, 1864. St. Luke's was a new and modern hospital on Fifth Avenue at Fifty-fourth Street, in an elegant neighborhood far above the artist's address on White Street, near Canal. Run by the Episcopal Church for the express benefit of "the sick poor, without distinction of race or creed," the hospital welcomed Irish and English immigrants. Most of the patients were treated for injuries—like the street fighters in the draft riots the previous summer—and they did not stay for long. St. Luke's could not offer space to those with long-term, incurable, or infectious illnesses, accepting only those who were in crisis, so Harriet Chambers must have been very ill when she was admitted.[69] One of the most fatal diseases in the city in this period, tuberculosis killed people from all classes, although it was already recognized as a by-product of the crowded, damp, and airless tenement housing of the poor. Harriet's death in a charity hospital implies both poverty and grim housing for the whole family in the preceding years. Her burial in Green-Wood Cemetery, Brooklyn, tells a similar story, for though the New York death registry records the interment, her grave was unmarked, and the site cannot be identified today.

The two children listed in the census of 1860 also disappeared: Margaret, age fourteen, may have married before the commencement of indexed records in 1866; no death record under her maiden name appears in New York municipal archives. Samuel, listed in the city directory as a twelve-year-old apprentice carpenter in 1860, may have enlisted in the army six weeks after his mother's death and perished in South Carolina from disease, three months before the conclusion of the Civil War.[70]

Chambers acknowledged the war in his paintings, returning to the genre of naval battles to paint at least two subjects, *The U.S.S. "Cumberland" Rammed by the C.S.S. "Virginia"* (see fig. 2-21) and *The "Harriet Lane"* (unlocated).[71] The Union revenue cutter *Harriet Lane* (named in 1857 after the niece of President

James Buchanan, who served as First Lady) saw wartime action along the Atlantic coast and up the Mississippi River to Vicksburg. The capture of the ship in Galveston harbor on January 1, 1863, provoked headlines in Northern newspapers and many wood engravings, one of which surely inspired Chambers' last datable painting. Perhaps the name of the ship made it a sentimental favorite, or perhaps—along with the battle of the *Cumberland* and the *Virginia*—the painting was a last instance of work done to order for an interested client.

Chambers' last address in New York, at 3 Mott Street in 1865, was near Chatham Square, a famously boisterous intersection of transit, auction houses, theaters, and rowdy street politics that hints at his sinking fortunes. Most of his earlier addresses had been east of Broadway, on the then more affluent and respectable side of the city, but his last two residences drew close to the notorious slums west and north of City Hall, centered on the famous Five Points and the Bowery.

Return to Whitby, c. 1867–69

Chambers disappeared from New York City after 1866; apparently, he returned to his birthplace in England sometime between his last directory listing and the notation of his burial in Whitby, November 26, 1869. His name does not appear in Whitby directories before this date, but he may have had family members still in the area.[72] Whitby in the 1860s, with a population of about twelve thousand, must have seemed cozy after the bustle of New York, but Chambers appears to have been in no condition to enjoy the opportunities of its working harbor or its growing tourist industry, which would make the seaside towns around Whitby and Scarborough a magnet for artists. Instead, he was helpless and indigent enough to apply for admission to the Union Workhouse.[73] He would have known this "House of Industry" as a child, although it had been enlarged and "improved" in 1858. Still, it was an austere place, intentionally meant to deter able-bodied registrants. Dreary labor, monotonous food, and rough uniforms made for a Dickensian environment. "Entering its harsh regime and Spartan conditions was considered the ultimate degradation,"[74] so that most of the long-term residents in this period were aged, infirm, or insane.

The Larpool Cemetery workers recorded Thomas Chambers' burial in their ledger, noting him as an artist, age sixty-one.[75] The official registration of his death on November 24, ultimately filed in London, offers other sad details. Although he had insisted on his identity as an artist in American records for more than thirty years, the workhouse informant gave Chambers' occupation as "Seaman (Merchant Service)." More depressing, the cause of death was given as "softening of the brain" and "paralysis."[76] This last, forlorn government record may offer a final clue to how Chambers began his career, how he made it to the United States, and how he earned his way back to Whitby after 1866. Surely this listing suggests the bleak end of his life, alone and helpless in the poorhouse. Raised in poverty and resident of some of the most congested working-class neighborhoods in England and the United States, Chambers evidently suffered, like his wife and his brother, the ills summed up by John Neal's observation in 1838: "It is a thankless calling, and at best a precarious one, that of a landscape painter in our day."[77]

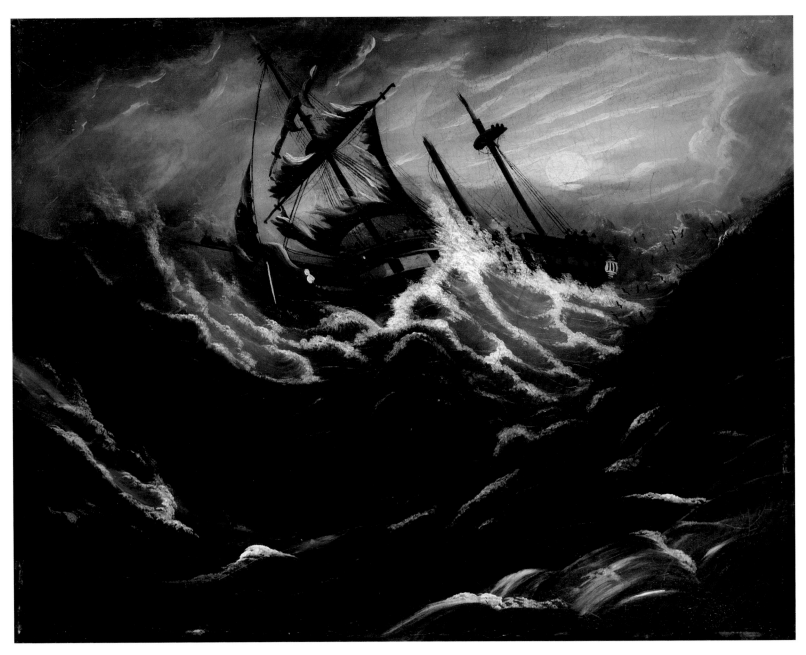

*FIG. 2-1 Thomas Chambers. *Ship in a Storm*, c. 1836–45. Oil on canvas, 13¾ x 17¾ inches (34.9 x 45.1 cm).
Indiana University Art Museum, Bloomington. Morton and Marie Bradley Memorial Collection, 86.27.10

MARINE PAINTER

To the audience of his own day, Thomas Chambers presented himself principally as a marine painter: Only a few of his paintings are signed and dated, and all of those depict naval battles or shipping.[1] From his earliest dated work of 1835 to his last known subject, the capture of the *Harriet Lane* in 1863, Chambers held to this professional identity, shaped by his childhood in Whitby and the example of his brother, the English marine painter George Chambers. From the days of the van de Velde family, who brought marine painting from Holland to England in the seventeenth century, British sea painters have typically come from seagoing families. Chambers' commitment to, as well as his competence in, depicting nautical subjects suggest both a childhood at the water's edge and personal experience as a mariner.[2] Although he was first described in the New Orleans city directory of 1833 as a painter, and then listed in New York as a landscape painter from 1834 to 1837, no extant landscape paintings attributed to Chambers can be securely dated to this early period. However, from 1835 to 1837 he advertised in the *New-Yorker* as a "marine and landscape painter," and then listed himself exclusively as a marine painter in city directories from 1838 to 1842. In 1843, about the time his interest in landscape subjects increased, he began to identify himself more generally as an artist, but even so, the Newport auction of 1845 showcased only marines under his name, and major naval subjects dating from the 1850s and 1860s indicate his continuing interest to the end of his career.

Early Work

Chambers' debut in New York at the American Institute's fair in the fall of 1834 involved a marine subject in watercolor, perhaps *Ships in a Choppy Sea* (see fig. 1-5) or something very like it. The practiced handling of the subject and the medium in this composition connect nicely to the work of his brother, who was elected to the Old Water-Colour Society in London at about this time with similar but more sophisticated watercolor views of English shipping (see fig. 1-6). While anticipating his later harbor subjects in oil, the basic organization and style of Thomas' view calls up the larger legacy of his brother's work and the mainstream marine painting tradition in England in this period. He could have learned all the components of this painting from his brother—the three-quarters perspective of the ship, the mannerisms of handling water, clouds, and distant vessels—but these conventions were so widely held that it is difficult to pinpoint his models.

Looking from this watercolor to Chambers' more stilted oil from the following year, *Cutting Out of His B.M.S. "Hermione," from the Harbor at Porte Cavallo* (fig. 2-2), we might consider the idea that he was trained in watercolor and that he took up oils after arriving in the United States. Certainly there was no popular following for watercolor in the country at this time, as there was in England, where watercolor societies and annual watercolor exhibitions enjoyed prestige and support. Chambers, in a pattern typical of his entire career, seems to have taken a more commercially viable path. This first known signed and dated oil painting, of 1835, known only from a murky photograph, offers a tantalizing glimpse of his earliest work.[3]

The story, a pulse-pounding tale of the stealthy midnight recovery in 1799 of a British ship held by the Spanish in the harbor of Puerto Cabello in Venezuela, would not seem to have been topical in New York four decades later. However, the captain and crew of H.M.S. *Surprise* were remembered for their audacious action, "as daring and gallant an enterprise as is to be found in our naval annals."[4] Perhaps the painting was commissioned by someone with ties to the event who delighted in the details given in the calligraphic inscription on the back of the wood panel: "Cutting out of his B.M.S./ Hermione from the Harbour at/ Porte Cavallo by Capt. Hamilton/ With 100 Men Octr. 25th 1799 Under a Continued [*sic*]/ with 300 Spaniards on Board." This elaborate inscription, followed by the artist's signature, "T. Chambers," and the date within a fluttering banner, is unique in his surviving work. The wood panel, also unusual in Chambers' extant work, and the

FIG. 2-2 Thomas Chambers. *Cutting Out of His B.M.S. "Hermione," from the Harbor at Porte Cavallo*, 1835. Oil on panel, location unknown. Photograph courtesy Historic New England, Boston. Nina Fletcher Little Papers

variety and decorativeness of his curly calligraphy on the verso hint at the "fancy painting of every description" that he advertised this year, which might have included decorative sign painting. By far, it is the longest text in his hand to survive.[5]

More typical of Chambers is the use of a print source for this composition, in this case, an aquatint after the English marine painter Thomas Whitcombe, an artist admired by George Chambers, who owned one of his paintings.[6] His work would have been familiar to many marine painters and naval history buffs because of the book that contained this print, James Jenkins' lavishly illustrated *The Naval Achievements of Great Britain, from the Year 1793 to 1817*, first published in London in 1817 and reprinted in 1820 and 1835. The fifty-five prints in this book, describing the greatest exploits of the British navy during the Napoleonic era, must have served as a primer in marine battle painting for many artists, and Chambers seems to have mined these plates for years. His student status in 1835 shows in his timid handling in this painting, but the running ripples of the harbor water and

the characteristic treatment of the stern gallery of the ship will be seen in his battle and harbor scenes to come.

Literary Marines

No other work survives that can be securely dated to the 1830s, although the advertisement for the Levy auction in April 1837 indicates that Chambers produced "a number of sea pieces" that were the featured part of the sale, including four paintings from Captain Frederick Marryat's *The Pirate*.[7] These Marryat subjects, like the artist's depiction of headline news seen in *Rockaway Beach, New York, with the Wreck of the Ship "Bristol"* (see fig. 1-9), reveal an imagination and entrepreneurial initiative seen in few other American marine painters of the period. Marryat, who was described the previous year as the most popular author in the United States, could claim to be one of the inventors of the modern sea story.[8] Following the success of a first novel based on his own action-packed career in the Royal Navy, Marryat retired in 1829 to continue writing. Loved for his sailor's eye for detail, his humorous characters, and his down-to-earth style, Marryat delighted an enormous audience fed by inexpensive pirated editions and serial publication in American periodicals. While opinions differed over his literary merits, few disputed his entertainment value: "No living writer has afforded more amusement to Americans than Captain Marryat."[9] Even so, among living American marine painters, only Thomas Chambers rose to illustrate Marryat's work.

The Pirate, published in 1836 along with Marryat's best-loved novel, *Mr. Midshipman Easy*, offered readers melodrama on the high seas. Separated in infancy by a shipwreck, twin brothers are drawn into confrontation as one advances in the navy while the other is raised by the villainous captain of the pirate ship *Avenger*. The disaster that opens the story, a storm that dismasts the ship *Circassian* and divides the twins en route to Liverpool from New Orleans, offered classic opportunities to a marine painter. Two extant paintings attributed to Chambers, *Ship in a Storm* (fig. 2-1) and *Storm-Tossed Frigate* (fig. 2-3), suggest the distressful circumstances likely to have been depicted in his *Pirate* subjects. Remarkably, these compositions do not follow the lead of the lone source of inspiration for such imagery, found in the plates of the first edition of *The Pirate*, the first of Marryat's works to be illustrated. Designed by the author's friend Clarkson Stanfield, one of the greatest marine painters of the period, these illustrations must have been familiar to Chambers, who probably knew Stanfield by reputation, if not by association with

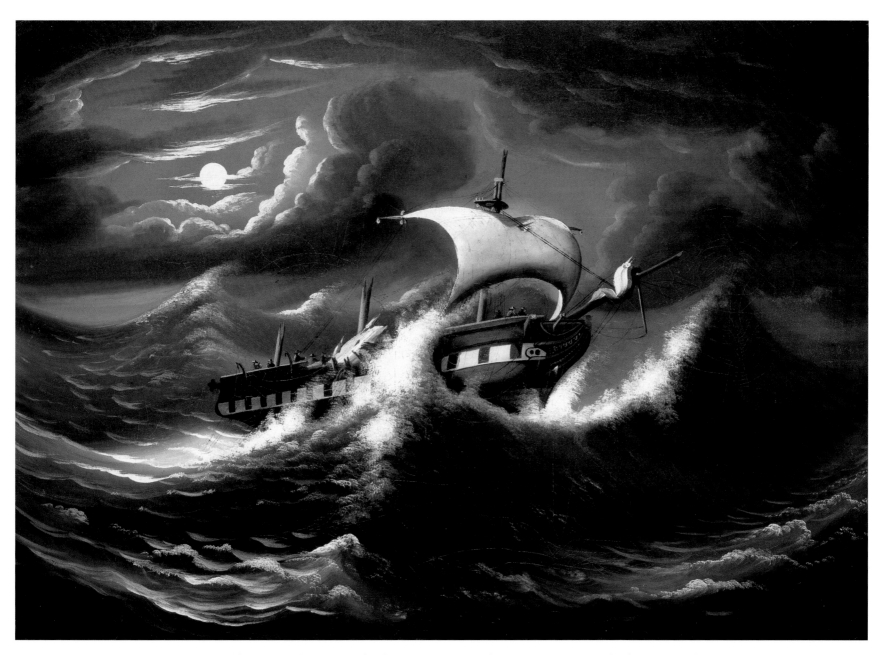

*FIG. 2-3 Thomas Chambers. *Storm-Tossed Frigate*, c. 1836–45. Oil on canvas, 21⅜ x 30⅜ inches (54.4 x 77.2 cm).
National Gallery of Art, Washington, D.C. Gift of Edgar William and Bernice Chrysler Garbisch, 1969.11.1

his brother in London; surely he noticed Stanfield's great moving panorama, which played in New York at Niblo's Garden in July 1836.[10] Like George Chambers, Stanfield represented the fluidity of the visual arts in this period, moving up from the world of a coach painter and sailor, and then sweeping across the realms of Royal Academy painting, illustration, scenographic design, and popular spectacle with equal success.[11] Stanfield's example may have been inspiring, but evidently his illustrations to *The Pirate* were too well known to copy exactly; perhaps, with their complex perspective and larger figures, they were also too sophisticated. The only specific title known from Chambers' series, "The Burning Ship, from Capt. Marryats Pirate" (listed as no. 50 in his 1845 Newport sale, perhaps a fresh version of one of the four subjects sold in 1837), indicates a composition unlike any of Stanfield's illustrations. Such a title suggests a strategy that aimed to be original, topical, and, like the storm-tossed ships, appealingly generic.

The difficulty in identifying extant stormy marines by Chambers with the Marryat *Pirate* subjects is increased by this generic quality as well as by the appearance in his 1845 auction sale of other, equally likely titles, such as no. 62: "The ship John Quincy Adams, scudding in the Atlantic, after loss of main, mizzen and foretopmasts. A very spirited sea piece." The possibilities also proliferate with the introduction of new literary themes in this sale, such as pictures from another, equally stylish contemporary author, James Fenimore Cooper. Included in the sale (and, like all these titles, unattributed to any artist) were no. 35, "The Red Rover, making sail after taking on board, Gertrude, Mrs. Wyllys, Wilder and Cassandra, from the launch of the foundered Bristol trader Royal Caroline, (from Cooper's Novel of the Red Rover)," and no. 36, "The Red Rover passing the Bristol trader in the night. Companion to 35, a pair of very spirited original sea pieces."

If Marryat was, as one writer put it in 1856, "the *King* of the naval novel" in Great Britain, then James Fenimore Cooper was "the EMPEROR of the naval novelists" worldwide. Deemed a national treasure in the United States, Cooper was also widely respected internationally, an anointed genius recognized as a more "gorgeous" if perhaps less naturalistic writer than his competitor Marryat, who learned from Cooper's innovative precedents.[12] Like Marryat, Cooper could draw on personal experience at sea, and his stories were awash in nautical argot and barnacled characters that delighted a citizenry thrilled by the country's recent emergence as a naval power. With an audience already devoted to his novels set in the American landscape, Cooper presented *The Red Rover*, the second of his major sea novels, to eager British readers in 1827. Publication in the United States in 1828 was followed almost immediately by a stage play of the same name in Philadelphia, and it was not long before ships and racehorses were christened Red Rover in honor of the dashing eighteenth-century pirate at the center of his adventure. Packed, much like *The Pirate*, with mysterious characters, storms, shipwrecks, a rip-roaring naval battle, and emotional scenes of repentance and long-lost relatives reunited, *The Red Rover* was simultaneously moralizing, patriotic, sentimental, and hugely entertaining.

Unlike Marryat, Cooper often saw his texts inspire American artists, perhaps because his subjects embraced national landscape themes, or because his work was generally held to be more literary and artistic than Marryat's.[13] Before his death in 1851, several of the leading lights of the New York art world—particularly Thomas Cole and William Dunlap, but also Thomas Doughty, Thomas Sully, John Quidor, George Harvey, and other lesser-known artists—had exhibited works based on Cooper's novels and tales. But few American painters took up his sea stories, nor were the books themselves illustrated, until the subjects turned up in Chambers' auction sale of 1845.[14] Unusual in his enthusiasm for literary marines, Chambers also may have been astute enough to direct these subjects to collectors in Newport, where Cooper had set the opening chapters of *The Red Rover*.

From their titles, the pair of Cooper-inspired paintings in the Newport sale would have depicted the Red Rover's sinister ship, the *Dolphin*, and her desperate prey, the ill-fated *Royal Caroline*, a Bristol trader foundered by a powerful squall. Following the description of this pair, two marines attributed to Chambers that emerged together in the twentieth century bearing titles from *The Red Rover* may be related to the paintings sold in 1845: The same sleek ship appears in both, first in sunlight with a wreck in the distance, and then in stormy moonlight, passing behind a struggling vessel in the foreground.[15] Although much more generic, *Ship in a Storm* (fig. 2-1) and *Storm-Tossed Frigate* (fig. 2-3) might also be read as the beleaguered *Royal Caroline*, her rail lined with anxious figures in broad-brimmed hats, scanning the horizon for the terrifying "ghost ship" that the reader knows to be led by the predatory Rover.[16]

Whether a narrative from Marryat or Cooper can be read in these paintings, at least *Storm-Tossed Frigate* seems to have been modeled on an engraving in the popular gift book *The Token and Atlantic Souvenir* of 1834 (fig. 2-4).[17] Such a source reveals Chambers trolling popular literary publications as well as view books, journals, and newspapers for inspiration, transforming these prints into more topical contemporary images. Chambers' modernization of the seventeenth-century ship ("after van de Velde") is the least of his alterations, as his swinging rhythms reshape

FIG. 2-4 John B. Neagle (American, 1796–1865), after Willem van de Velde the Younger (Dutch, 1633–1707). *The Night Storm*. Etching. From *The Token and Atlantic Souvenir*, 1834 (Boston: Charles Bowen, 1833), opp. p. 195. The Library Company of Philadelphia

the sea and sky into a vortex of energy. His small figures dotted with red and blue, and the painting of the ship itself, with its snapped masts touched in red, are in the style of *The Wreck of the "Bristol,"* showing the same swirling clouds, streaked and dabbled foam, and olive-tinted water, which build an effect we begin to recognize as Chambers' own, setting him apart from amateurs or more faithful copyists. But most characteristic of all are the sweeping curves of the composition that loop around the tiny ship and its dramatic light source. The effect is theatrical and decorative, representing the dangers of the sea in miniature, both simplified and exaggerated, satisfying to contemplate with a pleasant shudder but not really frightening. Comparing Chambers' work to the more naturalistic storm and shipwreck subjects of his contemporaries, including Thomas Birch, or the sublime effects of the Vernets in the eighteenth century, or the work of the fathers of the genre in seventeenth-century Holland (such as the van de Veldes)—the legacy of this tradition, as well as the departure from it, is striking. Remembering Chambers' offer to make "fancy painting of every description," one might categorize these works as the fanciful treatment of a storybook ship in a storm.[18]

Harbor Views: Images of Sail and Steam

Chambers' decision to list himself as a marine painter in 1838 followed his probable return to New York from Liverpool in December 1837 and the launch of a new age of rivalry between steam and sail in transatlantic shipping. We can speculate that the happy response to his marines in the Levy sale of 1837, possible renewed contact with his brother in England, or perhaps another sea crossing stirred his imagination and renewed his conviction as a marine painter. Whatever the reasons, his eye seems to have fallen on ships like the *Sheffield*, which brought him from Liverpool—transatlantic packets that sailed on regular schedules between American ports and northern European harbors.

By the time of Chambers' Newport auction in 1845, these vessels had become an important part of his repertory. For a marine painter, the packets offered a generic class of vessels appealing to a wide audience of potential patrons. The most familiar repeat visitors to the major ports, these ships were the sturdy protagonists of an intensely competitive business that involved many proud owners, hundreds of hardworking seamen, and thousands of immigrants. The race to give fast, reliable, comfortable, and inexpensive passage across the Atlantic engaged many admiring onlookers. "The noble American vessels have made their packet service the finest in the world," noted Charles Dickens in 1842, when he crossed to New York. By the following year, there were twenty-four packets working the New York–Liverpool line alone.[19]

Packet Ship Passing Castle Williams (fig. 2-5) illustrates the classic type in the glory years of the 1840s: a three-masted square-rigged ship, belted by a white stripe with painted gunports to mimic—at least from a distance—the threat of an armed vessel. Sailing past Castle Williams on Governor's Island, with Staten Island in the distance, the ship heads for the wharves on the Hudson River just north of Manhattan's Battery Park. Perhaps this painting depicts the packet ship *George Washington*, in service between New York and Liverpool from 1832 to 1845 for the Fourth, or Swallowtail, Line,[20] seen in no. 11 in the Newport auction: "New York bay, with a fine view of Staten, Governor's and Bedlow's Islands, the George Washington, Liverpool packet ship, homeward bound, taking in sail to anchor,—one of the finest pictures in the collection, painted by Mr. Chambers of New York." Further down the list in the Newport sale was a pendant, no. 17: "George Washington, New York and Liverpool Packet ship, outward bound, leaving Sandy Hook, outer Bay of New York,—a very lovely sea piece, and perfect likeness of the ship (companion to

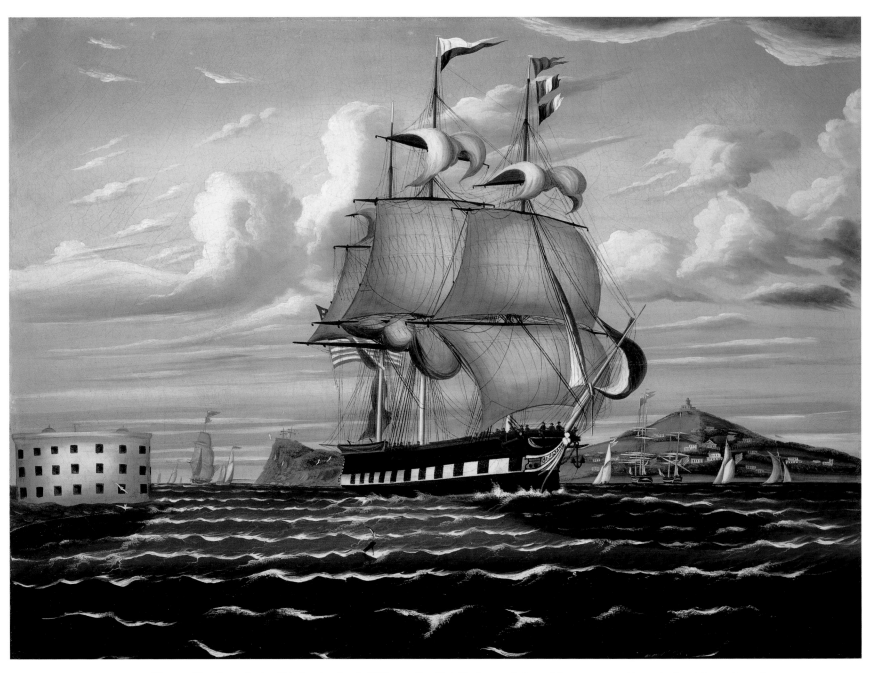

*FIG. 2-5 Thomas Chambers. *Packet Ship Passing Castle Williams, New York Harbor*, c. 1838–45. Oil on canvas, 22¼ x 30 inches (56.5 x 76.1 cm).
National Gallery of Art, Washington, D.C. Gift of Edgar William and Bernice Chrysler Garbisch, 1980.62.5

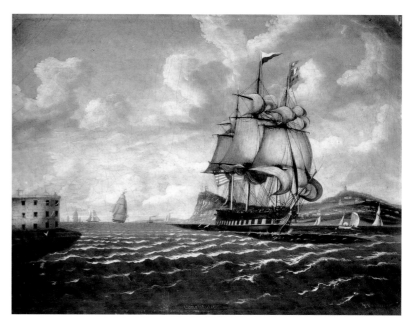

FIG. 2-6 Thomas Chambers. *The Ship "George Washington,"* c. 1838–45. Oil on canvas, 21 x 30 inches (53.3 x 76.2 cm). Rhode Island Historical Society, Providence. Gift of Robert P. Brown, 1905.8.1

FIG. 2-7 Thomas Chambers. *The "Constitution" in New York Harbor [New York Bay, Liverpool Packet Ship Homeward Bound?],* 1847. Oil on canvas, location unknown. Photograph courtesy Frick Art Reference Library, New York

No. 11)." The identity of the packet ship passing Castle Williams (fig. 2-5) might be confirmed by comparison to *The Ship "George Washington"* (fig. 2-6), also attributed to Chambers, showing a similar packet setting out from Liverpool, passing the distinctive Perch Rock Fort and Lighthouse at the top of the Mersey. This ship carries a pennant with the ship's name, "G. Washington," on the mainmast—a rare occasion in Chambers' work when the ship is so explicitly identified—and the same white bust-length figurehead, no doubt a portrait of the first president.[21]

The exact painting that sold as no. 11 in 1845 may be difficult to determine, because it was one of Chambers' most popular subjects, and many variants survive. Seven related paintings, all in the track of *Packet Ship Passing Castle Williams,* include *Threatening Sky, Bay of New York* (see fig. 1-10) and the so-called *"Constitution" in New York Harbor* (fig. 2-7), which is the only one in the series signed "T. Chambers" and dated 1847.[22] All show a foreshortened starboard view of a ship against a perspective of New York harbor from lower Manhattan, with the battery of Castle Williams on Governor's Island at the left. But the details differ: The

cylindrical fort with its rows of gunports is more or less cropped, the shipping in the harbor changes, a snippet of Bedloe's Island sometimes appears at the right, and—most dramatically—the weather and times of day alter from a breezy, blue sky to a calm, pink sunset or sunrise.[23] The ships also display different signal and house flags—mostly unidentified and quite possibly meaningless—and show different amounts of sail stowed as the ship comes into port.[24] Chambers' success in depicting the weight and forward motion of the ship varies as well: Sometimes it rides in, sometimes on the water, which likewise modulates from opaque to more translucent in the different versions. A parallel series of four related New York harbor paintings from the same vantage point, best represented by the National Gallery of Art's *Bay of New York, Sunset,* depict a hermaphrodite brig from the port side, parallel to the picture plane, in various stages of setting or reducing sail; placed in sequence, they are like a stop-action series.[25]

Deborah Chotner, in her study of Chambers' paintings at the National Gallery of Art, found no print source to supply the basic compositional scheme that

underlies all of the New York harbor views. The variety of solutions within this format—as well as the description of this title as among the artist's finest works in the Newport auction listing—tells us that this was Chambers' original design, probably based on some on-the-spot study of the view and the shipping. He pursued this basic strategy of variations on a theme in many other subjects, either his own compositions or borrowed ones that had found popularity. He inserted many changes, small and large, to please himself and keep his work interesting, finding it faster and easier to improvise within a familiar format than to carefully replicate an earlier picture. In this pattern he was following the practice of generations of painters, folk and fine, responding to their market, such as Thomas Birch, who made numerous variant views of the harbors of both New York and Philadelphia beginning in the late 1820s (see fig. 4-9). As in Birch's paintings, perhaps Chambers' small alterations made each version arguably original and unique to each new customer.[26]

Speed of execution may play a part in the variety of styles seen in these harbor views. They range from the smaller, more delicate and atmospheric *Threatening Sky, Bay of New York* (see fig. 1-10), which is close to the effect of more conventional luminist marine painting of this period, to the broader, brighter *Packet Ship Passing Castle Williams* (fig. 2-5). It is tempting to postulate that the finer, more complex and patient renditions came first, the plainer, flatter versions later, but the whole series shares habits of painting throughout, such as the running ripples on the water, the handling of the details of the ship, and the propensity for active, multicolored sunset or twilight skies. Although the "threatening sky" may hint at the travails of shipping or the generally bleak economy that followed the financial crisis of 1837, the overall spirit of these harbor views seems upbeat, energetic, and orderly, representing to Americans a vision of commercial enterprise.

Other paintings of New York's harbor with the qualities of this core group may also be original compositions, such as *New York Harbor and Pilot Boat "George Washington"* (National Gallery of Art),[27] *Staten Island and the Narrows* (Brooklyn Museum), and an evidently popular string of at least six views of flaming skies behind Battery Park, such as *Sunset, Castle Garden* (Museum of the City of New York). Surely such an image sold at the Newport auction as no. 48—"Castle Garden and Battery New York," described as a "pleasing and also very beautiful" painting paired with its mate, no. 47, "Bay of New York, Governor's, Staten Islands and Shipping."[28]

While "Mr. Chambers of New York" was selling these views in Newport, he was recorded as living in Boston, so it is not surprising to find related views in this sale from that city as well as from Baltimore, where he had lived in 1842 (see fig. 1-11). Although none is signed and dated, familiar stylistic traits appear in a string of harbor views, including two scenes of Boston harbor (see figs. 1-12 and 2-8) that feature a steam packet at the far right, very likely the subject of the work sold in the Newport sale as a companion to a version of New York harbor such as *Packet Ship Passing Castle Williams* (fig. 2-5):

> 59. Boston Bay and Harbor, with a quarter view of the U. S. Ship Ohio, 74 guns, at anchor; the Royal Mail Steamer Hibernia, leaving port for Liverpool,—a splendid original picture, and matches New York Bay, No. 11 [by "Mr. Chambers of New York"].

This striking composition of Boston harbor, at once awkward and exciting, seems to have been Chambers' own design, and a popular one, for at least five versions have survived.[29] Looking more or less south from Charlestown and Boston toward the harbor's main shipping channel, the view centers on Governor's Island and old Fort Warren, looming with exaggerated importance in the distance. The surprising placement of the stern quarters of the *Ohio* in the foreground has the feeling of a stage flat projecting into the theatrical space of the harbor beyond; it may have been an idea that Chambers got from a 1799 print after Archibald Robertson, who similarly positioned the cropped bow of a ship against the skyline of New York, or from more recent work by Robert Salmon and Fitz Henry Lane (see fig. 4-10).[30] Cropping the stern instead of the bow, Chambers gains the view across the bustling deck right into the gunports of the *Ohio* and sets up the spectacular effect of the gigantic ensign on the stern gaff rippling in the dawn's early light. At the distant right, with all sails set, more flags flying, and smoke and steam (softened by the artist's fingerprints) pouring from her stacks, a British steamer heads out of the harbor while a schooner in the middle ground reduces sail. As in its New York pendant, *Packet Ship Passing Castle Williams* (fig. 2-5), both the sea and the sky are alive with activity. Long shadows slope across the water, and wave crests dance below a sweeping curve of clouds that circle deep into space, pointing to the invisible sun and the open sea. And as in the New York series, all the versions contain many variations in all parts of the canvas: Wave patterns and clouds are more or less subtle, details on the ships alter, and the stripes in the mid-ground vessel change, as do its flags and its amount of sail. In these changes in the schooner, we can read opportunities for Chambers to work "to order" for a patron pleased to see a favorite vessel set between two celebrities in the harbor.[31]

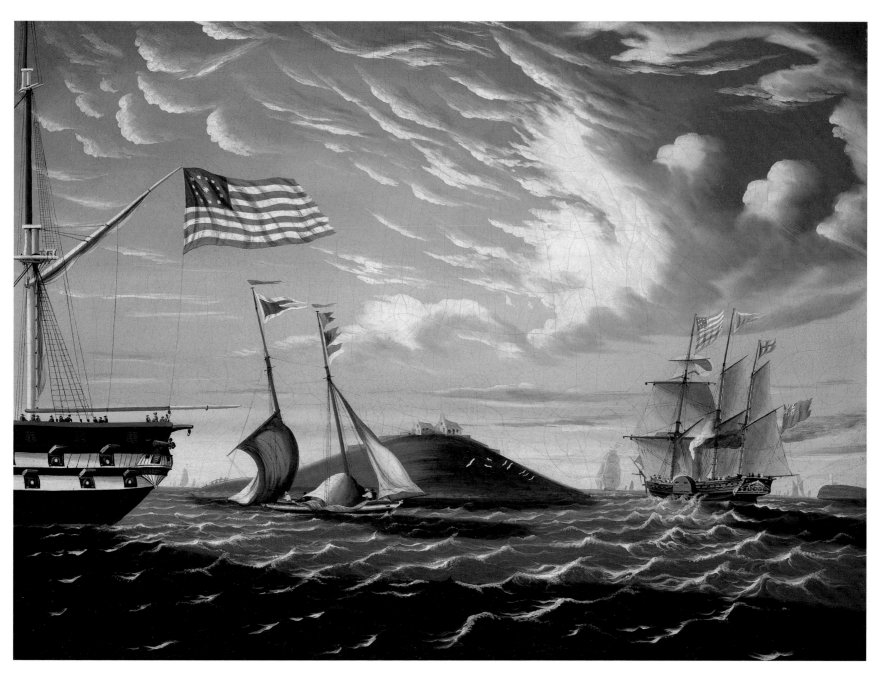

*FIG. 2-8 Thomas Chambers. *Boston Harbor*, c. 1843–45. Oil on canvas, 22 x 30⅛ inches (55.8 x 76.5 cm).
National Gallery of Art, Washington, D.C. Gift of Edgar William and Bernice Chrysler Garbisch, 1980.62.4

Launched in 1820 in New York only to molder "in ordinary," uncommissioned, the ship *Ohio* was refitted for service in 1838 and sent to the Mediterranean. Described as "one of the finest 74s in the world," fast and seaworthy, the *Ohio* returned to Boston in 1840 to become the pride of the navy yard at Charlestown just before Chambers arrived in 1842 and set up his household directly across the river. Probably he composed this image sometime after 1842 and before the Newport sale in 1845, but interest in the ship was renewed when the *Ohio* was called into service for the Mexican War in 1847, so versions of this composition could have been painted years later.[32]

The other star of *Boston Harbor*, the adorable little sidewheel steamer (which we might expect from the auction title to be the *Hibernia*), was a second headliner whose presence helps narrow the date of the composition. After 1838, when Samuel Cunard won a lucrative contract to carry the British mail, a suite of new steamships were built to run on schedule between Liverpool, Halifax, and Boston. The first, the *Britannia* (seen in figs. 2-11 and 2-13), crossed in July 1840 in record time, carrying passengers and goods in what was to be the primitive beginnings of the Cunard tradition of transatlantic ocean liners. The date of Chambers' composition might be narrowed by the heyday of the *Hibernia*, the first of the replacements for the original fleet and slightly longer and more powerful than the original group. Launched from Liverpool in May 1843, she held the "blue riband" for the fastest crossing to Boston at the moment when Chambers was selling his painting in Newport. A few weeks later, on July 30, 1845, the record was taken by the next Cunard ship, the *Cambria*, and three years later the *Hibernia* was transferred to New York.[33]

The competition between sail and steam became the subject of *Ships Meeting at Sea: The "British Queen" and an American Packet* (fig. 2-9), a painting that expresses the wrestling match in technology at a time when the winner was by no means clear. The early steam packets were famously unsafe and uncomfortable, but twice as fast as conventional sailing ships; the sailing packets remained less expensive, more commodious, and more frequently scheduled. Here, the two vessels awkwardly commune at close quarters, their captains shouting to one another through trumpets and their overlapped masts and flags visually tangled—much like the confusing layering of vessels in *Rockaway Beach, New York, with the Wreck of the Ship "Bristol"* (see fig. 1-9).[34] Equally at odds are the relatively sophisticated, naturalistic treatment of the water and the generic handling of the sky, although this same wide range in skill or effort also can be found in Chambers' harbor series and marine battle scenes, where different wave treatments appear, and skies vary

from radiant to woolly.[35] Likewise, the treatment of the figures and the handling of the ships—particularly the modeling of the sails—can be found in Chambers' other marines. The relative blandness of the setting and the palette, the static composition, and the unusually patient attention to the ships and the water show Chambers steering close to the course of conventional ship portraiture of the moment—best represented by Liverpool painters such as Samuel Walters, well known to Americans in the transatlantic trade.

In *Ships Meeting at Sea*, the sailing packet "speaking" to the *British Queen* carries an American ensign at its stern gaff, an unidentified blue and white swallowtail pennant on the mainmast, and the unmistakable broad red stripe of an American paint treatment. She flies several unidentified or nonsensical signal flags on the foremast and carries a red-haired figurehead bust holding aloft some object. Gleaming in the foreground at the expense of the steamer behind, this packet is clearly the protagonist of the composition, seemingly a celebrity, if only to its owners or the patron of the painting.[36] In a supporting role, the *British Queen* (named on her large red pennant and further identified by a full-length female figurehead) would have been a subject of greatest interest after July 1839, when she sailed on her maiden voyage from London to New York. The pride of the British and American Steam Navigation Company, she was the largest ship in the world when launched. With scale came the promise of luxury, and the ship recruited passengers by offering champagne en route, but the prestige of the *British Queen* was eroded by complaints of poor service, and bad publicity followed the loss of life in a pilot boat accident in 1840. The wish to be associated with the ship declined after this year, and she was sold to the Belgian government in 1842.[37] Most likely, Chambers' painting was inspired during the ship's brief reign between the summer of 1839 and May 1840, after which she was eclipsed by the launch of the "improved" sister ship from the same line, the *President,* probably painted by Chambers about 1841.[38]

The pace of competition was set for all these short-lived rivals by the most celebrated steam-powered ship of the age, Isambard Kingdom Brunel's *Great Western,* winner of the first transatlantic steamship race in April 1838 and the record holder until June 1841. Bigger, faster, and more elegant than any other passenger ship in the world, the *Great Western* was graced by a Gothic-style saloon painted with decorations by Edmund Parris, an artist who had employed George Chambers on the London panorama.[39] Challenged by the *British Queen* in 1839 and bested by a Cunard ship in 1841, the *Great Western* rallied to win back the blue riband in 1843, holding the prize until beaten again by a Cunard ship in 1845. The press on both

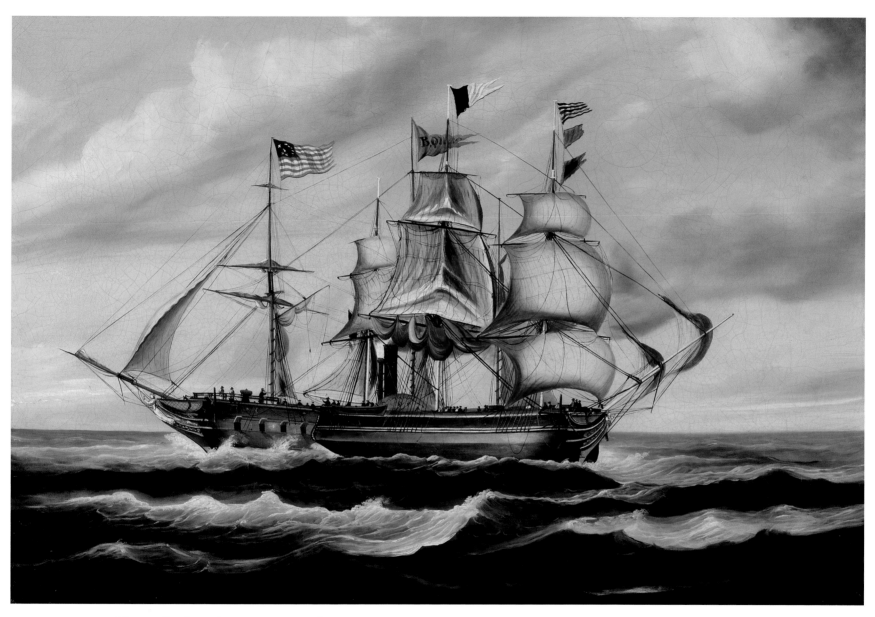

*FIG. 2-9 Thomas Chambers. *Ships Meeting at Sea: The "British Queen" and an American Packet*, c. 1838–40. Oil on canvas, 19¹³⁄₁₆ x 29⅝ inches (50.3 x 75.2 cm). Indiana University Art Museum, Bloomington. Morton and Marie Bradley Memorial Collection, 91.240

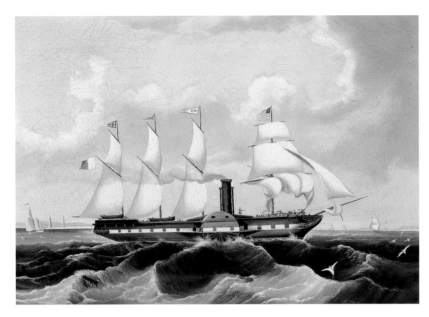

FIG. 2-10 Thomas Chambers. *Sidewheel Steamer "Great Western,"* c. 1838–46. Oil on canvas, 20 x 29 inches (50.8 x 73.7 cm). Peabody Essex Museum Collection, Salem, Mass. Museum purchase from the collection of Charles H. Taylor, 1949, M6531

sides of the Atlantic breathlessly followed the rivalry of these competing ships, their ambitious designers, and their enterprising companies, but the hands-down favorite in the visual record was the *Great Western.* Prints, paintings, and sheet music kept the ship a legendary presence, even after she was laid up at the end of 1846 and eventually sold into another route.

The familiar form of the *Great Western*, with its black hull, white wheelhouse with two oval vents, and the usual white stripe of false gunports (implausibly continued across the paddle-wheel housing), can be recognized in Chambers' several surviving views of this ship (such as fig. 2-10), one of which may have been no. 14 in his Newport sale: "The Great Western steamship leaving Sandy Hook, Bay of New York—a very delightful picture and perfect portrait of the ship, companion to No. 11."[40] Five similar versions of this composition, including *Sidewheel Steamer "Great Western"* (fig. 2-10), have emerged since 1949; four of them show the ship sailing from left to right, parallel to the picture plane, usually with two small lighthouses in the left distance. If they are indeed the twin lights of Sandy Hook, New Jersey, placed in operation in 1842, then the ship is inbound to New York, heading toward

the Narrows, and the first version must have been painted between 1842 and 1845.[41] With the ship always shown in profile view, her name clearly indicated by initials on a pennant, this composition follows the traditional conventions of ship portraiture with—for Chambers—unusual fidelity. As usual, changes from version to version in the amount of sail show Chambers at play. Variations in the handling of the water, from the relatively complex and transparent treatment seen in *Sidewheel Steamer "Great Western,"* with plumes of spray breaking off the side of the ship, to diagonal troughs or simple running lines of foam in the other versions, may indicate renditions of this popular subject made with greater speed or at a later date.[42]

These straightforward profile views of famous steamships come closest to the bread-and-butter work of ship portraiture, the genre that Thomas Chambers' brother George deemed the "lowest department" of the visual arts. Disdainful of such work, George "longed to paint pictures" and so enlarged such assignments into a kind of "portrait marine" that pleased his patrons while offering more of an artistic challenge.[43] This strategy, shared by all marine painters with similar impatience and ambition, such as Thomas Chambers' American colleagues Thomas Birch and Fitz Henry Lane, underlies all his harbor views, as well as the chain of pictures of Boston's North Shore featuring a celebrity vessel in a cameo role. This star, the steamship that snatched the blue riband from the *Great Western* in 1840, was Cunard's *Britannia,* the best known of the company's original group of ships running between Liverpool and Boston. Known for carrying such distinguished passengers as Charles Dickens in 1842, the *Britannia* gained the limelight again when the merchants and sailors of Boston spent their own time and money to cut a channel for the ship after she was frozen in the ice in the winter of 1844.[44] The pride and joy felt by the citizens of Massachusetts as they witnessed the Cunard ships regularly steaming in and out of the harbor is expressed in the last of the shipping scenes in the Newport sale, no. 63: "Nahant, from Lynn Beach; the Royal Mail steam ship Britannia, running in for Boston; a very handsome painting." Surely this painting resembled *Shipping off a Coast* (fig. 2-11) or *View of Nahant* (fig. 2-13), two of the five versions of this composition that have surfaced since 1950.[45]

Chambers, living in Boston after 1843, could have visited this coastline on the North Shore between Salem and Boston, but his grasp of topography is loose—as in the harbor views of New York and Boston—suggesting work done from memory, if not from a print source. The view from Nahant is more naturalistically rendered in the remarkably similar set of beach views of Nahant produced by Thomas Doughty in the mid-1830s, such as *Coming Squall (Nahant Beach with a Summer Shower)*

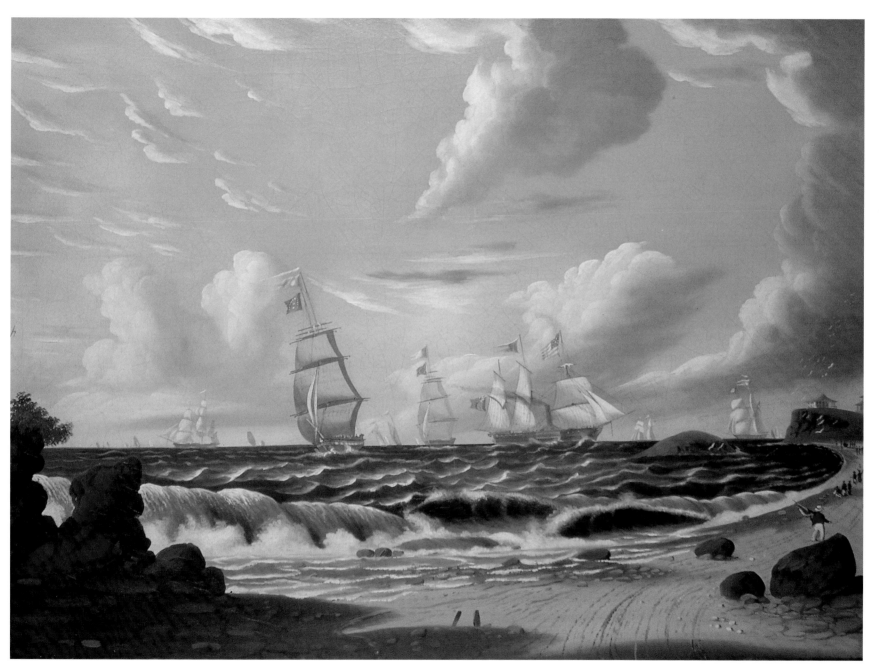

*FIG. 2-11 Thomas Chambers. *Shipping off a Coast [Nahant, from Lynn Beach]*, c. 1843–50. Oil on canvas, 22 x 30 inches (55.9 x 76.2 cm). Nahant Public Library, Nahant, Mass.

†FIG. 2-12 Thomas Doughty (American, 1793–1856). *Coming Squall (Nahant Beach with a Summer Shower)*, 1835. Oil on canvas, mounted on cradled panel; 20½ x 28⅛ inches (52.1 x 71.4 cm). The Art Institute of Chicago. Restricted gift of Mrs. Herbert A. Vance, 2005.159

(fig. 2-12), which may have offered a precedent for such popular, serial canvases. Or perhaps Chambers recycled one of his own earlier ideas, for all the Nahant views resemble in size and structure *Rockaway Beach, New York, with the Wreck of the Ship "Bristol"* (see fig. 1-9), having the same curling surf, sweeping curve of clouds, beach rocks and ruts, and tiny beach walkers, but with the addition of the bluffs of Nahant at the far right and Egg Rock rising offshore.[46] As usual, the details vary and the handling of sky and clouds swings in the range seen in the other harbor views; what holds consistent is the tiny *Britannia*, always heading southwest and into the shipping channel to Boston, behind the headland at the right. Most of these paintings show the long shadows, pink horizon, and bright blue sky of early morning, with the sun far to the left and invisible. The extravagant exception—and the only one in the group with a signature ("T. Chambers"), *View of Nahant [Sunset]* (fig.

2-13)—is significantly larger than the others, with the sun improbably setting to the southeast in a blaze of glory. This expressionistic flight of fancy, taking off from the familiar structure of Chambers' own theme, reaches the excited zenith of his sensibility, with florid color, dramatic light and dark contrasts, and looping rhythms of rock and cloud combining to an extraordinarily fantastic, darkly romantic effect.

Other than Chambers, who else would have enjoyed the bold impact of this sunset view, about 1845, or the packets sailing into New York harbor, or the celebrated steamships, or the storm-tossed pirate's prey? What do these ships tell us about the artist's patrons? They were not, most probably, shipowners or sea captains of the particular vessels, for in these paintings the artist was often too cavalier about detail to satisfy the criteria of a true ship portrait. We cannot imagine that Chambers, like his contemporaries the Bard brothers, borrowed the engineers' drawings of these ships in order to get the rigging right. Sailors might have been disdainful, considering the nonsensical signal flags, out-of-scale vessels, and perilous courses depicted—but perhaps they enjoyed his spirit. For these vessels are all celebrities of their day, effectively owned by the public and painted for an audience of admiring bystanders on the wharf. None of Chambers' marine paintings depicts private merchant ships or whalers; when they can be identified, they are packet ships, pilot boats, naval frigates, record-breaking steamships—the most familiar, prestigious vessels in the harbor. With enough nautical detail to be recognized individually—as the *Great Western*, the *George Washington*, or the protagonist of a Cooper or Marryat tale—these images of ships operate symbolically and emotionally within the context of harbor or storm as representations of local pride, disaster, fame, or adventure. This efficient, expressive punch, combined with Chambers' decorative vitality, sets these pictures apart from the two types of mainstream marine painting in New York and Boston. If these paintings were inadequate as documents for professional experts, such as owners and shipping agents, and unappealing to the connoisseurs of more atmospheric, illusionistic painting, their survival in numbers nevertheless suggests that the audience that purchased them was large. We can imagine the same group drawn to dioramas of shipwrecks and Currier and Ives lithographs, but with a little more money to spend: passengers, merchants, boosters of the port activity of the city, tavern owners, hoteliers, and those who catered to this population, as well as out-of-town tourists thrilled by the bustle of the modern seaport.

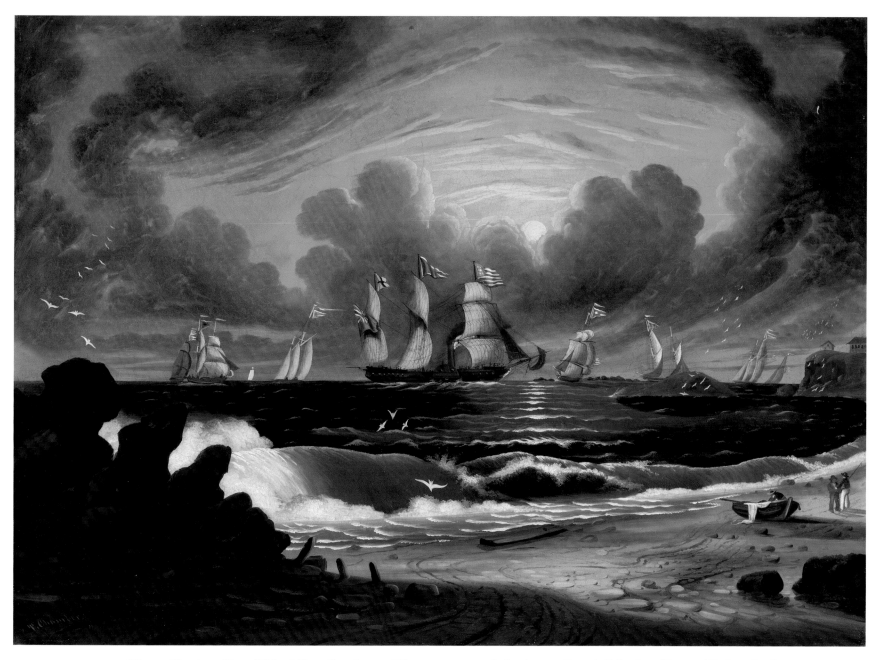

FIG. 2-13 Thomas Chambers. *View of Nahant [Sunset]*, c. 1843–50. Oil on canvas, 22 x 30 inches (55.9 x 76.2 cm). Collection of Peter and Barbara Goodman

Marine Battles

These views of harbors and shipping were not Chambers' grandest efforts as a marine painter. His largest investment of effort and pride, if the checklist of the Newport auction sale expresses his personal opinion, rested in two marine battle subjects suited to American history painting of the highest order:

65. The U. S. frigate Constitution's last broadside to the British frigate Guerriere. Nothing can exceed the elaborate finish of this splendid sea piece, (Painted from Coopers Naval History by Mr. Chambers.)
66. The U. S. Frigate United States, capturing the British Frigate Macedonian, — this is decidedly the noblest painting in the collection, (and also from Cooper's History of the American Navy[)].

These two titles were among the most popular in the repertory of American marine art, painted and engraved by artists of many nations for a public endlessly thrilled by the naval victories of the War of 1812. For a popular American marine painter, such subjects had everything going for them: strategy, seamanship, new technology, courage, death, and destruction, all framed by patriotism of the highest, most serious, and satisfying order.[47] The audience was large and fervent because the memory of "the late war" was still bright when Chambers arrived in New York in the 1830s. Rescued from decay following the publication of Oliver Wendell Holmes' stirring patriotic verse "Old Ironsides" of 1830, the *Constitution* was restored and recommissioned in 1835, inspiring reenactments of the capture of the *Guerrière* every night on Broadway at Hanington's Grand Moving Panorama.[48] Many of the heroes of the war—including the new president, Andrew Jackson—were still on hand, ready to tell their stories again, especially after the death of Isaac Hull, the captain of the *Constitution*, inspired a flood of reminiscences and tributes in 1843. Chambers, who seems to have known a popular topic when he saw it, devoted at least ten canvases to these two sets of dueling frigates from the War of 1812, including two of his largest, *The "Constitution" and the "Guerrière"* (see fig. 1-1) and *Capture of H.B.M. Frigate "Macedonian" by U.S. Frigate "United States," October 25, 1812* (see fig. 1-13), underscoring the importance of these images to both the artist and his audience.

In taking on these subjects, Chambers could feel that he was following his brother George to the loftiest heights of marine painting, but he also had to engage with the problems of a familiar subject and a restricted format. To the uninitiated, all marine battles between two ships blur into a few repeated and seemingly interchangeable formats—as seen in the generic engravings in popular publications that were recycled and retitled according to the occasion, or as demonstrated by the frequent misidentification of some of Chambers' paintings, such as *The "Constitution" in New York Harbor* (fig. 2-7). Some patrons clearly could not tell the difference between a packet ship and an armed frigate— or, more likely, the *Constitution* and any of her various conquests—and were happy with a picture that seemed more or less correct. But others would be looking for authentic details in a story that required much speculative invention to fill in the gaps. Hard facts might reside in the description of the ships, although information was often vague, especially of vessels lost in defeat. The *Constitution*, as an extraordinarily famous ship that was present in Boston for all to see, presented a special problem, because key identifying points, such as her figurehead, had been altered over time.[49] The weather, time of day, and conditions at sea, all tersely documented in reports of the battle, could be interpreted with artistic license, and finally, there was much vagueness about the placement and condition of the ships during the action. Such details must have been the subject of numerous barroom and dining-table debates, and they were at the heart of the marine painter's challenge.

For Chambers, much would have been known and represented concerning the *Constitution*'s capture of the *Guerrière* on August 19, 1812, six hundred miles off the coast of Massachusetts. The first major engagement of the war, the victory elated the young American navy, rallied the public to an unpopular war, and gave the nickname "Old Ironsides" to the ship that seemed impervious to enemy fire. Lengthy reports from eyewitnesses appeared in the newspapers, and the populace was hungry for satisfactory imagery. Many artists rose up to answer this call, but none more successfully than the British-born painter, resident in Philadelphia since 1793, Thomas Birch. With twenty-nine compositions celebrating the marine operations of this war, Birch could be said to own this subject by virtue of his many variant images, produced at different moments and in different sizes, not long after the events and immediately exhibited and engraved.

Chambers surely studied some of these paintings and prints or the secondary images derived from them, because Birch's views, endorsed by fellow artists and naval experts, were regarded as both the most artistic and the most correct. Chambers' basic reconstruction of the battle follows Birch's lead,[50] but his versions strike out into new territory (as the remarks in the Newport sale indicate), ostensibly supported by Cooper's controversial best seller, *History of the Navy of the United*

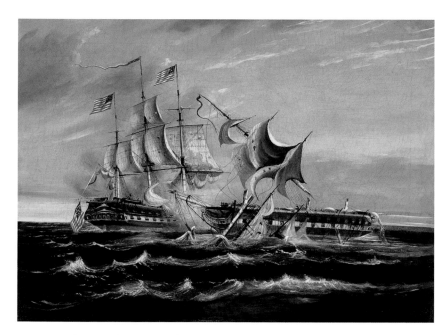

FIG. 2-14 Thomas Chambers. *The Capture of the "Guerrière" by the "Constitution,"* c. 1840–50. Oil on canvas, 25⅛ x 35⅜ inches (63.8 x 89.9 cm). Mead Art Museum, Amherst College, Amherst, Mass. Gift of Dr. Calvin Plimpton (Class of 1939), AC 1954.103

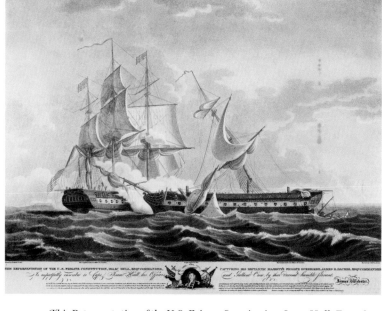

FIG. 2-15 *This Representation of the U.S. Frigate Constitution, Isaac Hull, Esqr. Commander, Capturing his Britannic Majesty's Frigate Guerrière . . .*, 1813. Engraving, 17¾ x 26 inches (45.1 x 66 cm). Collection of Edgar Newbold Smith

States of America, published in 1839. A popular abridged edition followed in 1841, supplemented between 1843 and 1845 by more detailed articles from Cooper on the officers and history of Old Ironsides. Fire from Cooper's critics, which he warmly returned, kept these battles and their causes alive in the early 1840s, as war spirit rose again, this time against Mexico.[51] With a surfeit of precedent and information on this subject, Chambers had to balance the need for a recognizable presentation of the event against the appeal of a novel perspective, interesting to aficionados. His many departures from Birch's prototypes may be partly his characteristic imaginative restlessness, and partly his ambitious attempt to revisualize the subject and make an original effect.

Four versions of *The "Constitution" and the "Guerrière"* by Chambers survive, depicting three crisis points in the battle. Although both Birch and the itinerant Italian American painter Michel Felice Cornè produced sets of four canvases, intended as a narrative sequence, Chambers does not seem to have meant his dif-

ferent compositions to be read together or displayed en suite. The earliest moment, seen in *The Capture of the "Guerrière" by the "Constitution"* (fig. 2-14),[52] following the lead of a composition by Birch engraved by Cornelius Tiebout (fig. 2-15), shows a three-quarters stern view of the *Constitution*, facing right, her bow obscured by smoke, and the overlapped form of the *Guerrière*, seen broadside, facing the opposite direction. The moment is about a half hour into the engagement, when the ships were entangled and the guns were blazing—the situation depicted by most artists from Birch forward, because it summarizes the disciplined poise of the *Constitution* and the chaotic collapse of the *Guerrière*, a ship so badly damaged in this fray that she could not be brought back to Boston as a prize.

However, in the unfolding of the triumph, there were nuances for partisans to debate and for artists to reimagine. All accounts agreed that the two ships met in the late afternoon, in heavy seas, and exchanged broadsides for fifteen minutes. The skill of the American gunners brought down the *Guerrière*'s mizzenmast,

*FIG. 2-16 Thomas Chambers. *The "Constitution" and the "Guerrière,"* c. 1840–50. Oil on canvas, 21¼ x 30½ inches (54 x 77.5 cm). The family of J. Welles Henderson

which fell into the sea over the starboard quarter. The *Constitution* turned across the bow of the British ship, caught the wind, and backed into the bowsprit of the *Guerrière.* Tangled together, the two ships briefly locked in the position that would come to define this particular battle. The American crew struggled with a fire in the ship's stern cabin while continuing to hammer her opponent. Then suddenly the *Constitution*'s foresail filled with wind and the ship shot forward, dragging down the foremast of the *Guerrière,* which in turn pulled down the mainmast. Building on the Birch-Tiebout composition, Chambers shows this sequence of events condensed—the backed sails, the fire, the falling masts—but with his own additions: The distance between the ships is greater, the mainmast has fallen farther, its sails are completely reconfigured, and the broken foremast hangs dramatically over the

port bow, with various spars and sails dragging in the water. With typical flair, Chambers also redesigned the stern boards of the *Constitution* and the bow decoration of the *Guerrière.*[53]

In *The "Constitution" and the "Guerrière"* (see fig. 1-1), Chambers captures the action slightly later, showing the British ship with all its masts broken, as Cooper wrote, "wallowing in the trough of the sea, a helpless wreck," while cannons continue to blaze from the American gunports.[54] Birch had also painted this moment (although it never was engraved), and Chambers may have seen his work, but again he made the situation his own, moving slightly later in time to show the foremast almost completely submerged, along with most of the sails and spars seen hanging off the hull in his earlier picture. As scholars have noted, other alterations all

heighten the emotional impact of the scene: Chambers cropped the two ships more closely to enlarge their presence on the canvas, added a dynamic cloud pattern that slopes across the sky in opposition to the running troughs of the water, increased the sense of violence by increasing the size and number of holes torn in the *Constitution*'s sails, doubled the size of the American flags at the mastheads, and added the Union Jack, pathetically attached to the stump of the mizzenmast.[55] He also turned the yards on the main and mizzenmasts, to emphasize their dark shapes, backed in the wind (as in the accounts) and torn by shot. With the exception of the detail of the British flag, reported in Cooper and other earlier accounts of the battle, all of these changes are speculative and pictorial, invented by Chambers rather than derived from other sources. Proudly, he signed this version "T. Chambers."

Chambers rethought the whole composition in two smaller paintings of *The "Constitution" and the "Guerrière"* (including fig. 2-16), swinging around to depict the same configuration from the other side.[56] Others, including Birch and the Irish American artist John James Barralet, had painted the battle from this vantage, but never exactly from this angle, or at this moment, midway between the situations seen in Chambers' two larger paintings and with the broken sails and masts reconsidered. The *Constitution* now seems to be too distant for the entanglement described in the battle accounts, and she carries an odd figurehead—perhaps an Indian with a headdress and a bow and arrow—that answers the description of none of the three known to have been on the ship. But the story, of the triumph of the relatively unscathed *Constitution* and the abject helplessness of her opponent, rings clear.

A second version of this smaller *"Constitution" and the "Guerrière"* has traveled through time paired with a painting celebrating the victory of the *United States* over the British frigate *Macedonian*. As seen in the broadside for the Newport sale, these two subjects seem to have been frequent companion pieces, for Chambers as well as printmakers, decorators, and other marine artists such as Thomas Birch.[57] According to Chambers' gloss in the Newport broadside, "The U. S. Frigate United States, capturing the British Frigate Macedonian," was the "noblest painting in the collection," and indeed a surviving canvas by him, *Capture of H.B.M. Frigate "Macedonian" by the U.S. Frigate "United States," October 25, 1812* (see fig. 1-13), is twice as large as his largest view of *The "Constitution" and the "Guerrière."* At least three versions of this subject by Chambers survive, showing two different compositions, and perhaps some of these three were once paired (such as figs. 2-16 and 2-18).

FIG. 2-17 Thomas Birch (American, born England, 1779–1851). *The "United States" and the "Macedonian,"* after 1813. Oil on canvas, 24 x 31½ inches (61 x 80 cm). The family of J. Welles Henderson

Chambers' sense of the importance of this subject and his own investment in it, signaled by the rare appearance of his signature and the date in the *Capture of H.B.M. Frigate "Macedonian,"* may express the greater historical significance of the encounter, which brought home to New York the first vanquished British frigate. The subject also gained glamour from the presence on the stern deck of the *United States* of Captain Stephen Decatur, already an American idol as the result of earlier daring exploits against pirates in Tripoli.[58] Discovering the *Macedonian* on a sunny morning off Morocco, Decatur's ship chased the British frigate through heavy seas, exchanging distant broadsides that soon brought down the enemy's mizzenmast. The *United States*, still unharmed, maneuvered around her stricken prey, delivering further devastation without coming close enough for her men to board. As a result, most depictions of this battle show the two ships apart, as in Chambers' three paintings (such as fig. 2-18) and in the six extant versions of the engagement painted by Thomas Birch, which were widely exhibited and also known through

*FIG. 2-18 Thomas Chambers. *Capture of H.B.M. "Macedonian" by the U.S. Frigate "United States," October 25, 1812*, c. 1840–50. Oil on canvas, 21 x 30 inches (53.3 x 76.2 cm). Collection of Susanne and Ralph Katz

two engravings by Benjamin Tanner and Samuel Seymour.[59] In Birch's many views, such as *The "United States" and the "Macedonian"* (fig. 2-17), the distance between the ships varies, but both are shown from the stern, with the *United States* to the rear, in the sunlight, and the *Macedonian* in the foreground at the left, in shadow.

Without knowing exactly which version of Birch's composition Chambers viewed, it can be seen that he adopted most of these ideas, although, as in his companion piece of the *Constitution*, he cropped the subject to emphasize the ships and drew them closer together—and seemingly nearer to the viewer—to increase the dramatic effect. In *Capture of H.B.M. Frigate "Macedonian"* (see fig. 1-13), the position of the *United States* is, with only small variations (and more emphatic holes in the sails), taken from the Birch model, but the *Macedonian* has been rethought, with the dark sails of the mainmast drawn to better describe the split main yard,

which—according to some descriptions (although not Cooper's account)—hung in two pieces, envisioned by Chambers as a dejected scarecrow. And with a final dramatic touch, he added the fallen Union Jack, draped over a broken yard and silhouetted against the sky—notwithstanding Birch's view (and Cooper's account) indicating that the flag was hung in the main rigging—at a moment when the British sailors were cheered by the mistaken impression that the wall of flame and smoke coming at them was a fire on board the American ship.[60] Such details show Chambers moving beyond his sources to find a later, more definitive moment in the battle, expressed by the tiny figures hauling in the flag and the officer in the stern—perhaps Captain John S. Carden—shouting capitulation through a trumpet to Decatur on the opposite ship. These additions demonstrate Chambers' efforts to make a novel effect, while exposing his citation of Cooper as pure marketing bluster.

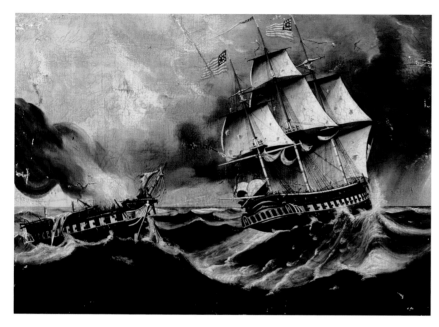

FIG. 2-19 Thomas Chambers. *The "Constitution" and the Burning "Java"*[?], c. 1840–50. Oil on board, 21¾ x 30 inches (55.2 x 76.2 cm). Brandywine River Museum, Chadds Ford, Pa. Bequest of Carolyn Wyeth, 1996, 96.1.510

FIG. 2-20 Thomas Chambers. *The "Constitution" and the "Java"*[?], c. 1840–50. Oil on board, 21⅜ x 30½ inches (54.3 x 77.5 cm). Brandywine River Museum, Chadds Ford, Pa. Bequest of Carolyn Wyeth, 1996, 96.1.509

More important to the originality of his overall effect is the strong design and vivacious surface, with its cartoonlike rolls of smoke and dancing waves, so boldly stereotyped and decorative by comparison to the more delicate and naturalistic Birch view.

As he had in *The "Constitution" and the "Guerrière,"* Chambers completely revised his image in a smaller version of the battle between the *Macedonian* and the *United States* (fig. 2-18), which reverses the positions of the two ships to show them head-on, the captains now communicating from their respective bows. In both extant examples of this composition, the *United States* is even more upright and serene, and the macabre dark sails, broken yards, and flying stays of the *Macedonian* are even more chaotically gesticulating. In this smaller version the cannon smoke and the waves are painted more painstakingly and naturalistically, suggesting that this canvas may be earlier than the larger, more broadly painted image from 1853.[61] Chambers also painted the triumphant aftermath of the battle, when the *United States* sailed into New York harbor in December 1812 with her prize in tow.

This picture, signed "T. Chambers" and reputedly dated 1847, may be another original composition that indicates his continuing development of these subjects after the Newport sale.[62]

Even more inventive, and therefore more difficult to identify, is a pair of Chambers sea battles once owned by the painter N. C. Wyeth (figs. 2-19 and 2-20). One of these paintings (fig. 2-19), showing an American frigate sailing away from a burning wreck, could be the *Constitution* and the abandoned hulk of the *Guerrière*, a subject that occasionally appears in paintings and engravings before 1850, although not exactly in this fashion.[63] Another British ship to meet the same fate was the *Java*, destroyed off Brazil in December 1812 after a furious exchange with the *Constitution*, then under the command of William Bainbridge. After the mortally wounded Captain Henry Lambert and his surviving officers and men were removed from the wreck, the *Java*—distinguished by a bowsprit splintered early in the battle—was exploded on New Year's Day of 1813. If this painting depicts the *Constitution* and the *Java*, then the other one in the Wyeth pair (fig. 2-20) may show a moment in the

heat of the same engagement, but with each ship reversed, so that the stubs of the *Java*'s bowsprit and foremast—both lost in the first hour of the battle—demonstrate the sequence of damage.[64] The story of the *Constitution* and the *Java* was not as popular as Chambers' other War of 1812 subjects, but it seems to have been a favorite in the Boston area, where Corné and his student George Ropes had both painted the subject in the early nineteenth century. All of the exploits of the *Constitution* were especially dear to Boston, the city that welcomed Bainbridge home and celebrated the first news of his victory while Decatur enjoyed the limelight in New York.

After the naval glory of the War of 1812, few events in the 1830s and 1840s offered material for a marine painter interested in so-called noble subjects. Chambers does not seem to have painted the naval action off Vera Cruz during the Mexican War. He noted the newer generation of warships, painting the seventy-four–gun *Delaware* at anchor near Annapolis (see fig. 1-11), perhaps while he was resident in Baltimore in 1842. About this same time he might have painted *The Great Ship "Pennsylvania,"* depicting the Navy's newest ship of the line anchored at the foot of the Chesapeake. The largest warship in the world when launched in Philadelphia in 1837 for her one majestic voyage to the Norfolk Navy Yard, she remained there until she was burned during the Civil War.[65]

Chambers would have to wait for the Civil War to be given new opportunities to paint naval warfare. For a decade after the *Capture of H.B.M. Frigate "Macedonian" by the U.S. Frigate "United States,"* made when he was residing in Albany in 1853, there are no surviving dated examples of his marine painting. Then, about 1863, he depicted the *Harriet Lane* (recorded by Merritt in 1956 and now unlocated), a Union ship, previously a revenue cutter, captured by Confederate gunboats in Galveston harbor on January 1, 1863. In this era, wood engravings frequently accompanied news stories in many periodicals, so Chambers probably composed this painting from images of the event, such as an illustration that appeared in *Harper's Weekly* not long after the fact.[66] He seems to have used a similar source for *The U.S.S. "Cumberland" Rammed by the C.S.S. "Virginia," March 8, 1862* (fig. 2-21), a composition based on an engraving in the same paper the previous year.[67] The print, titled *The Rebel Steamer "Merrimac" running down the Frigate "Cumberland" off Newport News*, identified the ironclad formerly known as the *Merrimack* (renamed *Virginia*) on the left and the doomed U.S.S. *Congress* on the right, with a Confederate gunboat emerging from the right. To clarify matters and, as usual, increase the drama, Chambers added another Confederate gunboat and more or larger flags all around. Extra drama was hardly needed, for the event sent shock waves through the country as the *Virginia* demonstrated the awesome force of a steam-powered ironclad against old-fashioned wooden, sail-driven warships. The *Cumberland* sank after being rammed, and the *Congress* was badly beaten and burned after running aground.

For Chambers, the painting shows remarkable consistency in his treatment of marine subjects, for the handling of the ships, the figures, and the sky and water all bear a direct relationship to his earlier naval pictures. The size of the painting, exactly the same as the largest *"Constitution" and the "Guerrière"* (see fig. 1-1), and the similar treatment of the water and clouds must make us extend the date range for all of his naval battles into the early 1860s. The subject itself, taken with the story of the capture of the *Harriet Lane* in Galveston, adds another surprise, for both events were disasters for the Union navy. The efficient and successful underdog in these pictures is not the fledgling U.S. Navy cheered in the War of 1812, but the new Confederate armada. One wonders what motivated these paintings: Sympathy for the Southern cause? Outrage in the North? A mariner's interest in naval battles in general? The old-school sailor would have been horrified by the dark, alien form of the *Virginia* and appalled by the fate of the helpless *Cumberland*; for such viewers, the good and bad forces in this awkward painting seem easy to identify. But the military-minded would have been thrilled by the destructive power of this new machine, and—if such paintings are usually tributes to the victorious—we have to speculate that Chambers or his patron enjoyed this vision of progress. In New York the war received little support from merchants whose international trade was disrupted or from working-class men, vulnerable to the draft, who rioted in Manhattan in July 1863 and died by the hundreds under fire from police and Union troops. Chambers, father of a fifteen-year-old son, must have wished to protect his boy from the war. But still listed as artist, he was also probably willing to paint subjects "of every description to order," as he had been thirty years earlier. Lacking provenance for these paintings, we may never know who wanted these last subjects, or why.

The fact that *The U.S.S. "Cumberland" Rammed by the C.S.S. "Virginia"* is closely based on a print source and not signed tells us that it was neither Chambers' own idea nor his favorite work, even if it is a marine painting. Excepting his earliest extant painting of the *Hermione,* the signed paintings seem to be his own designs, holding to a standard of originality established by his brother, a distinguished marine artist. What is more obvious, all the pictures that Chambers claimed under his own name in the Levy auction of 1837 and the Newport auction of 1845 were marine paintings, demonstrating exactly where his pride and effort were invested.

FIG. 2-21 Attributed to Thomas Chambers. *The U.S.S. "Cumberland" Rammed by the C.S.S. "Virginia," March 8, 1862*, c. 1862–66. Oil on canvas, 24½ x 34 inches (62.2 x 86.4 cm). Peabody Essex Museum Collection, Salem, Mass., M4635

The datable marines also correlate, quite naturally, with the pattern of his residency near the harbors of New York, Baltimore, and Boston, when he was most active in this genre. Albany's link to the sea may be visible in his marine magnum opus, *Capture of H.B.M. Frigate "Macedonian" by U.S. Frigate "United States"* (fig. 1-13) from 1853, painted after his move to upstate New York, but the evidence of his surviving paintings suggests that the majority of his work after 1845 centered on landscape and river scenery for his inland clientele.

Chambers' Civil War subjects indicate that he returned to marine painting when he was back in New York, after 1858, and to a method that was in place thirty years earlier, in his painting of the *Hermione.* He could have learned this method from his brother George's work. It was a practice based on memory and experience, on the study of other artists and prints, and to a much lesser degree on observa-tion and work done on the spot.[68] However, his brother had renounced copying prints and the compositions of other artists in the late 1820s, vowing to work from nature as much as possible. Thomas Chambers' work "from nature," if it existed at all, seems to have been banked into his original compositions, such as the harbor views, which may have been based on notes or sketches on the spot as well as outright invention. Then, once the first composition was made, others could be copied with improvisations or done from memory, with variations. Both parts of this method—the use of print sources, necessary for the historical battle scenes and the famous steamers, and the habit of working in a series of related images—created a practice for Chambers that would become the cornerstone of his second career, as a landscape painter.

*FIG. 3-1 Thomas Chambers. *View of Cold Spring and Mount Taurus from Fort Putnam*, c. 1843–57. Oil on canvas, 34⅛ x 49½ inches (86.7 x 123.2 cm). Fenimore Art Museum, Cooperstown, N.Y., N-11.99

LANDSCAPE PAINTER

UNDERSTANDING Thomas Chambers' identity as a marine painter opens the door to the much larger body of landscape work attributed to him, all of it unsigned and undated.[1] Two of these paintings (including fig. 3-1) are the size of his most monumental sea battle, *Capture of H.B.M. Frigate "Macedonian" by U.S. Frigate "United States"* (see fig. 1-13), indicating ambition in this arena, if not an important patron. However, the complete absence of dated pictures makes it difficult to track the changes in his work over time or make sense of the relatively wide swing in style seen between paintings of the same subject, while the absence of a signature—common in folk, sign, and decorative painting—raises other issues of training, authorship, and the place of landscape painting in Chambers' career. By contrast to his self-promotion as a marine painter, his anonymity as a landscape artist tells us something about his perspective on work, evidently based, for the most part, on designs found in contemporary books and prints. Unwilling to claim credit for another artist's composition, Chambers was nonetheless bold about making the image his own. Enlarging, simplifying, reorganizing, embellishing, and brightly coloring a structure derived from tiny black-and-white sources, he commanded a strong personal style. Howard Merritt described this as "dynamic" rather than "passive" copying, "genuinely creative" in its result, and other writers have identified this transformation of sources as key to Chambers' identity. As Deborah Chotner has noted in cataloguing his many paintings in the Garbisch Collection at the National Gallery of Art, a derivative method did not impede the development of a "highly original and distinctive artist."[2] Linking the traits seen in his marine paintings to his landscape work, the identifying character and method that emerge give us a painter with a forceful personality.

The harbor and marine views from New York and Boston studied in Chapter Two offer an idiosyncratic set of stylistic habits that can be found in Chambers' landscape work, which often includes shipping depicted in very similar ways. Reflections on the water, running ripples, and the construction of the vessels in a landscape such as *View of Cold Spring and Mount Taurus from Fort Putnam* (fig. 3-1) echo the handling of the marine paintings. Also familiar is the bright blue sky fading to pale lemon and rose at the horizon, with swooping cloud patterns shaded in gray. Even more fundamentally, the contrasting textures, active contours, and swinging rhythms of the composition demonstrate Chambers' design sensibility. Rocking and rolling his print source based on the work of William H. Bartlett (fig. 3-2), Chambers adds a gaunt tree to reinforce the sway of the hillside of Storm King at the far left, and remodels Fort Putnam on the right from a blocky architectural

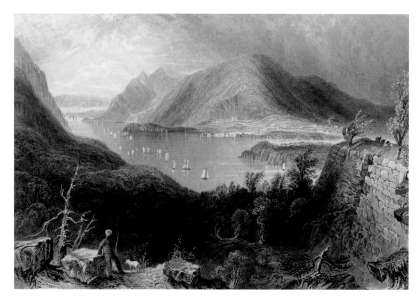

*FIG. 3-2 Robert Sands (English, 1792–1855), after W. H. Bartlett (English, 1809–1854). *View from Fort Putnam (Hudson River)*. Etching, 4¾ x 7 inches (12.1 x 17.8 cm). From N. P. Willis, *American Scenery* (London: George Virtue, 1840), vol. 1, pl. 20. Philadelphia Museum of Art, Library

mass to a curving bank. Although he alters or adds some details—such as the two tourists and the hunter, who replace the soldier seen in the print—Chambers' view is typically much broader and more simplified than his source, although in this instance thirty times larger. Characteristically, he emphatically increases the scale of the shipping and the houses in the distance, and freely reinvents the foreground with a road and a parade of three shadowed hillocks. The rocks and ruts in the embankments and road, and the stippled foliage in the hillside, show mannerisms seen occasionally in Chambers' coastal views, but here employed more extensively.

The stylistic links that can be traced from the marines to the landscapes are reinforced by shared patterns of format, technique, and materials. The marines reveal a pattern of sizes seen throughout Chambers' work: His favorite format in marine painting, about 21 or 22 inches by 28 or 30 inches, is also the most common in his attributed landscapes, and smaller subjects typically fall into categories of about 18 by 24 or 14 by 18.[3] Original stretchers on his paintings frequently have hand-finished mortise-and-tenon construction with keys, sometimes nailed in place. Morton C. Bradley, Jr., and Caroline Keck, two conservators who treated many paintings attributed to Chambers, commented on the fine weave of the canvas and the narrow, "stingy" tacking edges. They have also noted the warm pinkish or cream-colored ground frequently detected on his canvases, more visible if the paint surface has been abraded. These patterns, confirmed by the technical notes in Chotner's catalogue of the National Gallery's collection, are described in more detail in the essay (see pages 151–156) by the Indiana University Art Museum's conservator, Margaret Contompasis. Such study of method and materials provides technical fingerprints for the artist, linking signed and unsigned works.[4]

The other signature element of many unsigned works appears in the distinctive frames occasionally found on Chambers' landscape paintings, less often on his marines. These frames (fig. 3-3) come with a range of ornament applied to a simple ogee molding that has been covered first with netting to simulate the effect of cross-hatched carving. Although some of these frames carry only bold leaf designs or bosses at each corner (figs. 3-8, 3-9, and 3-22), others display flat, curling composition ornament applied, like decals, to and fro around the frame in different patterns (fig. 3-36). The result, when gilded, is an inexpensive imitation of the more elaborate composition-decorated frames used by such artists as Thomas Cole in this period, frames that are themselves less expensive imitations of hand-carved European old master examples. The aspiration to elegance expressed in these slightly cheesy "Chambers frames" (which have not been discovered on the works of any

other artists) calls to mind the enticement of the 1845 Newport auction broadside, which advertised "elegant oil paintings" in "splendid gilt frames" that were to be "SOLD WITH THE PICTURES" and were therefore "all ready for immediate removal to the Parlor."[5] In a powerful way, the visual impact and craftsmanship of Chambers' frames stand in exactly the same relationship to the more expensive frames of the Hudson River School as do Chambers' paintings to those of Cole.

Because these frames have only been found on Chambers' work, it might be imagined that, in his professional role as picture restorer, he dabbled in framing. Although many framers and gilders were on hand in New York, Boston, and Albany to assist him, he could have saved money by doing the work himself. Not all of Chambers' paintings are in these frames, and other frames that seem to be original come in many different patterns, mostly variants of the simple gilded moldings used widely in the early nineteenth century. But like the common formats and materials in his paintings, the presence of the more ornate Chambers frame—if it does not conclusively identify the painting as by Chambers—certainly marks a picture as from his circle.[6]

Chambers' American Views

Linkages of subject matter also help identify Chambers' work, by demonstrating a network of themes and sources that connect his marine paintings to his landscapes. The print that inspired Chambers' *View of Cold Spring* was one of 117 plates based on the watercolors of Bartlett, published with texts by Nathaniel Parker Willis in the celebrated book *American Scenery; or, Land, Lake, and River Illustrations of Transatlantic Nature* of 1840.[7] Willis, a famous man of letters in New York like Chambers' other favorites, James Fenimore Cooper and Captain Frederick Marryat, was a poet, journalist, editor, and tastemaker, influential from the early 1830s. The book was an immediate popular and critical success, and the subjects in it would have been widely recognized; perhaps Chambers intentionally traded on this familiarity, offering larger, colored versions of Bartlett's images to patrons fond of particular views. The unusual size of this painting and its mate in scale (perhaps based on Bartlett as well), *A View of the Hudson* (private collection), suggest a special commission during Chambers' Albany years, from an affluent patron who cherished the landscape of the Hudson highlands.[8]

Intrigued by Chambers' dynamic treatment of print sources, first tracked in a set of views of the Delaware Water Gap by Asher B. Durand, Chambers, and

*FIG. 3-3 Thomas Chambers. *Hudson Highlands from Bull Hill*, c. 1843–60. Oil on canvas, 18¼ x 24¼ inches (46.4 x 61.6 cm). Indiana University Art Museum, Bloomington. Morton and Marie Bradley Memorial Collection, 98.76

Thomas Doughty (see figs. 4-14, 4-15, and 4-16), Merritt began to search for other period sources. By 1955, he had found plenty: a total of twenty-two images in Chambers' work based on prints, including nine derived from Bartlett's *American Scenery*. After fifty years, as new work has emerged, this number has more than doubled, with as many as seventeen evidently based on Bartlett alone, such as the previously unknown *Hudson Highlands from Bull Hill* (fig. 3-3).[9] This view of the Hudson highlands, looking north from the base of Bull Hill (which Willis suggested we more gracefully call "Mount Taurus"), is a classic of the Bartlett-Chambers series, and much more typical in size than the monumental *View of Cold Spring*.

The petite 5-by-7-inch black-and-white print source is here enlarged in area twelve times, to 18 by 24 inches, and gloriously colored, with a golden sunset behind Butter Hill (likewise renamed by Willis as the more poetic Storm King). The basic format is faithful to Bartlett's design, for this is a famous view that had to remain identifiable, but many small details are changed: Bartlett's seated figure on the foreground promontory becomes Chambers' familiar standing hunter, now cast as a hiker; some cozy cabins have been installed on the far shore; the boats have doubled in size; and new foreground foliage has been added, including trees with snaky roots (that we will see again elsewhere) and foliage created with the repeated touches of a

*FIG. 3-4 Thomas Chambers. *Chapel of Our Lady of Coldspring*, c. 1843–60. Oil on canvas, 14 x 17¹⁵⁄₁₆ inches (35.6 x 45.6 cm). Indiana University Art Museum, Bloomington. Morton and Marie Bradley Memorial Collection, 98.148

*FIG. 3-5 Thomas Chambers. *Sabbath Day Point, Lake George*, c. 1843–60. Oil on canvas, 14½ x 18½ inches (36.8 x 47 cm). Indiana University Art Museum, Bloomington. Morton and Marie Bradley Memorial Collection, 98.65

small brush, trimmed to make a crescent-shaped mark. This "stamping" technique may suggest the habits of a scenic painter, working rapidly on a grand scale, but it is a shortcut seen in the work of many landscape painters from the baroque period to the nineteenth century (including Cole; see fig. 4-12). In other hands, the method is often disguised by the use of a variety of brushes, or the additional overlay of more varied, descriptive gestures. Chambers seems to have relied on this technique without bothering to cover up or diversify the effect, although he applied these foliage marks over different under-tints, and often layered the stamped leaves in two or three colors, using several different brushes. Certainly adopted for the sake of speed, but with the merry decorative texture familiar from the stenciled, sponged, and grained surfaces of painted walls and furniture in this period, the effect calls to mind Chambers' experience as a fancy painter in other realms. As the all-purpose New England artist Rufus Porter noted in his advice to mural painters in 1846, "on

finishing up scenery, it is neither necessary or expedient, in all cases, to imitate nature. There are a great variety of beautiful designs, which are easily and quickly produced by the brush, and which exceed nature itself in picturesque brilliancy, and richly embellish the work, though not in imitation of anything."[10]

The Bartlett views, like Chambers' marines, came in a few favorite sizes: In one of the smallest, based on the plate *Chapel of Our Lady of Coldspring* (fig. 3-4), Chambers sensibly chose a more focused subject for the 14-by-18-inch canvas.[11] The new Greek Revival chapel, dedicated in 1834 as the first Catholic church in the valley, was a landmark both austerely modern and romantically antique on its bluff above the river. Willis, in his text in *American Scenery*, imagined a stately monk under the portico of this little temple, blessing the river traffic as it passed below.[12] Responding to this spiritual mood, Chambers supplied an unusually intense teal blue sky above a pale lemon sunset, adding a Hudson River schooner sheltered in

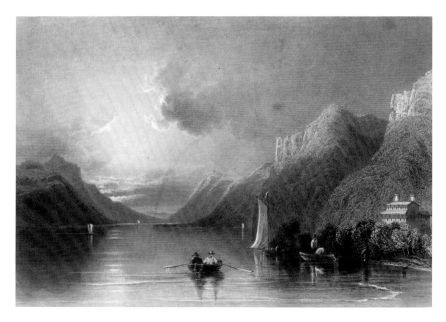

FIG. 3-6 Henry Adlard (British, active 1828–69), after W. H. Bartlett (English, 1809–1854). *Sabbath Day Point (Lake George)*. Etching, 4¹³⁄₁₆ x 7⅛ inches (12.2 x 18.1 cm). From N. P. Willis, *American Scenery* (London: George Virtue, 1840), vol. 1 pl. 66. Philadelphia Museum of Art, Library

*FIG. 3-7 Isidore Laurent Deroy (French, 1797–1886), after Jacques Gérard Milbert (French, 1766–1840). *Niagara Falls from the American Side [Chute du Niagara prise du côté américain]*, c. 1828. Lithograph. From *Itinéraire pittoresque du fleuve Hudson . . .* (Paris: H. Gaugain, 1828–29), pl. 35. The Lilly Library, Indiana University, Bloomington

the cove below and a broken tree limb poking out of the eddies as a snag—a signature touch seen in many of his river views.

In these smallest of Bartlett subjects by Chambers, the image may be greatly simplified, sometimes making the connection to the print source difficult to recognize. *Sabbath Day Point, Lake George* (fig. 3-5), has lost the hotel and many of the boats seen in Bartlett's view of this spot (fig. 3-6), although it has gained a schooner at the center, a handful of snags, and a procession of Indian canoes. The image is further transformed by the emphasis on the dark foreground promontory on the right and its reflection, and the dramatic zigzag of the sunset sky mirrored on the river, not to mention the surging animation of the hillsides. Versions more faithful to Bartlett's view include the missing hotel, allowing us to track the gradual metamorphosis of the image as Chambers repeated it, perhaps after years and without renewed reference to the print.[13]

In the search for Chambers' print sources, Merritt discovered another rich lode in a two-volume publication of 1828–29 containing fifty-four lithographs, mostly after the drawings of the French artist Jacques Gérard Milbert, *Itinéraire pittoresque du fleuve Hudson et des parties latérales [de] l'Amérique du Nord*. Milbert lived in the United States for eight years, from 1815 to 1823, and returned to France to oversee the publication of his drawings.[14] Merritt counted seven subjects based on Milbert within Chambers' known oeuvre; since 1956, others have shown up, to bring the count to ten or eleven.[15]

Chambers turned to Milbert for some of the most marvelous and iconic sites in North America, including the Natural Bridge in Virginia and a succession of waterfalls, including Niagara and Genesee. Chambers had three different views of Niagara in his repertory, from three different print sources: a pair of paintings based on Milbert (fig. 3-7) and after W. Vivian (from above), and a different view,

*FIG. 3-8 Thomas Chambers. *Niagara Falls from the American Side*, c. 1843–52. Oil on canvas, 18¹⁄₁₆ x 24 inches (45.9 x 61 cm). Indiana University Art Museum, Bloomington. Morton and Marie Bradley Memorial Collection, 98.16

*FIG. 3-9 Thomas Chambers. *Niagara Falls, from Above [Horse Shoe Fall from the Canada Bank]*, c. 1843–52. Oil on canvas, 18¹⁄₁₆ x 24 inches (45.9 x 61 cm). Indiana University Art Museum, Bloomington. Morton and Marie Bradley Memorial Collection, 98.17

organized vertically from below Table Rock, based on Bartlett.[16] The classic view from below on the American side, based on Isidore Laurent Deroy's lithograph after Milbert, has survived in medium-sized (fig. 3-8, with its mate, fig. 3-9) and large (fig. 3-10) versions. Both views from below show Chambers' familiar hunter-as-spectator, made relatively gigantic by comparison to the tiny figures that appear in the print, although this change in scale does little to diminish the awesome spectacle of the falls. Such outsized witnesses may have offered Chambers' audience an easily understood surrogate, clearly identified as an American backwoodsman claiming the continent's majesty. Chambers' adjustments between the two sizes are somewhat predictable, for the smaller version loses the houses and mills that line the horizon in the large version, where they testify to the industry that has harnessed the force of the falls.[17] More telling, however, is the overall revisualization of the composition in the smaller version, including a different strategy for painting the water, different cropping of the subject, different foreground, and additional

detail—such as the tiny birds and the logs trapped in the rocks. On his bigger canvas, Chambers added the silhouetted cliff edge at the right and the twisting column of spray (both brought in from another Milbert plate, by Léon Sabatier, *Horse Shoe of Niagara from the Canada Side*) to produce a condensed panorama of the entire falls. The lively echoing of this cutout edge in the shapes of roiling foam, rock, and foliage adds startling visual buoyancy to the image. These changes, as well as the differences seen between both images and the two print sources, tell us that Chambers was not referring to the print or to his own earlier work, except in the most basic fashion, perhaps only from memory, as he worked on any particular painting. Variety and spontaneity, rather than a close copy or a standard production, ruled his method. The overall flattening and decorative treatment of the print source also illustrate his typical two-dimensional play in creating an image intended as an icon of its subject, not an illusionistic view.

The degree of variation and creativity within a single theme can be well traced

*FIG. 3-10 Thomas Chambers. *Niagara Falls*, c. 1843–60. Oil on canvas, 22 x 30⅛ inches (55.9 x 76.5 cm). Wadsworth Atheneum Museum of Art, Hartford, Conn. The Ella Gallup Sumner and Mary Catlin Sumner Collection Fund, 1943.99

in two of Chambers' subjects after Milbert that were clearly popular favorites, far more plentiful today than Chambers' Niagara canvases. The most successful image he ever produced, if some ten or twelve extant versions—including *View of the Hudson River at West Point* (fig. 3-11), *View of West Point* (fig. 3-12), and *West Point* (see fig. 5-4)—can testify to the response of his clientele, was based on Milbert's *General View of the Military Academy at West Point*, an image also seen on imported ceramics (see fig. 4-26).[18] Another view from West Point, looking north, based on a Bartlett print, has also survived in at least seven versions, suggesting widely shared admiration for this subject among Chambers' customers between New York and Albany after 1840. Indeed, Willis' text to Bartlett's image declared that "of the river scenery of America, the Hudson, at West Point, is doubtless the boldest and most

beautiful," offering unforgettable views of the highlands.[19] In this spectacular setting, the United States Military Academy at West Point provided a nexus of natural beauty and patriotic pride that only increased in the 1840s as the nation's army battled to victory in Mexico and New York's painters campaigned to make the scenery of the Hudson River and the Catskills emblematic of national virtue.

Milbert's view of the 1820s, looking south from an elevated prospect on the slopes of Mount Taurus across the Hudson, surveys the scene with the sun low to the west, throwing light on the boxy buildings around the parade ground on its plateau high above the river. Chambers made his own alterations in each one of his versions, the most exciting being the reorganization of the sunset to the south, with a rainbow of different skies and reflections, sometimes pale yellow and blue,

FIG. 3-12 Thomas Chambers. *View of West Point*, c. 1843–60. Oil on canvas, 22¼ x 30⅛ inches (56.5 x 76.5 cm). Memorial Art Gallery, The University of Rochester, Rochester, N.Y. Gift of Elsie McMath Cole in memory of her parents, Mr. and Mrs. Morrison H. McMath, 43.43

sometimes tangerine and rust. Overall, he reduced the amount of sky in Milbert's composition and pumped up the bulk of West Point and the mountains behind it. This principle of selective emphasis, along with an overall simplification of detail, rules throughout Chambers' work: The tiny shipping described by Milbert, which serves to enhance the imposing scale of the cliffs, enlarges ten times under Chambers' brush. Ever the marine painter, he clearly thought the business on the river a significant aspect of the view. In every surviving version he deleted Milbert's sapling at the left in order to open an uninterrupted vista down the river, past a procession of headlands overlapping like stage flats into the distance. From version to version, the contours of the mountains undulate, the buildings and trees of the academy's parade ground move, and the foreground vegetation alters, although almost always

a ragged tree stump writhes at the lower right, below a stony bank and a clump of trees. In the Rochester *View of West Point* (fig. 3-12), trees sway and dance across the foreground; in Albany's composition (fig. 3-11), the copse at the right margin explodes almost to the top of the canvas, throwing jagged, leafy boughs against the sky in a fashion often seen in Chambers' work. All in all, the effect is less precise, less topographically correct than Milbert's, and many times livelier.

Chambers' second-most popular subject, judging by eight surviving examples and a chain of related compositions, was also based on a print by Milbert: *Lake George and the Village of Caldwell.* As rendered by Chambers in *The Hudson Valley, Sunset* (fig. 3-13) and *Lake George and the Village of Caldwell* (fig. 3-14), the subject seems to have encapsulated many of the emotions about the national landscape

*FIG. 3-13 Thomas Chambers. *The Hudson Valley, Sunset*, c. 1843–60. Oil on canvas, 22⅛ x 30 inches (56.2 x 76.2 cm). National Gallery of Art, Washington, D.C. Gift of Edgar William and Bernice Chrysler Garbisch, 1966.13.1

at mid-century. Like the views of West Point after Milbert, six of the eight extant close variants of this scene are Chambers' largest standard size—about 22 by 30 inches—indicating its importance in his repertory, and perhaps hinting that these two popular subjects were frequently paired.[20] Looking at this suite of paintings, which hold more steadily to his model than is sometimes the case, we can learn more about Chambers' characteristic choices. As usual, the sky is flushed with different degrees of sunset in the distance, regardless of the actual compass points of the geography, and the shipping on the lake looms large. The village of Caldwell likewise inflates in importance, its church spire sometimes stretching to the horizon and the chimneys of this flourishing tourist haven ostentatiously smoking with prosperity. As he had done in his West Point subject, Chambers eliminates Milbert's framing trees to open

up the view, and he changes the foliage silhouetted against the water from version to version, with animated sawtooth contours creating active negative spaces, as in *Lake George and the Village of Caldwell*. He does keep Milbert's clumps of flowers at left and right, however, inventing pink and blue blossoms and broad leaves in a juicy shorthand style that will supply foliage as needed throughout his landscapes. Most of the foreground traffic of humans and animals seen in Milbert's image vanishes in Chambers' versions. Typically, he avoids painting horses or cattle, preferring the familiar hunter, hiker, fisherman, or—once, in the Lake George series—a shepherd disappearing at the turn of the road with a flock of woolly dots. In the absence of Milbert's staffage, Chambers animates the foreground with long shadows from the left, raking across the ruts and stones in the road in a fashion totally unlike the dusky

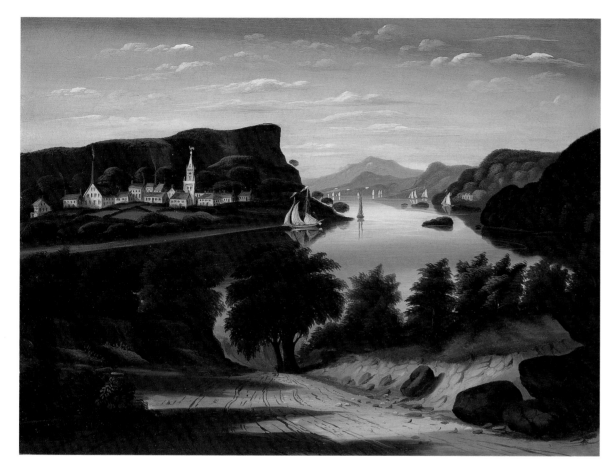

*FIG. 3-14 Thomas Chambers. *Lake George and the Village of Caldwell*, c. 1843–60. Oil on canvas, 22½ x 30½ inches (57.2 x 77.5 cm). The Metropolitan Museum of Art, New York. Gift of Edgar William and Bernice Chrysler Garbisch, 1966, 66.242.17

twilight in the print. Although we have seen these shadows in *Rockaway Beach, New York* and the Nahant paintings (see figs. 1-9 and 2-11), the tonality of these landscapes is often different from the sunny coastal views, which tend to be blue and white, set against yellow, ocher, and a range of greens. Although many of his inland landscapes continue the brighter, cooler palette of the marines, others, such as *View of the Hudson River at West Point* (fig. 3-11) and *The Hudson Valley, Sunset* (fig. 3-13), are warmer and lower in tone, tending to orange, red, dark green, and brown. This palette change may be Chambers' way of depicting different times of day and seasons, but it may also indicate a transition in his taste over time.

The print that inspired this series, and the correct title for the image, was identified by John Caldwell in the 1980s. Before then, the Lake George painting in the Metropolitan Museum of Art was known as *Stony Point, New York*. All of the variants of this scene have been associated with different Hudson Valley sites. The National Gallery's version, *The Hudson Valley, Sunset*, was earlier known as *Looking North to Kingston* and *Kingston on the Hudson*, while that in the Smith College Museum was previously labeled *Looking North to Kingston* and *View of Newburgh on the Hudson*.[21] While these titles may all have been newly assigned by those discovering Chambers in the 1930s and 1940s, the variety of identifications demonstrates a pleasantly generic quality to this composition that can explain its popularity with clientele a century earlier. The shipping that moves in and out, the islands that come and go, and the village that never appears exactly the same way twice made it easy for Chambers' customers to comprehend this view as their

*FIG. 3-15 Thomas Chambers. *Landscape with a Road Leading to Water*, c. 1843–50. Oil on canvas, 18½ x 24⅝ inches (47 x 62.5 cm).
Indiana University Art Museum, Bloomington. Morton and Marie Bradley Memorial Collection, 98.19

own favorite spot. It is a restful, idyllic vision, with a road leading the traveler to a snug village nestled under the hill, welcoming every nostalgic city dweller to a storybook countryside, or celebrating for proud residents the spectacular scenery of New York State, where nature and civilization unite in harmony.

This same serene and contented mood infuses a chain of paintings that may be inspired by a similar print, but demonstrate Chambers' talent for varying a theme and producing very open-ended content. All of these paintings have the welcoming road seen in *Lake George and the Village of Caldwell*, barred by long shadows, with the addition of trees at the left margin. This road leads directly to a body of water—either a lake or a river—where a characteristic pair of hunters contemplates the view. Across the water, neat green and gold fields crossed by hedgerows rise to tiny villages or castles, while overlapping mountain ridges in peach and blue march into the distance, as in *Landscape with a Road Leading to Water* (fig. 3-15). In the variants, all with the same sunny blue and apricot tonality, the spectators may include a fisherman or an artist sketching the view; an island, occasionally with a castle, appears offshore; and the distance contains different villages, castles, sheep, and waterfalls. Although the architecture and hedgerows suggest a European landscape, this image seems to be pure fancy painting that, like the Lake George subject, lets the audience attach to it the name of a beloved retreat. The eight extant variants of this composition have survived with different titles, mostly identified with the Hudson River, and perhaps Chambers meant to suggest the highlands to some New York customers and Europe to others.[22] His method in this chain of related paintings allowed for spontaneous revision in the distance, while the foreground stage and its flanking trees remained constant. Alternatively, the trees on the left and the mountain landscape with its patchwork of fields could hold, and the foreground road would drop out, to be replaced by more water and boats in *Summer: Fishermen Netting* (fig. 3-16).[23]

These paintings have been taken to be Hudson River subjects, and it seems likely that Chambers' generic structure allowed his customers to recognize—or imagine—their own native village, wherever it might be, on the far shore. Many of his landscapes remain unidentified, just barely reminiscent of familiar spots, and he may have been intentionally evasive in creating them for maximum flexibility in marketing. But many others were clearly intended to represent beloved American views, and when these subjects can be identified, they are usually from Bartlett's engravings (about fifty-three paintings are known, based on twenty-six images) or Milbert's lithographs (about thirty-seven known, from eleven of the plates). A

FIG. 3-16 Thomas Chambers. *Summer: Fishermen Netting*, c. 1843–60. Oil on canvas, 18¼ x 24⅜ inches (46.4 x 61.9 cm). Museum of Fine Arts, Boston. Gift of Maxim Karolik for the M. and M. Karolik Collection of American Paintings, 1815–1865, 62.266

handful of other landscape sources, such as works by Asher B. Durand, Thomas Doughty, or John Gadsby Chapman (whose *View of the Birthplace of Washington* supplied Chambers with his third best seller [see fig. 4-13]), show Chambers ranging widely through the gift books and print shops of his day. While others certainly will emerge, the extant paintings of known subjects follow a pattern that might be predicted: all but four of the Milbert images and three-fifths of the Bartlett pictures are New York State subjects. Natural Bridge, Virginia, and Eastport, Maine, at the far ends of his Eastern Seaboard repertory, were both popular subjects, but views in the triangle drawn from New York City to Lake George and Niagara Falls dominate his work, following the pattern of his residency in New York and Albany and the pattern of discovery of his work in upstate New York and down the Hudson Valley.[24] Some, like the views of West Point or the stone marking the site of George Washington's childhood home, are infused with patriotic sentiment in addition to picturesque appeal, but most are about pride of place, both local and national, shared by Chambers and his patrons, who wished to ornament their parlors with visions of American natural wonders and domestic tranquility.

The Newport Auction of 1845 and the Circle of Thomas Chambers

After looking deeper into these American subjects, we can also sift through period sources and find suggestive connections to extant paintings from the printed list of sixty-six "elegant oil paintings" in "splendid gilt frames" sold at Chambers' Newport sale in 1845 (fully listed in the Appendix). Only seven of the paintings listed on this broadside were actually credited to Thomas Chambers, and all of those—as itemized in Chapter One—were marines. We have already used this list in Chapter Two to suggest the complete period titles for some of Chambers' signed marine paintings, and we can drift over into the list of unattributed marines—such as the Marryat and Cooper subjects, the steamships, the wreck of the *Bristol*, and the Chesapeake and Nahant subjects—to attach eleven of those titles to extant, unsigned marines clearly by the same hand. From this, we might speculate that Chambers sold some marine paintings in this sale under his own name, and some anonymously. But what about the other two-thirds of the sale, all landscape paintings? Most of these (thirty-two) were sold simply by title, with no artist named; a few were credited to other artists (nine to "Mr. Corbin, of London," three to "Mr. Nesbit, of London," two each to "Roberts" and "J. Miller"), all never heard of before or since. Most remarkably, this list of landscape titles correlates very closely with subjects now recognized as Chambers' favorites, including "West Point, with a general view of the Military School. A splendid picture, the view taken from Cold Spring Mountains" and "Lake George and the village of Caldwell, a picture of great distance and beauty," remarkably akin to the titles of the Milbert-based images we have just examined. With suspicions aroused, we can look down the list of uncredited American titles and plausibly finger seven items that might be from Milbert subjects, and four others after Bartlett.[25] Other titles with foreign subjects yield a similar pattern: Merritt had spotted a subject by Chambers after a Bartlett illustration in William Beattie's *Scotland Illustrated*, and on the list are five titles familiar from that book, plus six from a related Bartlett and Beattie publication on Ireland. Even topics wildly unrelated to the known track of Chambers' work, such as *Road across the Plain of Waterloo* (fig. 3-33), are revealed as Bartlett subjects, lurking within a previously enigmatic image. Suddenly, Chambers' invisible role behind the curtain of the Newport sale begins to grow.

Before launching into the discussion of such foreign subjects, illustrated in extant paintings attributed to Chambers, we should stop to consider the implications posed by the discovery of two paintings of the same subject, very evocative of a title listed in the sale, displaying dramatically different color and handling. Or, more perplexing, we must pause to examine a painting with all the hallmarks of Chambers' style, but of a subject clearly credited in the auction list as by "Mr. Nesbit" or "Mr. Corbin." In a very slippery fashion, the sense of Chambers' identity begins to slide, just at the moment we also seem to find his style manifested in the work of other named artists. As the number of paintings in the sale that might have been painted by Chambers increases, two different scenarios arise, both interesting to contemplate as we explore his work further.

Looking at the diversity of styles loosely embraced since 1942 by the attribution "Thomas Chambers," the first explanation would propose a workshop of two or more artists, working on the same repertory of images. Merritt, surveying the range of quality among the variants, noted the possibility of "close followers" or students.[26] These could have been family members—his wife, his children—or other persons (such as Corbin, Nesbit, Miller, and Roberts) even more obscure than he. Harriet Shellard Chambers is never mentioned in the census or directories as an artist, but she could have been assisting behind the scenes, layering in the foliage or dabbling flowers in the foreground.[27] With the possibility of four or five artists in two generations of the Chambers family in Whitby, there are precedents for a household operation, in keeping with centuries of guild practice. Another model close at hand at the time of the Newport sale would have been the "Painting Garret," the studio in East Boston where William Matthew Prior and his brothers-in-law the Hamblins produced portraits and landscapes in a common style that has only recently been sorted out (see figs. 4-4 and 4-5). The existence of a Chambers studio would explain the diversity of style and detail in any two versions of the same composition, as well as the impressive proliferation of examples, many in standard sizes, in similar materials and frames. However, such a school of Chambers would oddly challenge the conventional wisdom on his highly individualized style by proposing that the expressive and personal qualities so admired by collectors in the twentieth century were actually taught to others.[28]

Against this hypothetical workshop might be the simpler but impressively energetic scenario that would have Thomas Chambers himself producing all or most of the work in the Newport sale, highlighting his original marines and then choosing anonymity or the fiction of different London alter egos in order to give the rest of his work an air of diversity and a sense of cachet. As a marketing strategy, his deceit—if that's what it was—created a sense of variety confirmed by the range of subject matter, perhaps to pique the interest of customers who otherwise might have

sniffed at a sale of sixty-six paintings by the same thirty-seven-year-old unknown artist, even if he was "of New York." In this fashion, he protected his name as an artist and a marine painter, and kept the pot boiling at home with anonymous paintings of Niagara or Scotland. Perhaps, then, the diversity of style might be a posture, akin to the legendary workshops of tourist art in Italy or Asia, where a single painter might proudly produce copies in different styles or work under multiple modern signatures. However, because no landscape paintings signed "Nesbit" or "Corbin" have emerged, and (as we shall see) the Chambers style seems to slide across these identities, the idea of consciously adopted alternate hands seems remote, especially because the differences seem to be more of quality than style.

Tempting, then, is the narrative that an art historian would naturally concoct—that Chambers repeated these subjects over thirty years and gradually developed a later style that is looser, faster, simpler, darker, muddier, and sometimes—as in the case of the Castles on the Rhine subjects painted in the late 1850s (and ascribed, as discussed below, to "European artists")—more fantastic. Over the course of three decades, such a change of style seems not only normal, but inevitable; holding the same practices steady over that time would be superhuman. Although the early nineteenth century was not known for chameleons like Picasso, the example of Ammi Phillips (see fig. 4-6), whose work was for years ascribed to three different painters, reminds us that this type of transforming artistic personality can be found anywhere. A different, but related trajectory has been traced by scholars considering the career of Ralph Earl, who returned from the studio of Benjamin West in London with a cosmopolitan style that gradually "folkified"—that is, became simplified and flattened—within the culture of his Connecticut patrons, in a process further hastened by intemperance.[29] Some of any of these possibilities outlined may be true for Chambers—perhaps he had studio mates *and* multiple styles—although his late marine *The U.S.S. "Cumberland" Rammed by the C.S.S. "Virginia"* (see fig. 2-21) does not show a drastic evolution from earlier dated work. A messier reality, much more natural and irregular, would suppose good days and bad days for Chambers, moments of focus and inspiration and other hours of boredom, depression, fatigue, illness, or inebriation.

Allowing Chambers to be inconsistent and human may account for much of the variety in his work, as well as the totally practical arithmetic of time and effort to produce his product. Insight into this factor fell upon scholars of American folk art with the revelation of William M. Prior's famous newspaper advertisement of 1831, offering portraits "without shade or shadow at one-quarter price."[30] At the edges of so-called folk and commercial art, where Chambers and Prior worked, much painting was undertaken as workaday craft or commodity, with a low level of art spirit; likewise, his colleagues on the so-called fine art side of the street produced replicas and variants of popular items to pay the rent, as seen in works by Birch such as *Philadelphia Harbor* (see fig. 4-9) and by Doughty such as *Coming Squall (Nahant Beach with a Summer Shower)* (see fig. 2-12) and *River Landscape, New England* (see fig. 4-17). For Chambers the working man, the disparity of effect may literally have been a question of time, effort, and materials. The fee scale of a portrait painter, who charged by size, whether the hands showed, and with or without shadows, might be translated to landscape and marine painting in equivalent terms. Generally, Chambers' largest and most time-consuming paintings are his best work, most likely to be original, careful, and signed. As a rule, his dullest paintings are also the smallest, evidently the most quickly produced, and probably the cheapest ones in his inventory. In these terms, as we consider the problematic range of things attributed to Chambers, it seems very possible that Chambers executed almost all of it himself, over three decades of work.

Foreign Lands

Be they by Chambers or his associates, more than half of the pictures sold at the Newport sale carried titles indicating foreign landscapes and harbors. Nothing in Chambers' biography or in the fantastic quality of these paintings suggests that he actually traveled to any of these sites; he probably never visited many of the sites painted in his American repertory either. Looking back and forth between the list of paintings sold in Newport in 1845 and the assembly of work attributed to Chambers that has survived to the present day, and then rummaging through the illustrated books of the 1830s, we can produce a few provocative matches. If correct, these newly identified subjects further implicate Chambers' hand in the lineup of work produced for that sale—tying him to almost two-thirds of the paintings on the list—and open new paths to explore Chambers' identity and the taste of his audience. Groups of unattributed British and European subjects in the sale, particularly of Scotland, Ireland, and Italy, test the problem of a circle of Chambers, and they prepare us to comprehend new subjects to come after 1845, from Mexico and China, that follow the same patterns. The American views express Chambers' principal focus on the national landscape, and probably his businessman's understanding of his audience's patriotic and emotional response to native subjects. More

diverse and unpredictable are the foreign subjects that we can likewise imagine as personally interesting to Chambers, or perhaps undertaken speculatively, in hopes of appealing to a special customer. These foreign views tend to survive in unique examples, or with only two or three known variants, indicating that they were less popular or made for a brief period of time. As experiments, personal whims, or strategic responses to popular culture and current events, they give us a clue to the kind of paintings that Chambers meant when he advertised "A great variety of Cabinet Pictures constantly on hand."

SCOTLAND, IRELAND, AND ENGLAND

A subject identified as *The Bridge of Doune*, now unlocated, was one of five foreign subjects by Chambers known to Merritt, who discovered the source in a Bartlett illustration to William Beattie's *Scotland Illustrated* of 1838.[31] In the Newport sale the same subject appears as no. 61, "Bridge O'Downe, (Tam O'Shanter, Scotland) from Burns," as a companion to a view of Bothwell Castle. Over time, other Scottish subjects have emerged, several depicting sites associated with Robert Burns and his poetry, such as the "Brig o' Doon" that the panicked Tam O'Shanter galloped across, pursued by witches. Most amusing to recognize is "Alloway Kirk, with Burns' Monument, moon rising," no. 6 in the sale, another title from the Bartlett-Beattie book (fig. 3-17) that surely inspired Chambers' painting known for many years as *Old Sleepy Hollow Church* (fig. 3-18).[32] Just as Chambers' Lake George subjects drifted toward Hudson River titles, this painting acquired an apt Hudson Valley narrative. Associated with Washington Irving and the spooky context of Ichabod Crane's pursuit by the headless horseman, Sleepy Hollow's churchyard was familiar to Hudson Valley collectors in the twentieth century, and many of Chambers' patrons could have made the same mistake a century earlier. The story of Crane's wild ride, told in "The Legend of Sleepy Hollow" by Irving in 1820 and immediately acclaimed as a national classic, followed the tradition of Burns' poem of ghostly pursuit, written in 1790 and sensationally popular for much of the nineteenth century. Both the Bridge of Doune and the nearby ruin of the "auld haunted kirk," where the drunken Tam O'Shanter envisioned the witches' frolic, had become tourist pilgrimage sites by the time Beattie's book was published in 1838. In the Bartlett plate, the monument to the poet rises beyond the churchyard in the moonlight, uniting present reality with the aura of Burns' comic horror story, lurking in the soft shadows of the old church. Chambers erases the modern references, deleting the figure in the churchyard and masking the new monument in

FIG. 3-17 J. T. Wilmore, after William H. Bartlett (English, 1809–1854). *Alloway Kirk, with Burns' Monument.* Etching, c. 5 x 7 inches (12.7 x 17.8 cm). From William Beattie, *Scotland Illustrated* (London: George Virtue, 1838), vol. 1, opp. p. 139

FIG. 3-18 Thomas Chambers. *Old Sleepy Hollow Church [Alloway Kirk, with Burns' Monument]*, c. 1843–60. Oil on canvas, 18¾ x 24⅜ inches (47.6 x 61.9 cm). Flint Institute of Arts, Flint, Mich., 1968.18

foliage, and he jacks up the fear, adding more clouds and an electrifying light source in addition to the moon that rakes the tilting headstones for a caricatured Gothic effect. Painted in Chambers' wildest manner, the scene offers a horror story for an audience that likewise enjoyed the contained and theatrical thrill of his storm-tossed ships.

How benign by comparison is a view by Chambers of a thatched cottage, *Cottages in a Landscape* (fig. 3-19), very likely inspired by an etching by John Cousen after Thomas Creswick's *Birthplace of Burns*, published as the frontispiece to *Pictures and Portraits of the Life and Land of Burns* of 1838, based on a well-known image by Thomas Stothard.[33] Two other versions of this composition survive, both small, one in an original decorated Chambers-style frame, suggesting—with the other Burns subjects—a healthy American market for mementos of Scotland's great national poet.[34] And there, as no. 2 in the Newport auction list, with no artist named, is "Birthplace of Robert Burns, (Scotland)," perhaps something like one of these extant paintings. Renowned before his death in 1796, Burns acquired cult status in the Romantic period, reaching a new level of fame after 1834 with the publication in England of rival editions of his collected works and new biographies, to be enjoyed along with Staffordshire figures of "Tam O'Shanter" for the mantel and books on the "Life and Land" of Burns for the parlor table. Chambers, as a Yorkshireman, may have had some Scots connections or admired Burns' work, or

*FIG. 3-20 Thomas Chambers. *Kilchurn Castle, Loch Awe, Looking Toward Dalmally*, c. 1843–60. Oil on cardboard, 13¹³⁄₁₆ x 19 inches (35 x 48.3 cm). Indiana University Art Museum, Bloomington. Morton and Marie Bradley Memorial Collection, 98.91

FIG. 3-21 Thomas Chambers. *Kilchurn Castle, Loch Awe*, c. 1843–60. Oil on cardboard, 13¾ x 19 inches (34.9 x 48.3 cm). Indiana University Art Museum, Bloomington. Morton and Marie Bradley Memorial Collection, 98.53

perhaps he was just appealing to the literate public, and particularly Americans of Scottish descent, who enjoyed the humor, the satire, the winking critiques of religion and authority, and the celebration of everyday profundities that made Burns beloved. Like Chambers' literary seascapes based on popular fiction by Cooper or Marryat, these Scottish paintings are a type of literary landscape, representing respect and affection for the writer, characterized as a farmer, who spoke for the common man in dialect verse and song.

Paired in the Newport auction with the Bridge of Doune was a view of Bothwell Castle on the Clyde, no. 34, and two other landscapes, no. 41, "Rob Roy's Castle, Loch awe (Scotland,)," and its companion, no. 42, "with a view near the Caledonian Canal," both unattributed. Although the castle and canal subjects have not been discovered, one of two previously untitled paintings attributed to Chambers—showing a castle on a lake (fig. 3-20) and a closer view of a similar ruin (fig. 3-21)—may be the Loch Awe view, or a variant of it, based again on steel engravings from Beattie's

Scotland Illustrated. The two plates from Beattie—*Kilchurn Castle, Loch Awe (looking toward Dalmally, Argyleshire)*, engraved by T. Barber after Thomas Allom, and *Kilchurn Castle, Loch Awe*, engraved by E. Wallis after H. M'Culloch—both depict "one of the most picturesque ruins in Great Britain," a fifteenth-century Campbell fortress on lands that had once belonged to the clan MacGregor.[35] The famous eighteenth-century outlaw Rob Roy MacGregor shared little but his ancestral name with this site, so the description of this subject as "Rob Roy's Castle" would have blurred both history and geography in an ignorant or wishful way. But the association makes another literary connection, attaching the picturesque scenery to a Robin Hood character known well from fictionalized accounts even in Chambers' own lifetime, most recently in Sir Walter Scott's *Rob Roy* of 1817. Scott was one of the most popular writers of the nineteenth century, and an icon (like Burns or Rob Roy) of Scottish nationalism, so the title reiterated the appeal, both picturesque and symbolic, that Chambers was directing to sentimental Scots Americans.

FIG. 3-22 Thomas Chambers. *Ruins*, c. 1843–60. Oil on cardboard, 14⅛ x 20 inches (35.9 x 50.8 cm). Indiana University Art Museum, Bloomington. Morton and Marie Bradley Memorial Collection, 98.131

FIG. 3-23 Thomas Chambers. *Mill and Cottages by a Waterfall*, c. 1835–60. Oil on cardboard, 13¾ x 18 inches (34.9 x 45.7 cm). Indiana University Art Museum, Bloomington. Morton and Marie Bradley Memorial Collection, 98.46

The two Kilchurn Castle paintings by Chambers, found together in Maine, are identical in size, close to his familiar 14-by-18-inch format, and painted on artist's board, as are a very few of Chambers' smallest paintings.[36] This hard surface makes it easier to read his quick pencil underdrawing, and it retains the richness of his textures, often softened by conservation in other examples. The stamped foliage, the golden sunset, the ripples on the water, and the generally low tone are all familiar from his American views. Chambers evidently supplied other Scottish views, also from Beattie's plates, such as *Ravenscraig's Castle, Fifeshire, Scotland*, and *The Carlton Hill, with Nelson's Monument*, retitled in the twentieth century to connect to an American view by Bartlett of Kosciusko's Monument at West Point.[37]

Not surprisingly, the Newport sale included just as many views of Ireland as of Scotland, again with titles that sound suspiciously like the plates in another of Bartlett's pictorial adventures, *Scenery and Antiquities of Ireland*, published in London in 1842 with a text by his friend Willis and the Irish writer J. Stirling

Coyne. Only one likely match has emerged to set against the list of six Irish titles appearing in the sale (nos. 10, 19, 23, 26, 56, and 57): two versions of *Innisfallen, Lake of Killarney*, with the ruined stump of a castle swaying in the middle of a lake ringed by mountains.[38] Eight subjects in the sale were English views (nos. 3, 20, 27, 28, 33, 38, 39, and 46; plus no. 29, of Wales), but none of these can be reasonably affiliated with the many unidentified subjects attributed to Chambers that feature picturesque ruins, such as *Ruins* (fig. 3-22), in its original Chambers frame. Only a small wood panel, *Mill and Cottages by a Waterfall*,[39] may conjecturally be connected to subjects in the sale such as "Hampshire Water Mills, (England)" (said to be by "Mr. Corbin"), or its companion, "Franklin Water Mills, Kent, England." Typically romantic in their emphasis on ruins, village simplicity, and only the earliest, quaintest industrial architecture, such views demonstrate Chambers' lack of interest in modern urban sites. Sources for these small, quickly painted subjects may be the most difficult to identify because they are so generic and so much the

dullest of Chambers' work, no more charming than the numerous other fancy landscape-with-cottage (or windmill, or ruins) compositions on the clocks, chairs (see fig. 1-7), mirrors (see fig. 4-11), window shades (see fig. 4-27), sugar bowls (see fig. 5-3), and "Buckeye" paintings of the mid-nineteenth century.

More unusual are the unidentified but clearly northern European subjects, such as *Flooded Town*, which show Chambers at his most surreal. Soldiers in a boat drift down the flooded street of a medieval town, against the backdrop of a fantastic building pierced by light as if ruined, but crowned by a rooftop palace. Chambers applied some unusual techniques in this painting, scoring lines in the wet paint of the tree trunks and dabbing "moss" on the nearest house with his fingers. This painting becomes even more curious when considered alongside the picture that came to light with it, an unidentified village scene with half-timbered cottages.[40]

ITALY

Italy, by comparison, interested Chambers greatly, judging by the size and number of extant paintings by his hand that can generally be identified as Mediterranean subjects. His taste, of course, was shared by many of the artists of his day in the United States and Britain, continuing a long romance with Italy that had flourished since the eighteenth century. American artists yearned for Italy, and many painters and sculptors of Chambers' generation, such as Chapman, Cole, and George Loring Brown either toured or settled there for long periods. Returning, they would spin the memories of Italy into imaginative landscapes dotted with ruined aqueducts and rustic shrines. Others invented similar fancies of temples and towers without ever leaving home, learning from engravings after the venerated work of Claude Lorrain, Nicholas Poussin, Gaspard Dughet, Richard Wilson, and Claude-Joseph

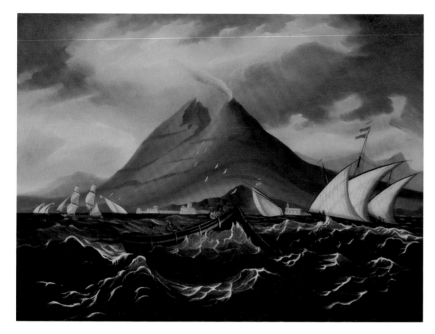

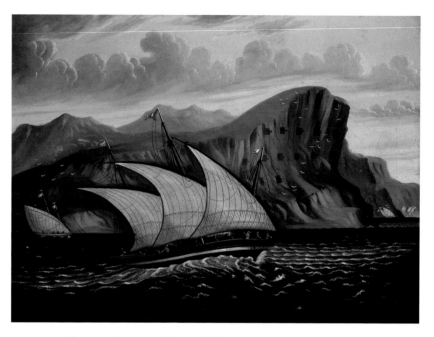

*FIG. 3-25 Thomas Chambers. *Mount Vesuvius and the Bay of Naples*, c. 1843–60. Oil on canvas, 21¹⁵⁄₁₆ x 29⅞ inches (55.7 x 75.9 cm). Indiana University Art Museum, Bloomington. Morton and Marie Bradley Memorial Collection, 98.39

*FIG. 3-26 Thomas Chambers. *Felucca off Gibraltar*, c. 1843–60. Oil on canvas, 22 x 30¼ inches (55.8 x 76.6 cm). National Gallery of Art, Washington, D.C. Gift of Edgar William and Bernice Chrysler Garbisch, 1968.26.2

Vernet, or contemporary illustrated travel books with steel engravings after Bartlett, J.M.W. Turner, Clarkson Stanfield, James Duffield Harding, and many others, all very dependent on the baroque landscape tradition. Chambers, without ever leaving North America, could have absorbed three centuries of Italian reverie.

A marine painter first, Chambers composed his most ambitious Mediterranean images as harbor views, painted on canvases of his largest standard size, such as *Mount Vesuvius and the Bay of Naples* (fig. 3-25) and *Felucca off Gibraltar* (fig. 3-26). Both paintings show swift Mediterranean vessels with lateen sails against famous landmarks. Painting the bay of Naples, Chambers seems to have become obsessed by the unusual and elaborate veinlike pattern of foam and strongly three-dimensional wave troughs upon which the fishermen rock like actors on a stage, posed against a flat scenic backdrop. The swing of their boat and nets echoes the peak behind them and the nested sails of the xebec bounding in from the right. In the Gibraltar view, the taut, bright sails of the vessel again cut dynamic repeating curves, while the waves oddly lift and bend the hull against the mass of the moun-

tain. Although these two paintings could be a pair in size and composition—bracketing the stretch of the Mediterranean between Italy and Spain—the handling of *Felucca off Gibraltar* seems, as Chotner has noted, even more "abstract or decorative," the mountains painted in broad, creamy stripes, the sky arbitrarily modeled from pink to blue and yellow, and the waves willfully organized, as if a force field from below is carrying the vessel forward in an otherwise level sea.[41] But a similar diversity of sea-painting styles appears in Chambers' American marines, and both paintings show the treatment of figures, sails, and landscape seen before, including the familiar sprinkling of seagulls.

No titles answering to these marines appeared in the Newport sale, which included only four paintings with Italian subjects, all credited to two other artists. However, another large volcano composition surviving in three versions (including figs. 3-27 and 3-28, both called *Landscape with Mount Vesuvius*) must make us wonder about the appearance of "Mount Vesuvius, from the Environs of Naples," a splendid landscape painting that the broadside insisted "should not be separated

*FIG. 3-27 Thomas Chambers. *Landscape with Mount Vesuvius*, c. 1843–60. Oil on canvas, 22 x 30 inches (55.9 x 76.2 cm). Collection of Susanne and Ralph Katz

from No. 18, its companion," "Lake of Albano, Rome, in the distance," both by "Mr. Corbin of London." Looking back and forth between the two large versions of Vesuvius now attributed to Chambers, the disparity of style and color immediately raises the possibility of a Chambers circle, including different artists working together from the same source. The profile of the volcano and its plume of smoke have not changed, although now we seem to be looking across a cove into a wider Bay of Naples, perhaps from the ruins at Posilippo, suggested by the fallen column and the vine-covered arches at the left. However, between the two versions, every detail that could be changed has been altered. The sky in the Katz view (fig. 3-27)

is graduated to pale yellow at the horizon, with neat hedgerows on the slopes of the distant hill, a profusion of dotted flowers in the foreground and silhouetted against the water, and long shadows across the road, with its ruts and stones, all familiar from Chambers' views like *Landscape with a Road Leading to Water* (fig. 3-15). The mood is tranquil and Arcadian, evoking a storybook springtime in Italy, with some of the spirit of a classic Disney cartoon.

The Indiana version (fig. 3-28), by comparison, is darker and less colorful, varied, and atmospheric, almost as if Chambers ran out of time as well as carmine and gamboge. Painted in a lower tone, with a more restricted palette emphasizing olive,

*FIG. 3-28 Thomas Chambers. *Landscape with Mount Vesuvius*, c. 1843–60. Oil on canvas, 22⅛ x 30⅛ inches (56.2 x 76.5 cm). Indiana University Art Museum, Bloomington. Morton and Marie Bradley Memorial Collection, 98.38

orange, and blue, this is twilight and autumn in Italy. The sky is more simply painted in broad bands of color, and the detail has everywhere been reconsidered: Even the palm tree bends the other way. But this painting also contains many familiar Chambers notes, beginning with the tiny fisherman on the bank, and including the characteristic foliage, the road cuts, the snaky roots, the running ripples. Quite possibly, this is Chambers himself, maybe several years later, with less patience and fewer pigments. Then again, it could be someone working with Chambers, perhaps "Mr. Corbin of London," about whom nothing is known.[42] All of Corbin's paintings in the Newport sale involved English or Italian subjects, with one remarkable

exception, no. 7: "Washington's birthplace, with a view of the Potomac River, and the Maryland shore; the stone in the foreground denotes where the house stood; the old vine, which is still growing, was planted by the Washington family.—A very fine and highly interesting Painting." Indeed, highly interesting in this title is its evocation of one of Chambers' most popular subjects, known in at least six versions (see fig. 4-13), based on an image by Chapman.[43]

The title of the other painting (no. 18) in the Corbin pair of Italian subjects, a view of Lake Albano looking toward Rome, must make us inspect with greater interest one of Chambers' most popular European compositions, *Landscape with*

Lake and Monastery (fig. 3-29), which shows a monastery poised on a cliff above a lake, with a city in the distance. Resembling Castel Gandolfo on Lake Albano in the mountains south of Rome, this subject is known in five versions, one of which has traveled through time as a companion to *Landscape with Mount Vesuvius* (fig. 3-27). Like the views of Naples, this image has no known print source, but the repeated variants and the complex composition, richly suggestive of the picturesque travel views of the 1830s by James Duffield Harding, Bartlett, and many others, hint that Chambers had a model. The picture pairs nicely with the view of Vesuvius, for just as the volcano appears behind a central palm tree, the monastery and city are

glimpsed beyond a clump of trees, again circled by a foreground road lined with Chambers' familiar roots and flowers. In *Landscape with Lake and Monastery* (fig. 3-29), at least four different brushes create the stamped foliage patterns, layered over transparent washes. The sky is flushed with pale pink and yellow at the horizon, although the overall tone is cooler and darker, and the shadows are long, creating the contemplative and idyllic mood seen in other Chambers views, here appropriately fitted to the romantic musings inevitably called forth by the Italian landscape. In one of the larger versions of this composition (in the collection of Emmy Cadwalader Bunker), the trees at the left, with their fantastic gnarled roots

*FIG. 3-30 Thomas Chambers. *Landscape with a Walled Town*, c. 1843–60. Oil on canvas, 18¼ x 24¼ inches (46.4 x 61.6 cm). Indiana University Art Museum, Bloomington. Morton and Marie Bradley Memorial Collection, 98.89

and swaying trunks, have been described as sinister, animated characters. Indeed, there is a fairy-tale quality to these landscapes that suggests the imminent appearance of trolls, mysterious travelers, or talking animals.[44]

Yet another mystery figure, "Roberts," supposedly painted the last two Italian subjects listed in the Newport sale, a pair of paintings of the "Environs of Rome." With a name so vague and so common, perhaps deliberately implying the famous landscapist David Roberts, the identity of this artist will likely forever remain obscure. Lacking more descriptive titles, and suspecting that Chambers could be at work here too, we might link these titles to a large group of extant Chambers paintings showing classical architecture—temples, domes, and bridges—amidst arcadian scenery, such as *Landscape with a Walled Town* (fig. 3-30). Known in three versions, usually titled *Imaginary Landscape*, this composition was surely based on a print, perhaps to be identified someday by the moss-covered sculpture (of a horse?) under the tree at the right. As usual, the artist plays within his format across the different versions, replacing the grave monuments with boaters, and reinventing the buildings of his walled city. But the pale pink and blue sky, long shadows, and rutted road remain, and the peaceful mood persists.[45] Like similar Italian fancies by Cole and Doughty, this is a sunny dream of Italy.

FIG. 3-31 Thomas Chambers. *Corsica, Birthplace of Napoleon*, c. 1843–60. Oil on canvas, 18 x 24½ inches (45.7 x 62.2 cm). Hirschl and Adler Galleries, New York

NAPOLEONIC SITES

The suites of Italian paintings all vary slightly, as usual, but none look remarkably unlike the work of Thomas Chambers as we have come to recognize it. However, to the dilemma of finding Mr. Corbin and Mr. Roberts as well as Mr. Chambers within this body of work, we must also add the mystery of Mr. Nesbit, also of London, who is supposed to have painted the "beautifully and highly finished Picture," no. 1 in the auction of 1845: "Corsica, the birthplace of Napoleon, with a view of the town and road of Bastia,—the victory of 100 guns, Lord Nelson's ship at anchor." The first five words of this eccentric title were inscribed on the stretcher of a painting attributed to Chambers (fig. 3-31), discovered about 1975.[46] The longer title in the auction list helps uncover the source, *A View of Bastia*, an aquatint by T. Medland after Nicholas Pocock, published in the *Naval Chronicle* of July 1, 1799. The text accompanying the print mentions neither Napoleon nor Nelson, instead noting the

presence of Admiral Samuel Hood's flagship, *Victory*, at anchor in the harbor of Bastia; Chambers (or Nesbit) makes it clear that an admiral is being rowed ashore, evidently following the successful siege of the town in 1794, when Hood's forces routed the French from Corsica. However, like Rob Roy's castle, the subject has been blurred in the broadside to identify the ship as Nelson's, although he was only a captain during this campaign and would not take command of this ship until later—and to mention the site as Napoleon's birthplace, although Napoleon was nowhere near Corsica at this time. Such a title transforms the print subject into a premonition of Napoleon's downfall, hinting at Nelson's triumph (on the *Victory*) twelve years later at the Battle of Trafalgar, foreshadowed by the conquest of Napoleon's very birthplace.

This odd subject gains meaning from its pendant in the Newport sale, no. 37, "Indiaman saluting, at the Island of St. Helena, where Napoleon was exiled,

FIG. 3-32 Thomas Chambers. *Indiaman Saluting at the Island of St. Helena*, c. 1843–60. Oil on canvas, 18¼ x 23½ inches (46.4 x 59.7 cm). Collection of Emmy Cadwalader Bunker

Companion to No. 1," also presumably by Mr. Nesbit, although no artist is given. This second title leads to another print in a different issue of the *Naval Chronicle*, a view of *St. Helena* that served as the inspiration for two versions of a previously unidentified subject by Chambers, including *Indiaman Saluting at the Island of St. Helena* (fig. 3-32), now worth considering as the companions of the two views of Corsica. In each, a ship fires its cannons below cliff-top batteries, signaling for recognition and permission to enter this closely guarded port, "the most distant island from the continent of any in the known world," where East India ships found a safe harbor on their return from the Orient.[47] Although the print was published as a descriptive tribute to the island's security long before Napoleon was anywhere near the site, the Newport title finds new significance in the view based on his later imprisonment and death there. By 1837, "the spot where the dust of Napoleon reposes on this desolate island, has almost become a Mecca or a Delphos to the

errant countrymen of the departed Emperor," noted the *New-Yorker*.[48] As a pair, the two subjects of Corsica and St. Helena bracket Napoleon's life in parallel scenarios of capitulation, in picturesque harbors stocked with powerful ships.

In the United States, the appearance of a pair of such subjects about 1845 indicates the undying celebrity of Napoleon, whose death in 1820 was, like the events of the War of 1812, within the memory of many living Americans, particularly those with ties to Britain and a seafaring life, like Chambers. The return of Napoleon's ashes to Paris in 1840 for deposit in glory at the Invalides inspired a revival of Napoleonic sentiment in France that accompanied the increasing unpopularity of King Louis Philippe and the maneuverings of Napoleon's nephew, the "pretender" prince, later Napoleon III. The death in 1844 of Joseph Bonaparte, who had been for a time a popular figure in the United States, and the subsequent sale of his estate at Bordentown, New Jersey, kept the Napoleonic legacy in the news. Like-

wise, the thirtieth anniversary of Napoleon's final defeat in 1815 may have inspired another title in the Newport auction, no. 40: "Road across the Plain of Waterloo, the distance in this picture is wonderful when viewed through a Magnifying glass," provocatively similar to the title of a Bartlett print that inspired Chambers' surreal painting (fig. 3-33).[49]

Considering at least the first of these paintings as representative of the style of "Mr. Nesbit," it is difficult to find anyone but Chambers at work within them.

Noting the usual originality of his manner, we can also remark his marine painter's bias, his historical imagination, and his marketing flair, in gathering two unrelated subjects from a fifty-year-old magazine into a narrative pair, hoping to appeal to a buyer still enthralled by the events and personalities of the Napoleonic era. Like his views of the birthplace of George Washington or the cottage of Robert Burns, these paintings are decorative and symbolic at the same time, gaining meaning from titles that suggest the invisible presence of celebrated historical figures.

*FIG. 3-34 Thomas Chambers. *Hill Town and Garden [Mexico?]*, c. 1846–50. Oil on canvas, 18 x 24½ inches (45.7 x 62.2 cm). Indiana University Art Museum, Bloomington. Morton and Marie Bradley Memorial Collection, 98.137

FIG. 3-35 W. Croome and other artists. *Ornamental headpiece [Mexican mountain landscape]*. Wood engraving. From John Frost, *Pictorial History of Mexico and the Mexican War* (Philadelphia: Thomas, Cowperthwait, 1848), p. 631

MEXICO

Surviving paintings tell us that Chambers' repertory of titles in 1845, gleaned from the list of the Newport sale, expanded after that year to include more exotic subjects that demonstrate his continuing alertness to popular topics. A sequence of images of Mexico must have been inspired by the war that followed the United States' annexation of Texas in December 1845. Chambers could have traveled to Mexico, but this seems unlikely, given the close correlation of his subjects to prints that were readily available in Boston, where his name appears steadily in the city directories from 1843 to 1851. The American illustrated press fed curiosity about the heroes and events of the war with lithographs, etchings, and engravings, often based on eyewitness accounts that were quickly copied in wood engravings for mass printing in newspapers and popular books. The widespread piracy of these images and the reuse of the same blocks by different authors and publishers make

it difficult to know when and where Chambers discovered the views that inspired his paintings, but it is reasonable to assume that all three of his subjects that I have identified as Mexican were painted not long after the war, when the topic was of greatest interest. Joining the fray with other engravers and opportunistic publishers in this general circulation of images, Chambers was remarkable for being one of the few painters interested in these views (such as fig. 3-34).

Chambers' first Mexican subject image to be correctly identified, *Molino del Rey—Chapultepec in the Distance* (collection of Frank Moran), demonstrates the difficulty in tracking his sources. A lithograph published in Mexico late in 1847 first depicted this view, showing the aftermath of a major victory of the American forces outside Mexico City that September. Within weeks, this image was redrawn on stone and published by Nathaniel Currier in New York. Translated into a wood engraving, it appeared, uncredited, in the *New York Weekly Herald* that Novem-

ber, and then the following year in John Frost's *Pictorial History of Mexico and the Mexican War*.[50]

Frost's book was probably the source for Chambers' view of Chapultepec, because the painting, although typically personalized, seems based on the much simpler and somewhat garbled rendition of the view of the fortifications in Frost's wood engraving. Chambers also drew upon at least two designs from other plates in this book. The wood engraving *Monterey from the Bishop's Palace* served as the headpiece for Frost's chapter "The Storming of Monterey," recounting the success of General Zachary Taylor's forces in September 1846. Chambers' painting, previously identified as just *Village in the Foothills* (Flint Institute of Arts, Michigan), seems to have been based on this print or versions that appeared in Frost's book and elsewhere.[51] Characteristically, Chambers added a flaming sunset, exaggerated the height and number of spires on buildings in the city, and found a swinging rhythm in the radiating grid of streets.

The view seen most often in Chambers' surviving Mexican pictures (for example, fig. 3-34) is the most difficult to identify today, because the related wood engraving in Frost's *Pictorial History* (fig. 3-35) has no title.[52] The headpiece for the chapter "The Close of the War" is an image of a hill town, illustrating the discussion of the last maneuvers near Mexico City and the signing of the treaty at Guadalupe Hidalgo on February 2, 1848, which transferred Texas, New Mexico, and upper California to the United States. Like the hundreds of generic embellishments in Frost's book that may have been recycled through many publications, this image could be from an older block completely unrelated to the topic, but it seems to have served as an emblem of the peaceful conclusion of the war. The significance of the subject can be measured by the fact that Chambers painted it at least six times in his four most popular sizes: three surviving examples are about 22 by 30 inches, and one (fig. 3-34) is 18 by 24½. The contours of the mountains, the number of spires on the hillside, and the configuration of the "road" in the middle distance change in each version, but, like the engraving, all four show a building with a balcony decorated with a gaily striped roof at the far right and a small building at the center, surrounded by Chambers' signature vegetation.[53]

CHINA

Chambers' most exotic view may be his painting of the harbor of Whampoa (fig. 3-36), which is evidently based on a tiny aquatint from the *Naval Chronicle* of June 1802.[54] Found in one of the ornately decorated frames that may correlate to his work in Boston in the 1840s, this painting reiterates Chambers' alertness to current events in this decade, following the pattern of his Mexican War subjects. Resourcefully, Chambers turned an older image to new uses as interest in China rose during the British Opium Wars, which concluded with the Treaty of Nanking in 1842. Whampoa (or "Wampooh," as it is spelled on the print), a harbor below Canton (modern Guangzhou) on the opposite side of the Pearl (now Zhu Jiang) River, would have been a familiar base to British and American merchants in the China trade in the era when Canton was the only harbor open to foreign ships. Boston, as a North American center of this trade, harbored many merchants with an interest in the outcome of the treaty, which opened five ports to foreign commerce and conceded Hong Kong, an island at the mouth of the river below Canton, to British rule. Whampoa, halfway between Canton and the sea, offered wharves and offices for American and British shipping, defended by a British blockade in 1841 that pulverized the Chinese navy while forcing many American ships to unload and return empty. The armed vessels anchored across the river in Chambers' painting, although based on the more old-fashioned ships in his print source, nonetheless represent this recent British muscle. After 1842, Hong Kong became the new base of British operations, but Whampoa continued to serve in the transitional period, and the site would have lived in the memory of those involved in the China trade. This rare image suggests a special commission from a Boston or Salem patron interested in the subject, or someone who welcomed the insistence on British flags on the wharf and the ships beyond.[55] In keeping with its singular subject, the painting is unusually high-keyed in color, with an uncharacteristic green pigment in the foliage and an odd emphasis on yellow in the sky and water, perhaps to underscore the foreign locale.[56]

CASTLES ON THE RHINE

The Chinese boats with their gaily striped awnings in the harbor of Whampoa appear again in a series of at least a dozen paintings that combine the exotic appeal of the East and the legendary beauty of the Rhine Valley into the most fantastic landscapes in Chambers' repertory, *Castles of the Mind* (fig. 3-37) and *Castles on the Rhine* (fig. 3-38). These paintings, like his European and American views, may have been based on specific prints dramatizing scenery of cliffs and castles, found in abundance in nineteenth-century gift books and illustrated travelogues. The sublime landscape mode seen earlier in *Hudson Highlands from Bull Hill* (fig. 3-3), inherited from the seventeenth century and cultivated through the mid-nineteenth-century heyday of the steel engraving, drew upon the work of Salvator Rosa, Vernet,

∗FIG. 3-36 Thomas Chambers. *Whampoa, China*, c. 1843–50. Oil on canvas, 18½ x 24½ inches (47 x 62.2 cm). Indiana University Art Museum, Bloomington. Morton and Marie Bradley Memorial Collection, 98.15

Turner, and many contemporary popularizers such as Bartlett. In the United States, young Frederic E. Church was a master of these conventions by 1850, as seen in his *Scene on Catskill Creek* (Washington County Museum of Fine Arts, Hagerstown, Maryland) of 1847, with its strongly backlit foreground bluff. Chambers distilled the visual language of the sublime, simplifying and exaggerating the conventions of motif, scale, and lighting into wildly expressive and decorative caricature. His tiny towers perched on impossibly beetling precipices, seen beyond silhouetted foreground cliffs, remind us again of the sensibility of theatrical scene painting and the literal fancies of both imagination and decoration in this period.

Castles on the Rhine (first known as *Fantasy*), one of the first paintings pur-

chased by a museum from the Macbeth Gallery exhibition in 1942, illustrates all the flamboyant qualities of this group (fig. 3-38).[57] The strongly backlit cliffs produce dark, energetic contours set against bright and sometimes brilliantly colored sky and water. Often the sky is cloudless, tinted from dark to light in broad, washy, diagonal bands, sometimes very rapidly and crudely painted. *Castles of the Mind* (fig. 3-37), the second of this group to emerge, shows the more familiar cloud forms and sunset of other Chambers views. A dark zone of foreground shadow falls across the river, which then graduates quickly to a pale tint, then back to dark. In other versions, yet another band of light appears in the distance, reflecting the sky. Overlapping mountains step back in a fashion familiar from the artist's Hudson Valley

FIG. 3-37 Thomas Chambers. *Castles of the Mind*, c. 1845–60. Oil on canvas, 22⅜ x 30 inches (56.8 x 76.2 cm). Addison Gallery of American Art, Phillips Academy, Andover, Mass. Museum purchase, 1950.28

paintings, with snowy peaks occasionally concluding the view. Always, a vessel with a striped cabin awning sits in tranquil waters in the foreground, with many small figures on board.

The surviving paintings in this format are in two sizes—about 22 by 30 inches and about 14 by 18—and they fall into groups with a foreground cliff or road cut to either the left or the right, in front of the sun, as in *Castles on the Rhine* and *Castles of the Mind.* One pair of left and right designs in matching painted frames, discovered in upstate New York, suggests that many of the extant paintings belonged to such

pairs.[58] Seen side by side—or perhaps on either side of a fireplace—they create a panorama united by a range of snowcapped peaks, presenting morning and evening in a fantastic European Neverland. Variants of the Castles on the Rhine type, such as the small *Landscape* (Hemphill Collection, Smithsonian American Art Museum, Washington, D.C.) with a backlit natural arch seen against a florid sunset and cobalt blue Alps, may once have been part of diverse pairs.[59]

Although the mood is always quiet, these views are a sublime counterpoint to the picturesque or beautiful mode seen in Chambers' Italian landscapes. They may

*FIG. 3-38 Thomas Chambers. *Castles on the Rhine*, c. 1845–60. Oil on canvas, 22 x 29¹⁵⁄₁₆ inches (55.9 x 76 cm). Wadsworth Atheneum Museum of Art, Hartford, Conn. The Ella Gallup Sumner and Mary Catlin Sumner Collection Fund, 1944.36

have been undertaken at the same time, although no matching titles appear in the Newport sale. However, the extravagance of these paintings, including their rapid brushwork and intense palette, fits the art historian's model of a "late" style, and perhaps the whole group was developed after 1850. One from the series, faintly inscribed on the back in graphite "No. 9/ View [on?] the Rhine/ Painted by [European?] artists/ [at] No. 150 Spring St./ New York," connects to the address Chambers gave in the census of 1860 and the city directory for 1861, above a furniture shop and next door to a "fancy" store.[60] Such an inscription supports the implications of the Newport sale—that Chambers was passing off his work as by multiple European artists, or that others worked with him—without excluding either possibility. In any case, the Castles on the Rhine works leave us with an image of Chambers about 1860, and a glimmer of how he presented himself and marketed his paintings. From this close look at his work, we can now step back to consider his place in the American art world, comparing his style and subjects to the work of his peers.

*FIG. 4-1 Thomas Chambers. *City in a River Valley [Springfield, Massachusetts]*, c. 1843–60. Oil on canvas, 18 x 24¼ inches (45.7 x 61.6 cm). Indiana University Art Museum, Bloomington. Morton and Marie Bradley Memorial Collection, 98.84

{ CHAPTER FOUR }

FOLK ART, FINE ART, POPULAR ART: THOMAS CHAMBERS IN CONTEXT

A silhouette to us from the distance of a hundred and fifty years, Thomas Chambers is difficult to locate in the mid-nineteenth-century American art world. How did he survive as an artist? What did his contemporaries think of him? Where does he fit within the community of artists and art patrons in his lifetime? We might begin with what he called himself in city directories: "landscape" and "marine" painter for a few years, then relentlessly "artist," in every city he inhabited. Perhaps this last term was matter-of-fact nomenclature for a picture maker, more general than portrait or marine painter, and yet distinguished from common house and sign painters, stainers, decorators, and other fancy painters. It is hard to recover the nuances of Chambers' self-description, but if it was well-accepted parlance, surely it was also perfumed with the period's romantic notions of genius, inspiration, and self-expression. The astonishment of his mariner father, John, shaking his head over the prices paid in London's art market for George Chambers' paintings "that did but spoil good canvas," tells us that growing up to be an artist was not routine in working-class Whitby.[1] Thomas' insistent professional identity implies pride and a certain sense of distinction. Perhaps, like his brother, he was eager to shake off lesser forms of painting (ship portraits, scenery, and panoramas, not to mention decorative painting) to assert his higher, more liberated, and self-determined status as a maker of pictures. According to his early biographer, John Watkins, the mild-mannered, diffident George Chambers had an impatient and arrogant side: "He deemed himself ordained for a better life."[2] Learning from his brother, but choosing differently, Thomas fashioned an idiosyncratic artist's identity.

Thomas, unlike his brother, stood apart from any official or amateur exhibition forum, with the exception of the one early mechanics' fair. This stance suggests disinterest, disdain, suspicion, disappointment, or perhaps a more reliable income elsewhere. Describing himself as an artist, he must have been attentive to his colleagues, and it is hard to imagine his complete indifference to artists' societies, with

their promise of moral and professional support, even if he preferred other venues and other company. His brother George, deeply "vexed" by a rejection from the Royal Academy, stayed away for years; we can speculate Thomas suffered from a similar insult, or learned from his brother's behavior.[3] Comparing his early marine paintings, such as *Threatening Sky, Bay of New York* (see fig. 1-10), *Ships Meeting at Sea* (see fig. 2-9), and *Sidewheel Steamer "Great Western"* (see fig. 2-10), to those of his contemporaries who did exhibit with organized artists' groups in New York, Boston, Philadelphia, and Albany, Chambers' work may have been marginal, but it does not seem to have been unacceptably different. Class and education (or the lack of it), the social divide that separated mechanics and aspiring gentleman artists, or the sense of second-class status that afflicted many commercial artists, especially engravers, cannot entirely explain this separation; for many artists, including his own brother, moved from working-class backgrounds to the genteel circles of the academy and its affluent patrons. Under the sympathetic leadership of Samuel F. B. Morse, the art community in New York in the 1830s was much more fluid and inclusive than it would be in later decades.[4] So we can only imagine invisible factors of personality that might have swayed Chambers. Looking at his life and work, we can say that he was enterprising and productive, literate, inventive, and restless; his newspaper and auction texts indicate that he may have been a good salesman. But maybe he was also abrasive, drunken, unstable, uncouth, and generally disliked or avoided by the genteel. Or like hundreds of other hardworking and well-adjusted fancy painters and limners, he may have been perfectly content, working in a completely different market. Knowing none of this, we can only take him at his word, and call him "artist."

Chambers declared himself an artist, but he remains almost invisible to us as a person. We can hope to find him reflected in the mirror of his contemporaries, who shared and shaped his environment. His distinctive style has made it easy to

The leopard with the harmless kid laid down
And not one savage beast was seen to frown

The wolf did with the lambkin dwell in peace
His grim carnivorous nature there did cease

The lion with the fatling on did move
A little child was leading them in love;

When the great PENN his famous treaty made
With indian chiefs beneath the Elm-tree's shade.

*FIG. 4-2 Edward Hicks (American, 1780–1849). *Peaceable Kingdom*, 1826. Oil on canvas, 32⅞ x 41¾ inches (83.5 x 106 cm). Philadelphia Museum of Art. Bequest of Charles C. Willis, 1956-59-1

set him apart from the mainstream, but the study of his work demonstrates how his sources and enthusiasms were part of the popular culture of his period. Setting him among his colleagues helps refine these common qualities and also define the remarkable singularity of his work. In our day Chambers is usually called a "folk artist," and so—while testing the meaning of this category as we sort through it—the search for context and colleagues might begin in the world of paintings categorized as American folk art. It is a motley gathering, including the work of schoolgirls, amateurs, visionaries, craft artisans, decorative and commercial artists, as well as a host of provincial artists with some relationship to the cosmopolitan centers of the North Atlantic or New Spain. Not a label that Chambers himself would have

recognized, the term expresses the perspective of those who shaped his reputation in the twentieth century.[5] We will look at the taste and ideology of his modern admirers in the next chapter to understand the "folk" spirit they prized in his works; for now, let us consider these same qualities from the viewpoint of his contemporaries. For the sake of comparative study, the modern category of folk art quickly isolates work recognized (then and now) as kindred in style or attitude, by better documented artists, who can offer a richer context for Chambers' work. Within this group we can look only to his peers: trained professionals who earned their living from painting in the period between 1832 and 1866.

Edward Hicks (1780–1849)

Edward Hicks, the best-known and loved of America's folk landscape painters in the first half of the nineteenth century, shared many of Chambers' qualities and experiences, although he was a generation older. Hicks, born poor and apprenticed to a coach maker at the age of thirteen, learned to handle a brush on the job, gradually taking on sign painting, furniture decoration, and other decorative work, following an educational and professional path shared by George and probably Thomas Chambers and many other artists of this period. Such painters rarely had training in figure painting, which led Thomas Chambers to exclude figures, while Hicks struggled to achieve a charming, naive result. The language of decorative painting, with its strong contours and value contrasts, clear colors, and lively surfaces (such as the effect of stamping with a curved brush to create leaf patterns, or the sharply silhouetted cutouts of leaves, flowers, and droopy pine trees against a brighter ground), accounts for much of the visual impact in Hicks' work, just as it shapes Chambers' distinctive style.

From this same background may have come the love of varied repetition, seen most magnificently in Hicks' series of Peaceable Kingdom pictures (fig. 4-2), begun about 1816 and continued through at least sixty-two variants, including the canvas on his easel the day that he died. Described by Graham Hood as the "most widely recognized icons of American folk art today," these paintings compellingly illustrate the power vested in the reiteration of significant content and the endless richness and satisfaction to be found in variation within a familiar format, both typical of the practice of earnest traditional artists in many lands. As usual, this imagery was already infused with meaning, drawn from older art or prints and book illustrations, ranging—for Hicks—from an engraving of Benjamin West's *Penn's Treaty with the Indians* to images of the same landscape wonders that appealed to Chambers, Niagara Falls and the Natural Bridge in Virginia.

The message of peace, harmony, and nature's bounty intensified in Hicks' treatment, however, to become a heartfelt sermon in paint. He sold few of these paintings, apparently giving most of them to friends and family, particularly supporters of his Quaker ministry in rural Bucks County, Pennsylvania. The impassioned spiritual and intellectual polemic that drove his series, undertaken during a period of dispute within the Quaker community, lifted his work out of the realm of the commercial commodity, reminding us that Hicks did not earn his living with such paintings and was more famous in his day as a minister than as an artist.[6] This

FIG. 4-3 Erastus Salisbury Field (American, 1805–1900). *The Garden of Eden*, c. 1860. Oil on canvas, 34¾ x 45⅞ inches (88.3 x 116.5 cm). Museum of Fine Arts, Boston. Gift of Maxim Karolik for the M. and M. Karolik Collection of American Paintings, 1815–1865, 48.1027

combination of conceptual, symbolic, and decorative values underrides much folk art with a religious base. There is no way to know if Chambers shared Hicks' spirituality along with aspects of his style, although it seems unlikely that he suffered, as Hicks did, over the doctrinal conflict between fancy painting and Quaker values. Chambers' priority seems to have been making paintings that appealed to many tastes, but his penchant for rosy skies and serene views may hint at a deeper affinity with an artist such as Hicks.

Erastus Salisbury Field (1805–1900)

Chambers' visionary moments, represented by a painting that has come down to us with the title *City in a River Valley* (fig. 4-1),[7] call to mind the towers of another icon of American folk art, the huge and imaginative *Historical Monument of the American Republic* (Museum of Fine Arts, Springfield), begun in the mid-1860s

in a town just north of Springfield by Erastus Salisbury Field. Similarly, two versions of Chambers' *Landscape with Mount Vesuvius* (see figs. 3-27 and 3-28) and his various Castles on the Rhine images (see figs. 3-37 and 3-38) irresistibly suggest Field's *Garden of Eden* (fig. 4-3), with its idyllic palm trees, flowering plants, and snowcapped mountains. A harder look at Field, who was close to Chambers in age, reveals a shared taste for the imaginary, the literary, the historical, and the exotic, all fed by print sources. Field never traveled farther than two hundred miles from his home base in Leverett, Massachusetts, but he opened his horizons with a brief period of study with Morse in New York in 1824 before returning to the Connecticut Valley to launch a prosperous career as a portrait painter. He came back to New York for seven years in the 1840s, after Chambers had left the city, listing himself as a portrait painter and then as an artist, and exhibiting—like Chambers—at the American Institute fair his first literary and historical picture, *The Embarkation of Ulysses* (Museum of Fine Arts, Springfield) based on a book illustration.[8] Field moved back to Massachusetts about 1849 with the new photographic technology that Morse had introduced to New Yorkers a decade earlier and rebuilt his dwindling portrait practice with the aid of the camera, gradually devoting himself to exotic and celebratory subjects that came to decorate his local church and line the walls of his studio at the end of his life. More naive and stilted than Chambers' work, Field's landscapes, apart from their similar subject choices, nonetheless showed the same tendencies to flatness, pattern, and strong color.

These works were a late phase in Field's career and a sidebar to his principal business in portraiture, which earned him a good living in the 1830s and 1840s. In these portraits we see his family, friends, and neighbors, prosperous and stylish provincials, showing off their ringlets, lace, and most prized jewelry. Field's success within his Connecticut Valley territory implies the community's approval of his work, as well as his patrons' eagerness to decorate their homes with representations of their own worth as individuals. Portraits were likely the first oil paintings owned by most such Americans, but by the 1830s these customers were ready to acquire landscapes. Like Joseph Davis' portrait of the Demeritt family in New Hampshire (see fig. 1-8), Field's *Family of Deacon Wilson Brainerd,* of about 1858 (Old Sturbridge Village, Sturbridge, Massachusetts), shows his patrons seated within a parlor ornamented by a river landscape in a gilded frame, expressing, along with their portraits, both gentility and pride.[9]

*FIG. 4-4 Sturtevant J. Hamblin (American, 1817–1884). *Portrait of Three Girls*, c. 1850. Oil on canvas, 21¹³⁄₁₆ x 26¾ inches (55.4 x 67.9 cm). Philadelphia Museum of Art. The Collection of Edgar William and Bernice Chrysler Garbisch, 1973-258-3

William M. Prior (1806–1873) and the "Painting Garret"

The sense that we are looking at Chambers' customers as we examine Field's portraits increases as we discover the work of another close contemporary and even closer neighbor, William M. Prior. From his studio in East Boston, across the Charles River from Chambers' waterfront address, Prior and his partners served a middle-class urban constituency for decades, standing apart from the fine art community across the harbor. Looking at the strong sense of pattern and outline, bright colors, flattened space, and fleet liquid brushwork in work from the so-called Prior-Hamblin school, like *Portrait of Three Girls* (fig. 4-4), it appears that these are the contemporary portraits closest to Chambers' taste. It is easy to imagine them hanging side by side with his landscapes in the same parlors, on strongly colored and stenciled walls, above the bright floor cloths and grained tables depicted by Davis.

†FIG. 4-5 William M. Prior (American, 1806–1873). *Portrait of a Man*, 1829. Oil on canvas, 26⅜ x 22¹⁄₁₆ inches (67 x 56 cm). Philadelphia Museum of Art. Gift of the estate of Edgar William and Bernice Chrysler Garbisch, 1980-64-8

Born in Bath, Maine, Prior may have apprenticed with the all-purpose local fancy painter Charles Codman, who decorated furniture and produced signs, portraits, landscapes, and marines (fig. 4-11). By 1831, Prior's advertisements had announced his willingness to undertake portraits, ornamental painting on trays, bronzing, gilding, varnishing, sign painting, painting restoration, and "Fancy pieces painted, either designed or copied to suit the customer, enameling on glass tablets for looking glasses and time pieces," not to mention "lettering of every description, imitation carved work for vessels, trail boards and stearn moldings painted in bold

style." Prior moved to Portland after 1831 and then to Boston in 1839, along with his wife's brothers, who joined in a family enterprise in house, sign, and fancy painting, presumably including the same dazzling array of services they had offered in Maine. One brother-in-law, Sturtevant J. Hamblin, and his two sons may have studied with Prior; they produced work that was marked on the verso with the distinctive stencil of the "Painting Garret" at 36 Trenton Street, which served as the center of their portrait business from 1846 until Prior's death in 1873.[10]

The workshop of the "Painting Garret" presents a model of an operation in a shared space where more than one artist produced a very similar product, exactly at the period when Chambers was painting multiple versions of his landscapes and marines. Because Sturtevant Hamblin rarely signed his work, his pictures, such as *Portrait of Three Girls* (see fig. 4-4), have frequently been assigned to Prior or gathered under the term "Prior-Hamblin school." The difficulty in sorting out this collective work is compounded by the sliding scale of finish and price offered by Prior, who famously noted in 1831 that "persons wishing for a flat picture can have a likeness without shade or shadow at one-quarter price."[11] Indeed, signed work by Prior ranges from the academically finished, such as *Portrait of a Man* (fig. 4-5), to the unshaded, although the more atmospherically modeled portraits tend to be earlier, and the post-1846 style of the "Garret" more uniformly flat. Prior's business model, based on size and effort (or, in pragmatic terms, time), echoed a typical portrait painter's fees, which varied according to size of the image, difficulty of the pose, and ornateness of the frame, but no other painter has been discovered who simultaneously painted in two styles, with and without shade and shadow, or whose speed and focus so clearly depended on the size of the canvas. Over time, responding to his market and the competition of photographers, Prior's price scale lowered: Children were always done at a discount, and cabinet-size "Garret" portraits, about 17 by 13 inches, were labeled on the back with the note that work "painted in this style!" and "done in about an hour's sitting" cost $2.92, "including Frame, Glass, &c.," about one-tenth of the price he had cited for a full-size framed portrait in the 1830s.[12] Prior's range of services and his wish to accommodate patrons of modest means demonstrates a marketing strategy that can easily be read into Chambers' similar versatility and the similar gamut of products he offered, at different sizes and prices, with different degrees of finish. In attitude and method, Chambers clearly joins the class of limners categorized by David Jaffee as "artisan-entrepreneurs, market-oriented purveyors of 'cultural' commodities," who dominated American provincial portraiture before 1840.[13]

Prior industriously produced hundreds of portraits, large, small, and very small, in a campaign clearly aimed at profit through quantity rather than quality. Although his work has never been tallied, his output as well as his style might be compared to the five hundred surviving paintings from the hand of Ammi Phillips, a painter of the older generation working in western Massachusetts, Connecticut, and New York State in these same years. The startling value contrast, rich color, and brilliant sense of design in Phillips' stylish *Blonde Boy with Primer, Peach, and Dog* (fig. 4-6) evoke the taste of a household where Chambers' landscapes would have been right at home. Another itinerant painter based in Springfield, Joseph Whiting Stock, recorded his production of more than eight hundred portraits and "subject pictures" in a thirteen-year period between 1832 and 1845.[14] Alvan Fisher, better integrated into the fine art circles of Boston and New York, claimed to have sold a thousand pictures by the end of his career; Robert Salmon, straddling fine and vernacular markets in marine painting, sold a thousand, too.[15] Following this enterprising pattern, and presumably selling to a related market, Chambers' surviving works—including about 350 tallied at present—may represent an enormous original output, now much reduced by losses suffered during a long period when, unprotected by the sentiment attached to portraiture, his work was disdained as old-fashioned and cheap. Such productivity hints at the enthusiastic response of his audience as well as the energy of the artist.

Prior occasionally inserted landscapes into the backgrounds of his portraits and in the 1840s painted landscape fancies as a sideline that expanded in the 1850s as his portrait business suffered from competition with photography. Like Chambers, Prior drew from print sources and cheerfully repeated popular compositions. His repertory was smaller, however, favoring views of Washington's tomb at Mount Vernon (sometimes in pairs, of day and night), snowy Dutch villages, idealized bridge and cottage compositions, and moonlight river views.[16] His rustic cottage paintings, similar to generic views by Chambers, Hicks, and Codman, join the throng of countless related images on plates, chair backs, window screens, and mirrors throughout this period. Prior's nocturnal scenes such as *Moonlit Landscape with Ruins* (fig. 4-7) are more distinctive, although surely based on paintings and prints after the work of the seventeenth-century Dutch painter Aert van der Neer and his family that were a fixture of many old master auctions in the United States in this era. Gathering motifs from different lands, Prior rearranged a bridge, a boater, a windmill, a ruined abbey, and a city twinkling with lights in the distance into various combinations, delivered in a grisaille palette derived as much from mezzotint,

*FIG. 4-7 William M. Prior (American, 1806–1873). *Moonlit Landscape with Ruins*, c. 1850–60. Oil on canvas, 19½ x 25½ inches (49.5 x 64.8 cm). Indiana University Art Museum, Bloomington. Morton and Marie Bradley Memorial Collection, 91.427

aquatint, and lithographic print sources, or the mid-century fashion for marble-dust and charcoal drawings, as from van der Neer's warm and dusky example.[17] Less broadly painted and less colorful than Chambers' landscapes, but with some of the same techniques of stamped foliage and bright highlights, Prior's *Moonlit Landscape* shares the same romantic imagination, delivering a composite of quint-essential, old world picturesqueness or—as in the views of Washington's tomb—a site of national symbolic significance. Typically, both Chambers and Prior flatten the sense of space and atmosphere that van der Neer suggests with a different set of visual conventions, but all three painters were fundamentally working in the same business, producing small formulaic paintings of comforting emotional scenery for the homes of middle-class patrons.

If the kinship between the paintings of Chambers and Prior allows us to imag-ine the work of these two artists hanging in the same parlor, then a look at the cli-entele of Prior's portrait studio may, as do the patrons of Field or Phillips, offer a glimpse of Chambers' audience. According to the accounts of his family as well as the inscriptions on the backs of his paintings, Prior's reach was wide: He trolled the shipyards of East Boston and the hotel lobbies downtown, took to the countryside with horse and cart, or rode the train to the end of the line, where he left a trunk full of canvases that he toted out to find customers.[18] His sitters included sea captains and their wives, middle-class African Americans, and wealthy local manufacturers, such as the Allen family of Cambridge, all educated bourgeois patrons, both rural and urban, who shared the wish to own a painting of themselves or their children.[19] Chambers' patrons do not look back at us in this direct fashion, and his product (or service) was not so immediately obvious or necessary, but we can imagine that those who wished for a portrait and found Prior (or Hamblin, Phillips, Field, or Davis) satisfactory might also have been pleased by Chambers' work and aspired to own one of his paintings, at the right price.

The patterns seen in the careers of Field, Hicks, and Prior help us find common ground for Chambers among a certain group of professional artists in his day. They demonstrate the patchwork education—part guild training, part academic tutoring, and mostly on-the-job learning—that many American artists experienced, as well as the range of related painting skills often needed to make a living. They also illustrate the pressure to move, seeking customers. Itinerancy was not so necessary to a landscape or marine painter such as Chambers, who did not need to sit down with his patrons face to face. Roving, however, seems to have been part of his life. Perhaps coincidental, although certainly widespread in the period's Protestant culture, is a shared religious sensibility, clearly read in the work of Hicks and Field and less obvious but present in Prior.[20] Finally, these portrait painters remind us, in the faces and accoutrements of their sitters, that their patronage was firmly middle class, and both rural and urban. The terms "folk" and "provincial" must include artists, like Chambers or Field, living a few steps off Broadway. Few of the artists in this group appeared in academic exhibition venues or artists' societies other than the mechanics' fairs, perhaps because their flat style was not accept-able or, more practically and philosophically, because their immediate market was more important to them than cosmopolitan connections. Oriented to their local patrons rather than to other artists, unknown critics, or international ideals, such folk artists cultivated a very direct and pragmatic relationship with a clientele whose taste, expectations, and budget shaped their work more effectively than any distant European models or the dubiously useful prestige of an academic exhibition venue. Because almost all American artists, native and immigrant, came from the middle to

lower classes, what might be seen as class based in their professional choices actually concerned the class, education, aspirations, and pocketbooks of the audience they sought.

The North Atlantic Tradition in Marine Painting

Chambers fits among these figure painters by virtue, perhaps, of this orientation, but he is not completely comfortable in this niche; before working harder to normalize his existence alongside Prior and his ilk, we need to remember how odd he was, as a professional "folk" marine and landscape painter. In the world of American art before 1840, portrait painters—either "fine" or "folk" to modern eyes—were the most numerous professional artists; with their practical function, they found a market in every region and across a wide middle-class social and economic territory. By contrast, marine and ship painters were a much smaller group, usually tied to the principal ports and oriented to discrete markets in the businesslike, folk way. Chambers advertised both landscape and marine painting, but we have seen that he gave priority to harbor views, shipping scenes, battle subjects, and literary marines, at least through the mid-1840s. A look at his competition in such subjects from both academic and folk marine painters in this period reveals the professional difficulties of this genre, and Chambers' odd, marginal relationship to both camps.

Chambers' earliest models of both types were English, beginning with his brother in London (see figs. 1-3 and 1-6), who moved from the company of shipowners on the London docks to the circles of the greatest sea painters of the era. Most of the port cities of England had their own marine artists—each community with a few painters aspiring to cosmopolitan artistic status alongside a much larger group exclusively devoted to the patronage of local shipowners and sailors. For this second, less pretentious band, marine painting was frequently one of many decorative or maritime skills plied simultaneously. Painting for "cabin, cottage, shipping office or dockside tavern," these artists rarely used an exhibition venue to sell their work; most were not members of artists' societies, "and some of the best exhibited rarely or not at all."[21]

Competition was fierce in the provincial centers, where even the best artists vied for commissions from customers who could easily shop for such work in Salem, Hong Kong, or Marseilles. In England, the trade focused in London and Liverpool, cities that served American customers in their ports and also sent artists abroad, such as Robert Salmon, who painted in Boston from 1828 to 1842.

FIG. 4-8 Joseph Heard (English, 1799–1859). *The American Packet Ship "Margaret Johnson,"* c. 1840. Oil on canvas, 21 x 30⅛ inches (53.3 x 76.5 cm). Penobscot Marine Museum, Searsport, Maine. Gift of John A. H. Carver, 1970.23

Chambers' paintings of famous packet ships and steamers reflect from a distance the standard of excellence for the Liverpool school, represented by artists such as Salmon, Samuel Walters, and his father, Miles—the only full-time Liverpool painters who exhibited at the Royal Academy. Of the well-known and influential ship painters in this Liverpool circle, William J. Huggins, the father of a family of marine painters, and Joseph Heard (fig. 4-8) seem to be close models for Chambers as he undertook paintings such as *Sidewheel Steamer "Great Western"* (see fig. 2-10). Although his paintings lack the atmospheric subtlety of the work of these artists, and are also less sophisticated and observant in drawing, some of them come close to these models, indicating that, apart from his own brother, the artists of Liverpool shaped his style more than any marine painters he encountered in the United States. The conventions of the genre in the Romantic period, such as the dark foreground sea with a silhouetted gull, or the swirling dark and light clouds, sometimes with an irregular break opening to a clear sky beyond, spread throughout the North Atlantic marine painting tradition. In addition to such artistic devices, Chambers could also have learned the hustle of the trade from the likes of Miles Walters, a

†FIG. 4-9 Thomas Birch (American, born England, 1779–1851). *Philadelphia Harbor*, c. 1835–50. Oil on canvas, 20 x 30¼ inches (50.8 x 76.8 cm). Philadelphia Museum of Art. Gift of the McNeil Americana Collection, 2007-65-12

self-taught painter-sailor who did his own framing and gilding, advertising "real oil paintings on canvas," complete with gold frames, "cheaper than any Man in England."[22]

Below the group working in an academic style existed a crowd of scrambling "pierhead painters" who roamed the docks and pubs, cultivating patronage among sailors and sea captains, offering cheaper, more stereotyped ship portraits based on vernacular tradition, occasionally inflected by the Romantic style learned from prints after the better-known marine painters. Like his brother, Chambers had little patience for the fidelity to likeness and technical detail expected of such work, or the static profile of the conventional ship-portrait format, and—with exceptions like the *Great Western* series—he did not often try to compete in this genre. His rivals ranged from amateur sailor-painters to supremely skilled specialists: In the United States, his close contemporaries were the twin brothers John and James Bard, and Jurgan Frederick Huge, who joined many others willing to supply portraits of this kind.[23] As we have seen in the study of Chambers' marine paintings, he often played fast and loose with house flags, signal code flags, or the detailed construction of vessels, choosing to generalize in a way that might have dissatisfied ship portrait cli-

ents. His spirited style seems to have been gauged to attract the less expert customer, someone proud of the modern shipping in the port and knowledgeable enough to enjoy an image of the most familiar or most famous vessels of the harbor. More interested in the pictorial and symbolic impact of his image, Chambers placed himself midway between the vernacular portrait specialists and the academic marine artists, in a place occupied by no other American painter.

In the United States, Chambers' most influential model was Thomas Birch, thirty years his senior but also born in England, who established himself as the premier painter of American sea battles after the War of 1812. Chambers clearly availed himself of Birch's prints, as we have seen, and he followed Birch's practice of reworking these battle scenes with variants for new customers. Likewise, Birch's steady output of harbor views after 1835, such as *Philadelphia Harbor* (fig. 4-9), repeating a format developed in the 1820s, gave precedent for Chambers' similar strategy.[24] Driven, like many painters, to try his hand at different kinds of decorative painting to earn a living, Birch "was obliged, for several years, to devote much of his time to inferior sketches, for the embellishment of old-fashioned looking-glasses," as noted in an obituary in 1851.[25] When the market for battle painting faded, Birch—like Chambers—moved into landscape painting, developing a line of picturesque views that he also repeated in numerous variants. However, while keeping food on the table with fancy painting and serial canvases for the trade, Birch also annually sent works to the National Academy of Design and the Pennsylvania Academy of the Fine Arts, seeking the approbation of the critics and the maintenance of his reputation, if not actual sales. As the American standard for excellence in academic marine painting, Birch supplies a yardstick with which to measure Chambers' style and acceptability, and it is clear that Chambers followed a similar choice of subjects and marketing, but developed a style that was less naturalistic, less delicate in drawing, stronger in color, and more vivacious in surface design.

As a folk version of the more academic Birch (rather than a vernacular ship painter), Chambers is interesting to consider, not just because of their many similarities of background and practice, but because—unlike in the field of portraiture—there are few other candidates on either side of this matchup. No other American painters show the same combination of ambitious sea painting—battle scenes, harbor views, wrecks, and "portrait marines"—allied to a range of popular landscape subjects. Yet, although such painters were scarce, the competition in the small market for artistic marine painting was stiff. Of Birch's generation, another English-born artist, Thomas Thompson, was an academically trained painter who

FIG. 4-10 Fitz Henry Lane (American, 1804–1865). *The Yacht "Northern Light" in Boston Harbor*, 1845. Oil on canvas, 18¾ x 26 inches (47.6 x 66 cm). Shelburne Museum, Shelburne, Vt. 27.1.4-60

immigrated to the United States about 1818, settling in New York about a decade later. Thompson, an associate at the National Academy of Design, exhibited in every artists' venue in New York, showing harbor views and ship portraits in a style akin to Salmon's. Another, younger painter arriving from England in 1832 was James Fulton Pringle, who immediately began to show views of packets (including the *Great Western* and the *British Queen*), storm-tossed ships, and wrecks (including the *Bristol*) at the National Academy of Design, the Brooklyn Institute, the American Institute (in 1838), and after 1838 at the new Apollo Association.[26] But even Pringle, with his eagerness to exhibit everywhere, must have been daunted by the faint praise of one reviewer in 1834, who noted that his painting of the packet ship *United States* was "very neatly penciled, but after all, it is only a mere ship."[27] More naive in style and even more limited in scope were the works of James Guy Evans, another sailor-turned-painter working in New York and New Orleans in the 1840s, with a focus on naval vessels.[28] Birch's domination of the field in Philadelphia, alongside his accomplished English-born successor, George R. Bonfield, may have kept Chambers away from that city, and perhaps the presence of

Thompson, Pringle, Evans, Birch, and Bonfield together in the New York area gave him reason to head north for Boston, where he arrived just as Salmon returned to England.

In Boston, there were no marine painters with the same wide repertory of subjects in such a hybrid style. Chambers' harbor views would have found competition from his near-contemporary Fitz Henry Lane, who, learning from Salmon, worked both the artists' exhibition venues and the shipowners' haunts. In the 1840s, before mastering the quiet luminist style that he developed after his first trip to Maine in 1848, Lane shared aspects of Chambers' sense of decorative design and his penchant for sunset and sunrise effects over water. The intersection of taste can be seen in a painting by Lane made in 1845 after a sketch by the departed Salmon, *The Yacht "Northern Light" in Boston Harbor* (fig. 4-10), which shows a view much like Chambers' Boston Harbor paintings (see figs. 1-12 and 2-8). Flanked by the bow and stern of two ships at the wharf and set off by a shadowed stripe across the foreground, the *Northern Light,* just like the schooner in Chambers' pictures, slices across the view, flags flying. This is Lane at his most active (and most indebted to Salmon), but even in this lively and congested composition, he maintains a delicacy of observation and atmosphere that throws into relief Chambers' tendency to work from imagination and to simplify.[29] The other, less talented but certainly competent professional specialist in the Boston area while Chambers was in residence, Clement Drew, seems to have been steadily producing small ship portraits in a bland version of the romantic Liverpool manner.

This tiny number of marine painters with academic style and ambitions in Boston, New York, and Philadelphia must have been far outnumbered by the vernacular ship painters, who lived and worked with the insularity seen in the same trade in England. The Bard brothers, famed for their ship portraits, showed at the American Institute in 1838 and 1842 but never exhibited at the National Academy. Like their peers in England, and like their academic colleagues, they won work on commission from shipowners, and word-of-mouth on the docks seems to have kept them in business. Painters of packets and steamships such as John V. Cornell, John Childs, George Clark, A. J. Demarest, Captain Isaac Duncan, and Thomas Godwin appear fleetingly at the American Institute fairs before 1850 and rarely elsewhere. Some of them were printmakers or active in other trades; all of them were part of the vernacular marine painting community, largely invisible to mainstream art history. Chambers joined them in their obscurity, but his style and repertory indicate that he was not exactly of their type.

Pringle's death in 1847, followed by Evans' departure for New Orleans about 1850, Birch's death in 1851, and Thompson's death in 1852, made way in New York for the recently arrived James Buttersworth, who after 1850 became New York's favored painter of clippers and racing yachts. Also from England and the son of a sailor-turned-painter, he found employment with Currier and Ives, and successfully sold work through the American Art-Union. The success of Pringle, Thompson, Birch, and then Buttersworth at the Apollo Association and its successor, the American Art-Union, must make us wonder what might have happened if Chambers had remained in New York to take advantage of these new artists' venues, but the larger pattern suggests that most of the underclass "pierhead painters" did not exhibit with artists' societies. From the slight given to Pringle's work, one senses a kind of mutual shrug of indifference that encouraged this segregation. The critics saw conventional marine painting as "merely ships," while sailors, owners, racing enthusiasts, and their artists remained devoted within their own circle, as they do today.

Among the Landscape and Fancy Painters

No such division existed within the ranks of landscape painters, perhaps because it was a relatively new genre, without a traditional market or an inbred system that drew painters who were mariners or the children of marine painters, such as Chambers, Pringle, Buttersworth, and Evans. In the century before Chambers' arrival in 1832, most landscape art in the United States was made by educated visitors: topographers, military officers, scientists, and travelers in search of the picturesque. Setting amateurs aside, professional "folk" landscape painters, who produced murals and mantelpieces, were rare in comparison to vernacular marine painters, who were likewise scarce in relation to the number of itinerant portraitists. The landscape easel painting as a popular commodity seems to have waited for the artists of Chambers' generation, born after 1790, who formed the first national landscape school in the 1820s. Apart from the visiting topographers and tourists, their professional precursors—and for many, their training—lay in the realm of fancy painting. From this background came the English-born ornamental painter Francis Guy, who decorated furniture and produced cabinet pictures of notable landscapes, country estates, and fancy (imaginary) subjects in a delicate style in the first decades of the century in Baltimore and Brooklyn.[30] In Boston, such painting arose from the shop of John Ritton Penniman and his apprentices, including Charles Codman (fig. 4-11), who established his own ornamental painting business in Portland, Maine, in

FIG. 4-11 Charles Codman (American, 1800–1843). *Landscape*, c. 1823–28. Reverse-painted panel from a mirror, 9⅝ x 11⅞ inches (24.4 x 30.2 cm). Portland Museum of Art, Portland, Maine. Gift of Sara Shettleworth Mrosovsky and Earle G. Shettleworth, Jr., in honor of Esther Knudsen Shettleworth, 1988.15

the early 1820s, and John S. Blunt, who took up Penniman's market at the same time in Portsmouth, New Hampshire. Blunt and Codman (like his associate or apprentice William M. Prior) offered many services, including portraits, miniatures, military standards, decorative painting and gilding, and landscape and marine pictures, some topographically based and some fanciful.

Codman had the good fortune to be discovered and mentored by the critic John Neal, who characterized his early work as "smack[ing] of looking-glass tablets, apothecary furniture and tea-trays—perfectly smooth—perfectly flat—exceedingly positive, and as unnatural as heart could desire."[31] This tendency to be smooth, dainty, and naive in terms of drawing and perspective, as seen in the work of Guy and Blunt, characterized this first generation of fancy painters. The next group—including Chambers, Codman, and another Penniman apprentice, Alvan Fisher—developed a broader, more painterly style, befitting the more robust romantic

aesthetic of the second phase of fancy taste in the 1830s. Fisher, who later complained that it "required years to shake off" the legacy of ornamental painting, nonetheless retained the commercial outlook of his early training and an entrepreneurial versatility that, like the similar enterprise of Penniman or Prior, could have served as a model for Thomas Chambers.[32]

Fisher could have encountered the principal talents of this next wave, Thomas Cole (fig. 4-12) and Thomas Doughty (fig. 4-16)—subsequently recognized as the fathers of the national landscape school—as neophytes at the Pennsylvania Academy's exhibition of 1824. Like the older and more experienced British immigrants Thomas Birch and Joshua Shaw, who also exhibited at the National Academy this year, all were either self-taught or shop-trained, and bound for careers as academic artists. Within a decade, Asher B. Durand, George Loring Brown, and John Gadsby Chapman, all active in New York and Boston, joined Cole, Doughty, Codman, Fisher, Birch, and Shaw as painters of American, European, and fanciful landscape compositions, often with portraits, marines, genre and animal subjects, and the occasional old master copy on the side. Chambers' position against this backdrop of artists of more or less his same age and background is interesting to map, for they all had similar obstacles to overcome, including a patchy, on-the-job education in printmaking or decorative painting and a market that had not existed a generation earlier.

With so much in common with these few pioneers, and aspects of subject matter and style that overlap, Chambers shows us—by his differences—his place on the fringe of this small group, in the zone between so-called fine art and folk art. With the premature deaths of Blunt and Codman, the two painters who seem most like him, Chambers seems almost alone, at least as a well-recognized figure, working this territory in the 1840s. In the last hundred years, legions of "primitive" landscape paintings have been discovered, most of them by amateurs, some by part-time landscapists like Prior and Field, but no large, cohesive bodies of work have emerged to rival the oeuvre of Chambers, or the work of his less prolific, and in many ways more idiosyncratic, contemporary Edward Hicks. Placing Hicks and his personal mission to the Quakers aside, we can see Chambers as unique in this new field—the first American painter to bring professional landscape and marine easel paintings to an audience beyond the metropolitan elite.

Looking at Cole's *View of Fort Putnam* of 1825 (fig. 4-12), and remembering the legend of the discovery of this painting that year, when it was purchased by Asher B. Durand, part of the difference between Cole and Chambers can be ascribed to

*FIG. 4-12 Thomas Cole (American, born England, 1801–1848). *View of Fort Putnam*, 1825. Oil on canvas, 27¼ x 34 inches (69.2 x 86.4 cm). Philadelphia Museum of Art. Promised gift of Charlene Sussel

personal ambition and part to sheer luck.[33] Mentored after this moment by William Dunlap, John Trumbull, and Durand, three leaders of the New York art scene, Cole soon found the patronage that ultimately funded his travels overseas. Fisher, Doughty, Brown, and Durand likewise managed to visit Europe, acquiring cosmopolitan taste and a loftier sense of their professional goals. Codman was encouraged and championed by Neal. Chambers, evidently looking over the shoulder of such painters without participating in their culture, absorbed some but not all of their style and little of their wish to "shake off" the decorative painter's manner. The organization of Cole's *View of Fort Putnam*, with its flanking trees, rock-strewn road, and distant hilltop architecture, shows the same compositional structures borrowed by Chambers, Bartlett, and a thousand other painters working from baroque conventions. The handling of details may demonstrate a closer connection between the two artists, as the style of lush foreground foliage, snaggly roots, stamped foliage, and fanciful openings in the clouds all appear in more caricatured

FIG. 4-13 Thomas Chambers. *The Birthplace of Washington*, c. 1843–60. Oil on canvas, 21¼ x 30¼ inches (54 x 76.8 cm). Abby Aldrich Rockefeller Folk Art Museum, The Colonial Williamsburg Foundation, Williamsburg, Va., 1957.102.5

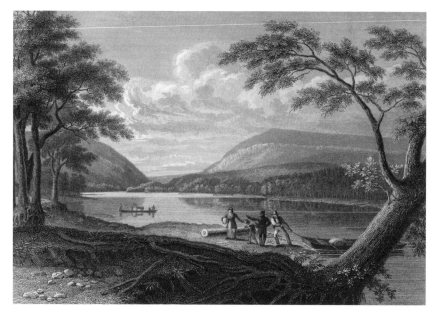

FIG. 4-14 Asher B. Durand (American, 1796–1886). *Delaware Water-Gap*. Etching, trimmed image 4⅞ x 6⅛ inches (12.4 x 15.5 cm). From *New-York Mirror*, June 7, 1834, p. 1. The New York Public Library; Astor, Lenox and Tilden Foundations. Emmet Collection, Miriam and Ira D. Wallach Division of Art, Prints and Photographs

form in Chambers' work, along with the pensive pedestrian leaning on his walking stick—although such habits can also be found in many so-called academic paintings of this period. However, Chambers would have had ample personal opportunity to study Cole's example in New York, Albany, and Boston; it is almost impossible that he did not know such pictures, as well as the more painterly and literary works that Cole produced in his maturity, in the last two decades of his career.

Chambers' respect for Cole might be signaled by the fact that he never stole one of his compositions, although he did copy works by Durand, Doughty, and Chapman that could be studied from a print source. Chapman's celebrated views of historical sites in Virginia, painted on a sketching tour in 1834, were exhibited to much acclaim at the National Academy of Design in 1835; one of these subjects, *View of the Birthplace of Washington*, appeared as the frontispiece engraving of James Kirke Paulding's *A Life of Washington* that same year. Six versions of this image survive in Chambers' style, indicating that it was one of his most popular

subjects (fig. 4-13). The topic was ensconced in his repertory by the time of the Newport auction of 1845 as no. 7, painted by Mr. Corbin: "Washington's birthplace, with a view of the Potomac River, and the Maryland Shore; the stone in the foreground denotes where the house stood; the old vine, which is still growing, was planted by the Washington family."[34]

Chapman was not mentioned in this title, nor was Doughty or Durand credited for no. 13 in the Newport sale, "Delaware Water gap . . . on the Delaware, Pa.," although extant paintings attributed to Chambers reveal the connection to their work. The association, first noted by Howard Merritt, between Durand's print after his own painting of the Water Gap (fig. 4-14), Doughty's earlier images from the 1820s (such as fig. 4-16), and Chambers' extant views of the Delaware aptly illustrate Chambers' place in the system of American landscape painting about 1840. Although his *Delaware Water Gap* (fig. 4-15), seems to be based on an engraving by George Ellis after Doughty that appeared in the gift book *The*

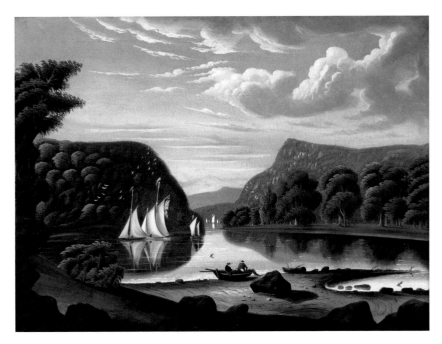

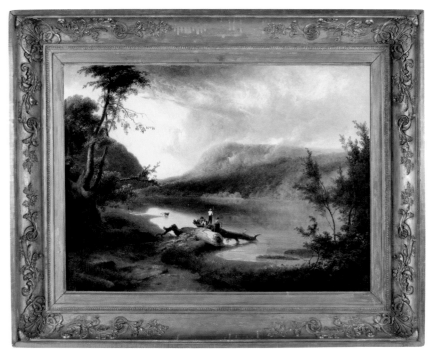

*FIG. 4-15 Thomas Chambers. *Delaware Water Gap*, c. 1840–50. Oil on canvas, 18 x 24 inches (45.7 x 61 cm). Collection of Ann Abram and Steve Novak

*FIG. 4-16 Thomas Doughty (American, 1793–1856). *Delaware Water Gap*, 1827. Oil on canvas, 23⅜ x 32⅜ inches (59.4 x 82.2 cm). Philadelphia Museum of Art. Gift of the family of J. Welles Henderson in honor of Robert L. McNeil, Jr., 2007-57-1

Atlantic Souvenir of 1828, Chambers' versions of this subject sometimes borrow the flanking trees and foreground bank of Durand's print of the same view, made about 1830 after one of his own early efforts as a landscape painter.[35] But typically, Chambers has transformed his composite of sources, adding his usual outsized sailboats (none of which appear in either Durand or Doughty) and reducing the larger, more active figures into smaller, pensive spectators or omitting them altogether. Differing from either of his sources, Chambers exaggerates the pattern of reflections to bring color down into the water's surface and silhouette his resting boatmen. Unlike the silvery broken color of Doughty (or Durand), Chambers' palette is by comparison much more saturated, generally dominated by the flush from pink to gold and blue in the sky and water, a clean and simplified version of Cole's color in the mid-1830s. Typically, Chambers' value contrast is extreme, with dark foreground rocks and the ridge of the mountains abruptly set against a bright sky or beach, or pale sails set against dark foliage, the better to emphasize the masterful rhythm of curving contours, repeated in the sailboats, the chain of boulders, or the spit of beach. As usual, his foliage textures are rapidly and simply done, unlike the dainty, varied application of Doughty or Durand. The Doughty, and its print, are everywhere softened and grayed to give a sense of distance and atmosphere, while the Chambers is flat, bright, and brilliantly decorative, without loss of the spirit of serenity and contemplation within the subject. A picture of space, rather than an illusionistic representation, such a painting calls to mind the strategies of Matisse.[36]

The Culture of Copies

Although sharing some training as commercial artists, all of these new landscape painters—Cole, Doughty, and Durand—seem to have been uniformly oriented toward the academic and cosmopolitan arena. They exhibited steadily with their local artists' institutions and managed to travel in Europe, absorbing a set of values that was both international and historical. Rhetorically, they were also urged to think of themselves as a native school, progressing individually and for the glory of the group and the nation. Such encouragement fostered an esprit de corps or competitive solidarity that reinforced the importance of the academy's annual exhibitions, the critical feedback of journalists and connoisseurs, and the collegial interaction among the artists on summer sketching tours and in shared studios. Chambers might have been excluded from this society by virtue of his flat and decorative style, although some of his daintier efforts are certainly on a par with (and sometimes more interesting than) Fisher's or Doughty's small paintings for the trade, such as *River Landscape, New England* (fig. 4-17). His retention of this style may well indicate his indifference to this international academic culture, but his copying of contemporary print sources also put his landscapes firmly beyond the academic pale.

The annual exhibitions were, of course, full of copies in this period, so many that the management of the Boston Art Association made a point of pressing for "as many *original* pictures of *native artists,* as possible" in 1847.[37] Many of the painters Chambers might have known and emulated in New York had learned by painting copies of the work of other artists, and many paid their way to Europe by making copies of the old masters in foreign collections, which they (or their patrons) then exhibited in the annuals.[38] Such paintings were clearly identified as by an American painter "after" Rembrandt (to note a work that Durand copied in Europe in 1841) and praised as demonstrations of the skill of the copyist as well as edifying facsimiles of the most admired, unfortunately distant masterpieces of European art. John Gadsby Chapman, George Loring Brown, and Benjamin Champney were particularly noted for their sympathetic copies, shown at the Boston Athenaeum in the 1830s and 1840s.[39] Less reputable were copies exhibited simply as after another artist, while a large class of optimistically attributed old masters (either misrepresented copies or outright forgeries) gradually gave the whole category a bad name. Occasionally, young artists would submit copies of a revered living master or teacher, but no working professional would submit to the annuals a painting based on the work of another contemporary painter, especially without giving credit. The critics

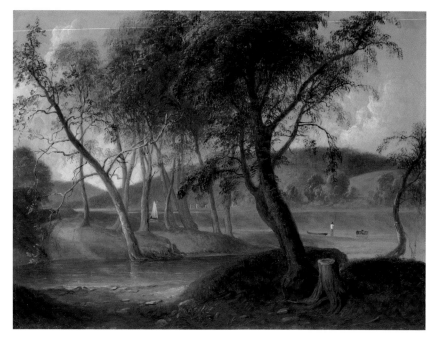

*FIG. 4-17 Thomas Doughty (American, 1793–1856). *River Landscape, New England,* c. 1840–55. Oil on canvas, 11¾ x 15¾ inches (29.8 x 40 cm). Indiana University Art Museum, Bloomington. Morton and Marie Bradley Memorial Collection, 91.260

were on guard, such as the reviewer in 1841 who paused before the work of "Hill" to note that the painting looked "very much like a copy" after a popular English painter, and queried, *"Is it original?"*[40] Chambers' recognition of this standard of honesty and originality is expressed in his auction catalogue, which lists his marine paintings under his own name, while his renditions based on print sources went out anonymously or under fictitious names.

Chambers' reticence about his relationship to print sources is key to his place in the art world, just as the issue of originality defines a sea change in that world during his lifetime that would forever disqualify him as a so-called fine artist in the eyes of his contemporaries. For centuries artists had been exhorted to study from nature, but copying was also the mainstay of their education, including tracing other artists' drawings or prints, drawing from sculpture, and imitating or replicating other work, all practices that became more important as schools and self-help instruction manuals replaced the apprentice education of earlier eras. Chambers was typical

of the artists of his age in being brought up in this transitional moment, but old-fashioned (like many of his contemporaries) in being shaped as well by guild practices, also heavily dependent on copying and repetition, that still remained strong in the crafts and decorative arts. This older tradition recognized the place of the professional copyist, skilled enough to satisfy patrons and confound experts centuries later. As the workshop system withered and artists found themselves solo entrepreneurs, painters more often copied their own work for interested patrons, in the fashion of Gilbert Stuart and his long chain of Washington portraits, Prior and his likewise long series of copies after Stuart, or Birch and his stream of harbor views. In such copies and variants, the reiterated image beloved by the folk painter (such as Hicks) and his audience met the popular American marketplace in the early nineteenth century.

The production of artistic commodities, obvious with Stuart, Birch, Prior, and Chambers, was sometimes more veiled, as in the still lifes of the Peales, where elements were freely copied and reorganized within new paintings made in the family circle, or in the flower paintings of Severin Roesen, who copied his favorite blooms in perpetually fresh arrangements. Such practices, including recycling motifs, pirating poses or costumes from prints, and creating new pastiches or variations from older solutions, were all part of earning a living for an artist, and probably treated as trade secrets best left hidden from customers. These methods, widely used by artists struggling to pay the rent, have little to do with the distinction we might make between fine and folk art before about 1850, although some artists were much better at generating work for sale that avoided the look of a potboiler. All of Chambers' stratagems, such as working from prints or repeating his own compositions with variations, are also seen in the work of John Singleton Copley or Stuart or Birch, with the principal difference that—like Prior—he granted himself a much looser standard of likeness and naturalism than Stuart's customers, for example, would have tolerated. But if Stuart, as a portrait painter, was hostage to the necessity for resemblance, and Chambers was free to be more expressive in his replicas, he was nonetheless vulnerable to the much more insecure and speculative new market for landscape and marine painting.

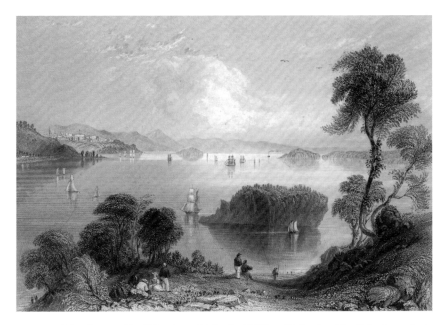

FIG. 4-18 John Cousen (English, 1804–1880), after William H. Bartlett (English, 1809–1854). *East Port, and Passamaquoddy Bay*. Etching, 4⅞ x 7⅟₁₆ inches (12.4 x 18 cm). From N. P. Willis, *American Scenery* (London: George Virtue, 1840), vol. 2, pl. 48

Victor de Grailly and the Bartlett Copyists of the Eddy Sales, 1841–55

From the distance of the twenty-first century, Chambers' transformation of his print sources seems remarkably original and personalized, but such dynamic theft had no place in a system that valued faithful, honest copies "after" another artist, but not expressively reinterpreted, anonymous work based on someone else's uncredited design. This distinction is easy enough to understand, but it becomes clearer—as does Chambers' position—by comparison with other painters who made both kinds of copies. Many artists copied prints; practitioners ranged from schoolgirls, amateurs, and country drawing masters who made awkward paintings and marble dust drawings for their own homes, to suave professionals in the business of producing enlarged oil versions for the market. Best-known today, most prolific, and most versatile among this latter group was Victor de Grailly, a Parisian painter who exhibited his own landscapes at the Salon for fifty years, beginning in 1830. De

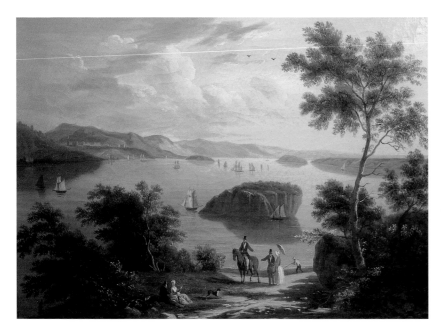

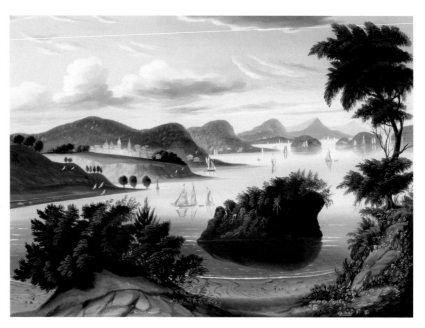

FIG. 4-19 Victor de Grailly (French, 1804–1889). *View of Passamaquoddy Bay*, c. 1841–55. Oil on canvas, 16⅛ x 22¾ inches (41 x 57.8 cm). Tides Institute & Museum of Art, Eastport, Maine

FIG. 4-20 Thomas Chambers. *Eastport, and Passamaquoddy Bay*, c. 1843–60. Oil on canvas, 22 x 30 inches (55.9 x 76.2 cm). Dallas Museum of Art. The Faith P. and Charles L. Bybee Collection, gift of Faith P. Bybee, 1992.B.52

Grailly was also a professional copyist, specializing in replicas of the paintings by Claude Lorrain and Claude-Joseph Vernet in the collection of the Louvre, and he seems to have launched a new career in painting oils based on Bartlett's prints not long after *American Scenery* was published in 1840. Although one period auction catalogue claimed that he had visited the United States about 1843, and one of his Bartlett views was painted on a canvas stamped by a New York art supply store, it seems that most of his paintings were produced in Paris to be sold to American tourists or shipped overseas for sale in the United States.[41]

Working, as Chambers did, from tiny etchings after Bartlett's dainty water-colors, de Grailly translated the images into the language of conventional French landscape painting in oils, using a delicate touch, a characteristic habit of bright dotted highlights, and a palette of gray-blues, greens, browns, and golds for a some-times glowing atmospheric effect. The jump from the Bartlett print *East Port, and Passamaquoddy Bay* (fig. 4-18) to the de Grailly oil of the same subject (fig. 4-19)

demonstrates the relative faithfulness of de Grailly's image as well as his person-alization. The composition and the topography hold constant, although the town of Eastport looms emphatically larger. Not a marine painter, de Grailly sticks to Bartlett's depiction of the shipping, but in his own realm of landscape he happily alters and enlarges all the foliage, and adds his own stock horseman and some styl-ish figures who seem to have wandered in from the Bois de Boulogne. The next leap—from de Grailly's image to Chambers' *Eastport, and Passamaquoddy Bay* (fig. 4-20)—although the scale and the medium are the same, lands us on another planet. Chambers' extant versions of this subject are all recognizably the Bartlett design, but transformed.[42] De Grailly's bright effect is now more strongly colored, and the town of Eastport grows even more prominent, although more compact and be-stee-pled, and the horizon rolls with more impressive mountains. The shipping is freely reinvented, with some odd results: Alterations to the vessels in the middle ground eliminate all scale markers, allowing the island, with its snaky roots and foliage, to

*FIG. 4-21 Thomas Chambers. *Mountain Landscape with Bridge and Monastery*, c. 1843–60. Oil on canvas, 18¼ x 24¼ inches (46.4 x 61.6 cm). Indiana University Art Museum, Bloomington. Morton and Marie Bradley Memorial Collection, 91.239

drift closer to the beach, its reflection confused with a sense of its shape underwater, so that it resembles a bristling creature merrily swimming offshore. Here, as in most of his versions of this scene, Chambers has omitted the elegant picnickers, leaving the foreground to the hyperactive bushes, dancing tree, and swelling forms of the landscape that give a sense of animation foreshadowing Walt Disney's *Fantasia*.

Chambers' work in the track of de Grailly continued into European subjects, such as the unidentified view *Mountain Landscape with Bridge and Monastery* (fig. 4-21), obviously based on the same source used by de Grailly in *Mountain Landscape* (fig. 4-22). Subjects from the south of France were a mainstay for de Grailly,

hailed in auction catalogues as "the modern [Jan] Both," so perhaps this was his own composition, if not one from his repertory of old master copies. Either way, we can believe from de Grailly's image in the existence of this particular site or a very similar print source. Chambers, with typical freedom, shows no commitment to his precedent: He eliminates the aqueduct and a tree at the right, makes the bridge a much larger feature of the composition, and reorganizes the skyline with his familiar receding bluffs. And, typically, he omits the parts he was not comfortable painting, such as cattle and sheep, allowing only a single cow and cowherd (as well as the return of the tree and the aqueduct) in just one of his five extant versions of this

subject.[43] Chambers makes up for the absence of figures by increasing the visual activity overall, with a rutted road and silhouetted foliage, ripples on the water, juicy rocks on the bank, and strong motion in the clouds. Most powerfully, however, he adds color: blue and yellow sky, lime green fields, and pink and gold buildings. By comparison, de Grailly's version is gray and boring. The number of surviving versions makes this one of Chambers' most popular European images, as well as a recurring subject for de Grailly. For both painters, and their customers, such Old World picturesqueness and simple decorative charm seem to have been perennially attractive. Layered associations, of classical and medieval, of pagan and Christian,

of rustic simplicity and monastic learning, added to the characteristic tranquility of Chambers' Italian subjects, and invited restful contemplation.

At least one of Chambers' paintings of a Bartlett subject, *Kosciusko's Monument at West Point,* seems more like de Grailly's version than the print.[44] Chambers could have inspected multiple versions of this painting in 1841, 1842, and 1844 in a series of major auction sales that may well have planted in his mind the whole idea of replicating Bartlett's subjects. These sales brought together hundreds of paintings gathered by a "gentleman travelling in Europe since 1837," including contemporary French landscape and genre painting, American scenery "painted in Europe

by distinguished artists," and modern copies of the old masters, mostly from the Louvre's collection. The gentleman, evidently the engraver-turned-businessman James Eddy, rolled out his first group of 250 paintings in New York in June 1841, followed by the sale of 150 in Washington in July, another 250 in Boston that December, and 250 more in Philadelphia in March 1842.[45] After a respite, presumably to gather a new collection in Europe, a similar set of sales marched from Boston to Providence and then New York from April 1844 to January 1845; after another pause, related material was auctioned in New York in April 1846, bringing a total of almost 900 more paintings to the market in the second wave.[46] This flood of paintings included numerous versions of more than forty Bartlett subjects (and a few after William James Bennett), the first arriving little more than a year after the publication of N. P. Willis' book *American Scenery*. Like most of the old master copies, all were carefully attributed, such as the first painting listed by de Grailly in the first Eddy sale, at the Apollo Association Gallery in New York on June 18, 1841: "*View of New York from Weehawken*. This beautiful painting was executed in Europe, from a drawing by Bartlett, [by] De Grailly."[47]

Given the scale of this enterprise, it is not surprising to find that de Grailly was not the only Bartlett copyist in these sales, although he produced twice as many as the total of all his colleagues, artists named Garnier, Barry, Giraud, Chimbaux, Lapito, Fontenay, Masson, Meslier, Veron, Vasseur (or Vassor), and Jugelet (or Jagelet), all of whom seem to have taken turns on these subjects. Hippolyte Louis Garnier, also a professional landscape painter and reputed to be "one of the best copyists in France," appeared the most frequently after de Grailly in these sales, gradually dominating the third and fourth waves of related sales in 1850, 1854, and 1855, which included other new names, such as Lemmens, Cibot, Tanneur, and Midi, on the Bartlett subjects.[48] Identified earlier by William Nathaniel Banks as part of the de Grailly circle, Garnier and his slightly softer technique can sometimes be distinguished in these Bartlett subjects.[49] However, the realization that there were at least seventeen artists, perhaps some of them working together, confuses the problem of attribution of all these copies, for sometimes three or four different artists were credited with the same subject in different sales. Only one subject, *West Point from Phillipstown* (fig. 4-23), based on a print from 1831 by Bennett, seems to have been the exclusive domain of a single artist, Garnier, who is cited in six different sales of this image. Surviving versions of this and many other Bartlett subjects, having once been attributed to Bartlett himself, may now deserve reattribution to one of the many copyists engaged by James Eddy in addition to de Grailly.[50]

FIG. 4-23 Victor de Grailly (French, 1804–1889) or Hippolyte Garnier (French, 1802–1855). *West Point from Phillipstown*, c. 1841–55. Oil on canvas, 21¼ x 28¾ inches (54 x 73 cm). Indiana University Art Museum, Bloomington. Morton and Marie Bradley Memorial Collection, 91.259

Surviving marked copies of the catalogues show that these paintings sold for between eight and fifteen dollars, with frames costing an additional few dollars. Many paintings were sold as pairs, including historical companion pieces, such as the morning and evening subjects of Claude or Vernet, twin views on the Rhine, inbound and outbound shipping in Boston harbor (copied from Robert Salmon and George Loring Brown), and newly invented pairs of complementary American views, such as Mount Vernon and the tomb of Washington. Some patrons—including doctors, dentists, and merchants—snapped up four paintings or more, suggesting either the decorative use of the pictures in such sets or the presence of dealers who were acquiring work for resale.[51] The lessons of these sales were not lost on American painters, and other American Bartlett imitators soon sprang up.[52] Prior's production of views of Washington's tomb in the 1850s follows the repeated appearance of this subject in the Eddy sales, and another artist, Edmund C. Coates, organized his own sale of original work and copies in Brooklyn in 1854, just as

FIG. 4-24 Attributed to Edmund C. Coates (American, born England, 1816–1871). *View of Mount Ida near Troy, New York,* c. 1841–55. Oil on canvas, 18³⁄₁₆ x 29⅞ inches (46.2 x 75.9 cm). Indiana University Art Museum, Bloomington. Morton and Marie Bradley Memorial Collection, 98.23

the Bartlett business seems to have been winding down.[53] Coates, another English immigrant who arrived in New York about 1839, was criticized in 1840 as an artist who painted "mostly *to sell*." He seems to have painted many views from Bartlett, such as *View of Mount Ida near Troy, New York* (fig. 4-24), and other titles popular in the Eddy sales, such as *Kosciusko's Monument at West Point, The Connecticut River and Mount Tom,* and *Boston and Bunker Hill,* mostly dated in the 1850s and 1860s. Coates worked from a wide number of sources and subjects, much like Chambers, from Canada to Italy, including picturesque cottage scenery paired with frilly frames, and grander copies of Cole's *Voyage of Life*.[54] Delicate and slightly stilted, showing a range of quality that may be the result of repeated subjects over many years, Coates' paintings carried on the work of de Grailly and his circle for fifteen years after the French Bartlett copies ceased to be imported.

First out of the blocks, however, and most idiosyncratic in this Bartlett business, seems to have been Thomas Chambers. Everything about the Eddy sales—the subjects, including Scotland, Ireland, Italy, Castles on the Rhine, as well as North American and Napoleonic sites, the cast of interchangeable artists, the pairs, the catalogue patter, the frames—all seem to have shaped the strategy of his Newport

sale in July 1845, which took place at the peak of the imports. Although Chambers had been working from print sources from at least 1835, and using auction sales as an outlet at least as early as 1837, the context of the Eddy sales allows us to see Chambers as inspired by the entrepreneurial picture importers and by the professional painters who, like de Grailly, created their own line of original pictures and simultaneously produced copies from other sources, including American landscape prints. Aiming for new markets, Chambers produced not so much copies of Bartlett as imitations of de Grailly, in different cities (such as Newport and perhaps Albany), probably for lower prices.[55] His repertory of subjects may have responded to the work that sold well in the Eddy sales, for some of his most common subjects are also ones that appeared repeatedly in these catalogues—Lake George, Fort Putnam and West Point, Eastport and Passamaquoddy—but he actually seems to have steered away from the most popular images (Mount Vernon and Washington's tomb; the Valley of the Connecticut from Mount Holyoke; *The Silver Cascade,* after Doughty; and Bennett's images of Niagara and the Hudson), while adding fresh subjects from Milbert (who is never referenced in the Eddy sales) and Bartlett subjects from New York State and Pennsylvania that, very logically, might have appealed to customers in his territory.[56]

Marketing Paintings

Well before the advent of the Eddy sales in 1841, American painters were learning to resort to such auction sales to market their works. To raise money quickly, perhaps to fund foreign travel or pay off debts, the one-man sale occasionally occurred, such as Alvan Fisher's string of studio sales in Boston. More commonly, an artist might consign one or two pieces to a general paintings sale; for Robert Salmon, who quickly knocked out popular cabinet paintings while waiting for commissions, auctions were his "favorite sales venue."[57] Less seasoned painters such as the unknown Robert Hill might try the market with items such as *The Young Fisherman* (perhaps fig. 4-25), a classic "fancy" painting that appeared in a sale in Boston in 1863 alongside views of Niagara, Lake Como, and castles on the Rhine by the amateur painter [Edward?] Ruggles.[58] It was a desperate strategy for some, and not just because of the likelihood of being lost within a motley group as in the sale in 1837 that set Chambers' marine paintings within a collection of "modern paintings," "fine old pictures," and, "if in not all cases the undoubted originals, at least the best copies of old masters." The auctioneer urged "those who wish to make bargains, to call

*FIG. 4-25 Robert Hill (American, active 1850–62). *Landscape with Fisherman [The Young Fisherman?]*, 1862. Oil on canvas, 13⅜ x 18⅝ inches (34 x 47.3 cm). Indiana University Art Museum, Bloomington. Morton and Marie Bradley Memorial Collection, 91.273

and judge for themselves."[59] The lure of the auction bargain, always an incentive to buyers, and the appearance of many paintings coming to market at once, could drive prices to low levels. At the same time, journalists decried the practice of sending lesser work or knockoffs to the auctions, which functioned as disappointing public displays of low behavior by auctioneers, customers, and artists alike.[60]

Apart from the auctions, there were more old-fashioned strategies. George Chambers' early view of Whitby harbor (see fig. 1-3), painted in London from memory, was first displayed to great effect in a "frame-maker's window" and then installed in his patron's pub. There, at the social and economic hub of Whitby seamen and shipowners in London, the painting was an immediate success, inspiring others to order a version with *their* ship in the foreground.[61] Looking at Thomas Chambers' serial paintings of Boston and New York, each with a slightly different ship in the middle ground, it is not hard to imagine similar marketing in the United States. George's success with the "frame-maker's window," reminiscent of the story of the discovery of Thomas Cole's work first in a frame shop on Broadway, and

then at an art-supply store in New York at about this same time (fig. 4-12), offered another option for painters in this era before art galleries were common, although the outlet was recognized as most appropriate for beginning artists.[62]

George Chambers also might have taught his brother a profound suspicion of art dealers who would "merely make a tool of him for their profit." This advice, repeated in Watkins' memoir, was first given to the young George by his patron the publican, who volunteered to "adopt" him "as his son, to keep him out of the picture dealer's hands."[63] Galled by the markup on Chambers' work by his dealer (who paid the perpetually poverty-stricken artist only a third of the sale price), Watkins harped on this theme at length: "Now the only way to remedy this, is for the artist to have a shop of his own wherein to exhibit and sell his pictures," he wrote, pointing to the enterprising William Hogarth, who would never let "a merchandizing dealer have a picture of his on any consideration."[64] By 1850, this was also the most desirable method for American painters, who were learning to bring patrons directly to their own studios. The top tier of artists worked almost exclusively in this fashion, on commission or from the annual exhibitions, and in this spirit, if not in an older tradesman-like practice, Chambers apparently sold work in his own studio-residence, as his newspaper advertisement indicates, or from the "fancy" store below his rooms.[65]

Finally, like Prior, Chambers may have taken to the road with a cart of paintings, marketing his work as a peddler. Although the romantic vision of the itinerant artist may be one of the most beloved fictions of "folk art," the roads were indeed full of dancing and drawing teachers, portrait painters, and other kinds of tradesmen and artisans, and Chambers may have been the first to peddle landscape and marine paintings in this fashion. Mary Black has described portrait painters, like Field, who set up small exhibitions in inns or taverns, following a practice well established by the late eighteenth century.[66] We might trace his wanderings by placing pins on the map where his work emerged a century later: the Hudson Valley, Albany, Woodstock, Buffalo, Rochester, Syracuse, Keene (New Hampshire), Boston, Cape Cod, Connecticut, and Long Island. One painting was found in a house in Duxbury, Massachusetts, with the story that the artist had traded it for hay for his horse; another small painting of the Catskill Mountain House has remained with the descendants of a household in Biddeford, Maine, who tell the story of the original owner, a traveling businessman who worked the territory between Massachusetts and Maine and purchased the painting directly from the artist.[67]

Chambers' Audience

Scattered across the Northeast in cities, small towns, and farms, Chambers' patrons were evidently attracted by a novel, fashionable, prestigious, and cosmopolitan item: the original framed oil painting of a landscape or marine subject. Generalizing from the portrait clientele of Field, Prior, Phillips, and others in this period, we can recognize these people as prosperous, bourgeois householders attentive to the latest urban style in costume and interior furnishings. More about these customers can be gleaned from Chambers' paintings, the pattern of their recovery in the twentieth century, and their style and subject matter. Some of his pictures may have been done to order, as his newspaper advertisement invited, and so they directly express the interests of particular customers.[68] But probably most were painted on speculation, in the daunting modern system that faced most easel painters in the nineteenth century. Like Cole or Corot, hopefully combining personal fancies and talents to catch the interest of an audience, Chambers lived suspended between the wish for old-fashioned patronage, still the way of life for traditional decorative painters hired to do a specific job, and the new practice of placing work in the market and hoping for sales. The survival of multiple examples of the same subject tells us that Chambers had success with a given image, and—lacking the critical commentary that surrounded the work of his better-known academic colleagues—these favorites allow us to generalize about the response of his audience and his success in anticipating or satisfying their desires.

Subject matter, sometimes framed by elaborate commentary in period titles, clearly drew Chambers' audience more than his name or reputation. He signed only the paintings that come closest to "academic" standards and practice; the rest are, like most vernacular painting in this period, unsigned, and we must conclude that this double practice recognized the expectations of two different sets of customers.[69] Evidently, it also did not matter to Chambers' patrons that the image might have been copied from a print or from another artist's work; perhaps recognition of an outside source such as Bartlett might even have recommended the subject. Simplification and expressive distortion apparently did not matter either, as long as the subject—be it the Natural Bridge in Virginia, the Ox-Bow of the Connecticut River, or Mount Laurel Cemetery—was identifiable in its most iconic form. The popularity of certain famous views, also found on Staffordshire transferware (fig. 4-26), hand-painted Tucker porcelain (see fig. 5-3), and countless other decorated surfaces, underscores the popularity and significance of a few subjects, such as

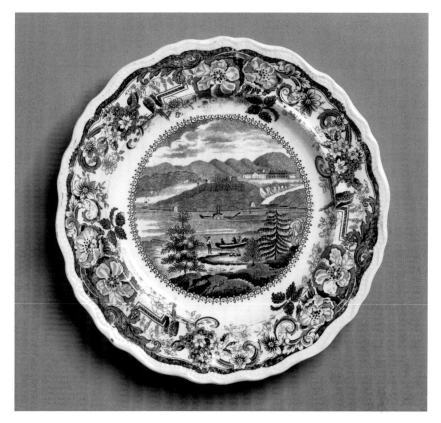

†FIG. 4-26 *Dish, with view of West Point after Jacques Gérard Milbert,* c. 1829–34. Made by James and Ralph Clews (Cobridge, Staffordshire, England, 1815–34). Glazed earthenware with printed decoration in black, diameter 7¾ inches (19.7 cm). Philadelphia Museum of Art. Bequest of R. Wistar Harvey, 1940-16-404

West Point and Niagara Falls, but Chambers' entire repertory can be assessed for its larger pattern of meanings. We have seen the parade of his landscape choices in Chapter Three, and the run of picturesque motifs—mountains, waterfalls, river valleys, castles, cottages—shared by many Romantic painters. More particularly, and not surprisingly, his choices are strongly nationalistic, stressing American natural wonders (Niagara), military strength (West Point, Mexico, naval battles), patriotism (Washington's birthplace), and tranquility (Lake George). Without belaboring the obvious, it can be said that Chambers, or his audience, was proud, patriotic, and nostalgic, seeking images of calm prosperity and national solidarity.[70] Probably

they were ardent Protestants, although little in the paintings makes direct reference to religion; most likely, they were Democrats, although the complex politics of the moment are paved over in deliberately generic subject choices.[71] They were also readers of contemporary fiction and poetry, as topics taken from Burns, Cooper, and Marryat attest, and they were history buffs, interested in Washington, Napoleon, and American wars. A large group of associative, nostalgic subjects of Ireland, Scotland, England, and Italy also suggests emotional ties to Europe, perhaps the sentiments of immigrants or wishful travelers, while generic compositions of river valleys and coastlines seem to have encouraged a more open-ended identification that allowed purchasers to project their own meanings.

Drawn to certain subjects, Chambers' customers were also encouraged to buy pictures as pendants. The frequent discovery of his work in pairs today,[72] and the pairing of titles in the Newport auction list (of ships sailing in and out of the harbor, of morning and evening, of Naples and Rome, of the *Constitution* in two victories), tells of a fondness for such companion pieces that is read in the work of Cole, Durand, and many other American painters of this period, and also found habitually in the Eddy sales. The popularity of pairs hints at the symbolic or narrative satisfaction derived from these sets, as well as the decorative display that the owners planned for their parlors. As the catalogue of the Eddy sale in Boston in 1844 assured its customers, the auction offered "a rare opportunity for our citizens of furnishing their parlors and drawing rooms with the fine paintings that will always afford pleasure for the eye to rest upon, and which considered only as furniture is the most ornamental and effective that can be purchased."[73] Such thinking may have motivated the clients in the auction who bought paintings in quantity, just as it explains the humorous "epistle" in the *Brooklyn Eagle* from "Corry O'Lanus," recounting how he and his wife ordered a "full set of pictures" from a long-haired artist who measured their walls and delivered in ten days "two landscapes, a marine view, a fruit piece, a scene up the Hudson, the White Mountains by Moonlight, Lake George, and a few other trifles," plus a view of the Alps ("every collection has the Alps and a Swiss Lake") and Niagara Falls.[74]

The domestic display of Chambers' paintings that we might imagine from his pendant subjects can also be read in the small size of his work. Only rarely did he work on the scale that his academic contemporaries in marine painting (including Birch, Lane, Pringle, and Bonfield) or landscape art (such as Cole, Doughty, and Durand) undertook for exhibition pictures or special commissions. All of these painters also made a living producing smaller works for collectors, but Chambers worked almost exclusively for this market in small and very small sizes, evidently aimed at smaller pocketbooks.

The descending staircase of sizes frequently accompanies an increased dash to Chambers' work that also signals, like Prior's inexpensive portraits without shadows, a painting intended to be produced quickly and sold inexpensively. His approach may have been condescending or canny, in the spirit of John Vanderlyn's advice to his son "to paint portraits cheap and slight, for the mass of folks can't judge of the merits of a well-finished picture."[75] But if Chambers aimed to sell landscapes cheaply, he nonetheless was committed to giving even his most modest customers an object that occupied the symbolic category of "elegant oil paintings" in "splendid gilt frames," ready (as his auction broadside promised) "for immediate removal to the Parlor." The invention of his characteristic Chambers frame, with its busy surface of curling ornament, offered an inexpensive imitation of a frame like those on Cole's paintings, to add satisfactory glitter to the wall. In the American dream, everyone's home could be a castle, perhaps a smaller, cheaper version of an Old World palace, but nonetheless outfitted with portraits and gilt-framed views, representing not just self-worth and the national landscape, but also the symbolic power of the splendid and valuable framed original oil painting and all that it meant about the aspirations of the owners.

The final impact of such a painting in an 1840s middle-class interior might have emulated more sophisticated, cosmopolitan taste, but with a difference. The paintings, with their strong contrast, curving contours, and sometimes saturated color, set in shining frames, echoed the boldly painted walls, patterned floor cloths or ingrain carpet, and faux-grained finishes of the interior, all effects that began by being imitative of more expensive materials (brocaded or papered walls, knotted carpets, veneered furniture, marble architecture) but ended, in the process of simplification and exaggeration, as a set of forms and effects almost unrecognizably distant from the source (like Chambers' paintings) yet delightful in their own right. This, the so-called fancy taste of the mid-century, arrived at a style of its own, playful, assertive, optimistic, expressing the new affluence and energy of Jacksonian America.[76] To meet this taste, technology and economics drove popular decor from the expensive and labor-intensive to the cheap and speedy. Stylish, the effect is also more "folk" in taste—strongly patterned and abstract rather than naturalistic, generic rather than specific, symbolic (in materials and content) and decorative.

Chambers and the Critics

The thought that American homeowners, creating such interiors full of imitations, might not notice the difference between Chambers' work and the paintings of Birch or Cole, or might not value the difference given an opportunity to buy work by Chambers less expensively, or—worse yet—might actually take pleasure in Chambers' expressive style, was the nightmare of American highbrow critics at mid-century. The English writer Frances Trollope, visiting the United States in the early 1830s, was amazed by the "utter ignorance respecting pictures to be found among persons of the first standing in society," and concern flowed from spokesmen for the academy and the intelligentsia, who were alarmed that the "average picture buyer" showed better taste in furniture and carpets than in paintings. Such voices warned against "contemptible pictures chiefly vulgar and coarse copies from Europe" foisted off on gullible American bargain-hunters who would learn a false canon.[77] Some were equally suspicious of the American Art-Union, fearing that it purchased too many cheap, inferior paintings to puff up the portfolio for its annual lottery. And they condemned the auctions for degrading both the taste of collectors and the income to be won by struggling American artists.[78]

A correspondent to the *Crayon*, the voice of the academic mainstream, seems to have been dragged to an auction in Albany in 1855 that included the work of the Eddy copyists, if not Chambers, who lived in the city at the time. The tongue-in-cheek account of the "highest pitch of Art excitement" surrounding this auction tells us much about the event and the highbrow reaction to such a sale, which was advertised around town with "flaming red and yellow posters" punctuated by exclamation points. "On entering the room, I was nearly lifted from my feet by the gorgeous array of Chrome Yellow, Dutch Pink, and inspiration, that hung about the walls in every direction," wrote "P. Green." Passing over a "defiant" copy of Raphael's *Madonna of the Chair* in the place of honor, the writer commented that "we, as a nation should feel highly flattered by the love for American scenery exhibited by the European masters. The astonishing manner in which they stay over there, and paint 'views from nature' in this country, is beyond all praise." In addition to many landscapes that "bore a striking resemblance to some of Bartlett's prints," there were Swiss views "depicting unapproachable cottages, nicely balanced on the brinks of frightful abysses, handsomely cleaned rocks with the most vividly blue water tumbling over them, pic-nic parties dancing in wild ecstasy on places where a chamois hunter would have a tough job to stand," and marine views

with "the most unique, original, and extraordinary specimens of naval architecture, either 'riding out gales,' or pitching head foremost into brilliantly illuminated lighthouses." Returning the following day to see the "Raphael" and other old master paintings knocked down for "ruinous" prices, he found the auctioneer desperately offering "duplicates at the same price!" and recklessly promising yet another sale to recover his losses.[79] Although it appears that this auction included imported paintings like those of de Grailly and his circle, the eye-rolling of the critic implies wilder, more-Chambers-like pictures, leaving us to imagine what such a viewer might have thought of Chambers himself. Clearly, he would have occupied a very low rung on the critical ladder of this writer, who would have disdained him not just as a Cole or Birch imitator and a Bartlett copyist, but as a low-rent native version of an imported imposter such as de Grailly, representing the "picture factories" of Europe and the worst side of the "humbug" American auction art market.[80]

The disdain for Chambers that we might imagine from the writer in the *Crayon* would have been based on both style and ideology. As noted, the copy, a cornerstone of education and traditional guild production, was increasingly suspect as the Romantic period continued to elevate the value of originality and sincerity. Prizing the personal and individual voice of the artist, the influential critic John Ruskin stressed the importance of working directly from nature, joining a chorus of American writers and artists, growing louder in the 1830s, advocating attention to the particulars of the national scene. By the mid-1850s, close observation and detailed description had been sanctioned as the path to artistic authenticity, and the more freewheeling, inventive, and artificial methods of earlier romanticism had fallen out of fashion. Twice vulnerable, by virtue of his reliance on print sources and his imaginative working method, Chambers would have been an example of everything about contemporary popular art that needed reform, according to the most progressive critics.

Favoring a finely finished, illusionistic effect, such critics also would have disliked the look of painting that might be called "folk art" today. To the academic eye of 1850, the works of Hicks, Field, Prior, Chambers, and their peers seemed amateurish, untutored, provincial, or incompetent, a type of failed academic art. If only they worked harder, looked at nature more, their drawing would be better, their art improved, such critics would have advised. To these judgments would have been added a condescending perspective on all commercial, decorative, applied, or industrial arts, whose workers included sign, carriage, furniture, clock, china, window-shade (fig. 4-27), panorama, and scenery painters, as well as decorators

FIG. 4-27 *Window shade*, c. 1830. American, artist unknown, nineteenth century. Location unknown. Photograph courtesy the William Jedlick Papers, New York State Historical Association, Cooperstown

of ships and architectural interiors. This attitude was based in part on the sense of lesser freedom in such occupations (assuming "fine artists" could somehow do as they wished), but also on content that was seen as less original, less profound, more repetitious, and more commercial. Adding all these prejudices together, a writer in 1839 surmised that the painter of the spurious old masters seen earlier at the Boston Athenaeum "probably emanated from the garret of some wretched tenth-rate sign painter, who was dying of delirium tremens."[81] Some artists, like Birch, could rise above a stint of clock painting, but others might be irretrievably dragged down. Cornelius de Beet advertised as a fancy and ornamental painter in Baltimore between 1810 and 1840, "ornamenting Windsor chairs for Messrs. Finlay," before branching out in the 1820s to include easel painting. "It is only of late that he has attempted to make pictures or landscapes," Rembrandt Peale wrote to Thomas Jefferson in 1825; "I cannot BUT think his practice on the chairs has been injurious to his taste."[82]

Perhaps the small scale or the subordinate relationship of the painted ornament to a useful object (like a chair; see fig. 1-7) threatened the integrity of de Beet's taste, or maybe it was just the bald presence of the market. Given the modern, romantic notion of the artist as a person working independently to an inner vision or a higher standard, it was disappointing to think that the market might drive a painter's choices or lower the quality of the work. The taste of the market was assumed to be "injurious," in part because it was inherently less refined than the artist's, and in part because it pressed the painter to work fast in order to make more money. The impulse to work "with the greatest speed or at the lowest cost," which Tocqueville noted in *Democracy in America*, threatened the quality of all crafts unsupervised by strong guild standards or fastidious aristocratic patronage. The cost-consciousness of customers of unstable fortunes—either those grasping for goods they could no longer afford or others "whose desires grow much faster than their fortunes"—likewise inspired inexpensive substitutes for high-quality goods. Responding to this market, the artisan in Tocqueville's assessment chooses "to sell at a low price to all" rather than at a high price to the few, and hustles to lower the price by discovering ingenious new methods to work quickly and cheaply, or by diminishing "the intrinsic quality of the thing he makes, without rendering it wholly unfit for the use for which it is intended." In the fine arts, according to Tocqueville, democratic society produces more artists, who suffer in poverty without adequate patronage, and more consumers with insufficient wealth for truly "fastidious" collecting. The result, he noted, was a "vast number of insignificant" pictures (rather than a few great art

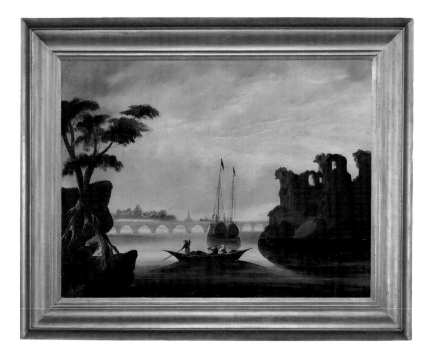

FIG. 4-28 Thomas Chambers. *River Scene with Ferry, Bridge, and Ruins*, c. 1850–60. Oil on canvas, 17¹³⁄₁₆ x 23⅞ inches (45.2 x 60.6 cm). Indiana University Art Museum, Bloomington. Morton and Marie Bradley Memorial Collection, 98.105

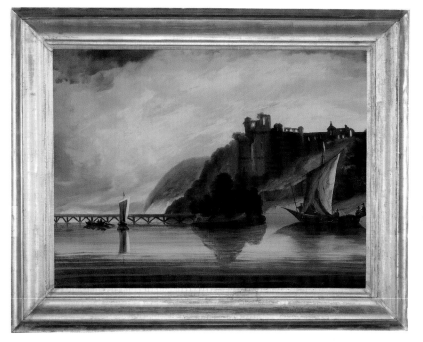

FIG. 4-29 Thomas Chambers. *River Scene with Sailboats and Ruins*, c. 1850–60. Oil on canvas, 18 x 24⅜ inches (45.7 x 61.9 cm). Indiana University Art Museum, Bloomington. Morton and Marie Bradley Memorial Collection, 98.51

works) and a culture of hypocrisy, in which objects affected "attractive qualities that they do not possess."[83] In such a patrician light, Chambers' "shortcuts" as well as the imagined compromises of his customers become part of a larger social and political phenomenon. From here, the ethic of the "true" and the original might be applied to make a painted imitation of veneer, like a low-cost substitute for a painting by Thomas Cole, not just cheap and slight, but also low and bad.

From this perspective, Chambers was surely victim of, if not collaborator in, all the injurious forces of the marketplace, and it is also likewise true that his output included many paintings done quickly, with little inspiration. His pair of harbor scenes—*River Scene with Ferry, Bridge, and Ruins* (fig. 4-28) and *River Scene with Sailboats and Ruins* (fig. 4-29)—the degraded remnants of an eighteenth-century European template, are muddy and dull; even if they are simply "school of Chambers," they represent the kind of heartless picture "for the trade" that so

amused or depressed the more sophisticated critics at mid-century. It is a long way from these paintings, however, to the pink-and-blue storybook landscapes and vivacious marines of his most appealing works, and it is presumptuous to assume that Chambers felt no pride and satisfaction in his art, or that his customers merely settled for his paintings because they could not afford better ones. However, Tocqueville reminds us that all of Chambers' paintings were crafted as commodities for a new, democratic market, as were indeed most of the paintings of the Hudson River School.

Deeper than the legacy of craft and commerce visible in Chambers' style, critics also might have detected and disliked a fundamental aesthetic opposed to the progressive realism of the day. At the core of most folk art worldwide is a conceptual and symbolic visual strategy, uninterested in the illusionism that had preoccupied elite European cultures of the last five centuries. This alternate tradition, found in

peasant or pre-Renaissance art in Europe and in many other cultures, maintains a strong sense of the two-dimensional surface that is being painted or decorated, and delights in the decorative potential of the image being made on that surface as an event in itself. The power of materials and making, added to old symbolic or iconic ways of seeing, made such art compelling to modernists, such as Wassily Kandinsky, seeking to reform the art of the early twentieth century with a more universal abstraction and spirituality. Folk painters may have been failures as academic realists, but they may also have been manifesting different, deeply entrenched principles of representation. Such a sensibility, encountering the wonder of illusionism, the high-minded humility of Ruskinism, or the seduction of photography, might resist, convert, or pioneer a creative and idiosyncratic path.[84]

To the progressives of the mid-nineteenth century, however, a hybrid like

Chambers would have been seen as a "fallen away" student of academic painting, the commercial black sheep artist in a family that included three or four painters who worked more conventionally within the academic mainstream. Injured by the low taste of decorative painting and pulled down by the pressures of the market-place, he might be seen as a half-trained artist who let his skills deteriorate and his ambitions sink, adapting to provincial taste and a low-budget clientele. From a distance, we might commend him as the first American artist to take on the "picture importers," aiming to supply the market, perhaps even singlehandedly, with home-made versions of the picturesque oil paintings flooding the art market from Europe, although such an enterprise would have made the elite critics shudder in 1845. But, however inspired or misguided, this commercial and artistic mission to the bourgeoisie, shared by Chambers after 1850 with Prior, Coates, and others, does not completely explain the distinctive qualities of his style, which cannot be reduced to issues of speed and marketing. His flair, a kind of folk romanticism seen in his subject choices as well as in the rhythmic drawing and handling of color in his best work, shows more conscientiousness than necessary, more spirit than required for a dull commodity. Moreover, his taste expresses the world of his customers, with their brash mix of confidence and provincialism, a fashion-conscious but not very sophisticated class of prosperous, upwardly mobile householders thrilled to own original oil marine or landscape paintings, probably for the first time.

Imagining this clientele, and Chambers' odd mix of fine and folk characteristics, it is tempting to call Chambers a popular rather than a folk painter. However, this runs against both the older European usage (where "popular" effectively means folk or vernacular) and the newer American definition of popular as mass-produced, mass-market culture.[85] His market, in fact, must have been a small niche within a population that generally did not own framed oil paintings at all. The patronage base in the first decades of Chambers' career drew from wealthy, "aristocratic" families with inherited collections and a new group of bourgeois patrons, including merchants, bankers, lawyers, doctors, politicians, clerics, and other professionals likely to be found on the boards of directors of institutions like the Pennsylvania Academy of the Fine Arts or the National Academy of Design. These people, such as the extraordinary collector Luman Reed, had their portraits painted by Durand, Rembrandt Peale, or Sully; they purchased landscape and figure paintings by Cole

and William Sidney Mount.[86] Chambers' market would have been at the expanding edge of this population, pioneering a territory of middle-class collectors acquiring work in the zone between Cole's oils and the chromolithograph. It was a new market, large enough to support Chambers, barely, but hardly "popular" by comparison to the burgeoning audience for truly inexpensive Currier and Ives prints. Still, it was a dynamic middle zone, linking the taste of the academics to the practices of the window-shade artists, and making a place for landscape and marine painting analogous to the provincial portrait, by artists such as Prior, Phillips, and Robert Street, who show a similar blend of cosmopolitan and folk taste.

Chambers did much to create and expand this category, and he worked in it almost alone, but he did not have long to enjoy it. In the vanguard of entrepreneurs, he also lived in the twilight of the culture of handmade copies. Just as photography drove miniature painters and provincial limners like Field to new strategies or different content, competition from chromos and other mass-produced or photographically based technologies must have stolen customers from the lower edge of Chambers' market. Meanwhile, the call for "truth to nature" from the critics, answered by the rising skill of the new generation of landscape painters, drove the market for Bartlett copies onto the rocks and made Chambers' work look ever more old-fashioned to the educated. After the Civil War, his folk aesthetic and its market must have been quietly relegated to amateur and commercial realms, or to the small hamlets of upstate New York. In Chambers' lifetime, the mainstream of painting had undergone a major shift, away from traditional practices based on copying, inherited conventions, and imagination, and toward a realism based on the direct study of nature. The record of observation, giving a sense of personal experience, offered a new measure of authenticity; falseness of all kinds became the enemy, as "the real thing" gained significance.[87] At the same time, artists were praised for being unaffected and unencumbered, valued for being true to themselves, sincere, and individual. Chambers, with his print sources and his folk manner, did not fit the new modern style and its ideology of originality, authenticity, subjectivity, and innovation. But attend: We shall see, a hundred years later, that the visual qualities deemed bad in Chambers' day—flatness, unnatural color, expressive distortion, abstraction, and simplification—are exactly the traits that will make him a model of liberated individualism and originality, "America's First Modern."

*FIG. 5-1 Thomas Chambers. *Undercliff, near Coldspring*, c. 1843–60. Oil on canvas, 22¼ x 30¼ inches (56.5 x 76.8 cm). Collection of Dr. Howard P. Diamond

"AMERICA'S FIRST MODERN" IN THE POSTMODERN AGE

THE second life of Thomas Chambers began when he was recovered from obscurity and revalued in the sunshine of modernist taste. A place for his work in American museums, private collections, and textbooks was won in the 1940s, at a time when almost nothing was known about his career. Nonetheless, his early admirers created a frame for understanding his work that has shaped the way we see Chambers today. At the outset, mystery gave him a historical advantage, because he arrived as an unknown, tantalizing new name—simply "T. Chambers," found at the corner of one painting—free of the biases of his own age, and ready to be reconstructed on the basis of the appearance of his paintings and the values of a new era antipathetic to those of a century earlier. All the prejudices of his own high-brow contemporaries, who would have disapproved of his loose handling of print sources, disdained his commercial art connections, and disliked his flat modeling and distorted drawing, were now overturned, replaced by an ideology that favored his style and actually sought it out. He was not the only obscure nineteenth-century American artist rediscovered in this moment—in fact, he was among the last of the figures that loom large in folk art collections today—but his rise to celebrity throws new light on both Chambers and the recovery of American folk art in the mid-twentieth century. At a time when museums were packing off their Hudson River School paintings to the basement or the sale rooms in order to show more abstract, surrealistic, or expressionistic art, and as homeowners were ditching everything fussy and Victorian in favor of clean, modern interiors, Chambers came into his own. It was, as his discoverers were happy to note, "one of the thrilling stories that are so often associated with the romance of the Art World."[1]

The first painting to come to light in this new era was a view of Undercliff (akin to fig. 5-1), found in Woodstock, New York, by the dealer Albert Duveen in about 1936. Two years later he found another version, clearly by the same hand, in a Lake George farmhouse. About the same time, another dealer, Norman Hirschl, found two related paintings, one with a signature that emerged after cleaning (see fig. 1-1). As Robert G. McIntyre told it, "the two dealers compared notes one day and set about combing the countryside for more dramatic creations by their discovery," culling work from farmhouses, country antique dealers, and private collectors. In 1941, Duveen placed his two paintings of Undercliff, identified as by an unknown artist, in a group show managed by Hirschl at the John Levy Gallery in New York. The organizers' interpretive spin was immediately picked up by the press: "Because of the high palette involved, and also because of the general treatment and scheme of composition," wrote Edward Alden Jewett in the *New York Times*, "these paintings, as a catalogue note remarks, look curiously 'modern.'"[2]

After the discovery of a signed painting gave a name to their artist, the partners approached McIntyre, owner of the Macbeth Gallery in New York, to arrange an exhibition of about eighteen paintings from November 24 to December 12, 1942, accompanied by an eight-page brochure that heralded *T. Chambers, Active 1820–1840: First American Modern.*[3] The venue of the respected Macbeth Gallery, known for modern American realist painting since the early years of the twentieth century, guaranteed serious attention and set the tone for Chambers' debut. Under the direction of McIntyre, the gallery continued to champion national landscape painting, representing distinguished older Post-Impressionists, such as Daniel Garber, recast in the 1930s as an "American Scene" painter, and brilliant new talent, such as the young Andrew Wyeth, with his expressive watercolors in the spirit of Winslow Homer.[4] In this context, the organizers solicited a few critical responses, which they published in their brochure to articulate the appeal of Chambers' work and to frame the argument for his modern sensibility.

Not surprisingly, the first theme of the brochure texts was the Americanness

of Chambers' work, in both style and content. Thomas Craven, an art critic and proponent of regionalist art, declared Chambers to be an "authentic American artist," one with "control of what may well be called an American idiom, a healthy and happy combination of an inborn and developed sense of design with a true love of native landscape." This promotion of national spirit was of course ignorant of Chambers' background and the European subjects of many of his paintings, but even after his debts to Bartlett had been identified, his transformation of these sources could be described as independent of the enthralling and decadent European traditions so disparaged by the regionalists, who might be expected to embrace an artist showing such "a spontaneous vitality, thoroughly American and completely devoid of foreign influence."[5]

In tandem with this American independence was the quality of "primitiveness" that made Chambers seem to be both innocent of foreign ways and a "pioneer" of the national tradition. The term "primitive," now generally discarded as condescending, carried an affirmative power in the early twentieth century, when it connoted the guileless, earnest beginnings of a more developed culture, valuable for an imagined purity, potency, and childlike directness of vision. In Europe, such qualities were celebrated in the art of Russian and Breton peasants, Tahitian natives, African sculptors, and self-taught painters like Henri "Le Douanier" Rousseau, all enthusiastically collected, studied, and emulated as a corrective to the effeteness of academic art. Primitive art, by contrast, was seen as sincere and authentic, free of stale conventions and lies. Assembling the work of Matisse, Picasso, and Soutine alongside such primitives, the Parisian dealer Paul Guillaume in turn fed the collection of the American Albert C. Barnes, who would display Native American, Pennsylvania German, and African art alongside his modernist masterpieces. In this same spirit, Holger Cahill, writing in *Masters of Popular Painting: Modern Primitives of Europe and America*, the catalogue of an influential exhibition at the Museum of Modern Art in New York in 1938, traced the lineage of American "folk and popular art" from the colonial limners to Edward Hicks and forward to John Kane and Horace Pippin, noting that such art had "qualities which European and American art have been trying to recover for fifty years or more." Rejecting fathers, grandfathers, and great-grandfathers, as Cahill insisted, the generation of the 1930s returned with delight to "the sources of American expression."[6]

With such statements, made a century after the ascendancy of realism in American landscape painting, appreciation for nineteenth-century academic naturalism fell to its nadir. Dismissed as prosaic and materialistic, Victorian realism had been replaced by abstraction or surrealism, and the truly original vision was now recognized in the dreams and constructs of the imagination. To those who saw realism as hopelessly *retardataire*, the efforts of a visionary working in the studio at night (such as Albert Pinkham Ryder, George Inness, or perhaps Chambers) seemed more compelling than any observation-based painting. In this light, the mainstays of the Hudson River School, already lost in the glare of Impressionism, were totally eclipsed. "If Chambers knew them at all he most certainly was not influenced by them," speculated McIntyre. "There was an aloofness about his work, especially in his landscapes, that adds to its fascination." Carl Drepperd, who had reproduced two images by Chambers in his book *American Pioneer Arts and Artists* earlier that year, shared this sense of Chambers' admirable distance from the realist mainstream. Drepperd objected to the catchall term "primitive" and preferred to call Chambers a "pioneer," one with "courage, verve and lusty appreciation of the scene" that made his work "direct, fresh, and natural." Prizing the artist's spontaneity, Drepperd noted that only two of the paintings in the show ("obviously of his later period") showed "the emasculating influence of formalized technique and restraint." "T. Chambers painted, I am sure," wrote Drepperd, "as the Hudson River School wished they could paint."[7] Chambers, "the American Rousseau," won a place among the moderns for exactly the reasons that might have excluded him from academic circles in his own day.[8]

For viewers in 1942, the curious modernity detected in Chambers' work largely resided in his expressive individualism. Easily understood as unlike that of the Hudson River School, his art was harder to categorize in any other way. This too was a good thing, for Chambers' uniqueness suited modern delight in bohemian eccentricity as well as anti-academic rebellion. McIntyre noted in the catalogue, "Here was an artist who had not only a new personal way of looking at nature, but a dash and independence in his manner." Howard Devree, writing in the *New York Times*, found the paintings "reminiscent of the color prints of the period, but they are freer in treatment, more imaginative, much more personal than the old prints."[9] These early voices, reacting to Chambers for the first time and with only a few examples of his work to measure, struggled to express how his lively visual personality stood apart from the Hudson River School, and also from the welter of self-taught, amateur, and provincial painters whose work was emerging from the attics of the northeastern United States in this period. The inadequacy of the term "primitive" burdened efforts to explain his idiosyncratic place, leading to contradictory descriptions such as "the most interesting and accomplished of the

*FIG. 5-3 *Covered sugar bowl*, c. 1826–38. Made at the Tucker porcelain factory (Philadelphia, 1826–38). Porcelain with painted decoration and gilding, height 4½ inches (11.4 cm). Philadelphia Museum of Art. Bequest of Constance A. Jones, 1988-27-12a,b

FIG. 5-2 Thomas Chambers. *Mount Auburn Cemetery*, c. 1843–60. Oil on canvas, 14 x 18⅛ inches (35.6 x 46 cm). National Gallery of Art, Washington, D.C. Gift of Edgar William and Bernice Chrysler Garbisch, 1958.5

Hudson River primitives" and "the most sophisticated American primitive." Admitting that there was still "something baffling about his work," it was easier to find a place for him as a loner and a "modern."[10]

Finally, and perhaps most powerfully, modern taste responded to Chambers' decorative genius, widely recognized as a strength of primitive art. The sense of color, rhythm, and two-dimensional design that made paintings such as *Mount Auburn Cemetery* (fig. 5-2) at home in American parlors in the 1840s alongside sprightly Tucker porcelain (fig. 5-3) now won praise from modernists in search of universal principles of decoration in the most avant-garde, abstract art of a century later.[11] "Consciously or otherwise, he certainly was a master of design," observed McIntyre, "and how he loved the curved line!"[12] A critic in *Art Digest* agreed: "Great curving lines sweep through Chambers' compositions, lending movement and depth. Details are selected judiciously, with the taste of a born designer."[13] American modernists, seeking ancestors outside the European mainstream, were delighted to recognize a brilliant national tradition for decorative design in quilts, fraktur, weather vanes, and other folk art of the American past. Taking a formalist sensibility to judge the art of the past, collectors (many of whom were also artists, such as Robert Laurent, Elie Nadelman, and Charles Sheeler) discovered modern sculpture in hay forks and trade signs, and modern paintings in backcountry portraits. Like the critic Margaret Breuning, who contributed a statement to the 1942

Chambers brochure, they were thrilled by "a directness, a boldness and a power of simplified statement which may well be termed 'modern.'"[14]

Happily, Chambers' work also fit in with the country antiques being arranged in American homes by those with more conservative, even antimodern, nationalist taste in the early twentieth century. The enthusiasm for decorating with "Americana," encouraged by the period rooms and house museums launched during the colonial revival at the turn of the century, gained even more popularity with the opening of the American Wing at the Metropolitan Museum of Art in 1924 and the advent of Colonial Williamsburg and other similar restored and reinvented historic environments in the 1930s. Drepperd, complimenting Chambers' "really good" handling of color, noted that his works were "decorative as well as documentary—which makes them good pictures to live with."[15] On this same note, Howard Devree remarked that "apart from the matter of sheer artistic merit, the canvases appear to be the answer to a decorator's dream of adjuncts for early American settings. Color is striking as well as composition, and landscape is treated with a personal dramatic flair."[16]

Chambers thus earned a large and mixed set of admirers: Liberals and avant-gardists in the circle of the Museum of Modern Art, hoping to invigorate contemporary art with lessons from so-called primitive, nonacademic, sources, found themselves for once in accord with the regionalists, committed to a national idiom, as well as in league with the Americana collectors, dedicated to the preservation of the country's heritage. All three constituencies were looking for roots to sustain a modern American identity. Their taste for Chambers may have been whetted by the rarity of folk landscapists other than amateurs and decorative painters. Many portrait painters had been discovered who offered a link to American folk taste in the past, but apart from the ship portraitists, there were few professional landscape painters of this type identified by 1942, and indeed few others have emerged since. However, the *type* had been discovered, in the pattern of painters such as Ammi Phillips—self-taught, itinerant, entrepreneurial, and naive—and Chambers was gathered in with the same set of assumptions and honors.

"A notable show and a notable discovery!" concluded *Art News*,[17] echoing a response that can be measured in the collecting of Chambers' work in the next decade by progressive museum directors such as A. Everett "Chick" Austin, Jr., at the Wadsworth Atheneum in Hartford, Henry Russell Hitchcock at the Smith College Museum of Art, and Gordon Washburn at the Museum of the Rhode Island School of Design, all of whom purchased work from the Macbeth exhibition.[18]

Both the Minneapolis Institute of Arts and the Memorial Art Gallery in Rochester, New York, acquired views of West Point in 1943 (see fig. 3-12 and a similar painting from this series, fig. 5-4). Not long after came gifts to and purchases by the Albright Art Gallery in Buffalo (1946), the Brooklyn Museum (1948), the Addison Gallery of American Art in Andover, Massachusetts (1959), and another *West Point* (fig. 3-11) for the Albany Institute of History & Art (1958). Chick Austin, "a pioneer of modernism in all its forms," defended his purchase of two paintings by Chambers for the Wadsworth Atheneum by noting that "the boldly abstract patterns of this recently rediscovered American painter are highly exciting and 'modern' to contemporary eyes."[19] Andrew Carnduff Ritchie, soon to become the director of the Museum of Modern Art, probably wrote the text in the Albright's "Gallery Notes," describing his purchase of Chambers' *Genesee Falls*, and summarizing all the attributes of the artist's work admired by museum professionals and the value-laden history and meaning found in these formal qualities:

> Chambers has been called "America's First Modern" and the "American Rousseau." The truth is he is a self-taught artist unspoiled by any of the academic conventions of the professional painters of his day. This freshness of outlook and an innocent delight in the picturesque grandeur of the Hudson River Valley and such scenes as ours, together with a strikingly clean palette and bold brushmanship, combine to produce canvases which have something of the naive purity of Rousseau's and the expressive freedom of approach to nature we call "modern."[20]

American museums may have embraced Chambers after 1942, but private collectors were enthusiastic from the very first moment of discovery. Certain collectors, such as Richard A. Loeb and Mr. and Mrs. Thomas A. Larremore, who lent to the Macbeth show and together owned a total of almost twenty paintings in the 1940s, found many Chambers paintings "good to live with." Scholars were not far behind them. Nina Fletcher Little, who already had reconstructed William M. Prior and Winthrop Chandler, took up the problem of Chambers' obscurity and published the first of three articles on his life and work in 1948.[21] Virgil Barker seized on the Smith College Museum of Art's new *Looking North to Kingston* (very like figs. 3-13 and 3-14) and included a discussion of its merits in his influential survey book, *American Painting: History and Interpretation,* of 1950.[22] Such opinions, followed by the more extensive research of Howard Merritt, published in 1956, launched the golden age of collecting Chambers' work. Better-known American folk art collectors quickly became interested, principally Edgar William Garbisch and his wife,

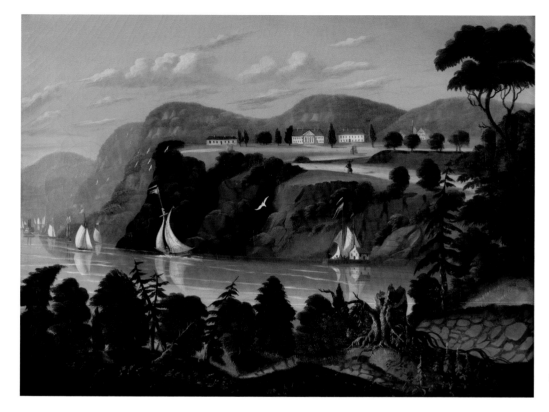

*FIG. 5-4 Thomas Chambers. *West Point*, c. 1843–60. Oil on canvas, 22⅜ x 30¼ inches (56.8 x 76.8 cm). Private collection

Bernice Chrysler Garbisch, whose collection of over 2,600 paintings included fourteen pictures by Chambers that were eventually distributed to the National Gallery of Art, the Metropolitan Museum of Art, and the Flint Institute of Arts in Michigan, after appearing in many loan exhibitions.[23] Also early in the field were Mr. and Mrs. William J. Gunn of Newtonville, Massachusetts, whose barn full of paintings, including at least three by Chambers, was culled for the New York State Historical Association in Cooperstown in 1958.[24] Not far away in Harvard, Massachusetts, Clara Endicott Sears had acquired two paintings by Chambers before 1946 for her Fruitlands Museum; and Maxim Karolik, Electra Havemeyer Webb, and Abby Aldrich Rockefeller all owned work by Chambers before 1960. These works ultimately went, respectively, to the Museum of Fine Arts, Boston, the Shelburne Museum in Vermont, and Colonial Williamsburg in Virginia.[25] New enthusiasts arose, such as the brothers Dana and Peter Tillou, Stuart Feld, Roderic Blackburn, and Howard Godel, all dealers and collectors who continue to seek out examples

of Chambers' work. Today, demonstrating the hybrid contemporary contexts that welcome Chambers' style, Susanne and Ralph Katz live with fourteen Chambers paintings and a collection of American folk art in an austerely geometric modern house in New England, while Dr. Howard P. Diamond tucks nine Chambers paintings into the rooms of his restored eighteenth-century Connecticut Valley house, noting that he also admires the work of Maurice de Vlaminck.

The most extraordinary representative of the modern Chambers collector, of course, was Morton C. Bradley, Jr., who gathered the group of twenty-nine paintings that he later gave to the Indiana University Art Museum and that ultimately inspired this study. Bradley, a classical pianist, mathematician, paintings conservator, and abstract sculptor, embodied the sophisticated taste that found Chambers irresistible in the 1940s. A graduate of Harvard in 1933, Bradley was raised as a modernist and a traditionalist, living amidst antiques and composing geometric sculpture based on color theory and Euclidian forms. He responded to the abstract sensibility in

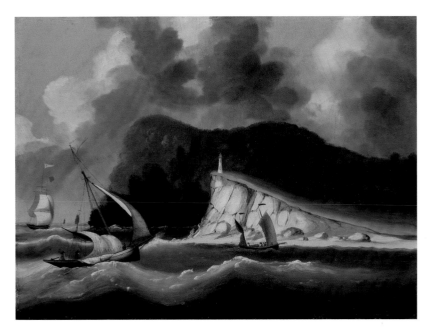

*FIG. 5-5 Thomas Chambers. *Coast with Lighthouse*, c. 1843–60. Oil on cardboard, 14⁷⁄₁₆ x 20¹⁄₁₆ inches (36.7 x 51 cm). Indiana University Art Museum, Bloomington. Morton and Marie Bradley Memorial Collection, 98.147

Chambers' work, its quirky individuality, and its old-fashioned American content, finding solidarity with the audience that once bought Chambers' pictures.[26]

This pleasure in the art of ordinary folks, so much a part of the enthusiasm for Chambers in the last seventy years, expresses a sincere modernist's wish to enfranchise artists outside the academic and elite circles of the past and appreciate their work "on their own terms," or at least in new and more complimentary ways. Laundered, over time, of the class and guild prejudices that colored the opinion of Chambers' own contemporaries, his work comes to us with nuances of subject matter and context likewise lost, and a measure of nostalgia and condescension added, as we smile over imagined naive and innocent citizens of the past decorating their fancy parlors. Countering this tendency in the late twentieth century, subtler art historical scholarship, driven by sociology, anthropology, folklore, and material culture studies, has looked harder at the lives of nineteenth-century American artists, folk and fine, and their patrons, listening for their opinions and seeking to complicate our sense of their lives. And since the great decades of Chambers' redis-

covery, from 1940 to 1960, which coincide tellingly with the high-water mark of modernism, the faltering of the modern ideology has also allowed new appreciation of the nineteenth-century academic art so reviled by the mid-twentieth century, and a more distant view of the biases and fictions of modernism itself. All three circumstances allow this study of Chambers a new perspective in the twenty-first century.

Our postmodern era, marked by the fragmentation of the American art world since 1970, has permitted the simultaneous appreciation of diverse modes, from Hudson River School naturalism to conceptual art, without any single elite authority or fashion akin to the opinion of high-minded tastemakers of 1840 or 1940. Scholarship since 1970 has grown increasingly interested in period criticism, investigating with greater sympathy and subtlety the opinions and patronage patterns of the past, while folklorists have brought new methods to the evaluation of American folk art.[27] At the same time, a wide range of previously disdained popular visual culture has been opened to dignified scholarly scrutiny (not to mention collector mania), ranging from comics, cartoons, illustrations, posters, and advertising to photography, film, video, and new digital technology. The taste of the late twentieth century, with its mass-media culture of recycled and transformed imagery, has made it easier to embrace the popular art of the past and also more difficult, as the present delight in kitsch, added to a seemingly unshakable sense of irony, has made it harder to measure whatever sincerity or mendacity "low" art may have had in the past.[28]

In such a general climate of tolerance, it is interesting to note the presence of a contemporary artist who makes the intelligentsia shudder, much as the Bartlett copyists with their use of strong colors repelled the elite of the 1840s and 1850s. Thomas Kinkade, "painter of light," has built an empire based on images similar to the repertory of Thomas Chambers—cottages by waterfalls, surf pounding below lighthouses, serene lakes ringed by mountains (figs. 5-5 and 5-6)—derived from the same sources from the seventeenth and eighteenth centuries that Chambers mined, but now delivered in a glowing impressionist manner. Although trained in an art school, Kinkade has found a market entirely outside the academic art world; indeed, he claims a mission to reform contemporary art, to make it meaningful and accessible to average people. With new technology and a team of assistants, Kinkade has perfected the individualized replica in ways that Chambers could only have dreamed: Limited-edition color prints, photographically reproduced from his paintings, are "highlighted" by his assistants, who travel to galleries around the country. For a price based on the time allotted, the customer can watch this highlighting process, and hear commentary on the meaning of the painting. Kinkade's thrilled customers

may be able to teach us something about Chambers' market, for they are generally a middle-class group, with little education in art, seeking a genuine ("authenticated") oil painting (or highlighted print) in a gilded frame, to decorate their homes. Interviews with these collectors reveal deep emotional responses to Kinkade's nostalgic, religious, and patriotic subject matter, which may remind viewers of their childhood haunts, their grandparents' cottage, or their favorite retreat. Even the most conventional, greeting-card images have elicited rich, spiritual readings and very personal, projected narratives. The landscapes, Kinkade's patrons report, help them remember lost loved ones, find solace in sad or stressful times, and recover a sense of peace, hope, and well-being.[29] The generic, storybook quality of the imagery hides one of the strengths of his paintings, which invite completion by the spectator, whose memories and fantasies enliven the view. Certainly, if modern Americans are capable of such imaginative responses to Kinkade's paintings, we can surmise that Chambers' audience, much less jaded by imagery and probably better read, was capable of investing his views with similar emotion. Likewise, we can consider the distaste felt by most educated members of the art community in response to Kinkade, and wonder if we are standing, perhaps uncomfortably, in the shoes of the art critics of 1850. So, if it was useful to call Chambers the "First American Modern" in 1942, is it helpful to understand him as the "first Thomas Kinkade"?

As little as we know about Chambers, the parallels are provocative, beginning with the disdain of the critics and including the relationship to older art, the replicas, the assistants, the entrepreneurial imagination, the symbolic and decorative driving force. However, it is not so much that Chambers was the first Kinkade, as that Kinkade may wish to be a Chambers for the modern era—revised, caricatured, and mass-marketed with breathtaking sophistication. But Kinkade's place in the contemporary art world makes it impossible for him to assume a position comparable to the one that Chambers held in the past, as difficult as that might be to map. At close range, from within the mid-nineteenth-century American art world, Chambers seems to stand apart: somewhere at the edges of the academic community and mirroring its practices, but excluded from it; akin to the market for provincial portraiture, but distinct; and perhaps unique in his production of popular landscape and marine painting. Yet, from the distance of the twenty-first century, his world seems remarkably tight and coherent, his market seamlessly connected to elite taste. In 1857, probably the entire population that cared about such things, from the editor of the *Crayon* to the working-class patron of panoramas, would have agreed that Frederic E. Church's magnificent *Niagara* (Corcoran Gal-

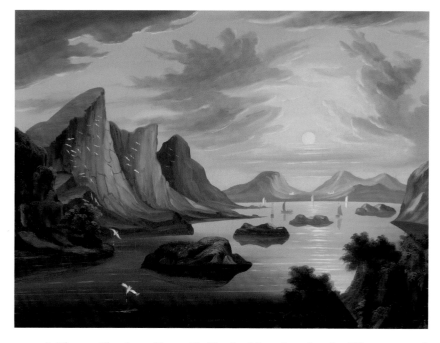

FIG. 5-6 Thomas Chambers. *River with Islands at Sunset*, c. 1840–60. Oil on canvas, 18 x 24¼ inches (45.7 x 61.6 cm). Indiana University Art Museum, Bloomington. Morton and Marie Bradley Memorial Collection, 98.20

lery of Art, Washington, D.C.) was the greatest contemporary American painting. From Church, who "obtains his own price" at the top of the market, to the second or third tier of the national landscape school, their imitators of a professional order (including Chambers), and the makers of hand-colored engravings, less expensive chromolithographs, even cheaper wood engravings, and amateur replicas—the picture makers of the mid-century were united on a staircase of skill and cost that ascended to the same pinnacle.[30] Kinkade's success tells us something about the enduring landscape and seascape tropes of Western culture, invented in the baroque period, lovingly cultivated in Chambers' lifetime, and now internationally embedded and accessible to thousands of artists, from Claude Lorrain forward. However, for Kinkade this is a distant, revived tradition, banally reinterpreted in the clothing of an unrelated old-fashioned style—Impressionism, now the most popular language of painting in the world. Chambers' nostalgia for cottage life, attenuated by another century and a half, returns in Kinkade's work as a power-

fully reactionary expression of late-twentieth-century taste. His brilliant pastiche bears no relation to mainstream modernism or any of the many rivulets of style, medium, or content that have claimed the attention of the art establishment for the past forty years. It expresses populist antimodernism, escapism, and commercialism, but neither a distinctive personal style nor a wider period flavor in the way that Chambers idiosyncratically affirmed the romantic values of 1840 and the boldness of fancy taste. Since his death, the market that Chambers ventured into has been flooded with mediocre late Hudson River School paintings, cheap and formulaic "Buckeye" landscapes, Bob Ross paint-by-number views, and Thomas Kinkade rose-covered cottages, but we should not allow this subsequent torrent of derivative popular imagery to obscure the brave and quirky quality of his art. However, taking stock of the work that followed, we can read more clearly the decline of his tradition and likewise measure the gap between avant-garde and popularizing art that has grown wider since Chambers' day.

The challenge of Kinkade in the present allows us to stand back and graph the historical roller coaster that has taken Chambers through the classic shift described by Russell Lynes in *The Tastemakers*: from "lowbrow" or popular art, mocked or scorned by the intelligentsia in his own day, to be rediscovered and validated by "highbrow" enthusiasm a century later.[31] Moving from Lynes' social commentary to the broader sociology of Pierre Bourdieu, we might find the reversal of judgments seen in the elite between 1840 and 1940, or my own ability to draw distinctions between Chambers and Kinkade, as a remarkably vivid demonstration of the way that educated taste asserts class hierarchy in ever-evolving ways.[32] Chastened by these lessons in the mutability of taste, and admitting that all viewers—Chambers' customers, modernist collectors, Kinkade's clientele—might project their own, very different experiences and expectations on a given painting, we can nonetheless attempt to understand the viewpoints of others. Honoring the ideals of 1840 and 1940, and recognizing the blind spots in every era, we can lay the different visions of Thomas Chambers side by side, and consolidate the truth of both perspectives into a more three-dimensional image of this artist. Up close, the nineteenth-century perspective reminds us of the commercial pressures of the art market, the complex divisions of the art community, and the wider context of popular visual culture that Chambers knew. We can also understand with more complexity the relationship of his work to the academic painters of the era—Birch, Cole, Doughty—sharing their themes of history, literature, and national pride, their compositional models and techniques, and an inexpensive version of their frames. At the same time, we can also imagine the disdain of the critics of 1850, offended by his pirated sources and unnatural effect, so apparently unsophisticated, cheap, and fast.

The modern viewer, from a century later, forgives Chambers for his faults and recognizes his originality. In tune again with the decorative sensibility of the 1830s, the modernist sees the pleasure in the two-dimensional, nonrepresentational play in Chambers' paintings and does not miss the loss of symbolic content over time. Appreciated as a workingman, poor and probably poorly educated, he is gladly celebrated by the modernist as a creative individual, a master of design, with a personality as richly developed and self-determined as any American painter in this period. Looking at *Delaware Water Gap* (see fig. 4-15) in 1956, Howard Merritt found nothing about the painting to support the idea "that Chambers would have done differently if he had known better."[33] The modernist perspective might overstate Chambers' individuality and independence, however, losing sight of his close relationships to the art of his period and assuming that he was self-taught and naive, when most likely he was professionally trained (but not in an art school), had a manner full of artifices and conventions, and had learned from the traditions of fancy painting as well as from academic models.[34]

Today, as Willem de Kooning and Milton Avery begin to look, from a distance, like American old masters, we can try to bring Chambers and the era of his rediscovery into a single perspective. From this vantage, it is even harder to recover the opinions of Chambers and his customers, but we have learned to appreciate the entire spectrum of material culture from his period—from folk to academic to popular—imagine how his work might fit in boisterous mid-century parlors, where the voluptuous rhythms of his landscapes echo the bold curves of sofa and sugar bowl. We can also understand how those parlors might find analogous living rooms in the present, filled with nostalgic, picturesque, patriotic, and inspirational images for our own, unsettled day. Weighing the meaning of his style in the light of an enduring folk aesthetic, we can see Chambers gather contemporary academic practice, decorative painting tradition, and personal expressiveness into an artistic composite arrived at deliberately, and with panache. Surely he *did* know the work of Birch and Cole, just as he knew the marine painting of his brother George—and yet he chose to paint in another fashion, for another market. Allowing Chambers to simply be, as he described himself, an artist, we can enlarge the formalist and populist appreciation of his work with a richer sense of his nineteenth-century social and economic context, to understand the truly pioneering nature of his career as a marine and landscape painter to a new American audience.

NOTES

CHAPTER ONE

1. Robert G. McIntyre, president of Macbeth Gallery, posed this question in the gallery's brochure that accompanied the exhibition held November 24–December 12, 1942 (see New York 1942). On the circumstances of this exhibition and the critical response, see Chapter Five.

2. Little 1948. Little published an addendum to this text the following month, "Earliest Signed Picture by T. Chambers," *Antiques*, vol. 53 (April 1948), p. 285, with a reproduction of *Cutting Out of His B.M.S. "Hermione" from the Harbor at Porte Cavallo* (fig. 2-2), signed and dated 1835. A composite of these two articles appeared in Jean Lipman and Alice Winchester, eds., *Primitive Painters in America, 1750–1950* (New York: Dodd, Mead, 1950), pp. 106–12.

3. Little, "More about T. Chambers," *Antiques*, vol. 60 (November 1951), p. 469. These confusing "facts" were also published in George C. Groce and David H. Wallace, *The New-York Historical Society's Dictionary of Artists in America, 1564–1860* (New Haven: Yale University Press, 1957), pp. 117–18.

4. Merritt 1956.

5. Ibid., p. 214.

6. Ibid., pp. 214–15. The examination of the 1855 New York State census also cleared up confusion created by the 1850 federal census (see n. 3 above). Merritt concluded that the 1855 census had superior information, and that the discrepancies in these two census records regarding his age and occupation (no portraits by Chambers have ever been discovered) were due to a secondhand report to the census taker by a neighbor, a fairly common practice.

7. Howard S. Merritt, in *The Genesee Country*, by Henry W. Clune and Howard S. Merritt, exh. cat. (Rochester, N.Y.: Memorial Art Gallery, University of Rochester, 1975), p. 85, cat. no. 18.

8. Merritt 1956, p. 216. Little's genealogical research also noted the emigration of many persons with the surname Chambers from Yorkshire; Little 1948, p. 196.

9. Watkins 1837, p. 22. An expanded version of this memoir was published after George Chambers' death; see Watkins 1841. Extracts from these small books are generously reprinted in Russett 1996.

10. On George Chambers, Jr., see Russett 1996, pp. 193–97. The path of George Chambers, Jr., said to include South America, has not been well traced, in part because the name Chambers (Thomas, William, or George) is common in Yorkshire and in the United States. A George Chambers was briefly residing with Thomas Chambers in Albany in 1851.

11. John Chambers (born 1800) may be the "master mariner" who ran a lodging house listed in Whitby city directories from 1857 to 1867; William (born 1815) is mentioned as going to sea as a teenager, but his brother noted in 1838 that he had begun to make portraits of ships (Watkins, cited in Russett 1996, pp. 34, 159). Another artist named William B. Chambers, discussed in n. 29 below, was also working in New York in the 1830s.

12. The Whitby Parish Church baptism record, held at the Whitby Literary and Philosophical Society, notes Thomas Chambers' baptism on December 11, 1808. I am grateful to Anne Dennier, who assisted me with these sources in Whitby.

13. Copy kept at the Family History Center, Whitby. My thanks to Sylvia Hutchinson, who assisted my research in Whitby. Thanks, too, to Mrs. J. Price at the Pannett Art Gallery and Library, and Graham Pickles, curator of the Whitby Museum. Confusing the local record slightly is another artist, Thomas Chambers (London, 1829–York, 1910), a figure and genre painter who worked in Scarborough, south of Whitby, between about 1849 and 1860, later turning to the millinery business in York. In 1850 and 1851 this "T. Chambers" lived at the same address in London as George Chambers' son, George, Jr.; from this we might speculate that the younger Thomas was George, Jr.'s cousin, the son of John Chambers. Their uncle, William Chambers (see n. 11 above), also was working in Scarborough by 1861, which would make five painters in these two generations of the Chambers family. Anne Bayliss and Paul Bayliss, *Scarborough Artists of the Nineteenth Century: A Biographical Dictionary* (Scarborough: Anne Bayliss, 1997), p. 10. Jane Johnson, *Works Exhibited at the Royal Society of British Artists* (Woodbridge, U.K.: Antique Collectors' Club, 1975), p. 81. Charles Hemming, *British Painters of the Coast and the Sea: A History and Gazetteer* (London: Victor Gollancz, 1988).

14. Agnes Halsey Jones speculated that Chambers decorated canal boats or gypsy caravans, or took part in "any other of the myriad decorative trades of the less sophisticated English classes"; *Rediscovered Painters of Upstate New York, 1700–1875*, exh. cat., Cooperstown: New York State Historical Association (Utica, N.Y.: Munson-Williams-Proctor Institute, 1958), pp. 30–31. For an introduction to English folk art and a useful bibliography, see James Ayres, *Two Hundred Years of English Naive Art, 1700–1900*, exh. cat. (Alexandria, Va.: Art Services International, 1996).

15. For a Frank Meadow Sutcliffe photograph of a similar yard in Whitby, c. 1895, see Russett 1996, p. 19. The tenement yard where the Chambers family lived was altered in 1901, with the enlargement of the nearby Methodist chapel.

16. Watkins 1841, p. 17. George Chambers' youth in Whitby is traced in Russett 1996, pp. 17–30.

17. Watkins describes the ignorance or indifference of the Whitby community to George Chambers' talent, and the amazement of his father over the prices paid for oil paintings. Watkins 1837, p. 23; Russett 1996, pp. 37, 102.

18. Russett 1996, pp. 24–27. George Chambers also took a few lessons with a local drawing master, John Bird. Thomas Birch evidently used Pyne's figures as well; see John Wilmerding, *American Marine Painting*, 2nd ed. (New York: Harry N. Abrams, 1987), p. 74.

19. Watkins, cited in Russett 1996, pp. 31–32.

20. Although George arrived in about 1825, I have not found him listed until *Pigot and Company's National London and Provincial Commercial Directory for 1832-33-34* (London, 1832). Other, unlikely Thomas Chamberses appear before this year, but none among the segregated listings for artists (including historical, landscape, miniature, portrait, etc.). In the mid-1820s this section of the directories included four hundred to five hundred names, giving an idea of the size of the London artist community—five to ten times larger than that of New York, Boston, or Philadelphia in this period.

21. Watkins notes that George Chambers pulled strings with his ship-owning patrons to get both his father and his brother William seamen's berths. Given this family spirit, it is likely that he helped Thomas, if he could. The biographer Watkins, born in Whitby and the same age as Thomas, did not meet George Chambers until he returned to visit his hometown in 1833, by which time Thomas was already in the United States. The silence or ignorance concerning Thomas in the record of George's life suggests that his career as an artist unfolded in the United States, outside the purview of his more successful brother. That George fails to mention him in extant letters may indicate a distant relationship, disapproval (perhaps Thomas was the family's black sheep), or just the incomplete record of surviving documents. See Russett 1996, pp. 42–43.

22. Horner (sometimes spelled Hornor), an engineer and surveyor, was born in Hull, north of Whitby. See Richard D. Altick, *The Shows of London* (Cambridge, Mass.: Belknap Press of Harvard University Press, 1978), pp. 141–50; Ralph Hyde, *Regent's Park Colosseum, or, "Without hyperbole, the wonder of the world": Being an Account of a Forgotten Pleasure Dome and Its Creators* (London: Ackermann, 1982), p. 21 and passim; and Scott B. Wilcox, "Unlimiting the Bounds of Painting," in *Panoramania! The Art and Entertainment of the "All-embracing" View*, ed. Ralph Hyde, exh. cat. (London: Trefoil Publications with Barbican Art Gallery, 1988), pp. 13–59. The project suffered a high turnover of artists because Parris overpainted much of the work to gain unity of effect. Annoyed by the revision of their work, the artists quit, and Parris replaced them with housepainters, who "at least would know their place—and they were not afraid of heights." Hyde, *Regent's Park Colosseum*, p. 27.

23. On George Chambers' involvement with the Colosseum, see Russett 1996, pp. 44–51. I have found no archival material or published discussion naming other painters hired to assist Horner and Parris.

24. On the social, artistic, and economic world of theatrical scenic design, see Sybil Rosen-field, *Georgian Scene Painters and Scene Painting* (Cambridge: Cambridge University Press, 1981). Few examples of the scene painting and panoramas of this period survive, as they were typically overpainted, dismantled, or, in the case of traveling panoramas, battered into oblivion, and many were lost in fires or ruined in storage. Discussing George Chambers' career as a scenographic designer, Russett shows examples of period stage sets preserved as miniature-dollhouse versions, demonstrating the picturesque conventions and cartoonlike drawing and coloring echoed in Thomas Chambers' work. Russett 1996, pp. 58–66.

25. Merritt discovered this document; see Clune and Merritt, *Genesee Country*, p. 85, cat. no. 18. I found no record of an approximately twenty-four-year-old Thomas Chambers arriving in the United States from England at about this time, although the passenger lists of this period have never been completely archived or indexed. Sadly, the quarterly abstract of passenger lists for the period October 1831 to June 1832 in New Orleans is missing from the National Archives. Even if a search of individual ships' passenger lists were undertaken, it is possible that Chambers eluded the record by working on board to pay for his passage. His uncle owned coastwise ships, and his father and brother George worked for a major Whitby shipbuilder and owner, so connections were at hand. A glance at immigration statistics from 1832 shows that New Orleans, with 4,400 arrivals, received only 7 percent of the total in this year; almost half landed in New York. Of the 61,654 documented arrivals, only 17 described themselves as artists. William J. Bromwell, *A History of Immigration to the United States* (New York: Redfield, 1856), pp. 71–75. The original Declaration of Intention, documented by a receipt retained by the clerk in New York City in 1838, has also disappeared. I am grateful for the best efforts of Geraldine Williams, at the federal courthouse in New Orleans, John Fowler, at the Louisiana State Archives Research Library, Wayne Everard, at the New Orleans Public Library, and Barbara Rust, archivist at the National Archives Southwest Region, in Fort Worth, who searched helpfully but fruitlessly for this document, which would have confirmed the date and place of his arrival, the port he embarked from, and his birthplace, and perhaps noted any accompanying family.

26. Multiple renumberings of the street make it difficult to pinpoint the address today. My thanks to Sally Stassi, at the Historic New Orleans Collection, for her comments, and to William Keyse Rudolph, for his advice and assistance on research in New Orleans. Rudolph's study of the French painter Jean-Joseph Vaudechamp, working every winter in New Orleans from 1832 to 1836, gives the character of the city in this era; see his *Vaudechamp in New Orleans* (New Orleans: Historic New Orleans Collection, 2007). The only directories published in New Orleans in this period were in 1833 and 1837. Merritt 1956, pp. 213, 215, usefully notes that the annual city directories, typically compiled in the spring and published in midsummer, frequently carry a date on the title page or spine indicating the currency of their information through the following year.

27. In conversation with me, Howard Merritt recollected finding the newspaper account,

now lost, of Chambers' exhibition entry. Such activity suggests that he was working as an easel painter, rather than (or in addition to) the common house and sign painting that the term "painter" connoted in this period. Jarvis, quoted in William Dunlap, *History of the Rise and Progress of the Arts of Design in the United States*, vol. 2 (New York: G. P. Scott, 1834), p. 82.

28. *Longworth's American Almanac, New York Register and City Directory* (New York: 1834), p. 185. Listings in Longworth's city directories record a move to 330 Broadway in 1835 and then a return to 80 Anthony Street, although his newspaper advertisement, cited in n. 37 below, makes it clear that the Broadway address (actually 333) was just the front door of the same building.

29. Little 1948, p. 195, first notes the coincidental arrival in New York of one William Chambers, a portrait painter and "artist" who showed watercolor copies of old master paintings at the Apollo Association in 1838. Without knowing about William Chambers of Whitby (born in 1815, see n. 11 above), Little suggested that they were brothers, and this theory was recapitulated in subsequent American-artist biographical dictionaries. However, there may have been at least two artists with this common name. As noted in Groce and Wallace, *Dictionary of Artists in America*, p. 118, and later dictionaries, the New York "William B. Chambers" (living at 319 Hudson or 48 Greenwich Street) may be the portrait and genre artist active in Italy in the 1840s and in Philadelphia from 1848 to 1857. Merl M. Moore's files at the Smithsonian American Art Museum library note the arrival from Liverpool in 1833 of a William B. Chambers, artist, age fifty, and track his travels in Italy in the company of other New Yorkers from 1842 to 1846. A generation older than Thomas Chambers, he could have been related, although their simultaneous residence in New York from about 1833 to 1841 may be just a coincidence.

30. Little 1948, p. 195. The addresses in these listings would have been current in the year before the publication date of the directories, as Merritt has remarked; see n. 26 above. Merritt 1956, pp. 213, 215. There is also no record of Harriet's arrival in the usual indices of passenger arrivals to the United States. Merritt calculated her arrival in 1834 from her testimony in the 1855 New York State census, when her husband claimed to have been in the country twenty-three years and his wife twenty-one years. Harriet described herself as forty-six and English; so she must have been born about 1809, but I have not been able to trace her birthplace or marriage. The couple is not mentioned in indices and databases consulted in England or in New York City (where records are patchy before the official commencement of a government marriage registry in 1847).

31. The census does not give addresses, so I have deduced this address by tracking his neighbors in the census ledger who do appear in the city directories. Evidently, he lived next door to a large rooming house at 17 Catherine Street. His neighbors included cabinetmakers, a pawnbroker, and a printer. Chambers' household included two girls and a boy, all under the age of five. None of these children seems to appear again in later census tallies, and no records of children named Chambers, born or deceased in New

York in this period, correlate to any of Chambers' known addresses. A sense of the neighborhoods and the general poverty and tumult in working-class Manhattan in this period can be gained from Tyler Anbinder, *Five Points: The 19th-Century New York City Neighborhood that Invented Tap Dance, Stole Elections, and Became the World's Most Notorious Slum* (New York: Free Press, 2001). An excellent general introduction to New York in Chambers' day is also given by Dell Upton, "Inventing the Metropolis: Civilization and Urbanity in Antebellum New York," in *Art and the Empire City: New York, 1825–1861*, ed. Catherine Hoover Voorsanger and John K. Howat, exh. cat. (New York: Metropolitan Museum of Art; New Haven: Yale University Press, 2000), pp. 3–45.

32. Horner was reputedly living high, something of a celebrity with his banker friends in the late 1820s, but he was in dire straits and plagued by alcoholism by 1836. Like Chambers, he moved up the Hudson and was living in Sing Sing when he died in 1844, destitute. "The brain of the artist turned and he died insane," by the side of the road, according to a contemporary source. See Hyde, *Regent's Park Colosseum*, p. 37; Wilcox, in Hyde, *Panoramania*, p. 82. Following the pattern of George Chambers and Clarkson Stanfield, who rose to celebrity in panorama and scenery painting, Chambers may have sought employment in one of New York's many theaters. No mention of Chambers appears among the scenery painters enumerated in George C. D. Odell's fifteen-volume epic, *Annals of the New York Stage* (New York: Columbia University Press, 1927–49), but only the principal scenic designer was mentioned on the bill or in the newspaper reviews, while numerous unnamed "assistants" were employed for the more ambitious spectacles.

33. "Seventh Annual Fair of the American Institute, Held at Niblo's Garden," *Mechanics' Magazine, and Journal of the Mechanics' Institute*, vol. 4, no. 4 (October 25, 1834), p. 245 (APS Online). The complete list of the awards for this year indicates that all winners received a diploma, and one or two "premiums" of an undisclosed amount were given in several categories, such as portrait painting, woodcarving, and shell-flower work. John William Hill won the first premium; Chambers and "Miss E. Johnson" won second prizes. By 1836 the judges gave out either diplomas or silver medals. I am grateful to Merl M. Moore for pointing out a reference to Chambers' entry in this fair.

34. Little 1948, p. 195, published this watercolor with the title *Ships in a Choppy Sea*, when it was in the collection of Mr. and Mrs. Thomas A. Larremore. The signature on the back is reproduced above on page xi. It matches the only known signature by Chambers, on his naturalization papers, filed in New York in 1838 (see half-title page).

35. For an overview on the art exhibitions in New York in this period and these annual fairs, see Carrie Rebora Barratt, "Mapping the Venues," in *Art and the Empire City*, ed. Voorsanger and Howat, pp. 66, 72, and p. 249, fig. 200, which shows Niblo's Garden packed with the annual display of 1845. For a thoughtful analysis of the history and meaning of these fairs, a list of the judges, and an annotated catalogue of the exhibitors before 1876, see Ethan Robey, "The Utility of Art: Mechanics' Institute Fairs in New York

City, 1828–1876" (PhD diss., Columbia University, 2000); on Chambers, see p. 492. Chambers' options in New York are described in Kenneth John Myers, "The Public Display of Art in New York City, 1664–1914," in *Rave Reviews: American Art and Its Critics*, ed. David B. Dearinger, exh. cat. (New York: National Academy of Design, 2000), pp. 32–43.

36. Robey, "The Utility of Art," p. 534.

37. *New-Yorker* (March 28, 1835), p. 3. This four-page folio devoted to literature and news included a genteel mix of essays, poetry, reviews, humorous anecdotes, disaster reports, and political news, although the editorial policy claimed to be nonpartisan. The moderate and literary tone of the paper expressed the outlook of the famed publisher Horace Greeley, barely thirty-three when he launched this venture. Two years after beginning the *New-Yorker* in 1834, Greeley began to publish it in a quarto format, without the advertisements. Both editions were printed until the fall of 1841, when the folio format was discontinued. The advertisement included the date March 21, 1835, probably indicating when it was placed. It ran every week until May 20, 1837. No other artists advertised in this paper, although the names of several sign and ornamental painters and carver-gilders appear.

38. See Sumpter T. Priddy, *American Fancy: Exuberance in the Arts, 1790–1840*, exh. cat. (Milwaukee: Chipstone Foundation, 2004). Priddy traces the phenomenon from the late eighteenth century in England, noting a peak of fancy style in the United States in the 1820s and 1830s, and its eclipse after 1840, when the lighthearted premises of the style, once seen as stimulating to creativity, lost favor to the more sober realism of the camera and the higher intellectual and moral qualities of "imagination." Nonetheless, the idea of fancy painting remained popular through the Centennial, as shown by hundreds of fancy-related titles in the Smithsonian American Art Museum's Pre-1877 Art Exhibition Catalogue Index, http://siris-artexhibition.si.edu. Setting aside the one early entry by Robert Edge Pine at the Columbianum's first exhibition in 1795 and the large group of fancy subjects in the posthumous display of the work of Francis Guy in Brooklyn in 1820–21, the majority of these titles appeared between 1825 and 1865, with a peak of activity from 1838 to 1860, precisely during Chambers' career. Guy, although dead a dozen years before Chambers' arrival in the United States, perfectly modeled the repertory of cabinet and fancy subjects that Chambers would take up, with landscapes of America and Europe (Scotland, Ireland, England, and *The Bay of Naples—View of Mt. Vesuvius*), marines and views "in the style of [Claude-Joseph] Vernet" or "Vandervelt [van de Velde]," and "sea fights" from the War of 1812. See Stiles Tuttle Colwill, *Francis Guy, 1760–1820* (Baltimore: Maryland Historical Society, 1981), pp. 90–91. Thomas Cole, Thomas Sully, Rembrandt Peale, and Robert S. Duncanson—to name just a few—painted fancy pictures or fancy subjects in Chambers' era, as did legions of amateurs. The mechanics' fairs were filled with items listed just as "fancy painting" (see Robey, "The Utility of Art"). For many artists, it was part of making a living: In 1836 in Lancaster, Pa., Arthur Armstrong undertook "portrait, history, landscape, &c., but depended principally, as a means of living, on sign and fancy painting." Anne Hollingsworth Wharton and Emily Drayton Taylor, *Heirlooms in Miniatures* (Philadelphia: J. B. Lippincott, 1898), p. 215. The connection between landscape, marine, and fancy painting is discussed in Chapter Four.

39. Little is known about Davis, who seems to have been active along the border between New Hampshire and Maine from 1832 to 1837. See Carol Troyen's discussion of this painting and the sitters in an entry in *American Art from the Currier Gallery of Art*, exh. cat. (New York: American Federation of Arts, 1995), pp. 32–33, cat. no. 7.

40. See Lewis 1994, pp. 8–9.

41. *Full Particulars of the Two Late Awful Shipwrecks Near Sandy Hook; Narrative of the Wrecks of the Barque* MEXICO *and of the Ship* BRISTOL, *on both of which dreadful occasions* TWO HUNDRED SOULS PERISHED (New York: New York Sun, 1837), p. 15. Demand spurred several editions of this pamphlet; the third edition, sold as an adjunct to the diorama, noted the applause of the crowds in response to the "ingenuity" of the artist (p. 16); "The Wreck of the Bristol," *Hempstead* [New York] *Inquirer*, November 30, 1836, http://www.longislandgenealogy.com/Bristol.html (accessed March 2008); "Disastrous Shipwreck," *New-Yorker*, vol. 2, no. 10 (November 26, 1836), p. 157, on the same page of the folio edition with Chambers' advertisement cited in n. 37 above; "Melancholy Shipwreck," *Newport Mercury*, December 3, 1836, p. 2 (Proquest, Early American Newspapers, series 1); "Appalling Disaster.—Shipwreck and Loss of 109 Lives!" *New-Yorker*, vol. 2, no. 16 (January 7, 1837), p. 253 (APS Online); S. A. Howland, *Steamboat Disasters and Railroad Accidents in the United States, to which is appended accounts of recent shipwrecks* (Worcester, Mass.: Dorr, Howland, 1840), pp. 286–88.

42. Pringle's painting at the National Academy of Design's exhibition, *The Wreck of the Ship "Bristol,"* may be the *Shipwreck* sold at Sotheby Parke-Bernet, New York, *Fine Americana*, April 27–29, 1978, lot 91a, which shows a ship on offshore shoals, with passengers clinging to the bowsprit and a giant figure standing in the stern, perhaps the noble captain who was among the last rescued from the ship. A review of the National Academy's exhibition commented that Pringle's painting was "about as honest a delineation of any other convulsion as of the sad disaster it is designed to represent. The waves are in a furious tumult as we should judge from the malicious manner in which they bespatter each other with their own foaming crests." "Exhibition: National Academy of Design," *New-Yorker*, vol. 3, no. 9 (May 20, 1837), p. 143 (APS Online). Ludlow, whose career is known only from six exhibition entries at the National Academy between 1828 and 1838, showed marine views with shipping and two shipwreck subjects, including *Wreck of the "Bristol" on Rockaway Beach*. From a compliment on the successful rendering of "the tremendous power of the waves," we can deduce that it also showed the ship in distress. "Editor's Table," *Knickerbocker, or New York Monthly Magazine* (June 1837), p. 619 (also http://books.google.com).

43. *Rockaway Beach* was no. 64 in the Newport auction sale. See Appendix, and discussion of this sale below and in Chapter Three. No artist is named for this title, following the pattern of other paintings in the sale that seem to have been after print sources. Other than the two described above, I have found no contemporary images of the wreck of the *Bristol*, and only the one Nathaniel Currier lithograph of the *Mexico*, which is very rare. The painting was received from Morton C. Bradley, Jr., with the title *Wreck of the Ship "Bristol" on Rockaway Beach, New York, 1836*, as given by Harry Shaw Newman, who sold Bradley the painting before 1962, when it was exhibited with this title. Evidence that might have been on the original stretcher or frame has been lost in the lining and reframing of the canvas. The melancholy, retrospective moment depicted in the painting, and the error given in the date in the auction title, may hint that the painting was done some time after the wreck. Another version of this composition has been discovered, also undated. Chambers could have painted this subject several times, over many years, although it seems likely that its currency would have declined after he left the New York area. Compositionally, the work relates to Chambers' Nahant views (figs. 2-11 and 2-13).

44. A photograph of another Chambers shipwreck subject, shown to me by Ralph Katz, may be an earlier moment in this same disaster, depicting a ship breaking up offshore below a headland with a lighthouse. A smaller version of this subject, 14 by 18 inches, was sold at Cottone Auctions, Mount Morris, N.Y., March 18, 2006, lot 250a.

45. *New-York Evening Post*, April 22, 1837, p. 2. I am grateful to Merl M. Moore for sharing this item from his files at the library of the Smithsonian American Art Museum. The Arcade Baths, at 39 Chambers Street in New York, would have been familiar to the city's artists and collectors as the principal rooms of the National Academy of Design between 1827 and 1830. Voorsanger and Howat, *Art and the Empire City*, pp. 66, 72.

46. Florence Marryat [Church], *The Life and Letters of Captain Marryat*, vol. 2 (London: Richard Bentley and Son, 1872), p. 2.

47. "Who does not remember old Aaron Levy, who held night auctions on the second floor, between Cedar and Liberty. . . ? Levy was as great a humbug, with his 'old master paintings,' as Leeds is by some regarded in the present day; but he was a pretty honest old fellow, as auctioneers go." Walter Barrett [pseud.], *The Old Merchants of New York City* (New York: Carlton, 1864), p. 44 (also http://books.google.com).

48. "Passenger Lists of Vessels Arriving at New York, 1820–April 5, 1906," M261-15, National Archives and Records Administration. Our Chambers would have been twenty-nine, but most of the ages in the ship's manifest seem to be round-number estimates by the captain. He is noted to "belong" to the United States and to "intend to become an inhabitant" there. George Noble (age twenty-five) may be the same man who appeared in New York city directories a year later as a "carver & gilder" in a shop at 146 Chambers Street, five blocks above the artist's address on Vesey Street. The conjunction of names on the passenger list may be coincidental, although Chambers' involvement in picture restoration suggests that he knew Noble, and such friendships offer a clue to Chambers' access to contemporary prints, and the origin of the characteristic frames seen on Chambers' paintings of the 1840s (discussed in Chapter Three). The packet *Sheffield* sailed from Liverpool to New York from 1831; by 1837 she was owned by the Kermit Line, which sailed from Liverpool on the twenty-fourth of each month. Carl C. Cutler, *Queens of the Western Ocean: The Story of America's Mail and Passenger Sailing Lines* (Annapolis, Md.: U.S. Naval Institute, 1961), pp. 154, 378, 379.

49. George Chambers' travels in 1837 are recounted in Russett 1996, pp. 141–56. Harriet Chambers may have had relatives in England as well.

50. *Matchett's Baltimore Directory for 1842* (Baltimore: 1841), p. 110, http://www.aomol.net (accessed March 2008). I am grateful to Alexandra Kirtley for her assistance in tracking Chambers' Baltimore listings and locating his address on period maps.

51. The painting is inscribed in graphite on the lower stretcher bar: "Baltimore Schooner Chesapeake passing Bodkin light house in a Brisk Breeze, the United States Ship Delaware R[illegible] in the Distance." I am grateful to Tara Cederholm and Diana Gaston for assisting me in deciphering this inscription. A related painting, showing the Maryland statehouse from a closer vantage and entitled *Ships off the Coast of Maine*, about 18 by 24 inches, was sold at Christie's, New York, sale no. 9314, *Important American Furniture, Silver, Prints, Folk Art, and Decorative Arts*, January 21, 2000, lot 34.

52. This pair of marine views was numbered 54 and 55 (no artist given) on the Newport auction broadside of July 1845 (see Appendix). The ship was the third of its name, launched in 1820, and in ordinary between 1836 and 1841, when it was sent to Brazil under the command of Commodore Charles Morris. The title in the auction broadside suggests that Chambers was in Baltimore to sketch the ship after it was recommissioned in Norfolk in May 1841 and before its departure that November.

53. Merritt 1956, p. 221 n. 5.

54. City directories and exhibition records from the 1840s indicate that most of Boston's portrait, miniature, landscape, and marine painters, as well as its architects, photographers, engravers, and lithographers, lived within blocks of the principal exhibition centers, the Athenaeum (which began on Pearl Street and ended the decade on Beacon Street) and Harding's Gallery on School Street. By contrast, the carvers, furniture painters, ship painters, and house, sign, and fancy painters gathered along Commercial Street and the wharves. "Ornamental and Standard" painters and looking-glass and picture framers seem to have been scattered throughout the city. Chambers is never listed in the business section of the annual directories, which, like business-telephone directories today, organized names by profession, presumably for an extra fee. All painters were gathered under one category, making it hard to determine if ship painters include ship portrait artists. Although it is hard to tally how many self-styled "artists" like Chambers opted out of the business directory, I found no other easel painters listed in this section residing in his neighborhood.

55. In the federal census, Chambers was enumerated in Boston's Fifth Ward, Suffolk County, September 10, 1850. He is described as a portrait painter, age thirty-five, born in England; his wife, Harriet, also from England, also thirty-five. No children are listed (although a decade later in New York he has two, ages fourteen and twelve), and no property ownership is mentioned, although the family resides alone in a dwelling house. The errors in the Massachusetts census—including his age and Harriet's, the absence of the children, who must have been born about 1846 and 1848, and the misrepresentation of his profession—suggest an unreliable survey, perhaps, as Merritt suggested, completed with secondhand information from a neighbor. To complicate matters, no record of the children's birth in Boston or New York has been discovered. Although it is not impossible that Chambers painted portraits, none signed or attributed to him has appeared. Little, "More about T. Chambers," p. 469; Merritt 1956, p. 214.

56. For an overview of the Boston art community in this period, see Carol Troyen, "The Boston Tradition: Painters and Patrons in Boston, 1720–1920," in *The Boston Tradition: American Paintings from the Museum of Fine Arts, Boston*, exh. cat. (New York: American Federation of the Arts, 1980), pp. 15–22; see also Leah Lipton, "The Boston Art Association, 1841–1851," *American Art Journal*, vol. 15, no. 4 (Autumn 1983), pp. 45–57. Only the catalogues for the first three Boston Art Association exhibitions survive.

57. Northeast Auctions, Manchester, N.H., sale August 4, 2006, lot 1109, as *Kosciusko's Monument at West Point*. In correspondence with the consignor, Margaret C. Godwin, I learned that the painting was purchased by a picker who attended the house sale in 1979.

58. The date of 1847 was recorded by Little 1948, p. 196.

59. Merritt 1956, p. 215. See *Hoffman's and Munsell's Albany Directory and City Register* for the years 1851/52–57.

60. S. Wilson, ed., *Albany City Guide, 1844–45* (Albany: C. Wendell, 1844), p. 1; John J. McEneny, *Albany, Capital City on the Hudson: An Illustrated History* (Sun Valley, Calif.: American Historical Press, 1998), pp. 17, 100–114. On a single day in 1854, Albany witnessed the passage through town of two thousand westbound settlers; see Cuyler Reynolds, *Albany Chronicles: A History of the City Arranged Chronologically* (Albany: J. B. Lyon, 1906), p. 581.

61. On the art world in Albany, see Mrs. E. L. Tenney, "Art and Artists," in *Bi-Centennial History of Albany: History of the County of Albany, New York, from 1609 to 1886*, ed. George Rogers Howell and Jonathan Tenney (New York: Munsell, 1886), p. 737; Jones, *Rediscovered Painters*; and Christine M. Miles, "History of the AIHA Collections," in *Albany Institute of History and Art: 200 Years of Collecting*, ed. Tammis K. Groft and Mary Alice Mackay (New York: Hudson Hills with the Albany Institute of History and Art, 1998), pp. 22–23. Annual loan exhibitions at the Albany Gallery of Fine Arts ceased after 1850, but the standing collection of contemporary art remained on view.

62. On the Harts, see Gwendolyn Owens, in *Albany Institute of History and Art*, ed. Groft and Mackay, pp. 104–6. A sense of the spectrum of artists working in the area in this period can be learned from Jones, *Rediscovered Painters*.

63. Merritt 1956, p. 221 n. 11. The date of Chambers' painting is sometimes read as 1852. Historians will note that the original *Macedonian* was taken into Newport as a prize, rebuilt for the U.S. Navy, and then broken up after twenty years of service, at which time a new frigate was named for her. This second *Macedonian*, carrying a name that kept alive the story of triumph, was the ship rebuilt in the 1850s.

64. *Brooklyn Daily Eagle*, February 25, 1853, http://www.brooklynpubliclibrary.org/eagle (accessed March 2008).

65. Reynolds, *Albany Chronicles*, p. 618.

66. The folk art collector and dealer Peter Tillou told me he saw a newspaper account of such a sale in an Albany newspaper. Merritt searched extant Albany newspapers (of which there are few in the period 1851–57) and found no advertisements for Chambers' work. A painting inscribed "Tho Chambers/Newburgh" on the back suggests that Chambers also may have lived in that city at some point. Photographs of the front and back of this painting, *New York from Weehawken*, are in the files of the Frick Art Reference Library, New York; according to the library's photo mounts 17370 and 17372, the painting was found in Albany. The cursive inscription on the back is very faint and difficult to judge because it seems to have been reinforced.

67. "Art News from Albany," *Crayon* (December 12, 1855), pp. 376–77. On this sale and the attitudes of the critics of so-called Bartlett copies, see Chapter Four.

68. The cursive scrawl in graphite reads: "No. 9/ View [on] the Rhine/ Painted by [European?] Artists/ at No. 150 Spring St./ New York." This is the only inscription I have seen that includes an address. On this painting, see discussion of the Castles on the Rhine subjects in Chapter Three. An Irish-born tailor and his family lived on the second floor. Next door at 148 Spring Street, where Chambers was listed in 1858, the ground floor was occupied by a furniture store run by an English immigrant. The block included many German immigrants and artisans as well—including carvers, frame makers, printers, turners, several painters, and one very obscure artist, the French-born Charles Meyer. Based on a listing in the city directory, Merritt speculated that Chambers returned to Boston at this time, although an examination of the federal census for 1860 indicates that this was a different (Irish) Chambers. Merritt 1956, p. 214.

69. James Grant Wilson, ed., *The Memorial History of the City of New York, from Its First Settlement to the Year 1892*, vol. 4 (New York: 1892), pp. 438–40. *An Account of St. Luke's Hospital* [annual report] (New York: 1860), pp. 41–42.

70. Thomas Chambers' last listing in New York appears in the 1865–66 city directory; the following year, a Samuel Chambers, carpenter, appears for the first time, at 183 West Thirteenth Street. After another year, he also disappears. A Samuel Chambers (age not listed) enlisted in the New York First Artillery, Battery B, on September 4, 1864; he died of disease on January 15, 1865, at Morris Island, South Carolina. See Richard A. Witt,

New York Soldiers in the Civil War, vol. 1 (Bowie, Md.: Heritage Books, 1999), p. 117. The census records both children as born in New York, although there is no registration of their birth in the city's vital statistics, which were kept more uniformly beginning in 1847. By calculation, they should have been born about 1846 and 1848, when Chambers is listed in the Boston city directories, but I have found no record of their births in Boston either.

71. Merritt 1956, p. 222, mentions this painting as owned by the Old Print Shop.

72. Perhaps his nephew was the master mariner William Chambers (1840–1894), the son of the master mariner John, very likely the artist's brother (1800–c.1867?), who ran a lodging house in Whitby between 1857 and 1867. The painters Thomas Chambers and William Chambers, also perhaps related, were active nearby in Scarborough in the 1850s.

73. Chambers' registration at the workhouse is confirmed only by the cemetery's notation of his residence there. The records of the workhouse seem to have gone missing for this period. Watkins, who knew George Chambers and his Whitby context, commented on the family's earnest, hardworking efforts to keep off the parish charity rolls and avoid any "eleemosynary arts for subsistence" (Watkins 1837, p. 4), which suggests that Thomas Chambers would have resisted entering the workhouse until truly destitute. He was not the only marine painter in such straits: Thomas Dove, another housepainter's apprentice in Whitby in the 1820s and briefly a student of George Chambers, worked in Liverpool as a ship portrait and marine painter before returning to Whitby, to die in the workhouse in 1886. Russett 1996, p. 99.

74. Bulmers, *History and Directory of North Yorkshire* (1890), cited at http://www.genuki. org (accessed March 2008). The Whitby workhouse closed in 1930, to be reopened as St. Hilda's Hospital in 1942. See Peter Higginbotham, *Workhouses of the North* (U.K.: NPI Media Group, 2006), or Higginbotham's useful website, http://www.workhouses. org.uk (accessed March 2008).

75. "Whitby Urban District Council Registry of Burials," Whitby Archives and Heritage Center; my thanks to Sylvia Hutchinson for her assistance with my research at the center. According to Hutchinson, the records of the workhouse have been lost. Chambers was buried in grave no. 4975; I was not able to visit the Larpool Cemetery, a modern, nondenominational municipal burying ground different from the parish cemetery of St. Mary's Church, where his mother and siblings were buried before his departure for the United States. These parish registers are kept at the Whitby Literary and Philosophical Society, at the Whitby Museum. My thanks to Anne Deniers for her assistance with these records. The registration of death is held by the General Register Office, London.

76. The diagnosis "softening of the brain" reflects the murky and sometimes euphemistic guesswork of the era; perhaps he suffered a stroke, which could result in paralysis and the actual softening of the brain tissue. It is possible that his liver and central nervous system failed after a lifetime of heavy drinking, bringing on dementia and coma. Less likely, because less common and not yet associated with "softening of the brain" in this period, would be tertiary syphilis. Also new to the lexicon in this period would have been pre-senile dementia, some forms of which are currently identified as Alzheimer's. I am grateful for assistance in interpreting these terms from the distinguished pathologist Dr. Anthony Pizzo.

77. John Neal, "Fine Arts," *First Exhibition and Fair of the Maine Charitable Mechanics Association* (Portland, Maine: 1838), p. 39, quoted in Jessica Nicoll, "Charles Codman: From Limner to Landscape Painter," *Antiques*, vol. 162 (November 2002), p. 130.

CHAPTER TWO

1. Merritt 1956, p. 221, identified a few signed and dated paintings: *Ships in a Choppy Sea* (fig. 1-5); *Cutting Out of His B.M.S. "Hermione"* of 1835 (fig. 2-2); *The "Constitution" in New York Harbor* (fig. 2-7), signed "T. Chambers" and said to be dated 1847 in Little 1948, p. 196; *The "Constitution" and the "Guerrière"* (fig. 1-1), signed lower left "T. Chambers"; and *Capture of H.B.M. Frigate "Macedonian"* (fig. 1-13), signed and dated lower left "T. Chambers 1853[or 2]." An inscription on the stretcher of a New York harbor subject, noted as "by T. Chambers," may also be authentic; see n. 27 below. Others can be dated by subject, such as the Civil War battles, for example, *The U.S.S. "Cumberland" Rammed by the C.S.S. "Virginia," March 8, 1862* (fig. 2-21). Only a few other signed works have emerged since, including *View of Nahant [Sunset]* (fig. 2-13), signed lower left "T. Chambers"; *The "United States" Bringing in the "Macedonian"* (private collection, New York), signed within a ribbon bottom right "T. Chambers"; and *The Capture of the "Guerrière" by the "Constitution"* (fig. 2-14), signed lower right (not seen).

2. Little 1948, p. 195, inspecting Chambers' sea battles, opined that his knowledge was "practical as well as artistic." Merritt 1956, p. 213, citing a text in *Panorama* from 1948, noted that the evidence of Chambers' early watercolor *Ships in a Choppy Sea* (fig. 1-5) indicated "precise nautical knowledge not displayed by the usual primitive."

3. *Cutting Out of His B.M.S. "Hermione"* was reproduced, along with a view of the inscription on the back, in Nina Fletcher Little, "Earliest Signed Picture by T. Chambers," *Antiques*, vol. 53 (April 1948), p. 285, as in the collection of L. A. Hocking, size unknown.

4. Sir Hyde Parker, in the *Naval Chronicle*, vol. 3 (January–July 1800), p. 310.

5. On his "fancy painting," see Chapter One. George Chambers painted similar retrospective naval subjects for his patron Vice Admiral Mark Kerr; see Russett 1996, pp. 67–69. The aquatint by Sutherland after Whitcombe is 8½ by 11 inches; published by L. Harrison, and included in James Jenkins, *The Naval Achievements of Great Britain, from the Year 1793 to 1817* (London: James Jenkins, 1817). Little correctly guessed that Chambers based his painting on a print, but identified the source as a different composition, after R. Dodd, published in the *Naval Chronicle* in 1801. The facts in Chambers' inscription

are slightly awry: the *Hermione*, overcome by mutiny, had been surrendered to the Spanish and taken into Puerto Cabello, Venezuela. Fifty men led by Captain Edward Hamilton of H.M.S. *Surprise* recaptured the ship from 365 Spaniards; 12 of his men were wounded, but 119 Spaniards were killed, 97 wounded, and 134 taken prisoner. Lit by firing from a fort at the left, the *Hermione* is towed out of the harbor by two long boats, while the *Surprise* stands off at the distant right, under a shrouded moon. Chambers' composition, being considerably larger than the print, has added detail throughout, the position of the moon is higher in the sky, and there is a shining path of reflected moonlight, most unwelcome to sailors undertaking this kind of stealthy action.

6. Russett 1996, p. 37.

7. *New-York Evening Post*, April 22, 1837, p. 3, col. 5. This sale is covered more completely in Chapter One, with discussion of the work of Frederick Marryat.

8. "Literary Notices," *Knickerbocker, or New York Monthly Magazine*, vol. 7, no. 4 (April 1836), p. 426. Marryat was also internationally famous as the designer of a system of signal flags, the Marryat Code, which remained the visual language of shipping through the 1850s.

9. *Waldie's Literary Omnibus*, vol. 1, no. 23 (June 9, 1837), p. 8. When the American poet N. P. Willis disparaged Marryat's work as "vulgar" in 1836, the resulting exchange of letters, insults, and challenges to duel were eagerly reprinted in the American press. See the *Knickerbocker* (April 1836), cited in n. 8 above.

10. The original edition was *The Pirate, and The Three Cutters* (London: Longman, Rees, 1836), with twenty engravings after the work of Clarkson Stanfield. Pirated American editions appeared almost immediately in New York and Philadelphia, but without the plates. On Stanfield's panorama in New York, see Catherine Hoover Voorsanger and John K. Howat, eds., *Art and the Empire City: New York, 1825–1861*, exh. cat. (New York: Metropolitan Museum of Art; New Haven: Yale University Press, 2000), p. 76.

11. See Pieter van der Merwe et al., *The Spectacular Career of Clarkson Stanfield, 1793–1867: Seaman, Scene-Painter, Royal Academician*, exh. cat. (Newcastle, U.K.: Tyne and Wear County Council Museums, 1979).

12. W. H., "Marryat's Sea Stories," *Eclectic Magazine of Foreign Literature, Science and Art* (May 1856), p. 60, orig. pub. in *Dublin University Magazine* (see http://books.google.com). "Editor's Table," *Lady's Book*, vol. 12 (March 1836), p. 141.

13. See W. H., "Marryat's Sea Stories," p. 60. Marryat's audience was generally characterized as less sophisticated than Cooper's, and many of his later works were written specifically for children.

14. Many of Cooper's books were illustrated by Felix Octavius Carr Darley, after the author's death in 1851. Thomas Sully exhibited *The Wreck of the "Ariel"* from *The Pilot* at the Pennsylvania Academy of the Fine Arts in Philadelphia in 1824, and James Hamilton showed a subject from *The Pilot* in 1858; see Anna Wells Rutledge and Peter Falk, *The Annual Exhibition Record of the Pennsylvania Academy of the Fine Arts*, vol. 1 (Madison,

Conn.: Sound View Press, 1988), pp. 221, 90. A "Mr. Williams" exhibited "illustrations" of *The Red Rover* at a gallery in Philadelphia in 1828; see *The Ariel: A Semi-Monthly Literary and Miscellaneous Gazette* (December 27, 1828). The Smithsonian American Art Museum's Pre-1877 Art Exhibition Catalogue Index records *A Scene from the "Red Rover"* shown in the Second Exhibition of Philadelphia Artists in 1839; see http://siris-artexhibition.si.edu.

15. Present location unknown. Both paintings are approximately 18 by 24 inches; see Christie's, New York, sale no. 6350, *Important American Furniture, Silver, Prints, Folk Art and Decorative Arts*, January 17–18, 1992, lots 285–86. The stormy moonlight composition, in a characteristic decorated Chambers frame, was also seen as *A Shipwreck Scene: The "Red Rover" in Storm-Tossed Seas* in Sotheby's, New York, sale no. 5551, *Important Americana*, January 28–31, 1987, lot 1068.

16. The scene depicted would be from Chapter 14 of *The Red Rover*, when both the *Royal Caroline* and her pursuer are overtaken by a squall. The Bristol trader loses her mizzen and mainmast in rapid succession, and is left with a single foremast topsail that bellies out and soon breaks loose, as suggested in both paintings. Chotner 1992, p. 58, has noted that *Storm-Tossed Frigate* probably depicts a merchant vessel painted, for protective disguise, in the manner of a naval frigate, a habit that became general practice for packet ships in the late 1830s. See also Frank C. Bowen, *A Century of Atlantic Travel, 1830–1930* (New York: Little, Brown, 1930), p. 23.

17. S. G. Goodrich, ed., *The Token and Atlantic Souvenir: A Christmas and New Year's Present* (Boston: Charles Bowen, 1833), p. 195; inscribed "After Vandevelde, by John B. Neagle." Chotner proposed that *Storm-Tossed Frigate* was based on a print source, noting a similar painting at the Fall River Historical Society in Massachusetts by an unknown artist, identified as Chambers by Jane Collins in "Thomas Chambers: A Romantic Primitive" (unpublished manuscript, 1975), National Gallery of Art, Library, Washington, D.C., cited in Chotner 1992, p. 58. I have not seen this painting, but the image appealed to other artists, as demonstrated by the photograph of a marble-dust drawing based on the same print (private collection), shown to me by Stacy Hollander at the American Folk Art Museum. The faithful and cautious translation of the image in this drawing underscores, by contrast, the willfulness of Chambers' use of such sources. Another version of this same composition, with a tangerine and yellow sky, *Ship in Stormy Seas (The "Red Rover")*, 20 by 30 inches (previously with Godel and Co., New York), is in some ways closer to the print source, although the sky has been totally re-envisioned in a much flatter and more decorative manner.

18. A pair of such fancy paintings of doll-like ships in stormy seas, both 14 by 18 inches and called *Ship in a Storm*, one seen from the stern and one from the bow, are now owned by Susanne and Ralph Katz and by Betty and Harry Waldman. In addition to his paintings of the *Bristol*, Chambers also seems to have produced more generic shipwreck paintings, following the practice of many sea painters such as Claude-Joseph Vernet

and, in the United States, Thomas Birch and Robert Salmon. Birch and Salmon also painted literary marines based on William Falconer's well-known poem "The Shipwreck." In this vein may be Chambers' subject, sometimes called *The Tempest*, known in two versions (now unlocated), both about 22 by 30 inches and showing figures in the foreground and a wreck on the rocks in the distance below a headland.

19. Melvin Maddocks, *The Atlantic Crossing* (Alexandria, Va.: Time-Life Books, 1981), pp. 89, 86.

20. Carl C. Cutler, *Queens of the Western Ocean: The Story of America's Mail and Passenger Sailing Lines* (Annapolis, Md.: U.S. Naval Institute, 1961), p. 378.

21. See Frank H. Goodyear, *American Paintings in the Rhode Island Historical Society* (Providence: Rhode Island Historical Society, 1974), pp. 65–66, cat. 85. The text does not name the port and misidentifies the ship as an eighteenth-century vessel of the same size and name owned by a Rhode Island firm. Another example of an explicitly identified packet is *"Black Hawk" Packet off Sandy Hook, New Jersey* (with Wayne Pratt, South Woodbury, Conn., in 2003), a painting 18 by 24 inches that may represent the type listed in the sale as no. 17, an outbound packet off the twin lights of Sandy Hook.

22. The ship in *The "Constitution" in New York Harbor* (fig. 2-7) is in all respects the same packet ship seen in the other versions, and not the older, multi-gun-decked warship seen in Chambers' views of the *Constitution* in battle, such as *The "Constitution" and the "Guerriére"* (fig. 1-1) and *The Capture of the "Guerrière" by the "Constitution"* (fig. 2-14), discussed below. Annotations on the photo mount at the Frick Art Reference Library indicate that the painting was found in New England and owned by the Harry Stone Gallery in New York in 1945. The date below the signature cannot be read clearly; it was in Merritt 1956, pp. 221, 222, as 1847. The title at the lower center, "Constitution," in a backhand decorative lettering similar to the inscription on the back of *Cutting Out of His B.M.S. "Hermione"* (fig. 2-2), seems to be in a cartouche painted on top of the paint surface, perhaps added later by another owner, or by Chambers himself, happy to retitle the subject for an uncritical patron.

23. On this view and the buildings and vessel types in the New York harbor subjects in the National Gallery, see Chotner 1992, pp. 44–47. In addition to the three reproduced here, I have seen photographs of *View of New York Bay, Governor's, Bedloe's, and Staten Islands*, and *The Packet "George Washington"* (Duveen papers, Archives of American Art, Smithsonian Institution, Washington, D.C.); *New York Harbor* (with Marguerite Riordan, Old Lyme, Conn., in 1995); and *Square Rigger Entering Port* (with Vose Galleries, Boston, 1962). All the paintings in this string are about 22 by 30 inches, except for the smaller *Threatening Sky* (fig. 1-10). Recently, a painting attributed to Chambers, *The "Constitution" in New York Harbor with Castle Garden in the Background*, was sold at Sotheby's, New York, sale N08400, *Important Americana*, January 19, 2008, lot 179. On an unusual panel and of an unusual size (15 by 23½ inches), this painting may actually depict the *Constitution*, alongside Castle Williams.

24. Three of these paintings show a blue and white swallowtail pennant on the mainmast. This may be the house flag of a particular packet line, although different pennants appear in this position in the other versions. The flags and pennants occasionally suggest maritime code systems, such as the Marryat Code in use in this period, but many seem to be simply plausible, invented designs. As the view of the *George Washington* in the Rhode Island Historical Society demonstrates (fig. 2-6, see n. 21 above), Chambers could be specific if the occasion required it.

25. Chotner 1992, p. 43. The other versions of this composition I have seen are both titled *View of New York Harbor with Castle Williams*, one 22 by 30 inches and the other 14 by 18 inches, both in the collection of Susanne and Ralph Katz.

26. Richard Anthony Lewis (see Lewis 1994, pp. 495–519) compares the many versions of Birch's harbor views, and connects them to the artist's sketchbook studies.

27. An old inscription on the original stretcher of this painting confirms it as one of Chambers' own designs: "New York Bay, Governor's and Statin [*sic*] Island, with Pilot Boat 'George Washington' dropping down, by T. Chambers." This inscription, recorded in the National Gallery's files, is mentioned in Chotner 1992, p. 57, but not transcribed.

28. The Brooklyn Museum's painting is reproduced in John Wilmerding, *American Marine Painting*, 2nd ed. (New York: Harry N. Abrams, 1987), p. 30. The Castle Garden subject was not attributed to any artist in the Newport auction list, which may hint that it was based on a print source. Examples of the Castle Garden subject include a version (17 by 24 inches) once in the collection of Nina Fletcher Little, which is illustrated in *Little by Little: Six Decades of Collecting American Decorative Arts* (New York: Dutton, 1984), p. 61, fig. 75; two with Godel and Co. (14 by 18 inches; 21½ by 29 inches); as well as two smaller sizes seen in recent auction catalogues, including an oil on panel, 14 by 19 inches in a characteristic Chambers frame, at Northeast Auctions, Manchester, N.H., *Summer Americana Auction*, August 3–7, 2007, lot 1066. The painting paired with this subject in the Newport auction, no. 47, would have been the same size, perhaps like the smaller New York harbor subject in the Katz collection, see n. 25 above.

29. On the National Gallery's painting (fig. 2-8), see Chotner 1992, p. 49. An earlier photograph of the painting, when it was owned by the Harry Stone Gallery, New York, gives the title as *The "Britannia" Entering Boston Harbor*, identifying the steamer as the other of the two Cunard mail ships. Other versions are *American Man of War in Boston Harbor*, about 21 by 30 inches, previously in the Dietrich American Foundation, Chester Springs, Pa., now unlocated; *Boston Harbor*, showing a single-masted vessel at center, 22 by 30 inches, private collection, Boston; and *Boston Harbor*, 20 by 30 inches, previously with Dana Tillou Fine Arts, Buffalo.

30. Robertson's print is illustrated in I. N. Phelps Stokes, *New York Past and Present* (New York: Plantin Press, 1939), p. 20, cited in Chotner 1992, p. 49.

31. The version of *Boston Harbor* previously in the Dietrich American Foundation has been titled *The "Hamilton" in Boston Harbor*, identifying the central vessel as a revenue

service craft. I have not been able to locate this painting to examine the back for the source of this title. See Stuart P. Feld, *Plain and Fancy: A Survey of American Folk Art,* sales cat. (New York: Hirsch and Adler Galleries, 1970), p. 12. The version in the private collection has also been given this title in the past, perhaps by association with the Dietrich painting, although it shows a different vessel, with only one mast. The revenue cutter *Hamilton* was a four-gun topsail schooner launched in New York in 1830, but active in Boston harbor until 1851. Another celebrity vessel like the warship and the steamer in this series of paintings, she was the fastest in her class, famous for daring rescues and so popular that "music was written entitled the 'Hamilton Quick Step.'" See "Hamilton, 1830" at the U.S. Coast Guard website, http://www.uscg.mil/History/webcutters/Hamilton_1830.html (accessed March 2008).

32. On the *Ohio,* see Karl Jack Bauer and Stephen S. Roberts, *Register of Ships of the U.S. Navy, 1775–1990: Major Combatants* (New York: Greenwood Press, 1991), p. 4.

33. Henry Fry, *The History of North Atlantic Steam Navigation, with Some Accounts of Early Ships and Shipowners* (London: S. Low, Marston, 1896), pp. 64–65. More detailed information on these ships can be found at http://www.maritimequest.com (accessed March 2008). I have not been able to locate reliable period images of the *Hibernia* or the *Cambria* and can only assume that these ships, while slightly improved on the first generation of Cunard steamers, basically resembled the more frequently depicted *Britannia,* also designed by Robert Napier. The generic quality of Chambers' treatment makes me think that they were all interchangeably introduced into his paintings.

34. George Chambers handled this kind of dicey meeting at sea in rough weather in *The "Cormorant" Speaking an American Ship Bound for Hamburg,* c. 1830; see Russett 1996, p. 69, pl. 10.

35. Many Chambers paintings have been unevenly cleaned. The frequently tenacious darkened varnishes in the skies have been energetically removed, while the shadows have been less cleaned. In some cases overcleaning has left some of the skies more cottony than Chambers intended and has abraded or erased the fragile paint of the rigging. See "Conservation Notes on the Thomas Chambers Paintings from the Collection of Morton C. Bradley, Jr.," by Margaret K. Contompasis, pp. 151–56.

36. In *Ships Meeting at Sea,* the second flag on the foremast of the unidentified sailing packet is green with a red initial that appears to be a *D* or *P* or perhaps an Irish harp; the bust figurehead seems to be a man carrying a book or gesturing. In the 1830s, the E. K. Collins (or "Dramatic") Line included a set of packets named after dramatists and actors, although the only house flag for this line that I have seen is a blue and white swallowtail pennant, divided horizontally, used in the 1850s. See "Flags of the World," http://www.flagspot.net (accessed March 2008). It can be noted that no. 19 in the Newport sale was "Cork Harbor, (Ireland,) New York packet ship Shakspeare, hove to for a pilot, one of the finest pictures in the sale, Original by Mr. Chambers." No painting of this description has been identified today. The *Shakespeare* sailed the New York–Liverpool run for the Dramatic Line only from 1837 to 1838 before being sold to a New Orleans–New York line, which suggests that the composition was developed by Chambers by 1838, and repeated. Cutler, *Queens of the Western Ocean,* pp. 380, 269.

37. Ibid., pp. 236–37. The sale date of the ship is sometimes given as 1841.

38. Bowen, *A Century of Atlantic Travel,* pp. 34–37. After the *President* was lost in the North Atlantic without a trace in March 1841, Chambers painted her from a Currier and Ives lithograph that imagined the ship's last struggles, somewhat in the format of the storm-tossed ships seen in *Ship in a Storm* (fig. 2-1) and *Storm-Tossed Frigate* (fig. 2-3). The painting is in the collection of Sharon and Bill Palmer, who kindly shared images of it and of the print.

39. For the history and iconography of the *Great Western,* see Denis Griffiths and Patrick Stephens, *Brunel's "Great Western"* (Wellingborough, U.K.: P. Stephens, 1985); "London in 1838," *Family Magazine, or Monthly Abstract of General Knowledge,* vol. 8 (May 1, 1840), p. 7 (APS Online).

40. No. 11, the view of New York Bay (such as fig. 2-5) that was described, was also said to be the companion to no. 17, the view of the packet ship *George Washington* off Sandy Hook, making a three-part set of New York harbor views.

41. All Chambers' steamship paintings are about the same size, 20 or 21 inches by 29 or 30 inches. The Peabody Essex version of the *Great Western* (fig. 2-10) is unlike the other three examples in being an inch smaller in both dimensions, showing the wind coming from the right rather than the left, lacking the British flag, and giving the ship's initials on the pennant. Other examples include *Sidewheel Steamer* (unlocated; described as "about to take on her pilot off Sandy Hook"), 21 by 30 inches, reproduced in *Panorama: Harry Shaw Newman Gallery,* vol. 5, no. 1 (August–September 1949), p. 1; *The English Steamship "Great Western,"* 21¼ by 30 inches, former collection of Mr. and Mrs. Thomas Larremore (unlocated), photograph in the Duveen papers, Archives of American Art, annotated with the phrase "passing the twin lighthouses of Sandy Hook, N.J."; *British Steamer,* also known as *"Great Western" Approaching Gloucester, Mass.,* 21 by 30 inches (unlocated; art market, 1995 and 1990, see http://www.askart.com [accessed March 2008]). All these images show the ship with an American ensign on the foremast; the latter three show a British ensign at the stern. Although some of the reproductions are poor, it appears that the rigging has been abraded to some degree on all except the Newman Gallery version. A fifth version in a private collection shows the ship at sea in a gale, sailing from right to left.

42. The connection of this plainer, more decorative style to later work might be demonstrated in the last of Chambers' known steamship subjects, the *Ben Franklin,* which he depicts as a sidewheeler like the *Great Western* with three (rather than four) masts, rigged as a bark. The *Franklin,* built in 1850 and put into service the following year between New York and Le Havre, was wrecked in New York harbor in July 1854. Because the painting probably dates from the years that the ship was in service, it offers a late

benchmark for Chambers' interest in this subject after his move to Albany in 1851. Presently unlocated, the painting was reproduced in Sotheby Parke-Bernet, New York, sale no. 3134, *Eighteenth-Century American and English Furniture, the Property of Channing Hare*, December 11–12, 1970, lot 88, as 21½ by 30½ inches. Chambers certainly never studied the *Franklin* in person, for he shows the ship outfitted with cannons that she never carried, but the subject suggests that he continued to travel and sell his work in New York—or to New Yorkers—in the early 1850s. The painting shows an unidentified fort at the far left. See Bradley Sheard, *Lost Voyages: Two Centuries of Shipwrecks in the Approaches to New York* (New York: Aqua Quest Publications, 1998), pp. 81–82 (also http://books.google.com).

43. Watkins 1841, p. 25. As his biographer Watkins noted, ship portraits for George Chambers were "scarcely regarded as pictures"; Russett 1996, p. 16. Lewis 1994, pp. 293–98, also uses the term "portrait marine" to describe Thomas Birch's more complex marines.

44. See Bowen, *A Century of Atlantic Travel*, pp. 30–33, 37–40; Cutler, *Queens of the Western Ocean*, p. 236. Dickens found the steamships crowded and uncomfortable; he took a sailing packet home.

45. Others include an untitled seascape at the Harry Shaw Newman Gallery in 1953 (photograph, Frick Art Reference Library, New York), with a sloop at anchor; *A View of Nahant*, in a private collection, Boston, with boys carrying fishing poles clambering on rocks at left; and *View of Nahant*, with three figures on the beach at right, which was sold at Sotheby's, New York (sale no. 5551, *Important Americana*, January 28–31, 1987, lot 1066) but is currently unlocated. All these seem to be about 21–22 by 29–30 inches, and the last three resemble *Shipping off a Coast [Nahant, from Lynn Beach]* (fig. 2-11) in their sunny blue and gold tonality.

46. I am grateful to Daniel A. deStefano, librarian of the Nahant Public Library, for his help analyzing the view in Chambers' painting of Nahant (fig. 2-11), which seems to be more or less from Lynn Beach, looking south, although Egg Rock is too close to shore in all these views and the shipping frequently seems to be oblivious of the shore. Like the *Wreck of the "Bristol,"* this composition has no parallels in extant print sources. Variations on this composition, with its generic dark foreground forms and the sweeping curve into space, are repeated in the beach views of many painters of this period, such as Fitz Henry Lane, Thomas Birch, and particularly Thomas Doughty, who painted a chain of at least six related Nahant beach scenes, including *Coming Squall* (fig. 2-12) and two smaller variants from 1834 and 1835 in the Museum of Fine Arts, Boston. Of course the same topography, added to the legacy of picturesque convention, might inspire the reinvention of a very familiar solution. A related series, probably done while Chambers was in Boston, would include *Rocks at Nahant, near Boston*, 18 by 24 inches (American Museum in Britain, Bath), and *American Shore Scene*, 22 by 30 inches, in an ornamented Chambers-style frame (collection of Dr. Howard P. Diamond).

47. Lewis 1994, p. 21, describes "The Constitution and the Guerrière" as "probably the most copied American image prior to the Civil War." The most famous of the printed images produced in this period are listed in two collection catalogues by Irving Olds, *The Irving S. Olds Collection of American Naval Prints and Paintings* (Salem, Mass.: Peabody Museum, 1959), and *Bits and Pieces of American History* (New York: [Author], 1951); and in Edgar Newbold Smith, *American Naval Broadsides: A Collection of Early Naval Prints (1745–1815)* (Philadelphia: Philadelphia Maritime Museum, 1974).

48. The Haningtons' panoramas in the "Marble Buildings" on Broadway between 1835 and 1837 also included the "Wreck of the Bristol," discussed in Chapter One, and in Voorsanger and Howat, *Art in the Empire City*, pp. 71, 76, spelled "Harrington." The program, when it traveled to Philadephia, advertised "The Constitution and the Guerrière." *Atkinson's Saturday Evening Post*, December 3, 1836, p. 3.

49. In her early years the *Constitution* carried a figure of Hercules, which was exchanged for a simpler scroll during the War of 1812. After the ship was refitted in the 1830s, this scroll was changed for a figurehead of Andrew Jackson, a controversial substitution that was vandalized almost immediately.

50. Other artists depicting subjects from the War of 1812 included Michel Cornè, John James Barralet, Hugh Reinagle, George Thresher, and Thomas Sully. Numerous printmakers reproduced or adapted these images; see the compilations cited in n. 47 above. According to Lewis 1994, pp. 146–215, Birch painted the *Constitution* at least fifteen times, including variant views and his own later replicas. The tally of replicas is difficult to analyze because of numerous oil copies by other artists (including Chinese painters) now attributed to Birch, and the complicating factor (also seen in Chambers' replicas) of a range of styles evident in Birch's own work.

51. James Fenimore Cooper's *History of the Navy of the United States of America*, 2 vols. (Philadelphia: 1839), was published in an abridged one-volume edition in Philadelphia in 1841. It had no illustrations until the edition of 1846, which included a wood engraving of the explosion of the *Guerrière*. Citations given here are from the reproduction of the 1841 edition (Delmar, N.Y.: Scholar's Facsimiles and Reprints, 1988), where Cooper's account of the battle appears on pp. 256–61. His book was posed as an attempt to right the error-ridden and partisan record of the war as written by English historians, principally William James. While James disparaged the American victories by pointing out the imbalance of forces (for example, the *Constitution*'s greater size, larger crew, and stronger firepower in comparison to the *Guerrière*), Cooper (p. 200) argued for the credit due to American gunnery and seamanship, and "cool and capable" leadership, against a navy fifty times larger. Chambers, like Birch, takes the American line, presenting the opposed vessels as visually equal, either by masking the larger American frigate, or setting it in the distance. See Lewis 1994, pp. 173–77. Cooper had American critics as well, principally John Frost, author of the rival *Book of the Navy* (New York: Appleton, 1842), who took issue with Cooper's account of the Battle of Lake Erie.

52. *The Capture of the "Guerrière" by the "Constitution"* (fig. 2-14) is signed, lower right. See Lewis A. Shepard, *A Summary Catalogue of the Collection at the Mead Art Gallery, Amherst College* (Middletown, Conn.: Wesleyan University Press, 1978), p. 45.

53. Birch—and his engravers—also changed such detailing from image to image; the *Guerrière* appears with a figurehead in the version in the Historical Society of Pennsylvania, Philadelphia, and with a scroll in the example in the Museum of Fine Arts, Boston, and in the Cornelius Tiebout engraving. His sketchbook, at the Independence Seaport Museum, Philadelphia, contains drawings based on interviews with Commodore William Bainbridge, indicating that the bow of the *Guerrière* carried a full-length figurehead.

54. Cooper, *History of the Navy*, p. 259.

55. Albert Ten Eyck Gardner and Stuart Feld, *American Paintings: A Catalogue of the Collection of the Metropolitan Museum of Art*, vol. 1 (New York: Metropolitan Museum of Art, 1965), p. 278; Caldwell and Rodriguez Roque 1994, pp. 522–24. The dinghy attached to the stern of the *Constitution* is another Chambers addition.

56. Another version of this composition, of the same size, was with the Kennedy Galleries, New York, as *The Destruction of the "Java" by the "Constitution,"* later seen on the art market as *The "United States" and the "Macedonian."* Such difficulty identifying marine subjects seems to be chronic. Internal evidence suggests that it cannot be the *Java*, and most likely the subject is the *Constitution* and the *Guerrière*. A pendant painting that has been sold with it seems to be *The "United States" and the "Macedonian,"* similar to fig. 2-18; see n. 61 below. See Sotheby's, New York, *Fine American Furniture, Folk Art, Folk Paintings, and Silver*, October 20, 1990, lot 167.

57. A Birch pair of these subjects at the Museum of Fine Arts, Boston, seems to have been together since the nineteenth century; another pair is at the Historical Society of Pennsylvania; and see Chambers' pair cited in n. 56 above.

58. Roderic Blackburn has told me of a Chambers painting, *The Burning of the Frigate "Philadelphia,"* about 20 by 29 inches, that sold in 1996. This subject, of Stephen Decatur's daring foray in 1804, was also frequently painted and engraved in the early nineteenth century; see Smith, *American Naval Broadsides*, pp. 64–65.

59. Birch's versions are listed in Darrel Sewell et al., *Philadelphia: Three Centuries of American Art*, exh. cat. (Philadelphia: Philadelphia Museum of Art, 1976), p. 186, in a commentary on the version at the Historical Society of Pennsylvania. Other versions are at the Museum of Fine Arts, Boston, and the New-York Historical Society. Both the Tanner (1813) and Seymour (1815) prints seem to be after a small version that the Schwarz Gallery in Philadelphia had in 2001; see Smith, *American Naval Broadsides*, nos. 81–83.

60. Benson J. Lossing, *The Pictorial Field-Book of the War of 1812* (New York: Harper and Brothers, 1869), chap. 22, http://freepages.history.rootsweb.com (accessed March 2008). Cooper, *History of the Navy*, pp. 262–64.

61. Another version, also about 21 by 30 inches, with the water painted in Chambers' more stylized manner, was with Kennedy Galleries about 1980 as *U.S.S. "Constitution" Capturing H.M.S. "Java,"* then later with Mongerson Wunderlich, Chicago, correctly identified. The changed relationship between the two ships in this composition gives an example of the freedom taken in interpreting the map of the battle, as well as the tendency to collapse events into a single image. Late in the engagement the *United States* crossed behind the stricken *Macedonian* and continued firing broadsides from her port guns, as shown in fig. 1-13, and then received the surrender of the enemy. As the *United States* still stands downwind in fig. 2-18 but faces the opposite direction at the same moment of victory, both versions cannot be correct or sequential.

62. I have examined this painting, in a private collection, and found it signed "T. Chambers" at the lower right in a ribbon, but the date, if present (as reported by Merritt in 1956, see n. 1 above), is no longer legible. It is 25 by 30 inches, an unusual size for Chambers. The two ships are seen in full sail against a pink sky, passing the twin lights of Sandy Hook in the company of pilot boat no. 5. The *Macedonian* looks suspiciously spruce considering the ship's condition after the battle, but it could be argued that it had been repaired en route, or in Newport, where it stopped before sailing to New York. See *Marine Painting, 1822–1978: An American View*, sales cat. (New York: Kennedy Galleries, 1980), no. 32.

63. For an example, see Benjamin Tanner after J. J. Barralet, in Smith, *American Naval Broadsides*, p. 90, no. 60. N. C. Wyeth acquired the pair of paintings together at an unknown date before his death in 1945. As Christine Podmaniczky, curator of the N. C. Wyeth collections at the Brandywine River Museum, has noted to me, the paintings may have come from his family in the Boston area; or perhaps he was introduced to Chambers' work through the Macbeth Gallery, where he and his son exhibited in the late 1930s. However, the paintings were not attributed to Chambers by the family, and both subjects were just known as *The "Constitution" and the "Guerrière."* Intractable darkened varnish was recently reduced by conservation treatment.

64. Margherita M. Desy, associate curator of the USS Constitution Museum in Boston, also suggested the identification of this subject as the *Constitution* and the *Java*, in a letter to the Brandywine River Museum, March 22, 1999. The best-known images of the *Constitution* and the *Java* are a series of four views by Nicholas Pocock, which end with *The "Java" in a Sinking State, Set Fire to and Blowing Up*; see Smith, *American Naval Broadsides*, pp. 123–24, no. 95. In this sequence, Chambers' first image would be a moment between Pocock's first and second plates. Other details—such as the rigging of the Union Jack and the damage to the main and mizzenmast—are differently told in Cooper's account (*History of the Navy*, pp. 270–73), but are depicted (from a different angle) in this same degree of distress in an aquatint by unidentified artist "W. G.," published again in a design after Garneray, in Paris; see Smith, *American Naval Broadsides*, pp. 126–27, nos. 96–98. Accounts of the engagement, and most images, show a calm sea.

The bow and stern treatment of the American frigate shows the same ship seen in other images by Chambers, such as *The "Constitution" and the "Guerrière"* (fig. 2-16), with the eccentric Indian(?) figurehead.

65. *The Great Ship "Pennsylvania,"* seen in a harbor with other shipping, 24 by 28 inches, with Peter Tillou Works of Art, Litchfield, Conn., in 2005.

66. Merritt 1956, p. 222 n. 14, cites the Old Print Shop, New York, as in possession of *The "Harriet Lane."* The wood engraving *Attack of the Rebels upon our Gun-boat Flotilla at Galveston, Texas, January 1, 1863,* published in *Harper's Weekly,* January 31, 1863, p. 73, is reproduced with other views of the event at the website of the Naval Historical Center, Department of the Navy, http://www.history.navy.mil/photos/sh-usn (accessed February 2008).

67. *Harper's Weekly,* March 22, 1862, pp. 184–85. Reproduced at the website of the Naval Historical Center, http://www.history.navy.mil.photos/events/civilwar (accessed February 2008).

68. Much of the work George Chambers produced before 1830 was based on such secondary sources, including the Horner-Parris sketches for the Colosseum, copies from prints and book illustrations, and harbor backgrounds taken from other paintings. See Watkins 1841, p. 23; Russett 1996, pp. 22, 30, 37, 40.

CHAPTER THREE

1. I have not seen a signed Chambers landscape, although several have been noted with signatures or inscriptions: *New York from Weehawken*, 13 by 15 inches, signed in graphite script (and apparently reinforced in ink) on the back "Tho Chambers, Newburgh, N.Y." (photograph, Frick Art Reference Library, New York); *Hudson River Landscape*, 20 by 25 inches, signed on the stretcher "Thos Chambers" (art market, 1984, no photograph seen); *River Landscape at Sunset*, 18 by 24 inches, signed on the back "Tho. Chambers NY. 1841" (Sotheby's, New York, sale no. 7025, *Important Americana*, October 9, 1997, lot 140); and *Peekskill*, about 19 by 23 inches, signed in red at lower center "Thomas Chambers Peekskill NY," in the collection of Martin Maloy. I have not seen any of these paintings, but it is often difficult to determine if inscriptions on Chambers' paintings are authentic. However, the rarity, irregularity of placement, medium, and handwriting style of these few examples confirm the general pattern of unsigned landscape work. His known signatures on marine paintings are given in Chapter Two, n. 1.

2. Merritt 1956, p. 217; Chotner 1992, p. 43. Virgil Barker linked Chambers to John Quidor as part of an imaginative tradition in nineteenth-century American painting, noting that his work, if derivative, went "much beyond any prints in energy of conception and impetuousness of execution." Looking at a version of *Lake George and the Village of Caldwell* (such as figs. 3-13 and 3-14), Barker praised Chambers' "mental stylization," which imposed a "positive and compelling rhythm to everything," extending "even into the brushstrokes." *American Painting: History and Interpretation* (New York: Macmillan, 1950), p. 496.

3. Merritt 1956, p. 216, first noted this pattern. Tallying about three hundred paintings with known dimensions, I have found that 37 percent are close to the size of 22 by 30 inches (although many variations appear); 35 percent are close to 18 by 24; and 23 percent are in the range of 14 by 18. These percentages shift in favor of larger sizes for the marine paintings, of which almost 60 percent are in the category of 22 by 30 inches or thereabouts. Of the entire sample, only 6 percent are larger than 22 by 30, although these bigger canvases sometimes may have been listed by their frame dimensions. Of the eight paintings securely identified as "oversize," five are marines.

4. Merritt 1956 quoted the dealer Harry Shaw Newman, who noted that Chambers' stretchers rarely vary: "They are always a little thick and 'homemade' looking, always a little out of plane and his canvas is usually fine. I have never seen a canvas maker's mark on the back of one of his pictures" (p. 217). In many conversations with Bradley over the years, he repeated these observations, adding that the original "handkerchief"-weight canvas often had a soft, fuzzy texture, and that the tacking technique often produced strong scalloping patterns in the canvas weave at the edges of the stretcher (figs. c-2 and c-4). Caroline Keck's observations are recorded on the reports filed at the Fenimore Art Museum, in Cooperstown, New York, for objects formerly in that collection as well as privately owned paintings that were examined or treated there, such as the large *Capture of H.B.M. Frigate "Macedonian"* (fig. 1-13), which the Kecks once owned. Like other conservators, she has commented on the intractable varnishes often found on Chambers' paintings, and on the severe cupping of the paint surface occasionally encountered on his work. These two conditions have frequently inspired severe remedial treatments that have flattened the paintings and removed delicate surface glazes. My thanks to Mike Heslip, conservator at the Williamstown Art Conservation Center, and to Mark Tucker, senior paintings conservator at the Philadelphia Museum of Art, for their observations. I am especially grateful to Margaret K. Contompasis for the insight gained from many conversations about the twenty-nine Chambers paintings at the Indiana University Art Museum; see her essay "Conservation Notes on the Thomas Chambers Paintings from the Collection of Morton C. Bradley, Jr.," in this volume, and the technical notes to the entries in Chotner 1992.

5. The broadside is reproduced in the Appendix. For an example of the type of expensive frames that Chambers was emulating, see Eli Wilner, ed., *The Gilded Edge: The Art of the Frame* (San Francisco: Chronicle Books, 2000), p. 143, fig. 108; a more modest related effect, familiar in frames of the 1820s and 1830s, can be seen on Doughty's *Delaware Water Gap* (fig. 4-16). In many auction sales of paintings from this period, such as those of James Eddy discussed in Chapter Four, the frames were purchased separately at the end of the sale.

6. Daniel Finamore, curator of marine paintings at the Peabody Essex Museum in Salem,

Mass., pointed out to me the frames on the work of the middling Boston marine painter Clement Drew, who was active from the 1830s to the 1880s. While generally plainer than Chambers' frames, they have a similar quality, and it seems likely that Drew sold his work to a similar market. I have located about two dozen of these decorated Chambers-type frames, many on paintings derived from Bartlett's prints, so I have guessed that he first produced them during his time in Boston, beginning in 1842.

7. N. P. Willis, *American Scenery; or, Land, Lake, and River Illustrations of Transatlantic Nature*, 2 vols. (London: George Virtue, 1837–40). Bartlett visited North America in 1836–37 and 1838 to prepare the sketches used for this book; the first plates were published in installments beginning in 1837. Two images by Thomas Doughty were also included in the 121 plates in the book, as well as a map and a portrait of Bartlett. See Mary Bartlett Cowdrey, *William Henry Bartlett and the American Scene* (Cooperstown: New York State Historical Association, 1941), reprinted from *New York History*, vol. 22 (October 1941). The plates, without Willis' texts, have been reproduced in *Bartlett's Classic Illustrations of America* (New York: Dover Publications, 2000).

8. The large *View of the Hudson*, previously with David Schorsch, was sold with its pendant of the same size (fig. 3-1) at Christie's, New York, sale no. 8894, *Important American Furniture, Silver, Folk Art and Decorative Art*, June 18, 1998, lots 95–96. The Bartlett source may be *View from Ruggles House, Newburgh*, although a smaller version of the same subject has been identified as *View of the Hudson from Kingston*; see New York 1942, cat. no. 9.

9. Merritt 1956, p. 217. He does not list the titles he identified. The following are reproduced here: *View of Cold Spring* (fig. 3-1); *Hudson Highlands* (fig. 3-3); *Chapel of Our Lady of Coldspring* (fig. 3-4); *Sabbath Day Point* (fig. 3-5); *Eastport, and Passamaquoddy Bay* (fig. 4-20); *Undercliff, near Coldspring* (fig. 5-1); and *Mount Auburn Cemetery* (fig. 5-2). Others probably include *View from West Point; View from Mount Holyoke; Crow's Nest; View below Table Rock; Tomb of Kosciusko; View from Ruggle's House, Newburgh; Forest Scene on Lake Ontario; Columbia Bridge on the Susquehanna; The Two Lakes, and the Mountain House on the Catskills; Villa on the Hudson near Weehawken; The Notch House, White Mountains; Wilkes Barre, Vale of Wyoming; Mount Tom and the Connecticut River; View of New York from Weehawken; Natural Bridge, Virginia; View from Gowanus Heights, Brooklyn; View on the Susquehanna, above Oswego; View near Anthony's Nose*; and *Hudson Highlands*. Of course, others may emerge.

10. Mark Tucker demonstrated to me how the effect of "stamping" can be made by trimming the bristles into a C shape. Similar handling can be seen in the murals of Rufus Porter from the 1840s; see Sumpter T. Priddy, *American Fancy: Exuberance in the Arts, 1790–1840*, exh. cat. (Milwaukee: Chipstone Foundation, 2004), pp. 125–26. Porter's advice was published in the magazine he founded, *Scientific American* (March 26, 1846), quoted in Nina Fletcher Little, *American Decorative Wall Painting* (Sturbridge, Mass.: Old Sturbridge Village with Studio Publications, 1952), p. 121.

11. This is the unique example of the subject that has turned up; it was found, unframed, in a barn in Keene, N.H., "some years" before 1975; correspondence from J. Herbert Groff to John K. Howat, March 13, 1975, curatorial files, American Paintings Department, Metropolitan Museum of Art. As a sign of the popularity of this subject, Bartlett's composition was reproduced in a lithograph by Currier and Ives, *The Hudson near Coldspring (Chapel of Our Lady)*, after 1856.

12. Willis, *American Scenery*, vol. 2, pp. 99–100.

13. The key painting in this chain of works, and the largest (22 by 30 inches) of nine extant versions, emerged in 2008 with Jeffrey Tillou Antiques, Litchfield, Conn. Other located versions include *Sloops on the River* (oil on wood panel, 18 by 24 inches) in the Smithsonian National Museum of American History and two (27 by 23 inches; about 10 by 14 inches) in the collection of Susanne and Ralph Katz. The Katzes showed me a photograph of a related version of unknown dimensions, now unlocated, that had been offered to them. I have also seen photographs of currently unlocated examples of the "Sabbath Day Point" type; *Cove on the Hudson*, about 14 by 18 inches, once in the Richard A. Loeb Collection (photograph, Frick Art Reference Library; Duveen papers, Archives of American Art); the so-called *Hudson River at West Point*, with Roderic Blackburn, Hudson, New York; and *Hudson River Scene*, about 18 by 24, with the Harry Shaw Newman Galleries, New York (reproduced in *Art Digest*, vol. 22 [September 1948], p. 8). Such transformations from print source to painting made Chotner doubt that Chambers' *Connecticut Valley* in the National Gallery of Art was based on Bartlett's *View from Mt. Holyoke* (Chotner 1992, p. 49), but the discovery of another version at the Fruitlands Museum, Harvard, Mass. (see http://www.fruitlands.org [accessed March 2008]), which contains additional detail from the print, helps to establish the connection, and demonstrate Chambers' tendency to move from the source print to new solutions.

14. See Constance D. Sherman, "A French Explorer in the Hudson River Valley," *New-York Historical Society Quarterly*, vol. 45 (July 1961), pp. 255–80. Sherman also translated and annotated Milbert's text as *Picturesque Itinerary of the Hudson River* (Ridgewood, N.J.: Gregg Press, 1968).

15. Merritt 1956, p. 217. These subjects are Genesee Falls, Niagara Falls, Tarrytown, West Point, Natural Bridge, New York from Weehawken, Lake George at Caldwell, Theresa Falls, Passaic River, and the Falls of Mount Ida near Troy. Another Milbert view, depicting the town of Hudson, New York, may be the source of the painting listed as "Hudson, on the Hudson River N. York" in the Newport sale. As discussed below, all the American views in the Newport sale can be identified with known paintings after Bartlett or Milbert; no view of Hudson has surfaced, but this print may tell us what to expect.

16. The view from above the falls is based on Thomas M. Baynes' lithograph from a drawing by W. Vivian, *Horse Shoe Fall from the Canada Bank*, published by Rudolph Ackerman in London in 1825; for a larger version of this same image, 22 by 30½ inches, see James L. Reinish and Meredith E. Ward, *The State of the Arts: 1990*, sales cat. (New

York: Hirschl and Adler Galleries, 1990), n.p., fig. 9-15. The vertical image, based on Bartlett's *View below Table Rock*, is also known in two images: 23 by 17 inches, Sotheby's, New York, sale no. 5551, *Important Americana*, January 28–31, 1987, lot 1070; and 23¾ by 17⅞ inches, owned in 2002 by Hirschl and Adler. They descended as a pair with a view of the Natural Bridge, Virginia. Another fine view of the Natural Bridge, 30⅜ by 22 inches, is in the collection of Zahava and George Schillinger, who purchased it in Deposit, New York, in the mid-1970s. A half-dozen paintings of Genesee Falls, based on Milbert's print, have been sighted, all in Chambers' largest format (about 22 by 30 inches). I have located versions in the Albright-Knox Art Gallery, Buffalo, and in the collection of Susanne and Ralph Katz.

17. See the good commentary on the large version by Elizabeth Mankin Kornhauser, in *American Paintings before 1945 in the Wadsworth Atheneum*, vol. 1 (Hartford: Wadsworth Atheneum; New Haven: Yale University Press, 1996), p. 178, cat. no. 97.

18. Other than the three examples reproduced here, versions are at the Minneapolis Art Institute and the Shelburne Museum in Vermont, both in the range of 22 by 30 inches. Two are in private collections, and many others at about this size have been noted in auction catalogues or with dealers. One smaller version (18 by 24 inches) was once with Hirschl and Adler Galleries, and two other small versions have been recorded or reported to me, but I have not seen images of them.

19. Willis, *American Scenery*, vol. 1, p. 6. Unlike the Milbert composition, only one of the seven versions I have found based on Bartlett's *View from West Point (Hudson River)* is 22 by 30 inches (previously in the collection of Mr. and Mrs. Max Seltzer); the rest seem to be 18 by 24 or 14 by 18 inches. The only one that I have examined, in the collection of Zahava and George Schillinger, is 14 by 18; it was purchased in the 1970s in Cuba, New York, in southwestern New York State. Another version was once in the collection of the New York State Historical Association, in Cooperstown, and then with Hirschl and Adler Galleries, which earlier had a similar view known as *Sunset, Hudson River*; see John K. Howat, *The Hudson River and Its Painters* (New York: Viking, 1972), pl. 36; and Stuart P. Feld, *Plain and Fancy: A Survey of American Folk Art*, sales cat. (New York: Hirschl and Adler Galleries, 1970), p. 11, cat. no. 4. Another is in the collection of the Senate House, Kingston, New York; others are in private collections or unlocated.

20. Although not described as a pair in the Newport auction broadside, the Lake George and West Point titles were listed sequentially. The same two subjects appeared together, evidently as a pair, at Northeast Auctions, Manchester, N.H., about 2003, emerging later with Godel & Co. Fine Art, New York. On the National Gallery's version, see Chotner 1992, pp. 52–53; on the Metropolitan Museum of Art's version, see Caldwell and Rodriguez Roque 1994, p. 524. On a version of the Lake George subject at the Smith College Museum of Art, see Virgil Barker's appreciative formal analysis in *American Painting*, p. 496, and Elizabeth Mankin Kornhauser, in *Masterworks of American Painting and*

Sculpture from the Smith College Museum of Art, ed. Linda D. Muehlig, exh. cat. (New York: Hudson Hills; Northampton, Mass.: Smith College Museum of Art, 1999), pp. 56–57, with a reproduction of Léon Sabatier's lithograph after Milbert. For a version at the New-York Historical Society, see Richard J. Koke et al., *American Landscape and Genre Paintings in the New-York Historical Society*, vol. 1 (Boston: G. K. Hall; New York: New-York Historical Society, 1982), pp. 161–62, cat. no. 299. Another version in a private collection in Bronxville, New York, descended by gift from a family from upstate New York.

21. Other titles include *Hudson River, Looking North to Kingston* (New-York Historical Society); *A View of West Point* (unlocated; Sotheby's, New York, sale no. 3438, *American Heritage Society Auction of Americana*, November 16–18, 1972, lot 426); *Hudson River Scene* (art market, 1986). Some of the confusion in these titles may be ascribed to the similarity of this composition to William Guy Wall's well-known image, engraved by John Hill in 1825, *View Near Hudson*, from the *Hudson River Port Folio*.

22. For example, see *Hudson Highlands*, size unknown, private collection, on view at the Desmond-Fish Library, Garrison, N.Y. Ellen Borovsky, in *Great Explorations: Research into American Folk Art Conducted by Students in the Museum Seminar*, ed. Caroline P. Adams (Northampton, Mass.: Smith College Museum of Art, 1980), pp. 38–39, cat. no. 19, describes one version, 18 by 24 inches. Other versions: the collections of Susanne and Ralph Katz and Mr. and Mrs. Howard Godel; with Joan R. Brownstein/American Folk Paintings, Newbury, Mass., in 2005; and in unlocated private collections.

23. *Summer: Fishermen Netting*, in Maxim Karolik's collection by 1948, is in a decorated Chambers frame. A similar painting was reproduced in "American Primitives," *Kennedy Quarterly*, vol. 11, no. 3 (1972), p. 150.

24. The views from Bartlett or Milbert that Chambers did not choose to paint are difficult to categorize, because previously unseen works may emerge eventually. However, in general, Chambers seems to have been uninterested in the urban views and modern architectural subjects in these portfolios. On the places where his work has been found, see Chapter Four.

25. The Milbert subjects are (following the auction numbering): 4. "Natural Bridge, Virginia"; 5. "Tarry town, where Major Andre was captured"; 8. "West Point"; 9. "Lake George"; 21. "Niagara Falls from the American side"; 32. "Gennesee Falls"; and 45. "Hudson, on the Hudson River N. York" (see n. 15 above). The Bartlett views would include: 12. "Weehawken, opposite New York, looking up the Hudson," corresponding to *Villa on the Hudson near Weehawken*; 51. "East-port and Passamaquoddy Bay, and Pick Nick Party" (figs. 4-18, 4-19, and 4-20); 60. "Lake George; Sabbath Day Point" (figs. 3-5 and 3-6); and possibly 44. "Northumberland, on the Susquehanna river."

26. Merritt 1956, p. 220. Merritt commented that he had found no convincing evidence for a school. A note in the file at the Fenimore Art Museum suggests that Chambers may have taught at the Amenia Seminary in Amenia, New York. Like Merritt, I have not

found confirmation of this idea, which seems to have been proposed by Agnes Jones, but additional research may be fruitful.

27. The apprentice records from 1820–30 at the Guildhall, London, note the master painter Thomas Shellard, of the parish of St. Anne Blackfriars, a member of the Livery Company that included sign and ornamental painters. Lacking documentation of Harriet Shellard's birth and marriage, her background remains obscure.

28. A similar contradiction is noted by Jacquelyn Oak in her study of the tangled identities of two painters sharing a distinctive style, "Face to Face: M. W. Hopkins and Noah North," in *Face to Face: M. W. Hopkins and Noah North*, ed. Jacquelyn Oak, exh. cat. (Lexington, Mass.: Scottish Rite Masonic Museum of Our National Heritage, 1988), pp. 23–28.

29. On Ralph Earl, see Elizabeth Mankin Kornhauser et al., *Ralph Earl: The Face of the Young Republic*, exh. cat. (Hartford: Wadsworth Atheneum; New Haven: Yale University Press, 1991).

30. Nina Fletcher Little, "William M. Prior, Traveling Artist, and His In-Laws, the Painting Hamblins," in *Portrait Painting in America: The Nineteenth Century*, ed. Ellen Miles (New York: Main Street/Universe Books, 1977), p. 121. On Chambers, Prior, and this market, see Chapter Four.

31. Merritt 1956, p. 216. The painting, previously in the Abby Aldrich Rockefeller Folk Art Collection, Williamsburg, was deaccessioned in 1982 and is currently unlocated. See William Beattie's *Scotland Illustrated; in a series of views taken expressly for this work by Messrs. T. Allom, W. H. Bartlett and H. M'Culloch*, 2 vols. (London: George Virtue, 1838); the plate appears in vol. 1, opp. p. 182. Typically, Chambers transforms the scale of the bridge by adding oversized river shipping.

32. The same image of Alloway Kirk also appeared in a compendium, *Poems, Letters, and Land of Robert Burns* (London: George Virtue, 1838). On the history of Chambers' painting, see Richard J. Wattenmaker and Alain G. Joyaux, *American Naive Paintings: The Edgar William and Bernice Chrysler Garbisch Collection*, exh. cat (Flint, Mich.: Flint Institute of Arts, 1981), pp. 76–77, cat. no. 34

33. *Pictures and Portraits of the Life and Land of Burns* (London: George Virtue, 1838); later editions credit Allan Cunningham for the text. Creswick seems to have based his image on a print after a drawing by Thomas Stothard made in 1812, reproduced again as *The Birthplace of Burns*, for the frontispiece to Cunningham's famous edition of the complete works of Burns, published in London and Boston in 1834. Small differences in detail indicate that Chambers knew Creswick's version, but even so he demonstrates the fifth-generation use of this image, typical of the period.

34. A version in an original decorated Chambers frame, *A Fine Country Landscape*, 14 by 18 inches, was reproduced in *Antiques*, vol. 92, no. 5 (November 1967), p. 664, in an advertisement for Good and Hutchinson Associates, Tolland, Mass. Another version of the same size is in a private collection in Pennsylvania.

35. Beattie, *Scotland Illustrated*, p. 103. The plates are published in vol. 2, opp. pp. 104 and 106.

36. Morton C. Bradley, Jr., told me that three Chambers paintings, including this pair, were found together in Maine by Dickie Faber and Bill Samaha.

37. *Ravenscraig Castle* may be seen in an image at http://www.askart.com (accessed March 2008), listed as on the art market in 2002; the view of Edinburgh from Carlton Hill was sold as *Kosciusko's Monument* at Sotheby's, New York, sale no. 5551, *Important Americana*, January 28–31, 1987, lot 1069.

38. One version of Innisfallen, 21 by 30 inches, was sold by Dana Tillou Fine Arts, Buffalo, about 1995; another, 23¾ by 29½ inches, was with Jeffrey Tillou Antiques, Litchfield, Conn., in 2006. The titles in the sale find close subject matches to images of the Abbey of Clare, Ross Castle, Innisfallen, and Cork harbor in N. P. Willis and J. Stirling Coyne, *Scenery and Antiquities of Ireland* (London: George Virtue, 1842); the images of Castledormot and Kilkenny seem to be from another source.

39. Bradley recollected that he obtained this painting from the Boston "picker" Jimmy Magrath. An inscription on the back indicates that it was once part of a pair. It is worth remarking that the Kilchurn Castle subjects, the ruins, and the cottage by a waterfall are all on a similar composition board, now sometimes very warped.

40. According to Bradley, the two paintings were purchased in "Chambers frames" in New England by W. T. Currier, who sold the pair to a doctor from Brookline, Mass., who subsequently sold *Flooded Town* to Bradley and the cottage scene to Barry and Linda Priest.

41. Chotner 1992, p. 52.

42. Margaret Contompasis has noted that the canvas and tacking edges on this painting are similar to others, but there is an unusual yellow ocher ground on the painting, and the treatment of shadows on the water is unlike that on other Chambers paintings at the Indiana University Art Museum. She also has commented on the possibility that Chambers' ability to distinguish certain colors diminished with age; see her essay in this volume. I have not seen the third, smaller version, *Volcano in the Tropics*, except in a black-and-white photograph from the archives of Kennedy Galleries, New York. In its profusion of foliage, it is more like the Katzes' version.

43. Merritt 1956 reproduces one version of *The Birthplace of Washington*, p. 218, fig. 5, noting its relationship to an engraving of a painting by John Gadsby Chapman, published in 1835. Chapman's painting was exhibited to much acclaim at the National Academy of Design in 1835, when Chambers was in residence in New York. The example in the Abby Aldrich Rockefeller Folk Art Museum (fig. 4-13) was published by Beatrix T. Rumford in *American Folk Paintings: Paintings and Drawings Other than Portraits from the Abby Aldrich Rockefeller Folk Art Center* (Boston: Little, Brown for the Colonial Williamsburg Foundation, 1988), pp. 19–21. Another version, 18 by 24 inches, in the Fruitlands Museum, is reproduced at http://www.fruitlands.org (accessed

March 2008). Others are in private collections, seen in photographs in the files at the Rockefeller Folk Art Museum. The variety of styles seen in these six versions is similar to the range seen in other groups.

44. This quality has inspired earlier titles such as *Imaginary Landscape* and *Romantic Landscape*, the latter title given to one of the largest extant versions (22 by 30 inches and now in the collection of Emmy Cadwalader Bunker), reproduced in the *Old Print Shop Portfolio*, vol. 13, no. 1 (1953), p. 23, with a note that "We have named this picture 'The Trees of Good and the Trees of Evil.'" This version includes a traveler on the road and a pair of tourists admiring the view. Another large version, which came as a companion to *Landscape with Mount Vesuvius* (fig. 3-27), is in the collection of Susanne and Ralph Katz. A version on a panel about 18 by 24 inches, with a warm reddish tone, was with Peter Tillou, Litchfield, Conn., in 2006; a fifth version in a private collection, size unknown, was reproduced in *A Bicentennial Exhibition of Furniture, Paintings, and the Decorative Arts, 1700–1976*, exh. cat. (Springfield, Mass.: Springfield Museum of Fine Arts, 1976), cat. no. 39.

45. Another version of the same size was in the collection of Peter Tillou; see *Nineteenth-Century Folk Painting: Our Spirited National Heritage; Works of Art from the Collection of Mr. and Mrs. Peter Tillou* (Storrs, Conn.: William Benton Museum of Art, 1973), fig. 130. Tillou's painting is described as being in its original frame, flat and painted black with a gilded inner bevel. Merritt described to me a similar painting in his own collection.

46. This painting was with Samuel L. Lowe, Boston; see advertisement in *Antiques*, vol. 108 (November 1975), p. 911, where the inscription on the stretcher is noted. I could not find this inscription when I examined the painting in 2005. Ralph Katz showed me a photograph of a larger version, 22 by 30 inches, which had been offered to him by the New York dealer Sidney Gecker a few years earlier.

47. The print, engraved by Ellis, was published in the *Naval Chronicle*, vol. 5 (March 1801), opp. p. 157. A similar view appeared in George Hutchins Bellasis, *Views of St. Helena* (London, 1815), no. 2. Notably, both prints precede Napoleon's death. Dana Tillou shared a photograph of a variant of this composition (size unknown; sold to a private collection in Michigan) with more lines of running ripples on the water, much in the style of Chambers' *Corsica, Birthplace of Napoleon* (fig. 3-31).

48. Cited from the *Philadelphia Gazette*, in *New-Yorker*, March 4, 1837, p. 4.

49. From a Bartlett image, *Road across the Plain of Waterloo*, engraved by Albert Henry Payne, in N. G. van Kampen, *The History and Topography of Holland and Belgium* (London, George Virtue, 1837), p. 202.

50. I am grateful to Frank Moran, who shared a photograph of his painting of Chapultepec (oil on canvas, 22 by 30 inches) and the Currier print, *View of Chapultepec and the Molino del Rey*. The multiple versions of this image are tracked by Ben Huseman, in Martha Sandweiss et al., *Eyewitness to War: Prints and Daguerreotypes of the Mexican War, 1846–1848*, exh. cat. (Fort Worth, Tex.: Amon Carter Museum; Washington, D.C.:

Smithsonian Institution Press, 1989), pp. 319–21, pls. 142–43. John Frost, *Pictorial History of Mexico and the Mexican War* (Philadelphia: Thomas, Cowperthwait, 1848), p. 552.

51. *Village in the Foothills*, once in the Garbisch collection, is 22½ by 30 inches. See Valerie Ann Leeds and Akela Reason, in *American Art at the Flint Institute of Arts*, by William H. Gerdts et al., exh. cat. (New York: Flint Institute of Arts with Hudson Hills, 2003), p. 40, cat. 13. Frost, *Pictorial History*, p. 297. This book, "embellished with five hundred engravings from designs of W. Croome and other distinguished artists" and a crude, but pioneering series of chromolithographed illustrations, seems to have pirated images from many sources. The same composition, in a larger and more detailed plate that actually included the bishop's palace in the foreground, first appeared in Frost's earlier book, *Life of Major General Zachary Taylor; with Notices of the War in New Mexico* (Philadelphia: G. S. Appleton, 1847). A similar, more atmospheric and naturalistic etching, suggesting the existence of an earlier, more sophisticated version of this image that was the mother to them all, appeared in Brantz Mayer, *Mexico, Aztec, Spanish and Republican: A Historical, Geographical, Political, Statistical and Social Account of that Country . . .* (Hartford: Drake, [1850]), p. 352. The blocks used in *Pictorial History*, the crudest of the family, were shared as well: the same block (among others, including Molino del Rey) was printed in C. J. Petersen, *The Military Heroes of the War of 1812; with a Narrative of the War with Mexico* (Philadelphia: W. A. Leary, 1848), p. 47, with the title *Monterey, and the Saddle Mountains*. Although Chambers' view has the simplifying spirit of this print, some of the details in his painting (and the absence of the bishop's palace) suggest that he knew Mayer's print, if not some other version.

52. Frost, *Pictorial History*, p. 631. The army was active at Tulancingo, San Cristobal, Guanajuato, and Tehualtaplan in February 1848; any of these sites may be represented by this image, although I have found no related period print.

53. Caroline Keck conserved one version (now unlocated) in 1980; her notes, commenting on the "stingy" use of canvas on the tacking edges, and a photocopy of the unframed picture are in the files at the Abby Aldrich Rockefeller Folk Art Museum. David Schorsch shared a color transparency of another version that he once owned entitled *Arcadia*, with a pale yellow sunset sky. A third large version, 22 by 28 inches, sold at Northeast Auctions, Manchester, N.H., February 23–25, 2007, lot 127. Another version, 22¼ by 30 inches, is in the collection of Dr. Howard P. Diamond.

54. *View of Wampooh, China*, engraved by Wells after a drawing by Owen. *Naval Chronicle*, vol. 5 (June 1802), opp. p. 387.

55. The provenance of this painting suggests that it was owned in the Boston area; the local "picker" Jimmy Magrath found the painting and brought it to Morton C. Bradley, Jr.

56. Observations from Margaret Contompasis. Nonetheless, the frame, type and size of canvas, warm pink ground, and general manner are consistent with Chambers' work.

57. See Kornhauser, *American Paintings before 1945*, p. 179. This painting was not listed in

the Macbeth catalogue (New York 1942), but a caption to a reproduction of the painting in *Town and Country*, vol. 98 (May 1943), p. 46, claimed that it had been shown in the Chambers exhibition.

58. Collection of Lex and Lynn Lindsey, Laurel, Mississippi. These paintings, now known as *Fanciful Landscapes*, both about 14 by 18 inches, were sold to Jean Lindsay around 1971 by Michael Bertolini of Goshen, New York. See his advertisement in *Antiques*, vol. 100 (November 1971), p. 716, where they are described as "Hudson Valley Views." The frames, "said to have been decorated by the artist," are painted broadly to emulate, perhaps, the effect of tortoiseshell and gilding; I have not seen similar frames on other Chambers paintings. According to the files at the Fenimore Art Museum, Bertolini found these paintings before 1971 in the same house with a third painting, *Baroque Landscape*, previously in the collection of the New York State Historical Association (now with Hirschl and Adler Galleries). Although not otherwise documented, this account suggests that Chambers may have made sets of three related paintings. The Lindsay collection records indicate that their Chambers pair was "part of a set of six" that included four others at Cooperstown. My thanks to Colleen Cagle for her assistance with the Lindsay records. *Baroque Landscape* (earlier called *Chinese Landscape*), about 22 by 30 inches, is larger than the Lindsay pair and could have been a centerpiece, except that its composition is very much like the right-hand, smaller image. Caroline Keck's treatment report indicates that it was in the New York State Historical Association, acquired from the Gunn collection, by 1960. Other Castles on the Rhine subjects have been sold by Dana Tillou, Peter Tillou, and Roderic Blackburn (the same painting, in a Chambers frame), and by Joan R. Brownstein. Two compositions with the dark bluff to the left, both about 22 by 30 inches, are in the collections of Costas Sakellariou and Dr. Howard P. Diamond.

59. See Linda Roscoe Hartigan, *Made with Passion: The Hemphill Folk Art Collection in the National Museum of American Art* (Washington, D.C.: Smithsonian Institution Press, 1990), cat. no. 166.

60. See Chapter One. *River View*, about 14 by 18 inches, was examined in 2003 when it was with Samuel Herrup Antiques, Sheffield, Mass.; it was with Joan R. Brownstein in 2007.

Chapter Four

1. Watkins 1841, p. 23, cited in Russett 1996, p. 37.

2. Watkins 1841, cited in Russett 1996, p. 43.

3. Watkins 1841, p. 35, cited in Russett 1996, p. 105.

4. See Chapter One, "New York, c. 1833–c. 1840."

5. The term "folk art" has been contested frequently, and I use it (like the term "fine" or "academic") throughout this text with a sense of caution, fearing that these categories close down and obscure more complex understanding. The bibliography on the topic is enormous, although for the present generation the massive survey of folk art organized by Jean Lipman and Alice Winchester, *The Flowering of American Folk Art* (New York: Viking with the Whitney Museum of American Art, 1974), summarized the research and taste of the collector-scholars, beginning with Holger Cahill, who defined American folk art in the twentieth century. The impact of their attitudes on the interpretation of Chambers' work in the 1940s is discussed below in Chapter Five. A new generation of scholars, with different concerns and methods, was heralded by Kenneth L. Ames' essay in *Beyond Necessity: Art in the Folk Tradition; An Exhibition from the Collections of Winterthur Museum at the Brandywine River Museum, Chadds Ford, Pa.*, exh. cat. (Winterthur, Del.: H. F. du Pont Winterthur Museum, 1977). The related conference, which explored the history of the field and its future, was labeled the "shoot out" at Winterthur in Scott T. Swank's introduction to the publication of the papers, *Perspectives on American Folk Art*, ed. Ian M. G. Quimby and Scott T. Swank (New York: W. W. Norton for the H. F. du Pont Winterthur Museum, 1980), pp. 1–12. Before this book appeared, the folk art establishment gathered to produce two more-focused surveys: the first, from the great collector and director of the Museum of American Folk Art, Robert Bishop, was *Folk Painters of America* (New York: E. P. Dutton, 1979); the second, with Jean Lipman and Tom Armstrong as editors, was *American Folk Painters of Three Centuries*, exh. cat. (New York: Hudson Hills with the Whitney Museum of American Art, 1980). Since 1980, the bibliography on folk art and material culture has mushroomed, with many focused regional or genre studies and the publication of several important collections of American folk art demonstrating the diversity of objects and artists included under this rubric. See *American Folk Art: The Herbert Waide Hemphill, Jr., Collection*, exh. cat. (Milwaukee: Milwaukee Art Museum, 1981), and successive catalogues of the Hemphill Collection, now at the Smithsonian American Art Museum; Jeffrey R. Hayes, Lucy R. Lippard, and Kenneth L. Ames, *Common Ground/Uncommon Vision: The Michael and Julie Hall Collection of American Folk Art*, exh. cat. (Milwaukee: Milwaukee Art Museum, 1993); Stacy C. Hollander and Brooke Davis Anderson, *American Anthem: Masterworks from the American Folk Art Museum*, exh. cat. (New York: American Folk Art Museum with Harry N. Abrams, 2001); Stacy C. Hollander, *American Radiance: The Ralph Esmerian Gift to the American Folk Art Museum*, exh. cat. (New York: American Folk Art Museum with Harry N. Abrams, 2001); and Jane Katcher, David A. Schorsch, and Ruth Wolfe, eds., *Expressions of Innocence and Eloquence: Selections from the Jane Katcher Collection of Americana*, exh. cat., Yale University Art Gallery (Seattle: Marquand Books; New Haven: Yale University Press, 2006). In this storm of beautiful publications, a beacon of clarity has been Henry Glassie, whose *Pattern in the Material Folk Culture of the Eastern United States* (Philadelphia: University of Pennsylvania Press, 1968) was the first in a series of influential texts on the subject. In a later, brief essay, "The Idea of Folk Art," in *Folk Art and Art Worlds*, ed. John Michael Vlach and Simon J. Bronner (Logan: Utah State University Press, 1992), pp. 269–74, Glassie

notes the tendency to use the term "folk art" to distinguish work by "others" who, from their viewpoint, see simply art or craft. In this spirit, I have attempted to imagine Chambers as he described himself, just as an artist. Glassie's most compelling exploration of the definition of folk art, *The Spirit of Folk Art*, exh. cat. (New York: Harry N. Abrams with the Museum of New Mexico, Santa Fe, 1989), sorts out the categories, unpacks the attitudes embedded in the modern usage of this term, and seeks the principles that unite American folk art with the world's art. His annotated bibliography offers a useful introduction to the history of scholarship on folk art.

6. Carolyn Weekly, *The Kingdoms of Edward Hicks* (New York: Harry N. Abrams with the Abby Aldrich Rockefeller Folk Art Center, 1999), p. 6 and passim for a discussion of the meaning of his series, and pp. 65–89 for a description of his decorative painting and its conflict with his Quaker culture. Although torn by this dilemma and perpetually plagued by debt, Hicks was an industrious businessman, happy to sell many other kinds of work. He had a repertory of patriotic subjects and bucolic cottage scenes akin to Chambers' work. The description of his paintings as icons of American folk art is from Graham Hood's foreword, in ibid., p. ix.

7. The title comes from an inscription said to be on another, larger (22 by 30 inch) version of the same composition, once in the collection of Peter Tillou and reproduced on the cover of *Portraits of New England Places* (Waterville, Maine: Colby College Museum of Art, 1984). I have found no related image of Springfield, so this identification remains speculative, although the bucolic riverside setting for an industrial powerhouse—much more exaggerated in the size and number of dark mills and smokestacks in the larger version—could symbolically represent Springfield and its famous armory. However, the composition also resembles a W. H. Bartlett view, *Vienna (Looking across the Glacis)*, engraved by John Cousen, from William Beattie, *The Danube: Its History, Scenery, and Topography* (London: George Virtue, 1844), p. 138.

8. See Mary Black, *Erastus Salisbury Field, 1805–1900*, exh. cat. (Springfield, Mass.: Museum of Fine Arts, 1984), pp. 30–32, cat. no. 68, pl. 22. Field's imaginary classical harbor shares the vision of Thomas Cole's *Course of Empire*, or Chambers' Italian landscapes.

9. See ibid., cat. no. 74, pl. 24. Field never signed his work, but family history and annotations have allowed the precise identification and dating of his portraits, from which Black reconstructed his travels and his client base with considerable richness. The best overview of the provincial portraiture of this period is Jessica Nicoll et al., *Meet Your Neighbors: New England Portraits, Painters, and Society, 1790–1850*, exh. cat. (Sturbridge, Mass.: Old Sturbridge Village, 1992). Essays in this book by Jack Larkin, Elizabeth Mankin Kornhauser, David Jaffee, and Nicoll study the social context of artists such as Field and his middle-class patrons, and the larger pattern and meaning of portraiture in this period of economic transformation. On the larger phenomenon of middle-class refinement, see Richard L. Bushman, *The Refinement of America: Persons,*

Houses, Cities (New York: Alfred Knopf, 1992). Related views of American parlors in this period and extensive bibliographies on this subject can be found in Edgar de N. Mayhew and Minor Myers, Jr., *A Documentary History of American Interiors: From the Colonial Era to 1915* (New York: Charles Scribner's Sons, 1980); Elisabeth Donaghy Garrett, *At Home: The American Family, 1750–1870* (New York: Harry N. Abrams, 1990), pp. 39–77; and Teresa A. Carbone, *At Home with Art: Paintings in American Interiors, 1780–1920*, exh. cat. (Katonah, N.Y.: Katonah Museum of Art, 1995).

10. Nina Fletcher Little, "William Matthew Prior, Traveling Artist, and His In-Laws, the Painting Hamblens," *Antiques*, vol. 53 (January 1948), pp. 44–48, reprinted in *Portrait Painting in America: The Nineteenth Century*, ed. Ellen Miles (New York: Main Street/ Universe Books, 1977), pp. 121–24; Beatrix Rumford, ed., *American Folk Portraits: Paintings and Drawings from the Abby Aldrich Rockefeller Folk Art Center* (Boston: New York Graphic Society for the Colonial Williamsburg Foundation, 1981), pp. 176–82; Laurie Weitzenkorn, in Chotner 1992, p. 296. Like Chambers, Prior seems to have stretched his paintings himself and, to some degree, produced his own frames. His materials, including artist board and canvas painted with a pinkish beige ground, also resemble those of Chambers.

11. Little, "William Matthew Prior," p. 121. Hamblin (also spelled Hamblen) seems to have been active from 1837 to 1856. For an analysis of his painting compared to Prior's, see Richard Miller, in *Folk Art's Many Faces: Portraits in the New York State Historical Association*, ed. Paul S. D'Ambrosio and Charlotte Emans (Cooperstown: New York State Historical Association, 1987), pp. 93–99, and D'Ambrosio's characterization of Prior, pp. 133–41. The *Portrait of Three Girls* (fig. 4-4) was until recently attributed to Prior.

12. Little, "William Matthew Prior," pp. 121–22.

13. David Jaffee, "'A Correct Likeness': Culture and Commerce in Nineteenth-Century Rural America," in *Folk Art and Art Worlds*, ed. Vlach and Bronner, p. 54; reprinted in *Reading American Art*, ed. Marianne Doezema and Elizabeth Milroy (New Haven: Yale University Press, 1998). See also Jaffee, "The Age of Democratic Portraiture, Artisan-Entrepreneurs and the Rise of Consumer Goods," in *Meet Your Neighbors*, by Nicoll et al., pp. 35–46. Jaffee's studies offer a portal to the bibliography on American folk portraiture in this period. Following from Prior's announced "flat" style, Vlach has characterized this kind of painting as plain; see his *Plain Painters: Making Sense of American Folk Art* (Washington, D.C.: Smithsonian Institution Press, 1988). Vlach, a folklorist, locates such painting in the realm of provincial fine art rather than traditional folk art, and discusses the sources and aspirations of artists such as Hicks, Field, Stock, Phillips, and Prior. Vlach's concept was revised by Charles Bergengren to propose a mixture of folk and academic qualities in such portraiture in "'Finished to the Utmost Nicety': Plain Portraits in America, 1760–1860," in *Folk Art and Art Worlds*, ed. Vlach and Bronner, pp. 85–120.

14. See Mary Black with Barbara C. Holdridge and Lawrence B. Holdridge, *Ammi Phillips: Portrait Painter, 1788–1865*, exh. cat. (New York: C. N. Potter for the Museum of American Folk Art, 1969); Stacy C. Hollander and Howard P. Fertig, *Revisiting Ammi Phillips: Fifty Years of American Portraiture*, exh. cat. (New York: American Folk Art Museum, 1994); and Juliette Tomlinson, ed., with Kate Steinway, *The Paintings and the Journal of Joseph Whiting Stock* (Middletown, Conn.: Wesleyan University Press, 1976). Interesting documentation of the fees and barter arrangements of an itinerant painter in this era can be found in Michael R. Payne and Suzanne Rudnick Payne, "The Business of an American Folk Portrait Painter: Isaac Augustus Wetherby," *Folk Art*, vol. 32, no. 1 (Winter 2007), pp. 58–67.

15. On Fisher, see Kathleen A. Foster and Nanette Esseck Brewer, *An American Picture-Gallery: Recent Gifts from Morton C. Bradley, Jr.* (Bloomington: Indiana University Art Museum, 1992), pp. 84–85; on Salmon, see John Wilmerding, *American Marine Painting*, 2nd ed. (New York: Harry N. Abrams, 1987), p. 88. On the thousands of ship portraits painted by the Bard brothers, see n. 23 below. The disparity between work claimed to have been produced and the actual survival of paintings must give pause to those attempting to generalize about the past inductively. Required reading for all art historians, not just those calculating the survival rates of artifacts from the past, is Gary Schwartz, "Ars Moriendi: The Mortality of Art," *Art in America* 84 (November 1996), pp. 72–75.

16. Prior's view of Washington's tomb, not based on Bartlett's image, may have been inspired by an image in *Gleason's Pictorial* in 1853; it has been spotted in many examples, including versions in the New-York Historical Society and in the Fenimore Art Museum, Cooperstown, New York. Two examples, including one from the Smith College Museum of Art, are reproduced in Caroline P. Adams, ed., *Great Explorations: Research into American Folk Art Conducted by Students in the Museum Seminar* (Northampton, Mass.: Smith College Museum of Art, 1980), pp. 29–31, with Kathleen Durning's comment on the print source. Day and night views of Mount Vernon were published in "American Primitives," *Kennedy Quarterly*, vol. 9, no. 3 (December 1969), p. 171. After 1850, Prior also produced many copies on glass, in different sizes, of Gilbert Stuart's "Atheneum" portrait of Washington (Museum of Fine Arts, Boston, and National Portrait Gallery, Washington, D.C.) and serial portraits of Napoleon and Lincoln.

17. I have located reproductions or citations of as many as fifteen of these moonlight views from auction and dealer catalogues; most are on canvas, about 19–20 by 24–25 inches. There are two variants in the Bradley Collection at the Indiana University Art Museum, and versions at the Shelburne Museum in Vermont; the Fruitlands Museum, Harvard, Mass.; and the Portland Museum of Art in Maine. Many have the "Garret" stamp on the back; one has Prior's address in Baltimore in 1855 on the back.

18. Little, "William Matthew Prior," p. 122. In addition to Baltimore, Prior is recorded to have been in New Bedford, Fall River, and Sturbridge, Mass.

19. On the Allens, see the entry on William Allen by Carol Troyen, in *The Boston Tradition: American Paintings from the Museum of Fine Arts, Boston*, exh. cat. (New York: American Federation of Arts, 1980), p. 104.

20. Prior, like Field, was a passionate abolitionist, a politic seen in his portraits of African Americans. He was also a devoted Millerite who published two books in support of the Adventist sect's founder. Jacqueline Oak has noted the themes of social and religious reform, including abolitionism and temperance, that unite many folk artists in this period; see Jacqueline Oak, ed., *Face to Face: M. W. Hopkins and Noah North* (Lexington, Mass.: Scottish Rite Masonic Museum of Our National Heritage, 1988), p. 28. Glassie, in *The Spirit of Folk Art*, identifies spirituality as a link uniting folk art worldwide.

21. C. H. Ward Jackson, *Ship Portrait Painters, Mainly in Nineteenth-Century Britain* (Greenwich, U.K.: National Maritime Museum, 1978), pp. 3, 34. Apart from making their work difficult to track, this practice also meant that such painters were little known in their lifetimes and many died, like Chambers, "in reduced circumstances" (ibid., p. 34). The struggle of provincial marine, landscape, and fancy painters in England, germane to the experience of many multitasking immigrant American artists in Chambers' day, is described in Trevor Fawcett, *The Rise of English Provincial Art: Artists, Patrons, and Institutions outside London, 1800–1830* (Oxford: Clarendon Press, 1974), esp. pp. 14–19. See also James Ayres, *Two Hundred Years of English Naive Art, 1700–1900*, exh. cat. (Alexandria, Va.: Art Services International, 1996).

22. See Daniel Finamore, *Across the Western Ocean: American Ships by Liverpool Artists* (Salem, Mass.: Peabody Essex Museum, 1995), pp. 7, 16–17, and passim, for examples of these painters. The larger story is told in Jackson, *Ship Portrait Painters*. On the French, Dutch, and British roots of American marine painting, see John Wilmerding, *A History of American Marine Painting*, exh. cat. (Salem, Mass.: Peabody Museum of Salem; Boston: Little, Brown, 1968), pp. 38–39, and his *American Marine Painting*.

23. See Roger Finch, *The Pierhead Painters: Naive Ship Portrait Painters, 1750–1950* (London: Barrie and Jenkins, 1983). As one instance of specialization, the Bards never painted packets, transatlantic steamers, or naval vessels, preferring to focus on everyday New York commercial shipping; see Anthony J. Peluso, *The Bard Brothers: Painting America under Steam and Sail*, exh. cat. (New York: Harry N. Abrams with the Mariners' Museum, 1997). Peluso counted seventeen major maritime painters in New York competing with the Bards in their heyday, from about 1840 to 1890 (see pp. 88–104); he calculates the Bards' total oeuvre to be three thousand to four thousand ship portraits (p. 105).

24. Lewis 1994, pp. 7, 507–10, traces a few provenance histories available for Birch's harbor views and notes that these paintings were rarely exhibited in the nineteenth century, suggesting that they were painted for private consumption, on speculation, and sold inexpensively as potboilers for the Birch family. As Lewis notes, "Specialization, innovation, and the mass production of standardized commodities—all aspects of a capitalist economy—characterized Birch's practice" (pp. 17–18).

25. Abel Thomas, "Sketch of Thomas Birch," *Philadelphia Art Union Reporter*, vol. 1, no. 1 (January 1851), p. 22, cited in Lewis 1994, p. 8.

26. Despite his active career, few paintings by Thompson survive in public collections to allow assessment of his style; see Caldwell and Rodriguez Roque 1994, pp. 270–73. On Pringle, see Chapter One in this volume; and Elizabeth Mankin Kornhauser et al., *American Paintings before 1945 in the Wadsworth Atheneum*, vol. 2 (Hartford: Wadsworth Atheneum; New Haven: Yale University Press, 1996), pp. 615–16. Pringle showed his work at the Royal Academy in London from 1808 to 1818; he exhibited at the National Academy of Design in New York from 1832 to 1844. His paintings shown at the Apollo Association in 1838 and 1839, which depicted the *Constitution* entering New York harbor, have not been located. Their titles suggest that they might bear comparison with Chambers' views of shipping near Governor's Island.

27. "Miscellaneous Notices of the Fine Arts," *American Monthly Magazine*, vol. 3, no. 3 (May 1, 1834) (APS Online, p. 207).

28. See Richard J. Koke et al., *American Landscape and Genre Paintings in the New-York Historical Society*, vol. 2 (Boston: G. K. Hall; New York: New-York Historical Society, 1982), pp. 14–15. Research materials on Evans are also in the files of the library at the Smithsonian American Art Museum.

29. See Wilmerding, *American Marine Painting*, pp. 115–16. Through about 1851 Lane (echoing Salmon) used various techniques to describe water and maintained habits in figure drawing and foreground detail that are reminiscent of Chambers; see John Wilmerding et al., *Paintings by Fitz Hugh Lane* (New York: Harry N. Abrams; Washington, D.C.: National Gallery of Art, 1988).

30. The contributing threads of the national landscape tradition have been surveyed by Edward J. Nygren et al. in the indispensable *Views and Visions: American Landscape before 1830*, exh. cat. (Washington, D.C.: Corcoran Gallery of Art, 1986), which includes discussions of Guy, Fisher, Codman, Doughty, Cole, and many of the lesser-known figures of this period. On Francis Guy, see Stiles Tuttle Colwill, *Francis S. Guy, 1760–1820* (Baltimore: Maryland Historical Society, 1981), and Sumpter T. Priddy, *American Fancy: Exuberance in the Arts, 1790–1840*, exh. cat. (Milwaukee: Chipstone Foundation, 2004), pp. 51–53, for examples of Guy's decorated furniture. Bergengren also notes the technical nicety of the sign-painting tradition, with its refined methods and materials; see his essay in *Folk Art and Art Worlds*, ed. Vlach and Bronner, pp. 118–19 n. 23.

31. Neal's quotation from the *Portland Magazine* in 1835 is cited in Jessica Nicoll, "Charles Codman: From Limner to Landscape Painter," *Antiques*, vol. 162, no. 5 (November 2002), p. 130. Indeed, Codman began painting clockfaces for the Willard brothers in Roxbury, Mass., before working for Penniman's sign-painting operation. On Penniman, see Carol Damon Andrews, "John Ritton Penniman (1782–1841): An Ingenious New England Artist," *Antiques*, vol. 120, no. 1 (July 1981), pp. 147–70. On Blunt, first identified by Robert Bishop as the "Borden Limner," see Deborah M. Child, "Coming of Age on the Piscataqua: The Marine Paintings of John Samuel Blunt," *Antiques and Fine Art* (August–September 2006), pp. 180-85, http://www.antiquesandfineart.com (accessed March 2008).

32. On Fisher, see Foster and Brewer, *An American Picture-Gallery*, pp. 84–85; Clara Endicott Sears' discussion of Fisher's work notes his presence in Philadelphia in 1824; see *Highlights among the Hudson River Artists* (Boston: Houghton Mifflin, 1947), pp. 26–31.

33. Darrel Sewell, "Thomas Cole, View of Fort Putnam," in *Gifts in Honor of the 125th Anniversary of the Philadelphia Museum of Art*, ed. Alice O. Beamesderfer, exh. cat. (Philadelphia: Philadelphia Museum of Art, 2002), p. 50. On the recent rediscovery of this painting, see Elise Effmann, "Thomas Cole's View of Fort Putnam," *Antiques*, vol. 166, no. 5 (November 2004), pp. 155–59. The legend of Cole's discovery, along with the facts, is told by Alan Wallach in "Thomas Cole, Landscape and the Course of Empire," in *Thomas Cole: Landscape into History*, ed. William H. Truettner and Alan Wallach (New Haven: Yale University Press; Washington, D.C.: National Museum of American Art, Smithsonian Institution, 1994), pp. 23–24.

34. Paulding's work was published in two volumes in New York by Harper and Brothers; the engraving by John Francis Eugene Prud'Homme was the first of Chapman's many book illustrations. The same image also appeared in other publications; see Beatrix T. Rumford, ed., *American Folk Paintings: Paintings and Drawings Other than Portraits from the Abby Aldrich Rockefeller Folk Art Center* (Boston: Little Brown for the Colonial Williamsburg Foundation, 1988), pp. 19–21, with a list of the variant versions by Chambers that have survived and two later appearances of the image in books. Like many prints in this period, the image was pirated and republished again and again; James Duthie's engravings of this same painting also appear in many publications, illustrated by variant prints in the Emmet Collection in the New York Public Library, http://digitalgallery.nypl.org (accessed March 2008). As in the case of his Mexican War subjects, this recycling of imagery makes it difficult to know which source Chambers knew. Chapman's original painting (now unlocated) was, like all the pictures in his series, 21½ by 29 inches, close to the size of Chambers' version in the Abby Aldrich Rockefeller Folk Art Museum (fig. 4-13); other versions in private collections or unlocated are 18 by 24 inches.

35. Durand's engraving (fig. 4-14) was first published as one of six plates in the first and only issue of *American Landscape*, written by William Cullen Bryant. The plates were sold to the *New-York Mirror*, and Durand's image was published again in the issue of June 7, 1834. His painting of the same title was exhibited at the National Academy of Design in 1832. Doughty's *Delaware Water Gap*, dated 1827 (fig. 4-16), seems to be a close variant, if not the actual painting engraved by Ellis in 1828. Probably exhibited at the National Academy in 1827, it became part of the celebrated collection of New York's mayor, Philip Hone. See Merritt 1956, fig. 1, for Chambers' 23-by-30-inch version of this same subject

at the Memorial Art Gallery of the University of Rochester; fig. 2, for Durand's engraving; fig. 3, for Ellis' engraving after Doughty; and fig. 4, for another version by Chambers, 18 by 24 inches, then with the Old Print Shop; all images appear in the plate section between pp. 218–19. In addition to the Novak painting (fig. 4-15, previously in the collection of the New York State Historical Association), I have seen another large *Delaware Water Gap* based on the Durand model, 22 by 30 inches, in the collection of Josef and Karen Fischer; and Dana Tillou shared a photo with me of a small version based on the Doughty image, about 10 by 14 inches, that he sold to a private collection.

36. Merritt, with the sensibility of the modern period, noted that "the main concern is with the texture of the painting as a whole, not that of the objects depicted, and the denial of 'correct' perspective and normal scale relationships is undertaken for positive emotional and design reasons, giving equal interest to both two-dimensional pattern and recession in depth." Merritt 1956, p. 218.

37. Leah Lipton, "The Boston Art Association, 1841–1851," *American Art Journal*, vol. 15, no. 4 (Autumn 1983), pp. 45–47. On the competing policies of the American Academy and the National Academy of Design in this period, see Carrie Rebora Barratt, "Mapping the Venues: New York City Art Exhibitions," in *Art and the Empire City: New York, 1825–1861*, ed. Catherine Hoover Voorsanger and John K. Howat, exh. cat. (New York: Metropolitan Museum of Art; New Haven: Yale University Press, 2000), pp. 47–55.

38. The exhibition records of the National Academy of Design, the Pennsylvania Academy of the Fine Arts, and the Boston Athenaeum provide numerous instances of such copies. Thomas Birch, whose practice was otherwise so similar to that of Chambers, exhibited a *View Near Naples after Unnamed Artist* at the Pennsylvania Academy in 1835, and other views of coastlines in England, Scotland, and Italy, either from prints or as copies.

39. See Robert F. Perkins and William J. Gavin, eds., *The Boston Athenaeum Art Exhibition Index, 1827–1874* (Boston: Library of the Boston Athenaeum, 1980).

40. "The Fine Arts: The Apollo Association," *New-York Mirror*, December 4, 1841, p. 390.

41. Mary Bartlett Cowdrey made the first study of these copies, many of which were attributed to Bartlett in the twentieth century, in "William Henry Bartlett and the American Scene," *New York History*, vol. 22 (October 1941), pp. 398–413. She identified three classes of this work: de Grailly–type copies, misattributed work by contemporary American artists, and intentional fakes. Her work was enlarged by Mary Ellen Earl, in her introduction to *William H. Bartlett and His Imitators*, exh. cat. (Elmira, N.Y.: Arnot Art Gallery, 1966), pp. 1–18. This exhibition contained work by Chambers as well as many de Grailly–type copies. Earl notes that de Grailly had an exhibition of his Bartlett copies in 1845 (p. 13), although she does not say where, and I have not discovered confirmation of this show elsewhere. A set of variations on the Bartlett views of the Connecticut River, all attributed to de Grailly, is examined by Martha Hoppin, in *Arcadian Vales: Views of the Connecticut River Valley*, exh. cat. (Springfield, Mass.: Springfield Library and

Museums Association for the George Walter Vincent Smith Museum, 1981), pp. 34–37, 73–74. A bibliography of Bartlett's illustrations, which lists other publications that Chambers evidently used, is given by Alexander M. Ross, *William Henry Bartlett: Artist, Author and Traveller* (Toronto: University of Toronto Press, 1973). The major source of information on de Grailly is William Nathaniel Banks, "The French Painter Victor de Grailly and the Production of Nineteenth-Century American Views," *Antiques*, vol. 106, no. 1 (July 1974), pp. 84–103, which includes a photograph of the Paris art supply–store stencil on the back of many of the paintings attributed to de Grailly. One painting, *View from Gowanus Heights, Brooklyn*, is stamped "Prepared by Ed Dechaux, New York"; see Elizabeth Mankin Kornhauser, in *Brooklyn before the Bridge: American Paintings from the Long Island Historical Society*, exh. cat. (Brooklyn: Brooklyn Museum, 1982), pp. 48–49. In 1850, the catalogue commentary to a Catskill Mountain subject by de Grailly noted that he painted it "while in this country about seven years since"; *Catalogue of a Collection of Valuable Paintings, to Be Sold at Auction, on Wednesday, April 24, 1850, by Leonard and Cunningham* (Boston: Red Mudge, 1850), p. 3; see Lugt's *Répertoire*, http://idcpublishers.info, cat. no. 19822 (accessed March 2008).

42. Stuart Preston likened the effect of one of these Eastport scenes to "an Italian primitive"; *New York Times*, January 24, 1954, p. xii. Like many of Chambers' paintings, the Eastport subjects have been recast over time as Hudson River views. The Dallas painting, fig. 4-20, although correctly identified in the 1950s when it was owned by Hirschl and Adler Galleries, New York, was known as *View of the Hudson River* in the 1960s. A version with a hunter at the right and two bare pines at the left (18 by 24 inches) was reproduced in the *Old Print Shop Portfolio*, vol. 14, no. 1 (August–September 1954), no. 28. Another of the same size, *River View of Town*, appeared in *Art Out of the Attic: An Exhibition of 19th Century American Paintings from Vermont Homes*, exh. cat. (Middlebury, Vt.: Christian A. Johnson Art Center, Middlebury College; Montpelier: Vermont Council on the Arts, 1970), p. 23, cat. no. 58, from the collection of Mr. and Mrs. Ralph Ryan. The smallest known version, 14 by 18 inches, known as *West Point on the Hudson River*, was with Godel & Co. Fine Art, New York, in 2002. Two other versions have been reported, but I have not seen them; they may be other sightings of the ones listed here.

43. All the versions I have seen are 18 by 24 inches. The version closest to the de Grailly was published in "American Primitive, Naive, and Folk Art," *Kennedy Quarterly*, vol. 11, no. 3 (1972), p. 153, no. 114, as *Monastery*, and recently sold at Northeast Auctions, Manchester, N.H., on August 5, 2006, as *Monastery by the Sea*, no. 1111, in an ornate Chambers-type frame. Another, with an explosion of Chambers' spearlike flowers on the left bank, is in the Shelburne Museum, acquired from Maxim Karolik; a fourth, in the collection of Costa Sakellariou, was purchased in Scranton, Pa.; and a fifth was sold within the last few years at Pook and Pook in Downingtown, Pa., according to Sakel-

lariou. De Grailly's epithet recurs throughout the Eddy catalogues, beginning with the New York sale of 1841, described in n. 45 below.

44. Chambers' painting *Kosciusko's Monument* (18 by 24 inches), sold at Northeast Auctions, Manchester, N.H., August 5, 2006, lot 109, can be compared to de Grailly's signed and dated 1844 version (22½ by 28¼ inches) of the same subject at the Fruitlands Museum. De Grailly's picture adds a large tree at the center, a blasted stump in the foreground, and a cliff at the right, all seen in Chambers' version, which has alterations of its own.

45. Born in Providence, Eddy worked as an engraver in Boston and New York before earning a fortune importing paintings and managing real estate; see *James Eddy: Born May 29th, 1806. Died May 18th, 1888. Biographical Sketch. Memorial Service. Selected Thoughts* (Providence: Reid, 1889). *A Catalogue of Nearly 250 Splendid Modern Paintings, by the most distinguished European living Artists, now exhibiting at the Apollo Association Gallery . . . June 18* (New York: John B. Glover, auctioneer, 1841); *150 Splendid Modern European Paintings, now exhibiting at the corner of Four and a half Street . . . July 24* (Washington, D.C.: Dyer and Wright, auctioneers, 1841); *A Catalogue of an entire new collection of 250 Splendid Modern European Paintings! By Eminent Living Artists, now exhibiting at Harding's Gallery, School Street . . . December 21* (Boston: Coolidge and Haskell, auctioneers, 1841); *A Catalogue of about 250 Splendid Modern European Paintings, by Eminent Living Artists, now exhibiting at the Artists' Fund Hall . . . March 8th* (Philadelphia: Thomas Birch, Jr., auctioneer, 1842). James Eddy is not named in these catalogues, although the "gentleman travelling in Europe" is described in the "Note to the Public" in each of them; his identity is revealed in three priced catalogues of these sales at the Frick Art Reference Library, New York. I have not seen the fourth catalogue, of the Dyer sale in Washington, D.C., but the contents of the sale (see the Smithsonian American Art Museum's Pre-1877 Art Exhibition Catalogue Index, http://siris-artexhibition.si.edu) are very similar to the other three. The surviving catalogues may not represent all the venues. The indispensable bibliography of American auctions of this period, Harold Lancour, *American Art Auction Catalogues, 1785–1942: A Union List* (New York: New York Public Library, 1942), lists many of these sales, but other auction catalogues have emerged since, including some that can be read online at SCIPIO: Art and Rare Book Sales Catalogs and Lugt's *Répertoire* (http://idcpublishers.info). However, the ephemeral nature of the original catalogues makes it difficult to track all the auction activity in this period.

46. *Catalogue of 129 Splendid Modern European Paintings, now exhibiting in the Horticultural Room in Tremont Street . . . April 5, 1844* (Boston: Coolidge and Haskell, auctioneers, 1844). The preface notes that fifteen months had been spent in Europe forming the collection. The second sale, with a marked catalogue connecting it to Eddy, is the only one that can be identified as his project, but the other three sales have the same artists and titles. See the untitled catalogue headed "Account Sales of Paintings by Wm P. Greene for Account of Mr. J. Eddy, Providence, May 10, 1844," and a second tally from a sale, also at Franklin Hall, May 18, 1844, both Frick Art Reference Library; and *Catalogue of 234 Splendid European Modern Paintings now exhibiting in the Granite Building . . . January 14, 1845* (New York: Glover, auctioneer, 1845).

47. Glover sale, New York, 1841, p. 3. The Bartlett subjects were all identified as such; the old master paintings were not always attributed to a copyist but sometimes just listed as "in the style of" a more famous painter. Copies of Vernet that were ascribed to de Grailly in later catalogues went unattributed in 1841 but had the same descriptive wording. De Grailly also contributed copies of his own work that had been shown recently at the Paris Salon.

48. *Catalogue of a valuable new collection of 225 Modern European Oil Paintings recently imported . . . Feb. 12, and . . . Feb. 14th* (Boston: Coolidge and Haskell, auctioneers, 1850); *Catalogue of a valuable new collection of 175 Fine European Oil Paintings recently imported . . . June 14th & 15th* (Philadelphia: C. J. Wolbert, auctioneer, 1850); and *Catalogue of a valuable new collection of 181 Fine European Oil Paintings Recently Imported . . . June 22, . . . & . . . June 25* (Philadelphia: C. J. Wolbert, auctioneer, 1850). Only two Bartlett subjects appear in a Philadelphia sale of 1852, and the copyists are not named; see *Catalogue of a Large and Valuable Collection of 176 Oil Paintings, at the New Assembly Buildings . . . Sept. 24th* (Philadelphia: C. J. Wolbert, auctioneer, 1852). The waning of the phenomenon seems to be indicated by the single Bartlett subject by de Grailly, which joined a copy by Damoulin of Cole's *Voyage of Life*, in the Patten sale, Portland, Maine, March 3–4, 1854 (see http://siris-artexhibition.si.edu). The final sale of these subjects and artists seems to have been *Catalogue of an Extraordinary Collection of about 211 Valuable, Original Oil Paintings . . . May 17 & 18* (Boston: Thompson, auctioneer, 1855), which included five paintings by Garnier of American subjects and two unattributed Bartlett views among the European paintings.

49. Banks, "French Painter Victor de Grailly," p. 90.

50. See Brewer, in *An American Picture-Gallery*, by Foster and Brewer, pp. 82–83. Another version of *West Point from Phillipstown*, of the same size, is in the collection of the Fruitlands Museum. The work by these artists, as tracked at http://siris-artexhibition.si.edu, appeared mostly in the auction sales, and only occasionally in local exhibitions, evidently lent by collectors. How many of these artists had careers in Paris, like de Grailly and Garnier, remains to be learned.

51. Annotated copies from several of these sales at the Frick Art Reference Library give the prices as well as the names of the customers; I tracked one set of buyers in Philadelphia city directories. The framer was paid an average of about $1.10 per frame, for which the customers paid between $1.50 and $4.50. A surviving pair of the Mount Vernon views is in the Bradley Collection at Indiana University Art Museum (2003.42 and 2003.43); both are about 16 by 21½ inches. Such pairs attributed to de Grailly, Garnier, and Alphonse Masson appeared in the Eddy sales, with these same subjects sometimes

appearing with other mates, such as the Natural Bridge, Virginia. Also common were double views of Niagara and paired views of the Rhine. A pair of harbor scenes, "View of Boston Light, and a packet sailing out of Boston harbor, highly finished pictures from sketches by Salmon and George L. Brown," appeared in the 1841 Boston sale, in Philadelphia in 1842, and again in Providence in 1844.

52. See Earl, *William H. Bartlett*. Boston's group of such painters in Chambers' day might be among those listed in a sale at Howe and Leonard, June 23, 1843 (Lancour 45), which included an assortment of American landscape subjects by contemporary painters (Cole, Doughty, Gerry, Fisher, Chapman, Lane) as well as generic European subjects of Scotland and Italy by Boston painters not known to have visited Europe, such as John J. Soren, the copyist Thomas T. Spear, the fancy painter S. [B.?] Foster, and two Bartlett-sounding subjects by L[orenzo?] Somerby, also known as a sign painter. The heyday of the professional copyists seems to have encouraged amateurs as well. The American Art-Union engravings, distributed by the thousands around 1850, inspired many copies, notably different from Chambers' work in either their timid fidelity to the print source or lesser skill. For a suite of amateur renditions of Jasper Cropsey's *American Harvesting*, engraved for the Art-Union in 1851, see Bishop, *Folk Painters of America*, pp. 98–99.

53. On November 27, 28, and 29, G. B. Pandolfini managed a sale of household art and fifty "splendid" oil paintings in "richly carved and gilt frames, comprising beautiful American and foreign landscapes, marine views, Madonna & Child, etc. etc. mostly from the pencil of E. C. Coates. Esq."; *Brooklyn Eagle*, November 21, 1854, p. 3. After the Philadelphia sale of 1850, the auctions based on work by the Eddy artists showed fewer American subjects. The Philadelphia sale of 1852 contained only two; the Portland sale of 1854 only one; the Boston sale of 1855 only seven.

54. Little is known about Coates, and accounts vary concerning his arrival in the United States. He exhibited at the Apollo Association in 1839 and 1840, and perhaps at the National Academy in 1840, the year he was described in the *New-York Mirror*, July 25, 1840, p. 38, as a teacher who painted "to sell" (Colonel Merl M. Moore, Jr., Files, Smithsonian American Art Museum/National Portrait Gallery Library). In 1858–59 he was listed in the Brooklyn directory as a picture framer. For the best summary of research on Coates, see Natalie Spassky, *American Paintings in the Metropolitan Museum of Art*, vol. 2 (New York: Metropolitan Museum of Art with Princeton University Press, 1985), pp. 8–12; and Hoppin, *Arcadian Vales*, pp. 65–66.

55. Peter Tillou recalls seeing a newspaper advertisement for a Chambers sale in a hotel in Albany in the 1850s. Given the quality of his Newport broadside, it is likely that he staged many sales with such ephemeral publications.

56. Chambers' subjects from Bartlett and Milbert are listed in Chapter Three, nn. 9 and 15. Two versions of Doughty's *Silver Cascade* (an image that is included in N. P. Willis, *American Scenery; or, Land, Lake, and River Illustrations of Transatlantic Nature*, 2

vols. [London: George Virtue, 1837–40]), attributed to de Grailly, are at the Fruitlands Museum.

57. John Wilmerding, *Robert Salmon, Painter of Ship and Shore* (Salem, Mass.: Peabody Museum of Salem, 1971), p. 46.

58. See Brewer, in *An American Picture-Gallery*, by Foster and Brewer, p. 88. First seen at the Boston Charitable Mechanics Association exhibition in 1850, Hill is known only through this work, which is probably the painting by this title, no. 18 in an auction at Leonard's in Boston, May 22, 1863 (Lancour 204).

59. *New-York Evening Post*, April 22, 1837, p. 3, col. 5. The Colonel Merl M. Moore, Jr., Files at the library of the Smithsonian American Art Museum indicate that Levy had sales every Wednesday and Saturday nights in the mid-1830s, mixing contemporary American paintings with pictures imported from Belgium, France, and Italy.

60. See "Clarquo's" assessment of the auction market in "The Fine Arts. Picture Sale," *Independent*, vol. 6, no. 312 (November 23, 1854) (APS Online). This article comments on the predictable cheating and rampant lying in the art business, as well as the notorious "mock auctions" that pitted gullible clients against invisible house bidders. The Eddy sales catalogues pointedly guarantee that "every painting will be sold without reserve to the highest bidder," Glover sale, New York, 1841. Similar fraudulent practices are described in "Picture Auctions and 'Dealings,'" *Anglo-American*, vol. 5, no. 8 (June 14, 1845) (APS Online, p. 188).

61. Watkins 1841, pp. 21–22, cited in Russett 1996, p. 33.

62. Ibid. Characterizing the different levels of skill and price in the American art market, a writer in 1860 noted that the youngest class of artists, still "immature and untutored," would discover that "their works only find the cash in the auction rooms or show windows of the picture framer." A medium-sized painting sold in this fashion by such an artist might bring $20, and much less at auction, owing to competition with imported pictures, sold in "immense numbers" for $10 to $20. "The Dollars and Cents of Art," *Cosmopolitan Art Journal*, vol. 4, no. 1 (March 1860), p. 30.

63. Watkins 1841, pp. 22–23, cited in Russett 1996, p. 33.

64. Watkins 1841, p. 126, cited in Russett 1996, p. 95.

65. "The Dollars and Cents of Art," pp. 30–31.

66. Black references an exhibition by Field in 1837 at the Hubbard Tavern in Plumtrees, Mass.; see Mary Black, "Patroon Painters to Republican Limners: Artisan Painting in America," in *Face to Face*, ed. Oak, p. 16. See Jaffee, "'A Correct Likeness,'" in *Folk Art and Art Worlds*, ed. Vlach and Bronner, and the series of papers in Peter Benes, ed., *Itinerancy in New England and New York* (Boston: Dublin Seminar for New England Folklife, 1984).

67. On the Duxbury painting, see Chapter One, n. 57. The provenance of the Catskill Mountain subject was given by the current owner, who inherited the painting from his grandfather, a man born in Biddeford, Maine, in 1883, who received the painting from

his uncle, who purchased it. These are the only two stories of provenance dating to Chambers' day that I have encountered. Typically, extant dealers' records lead back to antique stores and auctions in the towns I have listed above. Only a few Chambers paintings have come on the market in the twentieth century from south of New York City.

68. The owner of the Catskill Mountain House subject described in note 67 commented that the artist tailored the architecture of the Mountain House to resemble the family's home rather than the hotel shown in the Bartlett print.

69. John Wilmerding has noted to me that Fitz Henry Lane signed fewer than one-quarter of his paintings; most of those signed works had been sent to public exhibition.

70. Although Chambers evidently was drawing from imagery created by visiting French and British artists with celebratory missions, the harmony-seeking national (and New York–based) agenda expressed by his choices follows the pattern identified by Angela Miller in *The Empire of the Eye: Landscape Representation and American Cultural Politics, 1825–1875* (Ithaca: Cornell University Press, 1993). Miller also argues that the taste for paintings that aestheticize the landscape (especially wilderness), removing it from the purely local into the realm of the national, coincides with the development of the urban, middle-class market; see "Landscape Taste as an Indicator of Class Identity in Antebellum America," in *Art in Bourgeois Society, 1790–1850*, ed. Andrew Hemingway and William Vaughan (Cambridge: Cambridge University Press, 1998), pp. 340–61.

71. Chambers was born into the Anglican church in Whitby, and his patron base in the United States would have been overwhelmingly Protestant and probably anti-Catholic. As an urban artisan-entrepreneur, he was most likely a Democrat, and would have found a welcome in the Democratic strongholds of agrarian New York State worked by itinerant portraitists Ammi Phillips and John Vanderlyn; see Neil G. Larson, "The Politics of Style: Rural Portraiture in the Hudson Valley during the Second Quarter of the Nineteenth Century" (master's thesis, University of Delaware, 1980). This political affiliation might be confirmed by Chambers' distance from the circles of the conservative Whigs in the New York elite who patronized Thomas Cole, as well as the increasingly old-fashioned profile of the Democratic Party after 1838; see Wallach, "Thomas Cole, Landscape and the Course of Empire," in *Thomas Cole*, ed. Truettner and Wallach, pp. 34–38. However, Chambers' fondness for naval subjects from the War of 1812 shows his admiration for Cooper, an elitist conservative; the U.S.S. *Constitution* was recognized as a symbol of Whig policies. See also Chapter Two, n. 49; and Tyler Anbinder, *Five Points: The 19th-Century New York City Neighborhood that Invented Tap Dance, Stole Elections, and Became the World's Most Notorious Slum* (New York: Free Press, 2001), p. 27.

72. The Bradley Collection at the Indiana University Art Museum contains three pairs of Chambers paintings. Like the pair of Niagara subjects (figs. 3-8 and 3-9), the set of river views (figs. 4-28 and 4-29) came in matching frames. Morton C. Bradley, Jr., swapped the frames on these two sets. The two Scottish landscapes (figs. 3-20 and 3-21) were found together in Maine.

73. Preface to Coolidge and Haskell sale, Boston, 1844. The story that a single household contained more than two paintings by Chambers has accompanied a pair of Castle on the Rhine subjects described in Chapter Three, n. 58. See Appendix for pairs proposed in the Newport sale.

74. "Corry O'Lanus' Epistle," *Brooklyn Eagle*, March 25, 1865, p. 2. This account, even if meant to be funny, suggests how quickly such an artist might have produced work for an auction or on commission. The description of the artist, "Rembrandt Titian Jones," included a slouched hat, turned-down collar, and walking cane.

75. Vanderlyn in 1825, cited in Jaffee, "'Correct Likeness,'" in *Folk Art and Art Worlds*, ed. Vlach and Bronner, p. 53; and Nicoll et al., *Meet Your Neighbors*, p. 39.

76. See Priddy, *American Fancy*; see also Chapter One.

77. Frances Trollope, *Domestic Manners of the Americans*, 2nd ed., vol. 2 (London: Whittaker, Treacher, 1832), p. 203, cited in Wayne Craven, "Patronage and Collecting in America, 1800–1835," in *Mr. Luman Reed's Picture Gallery: A Pioneer Collection of American Art*, by Ellen Foshay et al. (New York: Harry N. Abrams with the New-York Historical Society, 1990), p. 12; "Fine Arts: The Drawing Master," *Anglo-American*, vol. 5, no. 21 (September 13, 1845) (APS Online, p. 500); "Spending Money for Worthless Objects," *Broadway Journal*, vol. 1, no. 21 (May 24, 1845), pp. 321–22.

78. "The Fine Arts Picture Sale," *Independent*, vol. 6, no. 312 (November 23, 1854) (APS Online, p. 376). A correspondent to the *Crayon*, criticizing the paintings available to members of the new Cosmopolitan Art Association, described them as "French copies" of old masters, "whose pictures have been reproduced hundreds and hundreds of times and sent to this country to supply the auction sales. Such pictures a man of taste would never buy"; "Sketchings," *Crayon*, vol. 2, no. 24 (December 12, 1855), p. 378. The character of the art criticism of this era and a survey of influential publications is given by David Dearinger, "Annual Exhibitions and the Birth of American Art Criticism to 1865," in *Rave Reviews: American Art and Its Critics, 1826–1925*, ed. David B. Dearinger and Avis Berman, exh. cat. (New York: National Academy of Design, 2000), pp. 58–82.

79. P. Green, "Art News from Albany," *Crayon*, vol. 2, no. 24 (December 12, 1855), pp. 376–77. The evasive identification of the source and the copyist suggested by this account follows the pattern of the later sales of Eddy-type paintings.

80. The *Cosmopolitan Art Journal*, continuing its characterization of the art world in 1860 in "The Dollars and Cents of Art" (see n. 62 above), described the artists of the lowest class as "those who hire themselves out by the month to certain well-known 'auctioneers,' who, by a great dash display of frames and gas light, in some well-chosen store on Broadway or the Bowery, succeed in palming off on 'greenhorns,' with more money than art-sense, a large number of most detestable daubs, at average good price. No sooner is

one store fill sold off 'at an alarming sacrifice' than another is ready which '*must* be sold to close out a consignment.' It is estimated that there are two hundred 'artists' in the employ of these mock auction shops" (p. 31). The estimate of two hundred such artists, even if exaggerated, must make us wonder who they were, and where all these paintings have gone. The description of such a large class of painters puts a new light on the possible existence of "Mr. Nesbit" and "Mr. Corbin" in the Newport sale.

81. "Paintings in Boston," *New-York Mirror*, June 8, 1839, pp. 16, 50 (APS Online, p. 399).

82. Colwill, *Francis S. Guy*, p. 25. On the Finlay brothers' painted furniture, see Priddy, *American Fancy*, pp. 48–54. My thanks to Alexandra Kirtley for sharing de Beet's story and offering information on the painted furniture of this era.

83. Alexis de Tocqueville, *Democracy in America*, vol. 2 (New York: Knopf, 1945), pp. 50–54. Tocqueville's remarks, first published in 1835, based on his nine months in the United States in 1831–32, were cited in the context of American provincial art by David Tatham, "Portrait Painters in Upstate New York, 1815–1845," in *Face to Face*, ed. Oak, pp. 19–20.

84. See Glassie, *The Spirit of Folk Art*. Modernist attitudes to folk art are examined in Chapter Five of this volume.

85. For two different perspectives on the dialogue between folk art and popular art, see George Kubler, "The Arts: Fine and Plain," and Kenneth Ames, "Folk Art: The Challenge and the Promise," both in *Perspectives on American Folk Art*, ed. Quimby and Swank, pp. 234–46, 312–13.

86. The cornerstone studies of patronage are Neil Harris, *The Artist in American Society: The Formative Years, 1790–1860* (New York: George Braziller, 1966); and Lillian Miller, *Patrons and Patriotism: The Encouragement of the Fine Arts in the United States, 1790–1860* (Chicago: University of Chicago Press, 1966). See also Craven, "Patronage and Collecting in America, 1800–1835," in *Mr. Luman Reed's Picture Gallery*, by Foshay et al., pp. 11–18. Alan Wallach characterizes the shifting patronage of this period, from the "aristocratic" model to the bourgeois pattern, in "Thomas Cole, Landscape and the Course of Empire," in *Thomas Cole*, by Truettner and Wallach, pp. 33–47.

87. See Miles Orvell, *The Real Thing: Imitation and Authenticity in American Culture, 1880–1940* (Chapel Hill: University of North Carolina Press, 1989). Beginning from a study of Walt Whitman, Orvell argues that the search for authenticity and the rejection of the mid-nineteenth-century's culture of imitation (roundly represented by Chambers and the faux-grained furniture of his era) was a cornerstone ethic of modernism. Michael Leja develops this thesis in turn-of-the-century American visual culture, with its anxiety over truthfulness and deceit, in *Looking Askance: Skepticism and American Art from Eakins to Duchamp* (Berkeley: University of California Press, 2004).

1. From New York 1942, preface. The history of this phenomenon of recovery and reinvention, often told in the biographies of artists and the catalogues of collections formed in this period, is surveyed by Beatrix T. Rumford, "Uncommon Art of the Common People: A Review of Trends in the Collecting and Exhibiting of American Folk Art," in *Perspectives on American Folk Art*, ed. Ian M. G. Quimby and Scott T. Swank (New York: W. W. Norton for the H. F. du Pont Winterthur Museum, 1980), pp. 13–53. More recently, this story has been told by Colleen Cowles Heslip and Charlotte Emans Moore in *A Window into Collecting American Folk Art: The Edward Duff Balken Collection at Princeton*, exh. cat. (Princeton, N.J.: Art Museum, Princeton University, 1999); and Virginia Tuttle Clayton, in *Drawing on America's Past: Folk Art, Modernism, and the Index of American Design* (Chapel Hill: University of North Carolina Press, 2003).

2. From New York 1942, preface; Edward Alden Jewell, "Art by Americans to Be Seen Here," *New York Times*, May 9, 1941. I have not discovered the catalogue of the Levy Gallery exhibition.

3. The catalogue lists eighteen works, but exhibition press, as well as Duveen's papers at the Archives of American Art, indicates that at least one other painting, *Fantasy*, was also in the show. See "Recent Discovery of a 19th Century Artist," *Town and Country*, vol. 98 (May 1943), p. 46. The New Jersey collector Richard A. Loeb, a client of Duveen who gathered the first large private collection of Chambers' work, was also a partner in the Macbeth project, lending many paintings to the show. An advance notice of the show commented that the partners had "unearthed" a total of thirty paintings by Chambers during the previous six years; "Chambers, America's First Modern," *Art Digest*, vol. 17, no. 4 (November 15, 1942), p. 23.

4. Exhibitions by Andrew Wyeth and N. C. Wyeth at the Macbeth Gallery in the late 1930s may give a context for the two Chambers paintings in N. C.'s collection, although these paintings (figs. 2-19 and 2-20) were not attributed to Chambers until recently.

5. From Craven's comment, and from Robert McIntyre's statement in New York 1942, pp. 3, 6.

6. Holger Cahill's essay, "Artists of the People," in *Masters of Popular Painting: Modern Primitives of Europe and America*, by Holger Cahill and Maximilien Gauthier, exh. cat. (New York: Museum of Modern Art, 1938), pp. 95–105, remains a primary statement of the values embedded in the recovery of American folk art; quotations are from pp. 97 and 95. Cahill's first exhibition in this vein, *American Primitives*, at the Newark Museum in 1930–31, grew out of his experience in the 1920s with the artists and folk art collectors in the circle of Hamilton Easter Field, the Whitney Studio Club, and Edith Halpert's Downtown Gallery; for two perspectives on his involvement with American folk art, see John Michael Vlach, "Holger Cahill as Folklorist," *Journal of American Folklore*, vol. 98, no. 388 (April–June 1985), pp. 148–62; and Wendy Jeffers, "Holger

Cahill and American Art," *Archives of American Art Journal*, vol. 31, no. 4 (1991), pp. 2–11. Cahill's subsequent exhibition and catalogue, *American Folk Art: The Art of the Common Man in America, 1750–1900* (New York: Museum of Modern Art, 1932), established the terms for understanding folk art (as quaint, childlike, simple, honest, innocent, and in some ways akin to modernist art), and defended their "frankly derivative" use of sources as a strength: "[B]orrowing has not been disdained by the great masters, in fact one of the signs of a vital art is the ability to assimilate the work of others" (pp. 3, 9, 27). Cahill's 1938 show, with its sophisticated pairing of European and American "folk and popular" artists, rose above the national narrative to argue for the merit of self-trained and shop-trained artists, and implicitly for artists of diverse ethnic, racial, and class backgrounds. Following Cahill, Jean Lipman set out to define the field in *American Primitive Painting* (New York: Oxford University Press, 1942), including a useful early bibliography and a list of early exhibitions and collections. With Alice Winchester, Lipman also edited *Primitive Painters in America, 1750–1950: An Anthology* (New York: Dodd, Mead, 1950), surveying the newly discovered favorites of the mid-century, including Chambers.

7. "Comments," New York 1942. For Drepperd's discourse on the problems of terminology in dealing with the range of "Americana," see "What Is Primitive and What Is Not?" in *American Pioneer Arts and Artists* (Springfield, Mass.: Pond-Ekberg, 1942), pp. 1–12. Against Drepperd's disdain for the Hudson River School and the rising tide of modernism, it is interesting to place the gradual rescue of painters such as Cole; see William Truettner's historiography of the study of American landscape painting in "Nature and the Native Tradition: The Problem of the Two Thomas Coles," in William H. Truettner and Alan Wallach, *Thomas Cole: Landscape into History*, exh. cat. (New Haven: Yale University Press; Washington, D.C.: National Museum of American Art, Smithsonian Institution, 1994), pp. 137–58.

8. [Andrew Carnduff Ritchie], "Gallery Notes," Buffalo Fine Arts Academy, Albright Art Gallery, Buffalo, N.Y., July 1946, p. 23.

9. Howard Devree, "A Reviewer's Notebook," *New York Times*, November 29, 1942.

10. Alice Ford, *Pictorial Folk Art: New England to California* (New York: Studio Publications, 1949), p. 19; *Panorama* (August–September 1948), cited by D. N., in Theodore E. Stebbins, Jr., *The Hudson River School: 19th Century American Landscapes in the Wadsworth Atheneum*, exh. cat. (Hartford: Wadsworth Atheneum, 1976), p. 33.

11. For a discussion of *Mount Auburn Cemetery* and its one known variant, both based on a print after Bartlett, see Chotner 1992, pp. 54–55.

12. "Comments," New York 1942.

13. "America's First Modern, T. Chambers," *Art Digest*, vol. 17, no. 5 (December 1, 1942), p. 11.

14. "Comments," New York 1942. The rise of the formalist aesthetic, which turned lack of context into an advantage by heightening decorative impact in art galleries or homes, was the most powerful force in transforming the status of Chambers' work, effectively "diverting" it, as the anthropologist Arjun Appadurai would say, from its original, intended path into a new phase of enhanced market value. Such a "cultural biography" for an object, often shaped by lack of information, is shared by much folk, ethnographic, or otherwise exotic art drawn into the sphere of Western collecting. See "Introduction: Commodities and the Politics of Value," in *The Social Life of Things: Commodities in Cultural Perspective* (Cambridge: Cambridge University Press, 1986), pp. 3–63.

15. Drepperd, *American Pioneer Arts and Artists*, p. 56.

16. Devree, "A Reviewer's Notebook."

17. "The Passing Shows," *Art News*, vol. 41 (December 1, 1942), p. 27.

18. M. A., "T. Chambers," *Smith College Museum of Art Bulletin*, vol. 24 (October 1943), pp. 14–15.

19. A. Everett Austin, Jr., quoted in Elizabeth M. Kornhauser et al., *American Paintings before 1945 in the Wadsworth Atheneum*, vol. 2 (Hartford: Wadsworth Atheneum; New Haven: Yale University Press, 1996), p. 178, cat. no. 97.

20. [Ritchie], "Gallery Notes," p. 23.

21. Little 1948, p. 194; Nina Fletcher Little, "Earliest Signed Picture by T. Chambers," *Antiques*, vol. 53 (April 1948), p. 285; and Little, "More about T. Chambers," *Antiques*, vol. 60 (November 1951), p. 469. In 1950 she owned at least two paintings by Chambers, *Villa on the Hudson* and *The Battery and Castle Garden* (both unlocated). Howard Merritt likewise owns three paintings by Chambers, all found near Rochester, New York.

22. Virgil Barker, in his chapter "The Mid-century Concept of Imagination," *American Painting: History and Interpretation* (New York: Macmillan, 1950), counterposed William Page and Chambers, suggesting that to the cultural elite "Chambers was just a sign painter." Noting his use of print sources, Barker argued that "the designs go much beyond any prints in energy of conception and impetuousness of execution." Commenting on Chambers' unusual color contrasts, his "positive and compelling rhythm to everything," with converging diagonals and repeated shapes, Barker also noted that "the rhythmic working of his mind extended even into the brush strokes, which repeat and repeat with little or no regard for naturalistic surfaces but with an evident pleasure in the way their large dottings and blunt curvings activate large areas of the picture surface. This mental stylization is the only element of control over a tendency to lavishness; and the stylization would seem to be as clearly derived from sign painting as that of Edward Hicks" (p. 496). Not long after, Edgar P. Richardson contributed similar remarks to his influential survey of American art, noting that Chambers "is interesting to modern taste because his flat, brilliant hues, boldly stylized drawing, and two-dimensional nonatmospheric style seem to foreshadow early twentieth-century modes of painting." *Painting in America: The Story of 450 Years* (New York: Crowell, 1956), p. 208.

23. The Garbisches began to give paintings to the National Gallery as early as 1953; the record of their gifts and bequests is documented in Chotner 1992. Thirty-one other

museums also received gifts or chose collections after the death of Mrs. Garbisch in 1979. See, for example, figs. 4-4 and 4-5, now in the Philadelphia Museum of Art.

24. On the story of the Gunn collection, see Agnes Halsey Jones and Louis C. Jones, *New-found Folk Art of the Young Republic*, exh. cat. (Cooperstown: New York State Historical Association, 1960); and Amy McKune, "The Gunn Legacy," in *Folk Art's Many Faces: Portraits in the New York State Historical Assocation*, ed. Paul S. D'Ambrosio and Charlotte Emans, exh. cat. (Cooperstown: New York State Historical Association, 1987), pp. 15–19.

25. The collection of the Fruitlands Museum is accessible at http://www.fruitlands.org; an additional painting by Chambers came in 1958. The earliest Chambers painting to enter an American museum was *The U.S.S. "Cumberland" Rammed by the C.S.S. "Virginia"* (fig. 2-21), bequeathed in 1928 to the Peabody Museum in Salem, Mass., by Francis B. C. Bradlee, but not attributed until 2007. The distribution of Chambers' work in institutions can be tracked in the Smithsonian's online inventory of American paintings, http://americanart.si.edu/search/search_data.cfm. Very few of Chambers' paintings, other than examples in Minneapolis and Flint, are in institutions west of the Ohio River or south of Williamsburg, although examples in private collections are more widely dispersed.

26. Bradley's life story is given in Kathleen A. Foster, "The Morton and Marie Bradley Memorial Collection," in *An American Picture-Gallery: Recent Gifts from Morton C. Bradley, Jr.*, by Kathleen A. Foster and Nanette Esseck Brewer, exh. cat. (Bloomington: Indiana University Art Museum, 1992), pp. 3–6. See also "The Geometric Sculptures of Morton C. Bradley, Jr.," http:www.iub.edu/~iuam/online_modules/bradley.

27. Fifty years after the first folk art exhibition at the Whitney Studio Club in 1924, and almost a quarter century after their first joint publication, *Primitive Painters in America*, Jean Lipman and Alice Winchester reconvened to summarize the mid-twentieth-century modernist-collector position in *The Flowering of American Folk Art, 1776–1876*, exh. cat. (New York: Viking with the Whitney Museum of American Art, 1974). The Whitney followed this exhibition with a more focused survey of painting organized by Lipman and Tom Armstrong, with contributions by Mary Black, Nina Fletcher Little, and many others, *American Folk Painters of Three Centuries*, exh. cat. (New York: Hudson Hills with the Whitney Museum of American Art, 1980). In the latter book, Lipman gives a chronology of key exhibitions and publications in the twentieth century (pp. 10–11, 220–22). Both exhibitions drew folklore and material culture scholars into the discussion, bringing new methods and attitudes represented by the work of Henry Glassie (see Chapter Four, n. 5) and the contributors to Quimby and Swank, eds., *Perspectives on American Folk Art*. Subsequent bibliography can be found in Chotner 1992, and in the sources cited above in Chapter Four, n. 5.

28. The concept of kitsch was introduced in the United States by Clement Greenberg in his influential essay, "Avant-Garde and Kitsch" of 1939, published just a few years before Chambers' rediscovery as a "modern." His definition, although subsequently much revised, offers an interesting theoretical and historical framework for judging Chambers' work. In Greenberg's terms, Chambers' paintings are indeed, like kitsch, derivative of higher and older art, and often depict unchallenging, widely recognized, and emotional subjects, although this could be said of much mainstream painting of the period. Also characteristic of kitsch would be his occasionally slapdash execution, and the hypothetical pretensions of his customers who, as Tocqueville might have described them, aspired to elite status and were ignorantly satisfied by low-cost imitations of high-style work. Chambers' willful disregard for his print sources, however, and the creative quality of his appropriation make his work unlike more heartless or mechanical commercial art. As discussed in Chapter Four, he shared methods with many other painters of his period, which in any case predated the onslaught of industrially produced popular art after the mid-nineteenth century, when the term *kitsch* was invented in Germany. Greenberg's essay is reprinted in *Art and Culture: Critical Essays* (Boston: Beacon Press, 1961), pp. 3–21. Although Greenberg saw kitsch as the enemy of modernism, subsequent critics have examined the affinities between the two that supported the enthusiastic reception of American folk art in the 1930s. The interchange between avant-garde and popular art was surveyed by Kirk Varnedoe in his exhibition and catalogue *High and Low: Modern Art and Popular Culture* (New York: Museum of Modern Art with Harry N. Abrams, 1990), and in a book of essays edited by Varnedoe and Adam Gopnik, *Modern Art and Popular Culture: Readings in High and Low* (New York: Museum of Modern Art with Harry N. Abrams, 1990), which includes an incisive critique of Greenberg's famous essay by Robert Storr, "No Joy in Mudville: Greenberg's Modernism Then and Now," pp. 160–91.

29. See Tessa De Carlo, "Landscapes by the Carload: Art or Kitsch?" *New York Times*, November 7, 1999; Susan Orlean, "Art for Everybody: How Thomas Kinkade Turned Painting into Big Business," *New Yorker*, October 13, 2001, pp. 124–31. Michael Clapper has analyzed Kinkade's romantic conventions and his relationship to the art world, noting the different value systems held by his admirers and detractors. Kinkade's critics comment on his lack of originality, poor artistic quality, and unchallenging sentimentalism, while the artist's admirers care little for these issues, focusing on subject matter, mood, and emotion. It is easy to read this same division of interests into the art world of 1850. See "Thomas Kinkade's Romantic Landscape," *American Art*, vol. 20, no. 2 (Summer 2006), pp. 76–99; and Alexis Boylan, ed., *Thomas Kinkade: The Artist in the Mall* (Durham, N.C.: Duke University Press, forthcoming 2008). My thanks to Alexis Boylan for sharing her bibliography on Kinkade, and to Marc Simpson for his account of a session discussing Kinkade's work at the conference "The Canon: Celebrating American Art," New York University, May 13–16, 2004.

30. "The Dollars and Cents of Art," *Cosmopolitan Art Journal*, vol. 4, no. 1 (March 1860), p. 30. In light of this early advice to collectors and the general dismay over bargain-hunt-

ing in the arts expressed elsewhere in the period, it is notable that there did not seem to be much stress on the value of art as either a future heirloom or a profitable investment, as seen in the marketing and collecting of Kinkade's work today. Interestingly, if Chambers sold his paintings for $10 apiece in 1845, their cost in relative terms would be quite similar to the price of Kinkade's prints, that is from about $275 in 2006 (based on the Consumer Price Index) to $2,110 (based on labor value); see Lawrence H. Officer and Samuel H. Williamson's scales for measuring change in dollar value over time at http//: www.measuringworth.com (accessed March 2008).

31. Russell Lynes, *The Tastemakers: The Shaping of American Popular Taste* (New York: Harper and Brothers, 1949).

32. Pierre Bourdieu, *Distinction: A Social Critique of the Judgment of Taste*, trans. Richard Nice (Cambridge, Mass.: Harvard University Press, 1984). Bourdieu would recognize the early modernist collectors of folk art, bestowing aesthetic importance on objects of everyday life from the past, as models of aristocratic behavior; Kinkade's customers, with their emphasis on representation and ethics, illustrate his description of popular or naive judgment.

33. "It is the work of a gifted and feeling designer in paint who has his medium and mode of expression well under control." Merritt 1956, p. 218.

34. The romanticism of the moderns about "self-taught" art might be compared to the attitude noted by Frances Trollope in 1832 that "self-taught" was deemed the highest praise among Americans who valued self-improvement and demonstrations of individual "genius." Cited in Agnes Halsey Jones, *Rediscovered Painters of Upstate New York, 1700–1875*, exh. cat., New York State Historical Association, Cooperstown (Utica, N.Y.: Munson-Williams-Proctor Institute, 1958), p. 7.

CHRONOLOGY

1808

Thomas Chambers is born in Whitby, North Riding, Yorkshire, according to the Chambers family Bible and the register of the Whitby parish church, where he was baptized on December 11, 1808. His father was the mariner John Chambers, who married Mary Appleby in Whitby in 1794.[1]

The family Bible lists other siblings: Ann (born 1795), possibly married to Thomas Robinson in January 1813 in Whitby; Sarah (1798–1799); John (born 1800), possibly the "master mariner" who married in Whitby in 1824, living in Whitby in 1857–67; George (1803–1840), the marine artist; Mary (1811–1813); William (born 1815), a mariner who became a marine painter in the 1830s; and Jane (born 1817). George's son, George William Chambers (1829–after 1867), also became a marine painter.

1824

Death of his mother, Mary Chambers, in Whitby, age fifty-one.

1825

His brother George leaves Whitby for London, to launch a career as a marine painter.

c. 1827

Death of his father, John Chambers, while serving as a ship's cook.

c. 1827–32

Marries Harriet Shellard (c. 1809–1864), born in England.

George Chambers is employed in London as a marine, panorama, and theatrical scene painter.

Thomas Chambers departs from London for the United States.

1832

On March 1, signs Declaration of Intention to apply for United States citizenship in New Orleans.[2]

1833

Listed as a "painter" in the New Orleans city directory for 1833–34 at 98 Poydras Street.[3]

1834

Listed as a "landscape painter" in the New York city directory at 80 Anthony Street.[4]

Wins a "Second Premium" and a diploma for "water colored Marine Painting" (see fig. 1-5) at the seventh annual fair of the American Institute of the City of New York, at Niblo's Garden.

His wife, Harriet, arrives about this time from London.[5]

1835

Listed as a "landscape painter" in New York at 330 Broadway (actually 333, the same building as 80 Anthony Street).[6]

Advertises in the periodical the *New-Yorker* as a "Marine and Landscape Painter," offering "Fancy Painting of every description"; the advertisement runs for two years.

Paints first known dated oil painting, *Cutting Out of His B.M.S. "Hermione"* (fig. 2-2).

1836

Listed in New York as a "landscape painter" at 80 Anthony Street.[7]

1837

Listed in New York as a "landscape painter" at 213 Greene Street.[8]

Marine paintings by him sold on April 22 at the Arcade Baths, Chambers Street, by auctioneer Aaron Levy.

Returns from a trip to England: "Thomas Chambers, artist" arrives in New York from Liverpool in December.

1838

Listed in New York as a "marine painter" at 213 Greene Street.[9]

Signs naturalization papers on November 7.[10]

1839

Listed in New York as a "marine painter" at 48 Vesey Street.[11]

1840

Not listed in the city directory but recorded by the federal census in the Seventh Ward at 15 Catherine Street, near Chatham Square; three children under age five are listed in Chambers' household.

1841

His whereabouts are unknown.

1842

Listed in the Baltimore city directory as a "marine painter" on Conway Street, east of Little Green.[12]

1843–51

Listed in the Boston city directory as an "artist" at 21 Brighton Street.[13]

Recorded in Boston in the federal census for 1850, along with his wife, Harriet.

1845

Many of his paintings are listed in an auction sale in Newport, Rhode Island, on July 11.

1851

Listed in Albany as an "artist" at 387 Lydius Street; a George Chambers, "clerk," is listed at the same address.[14]

1852–57

Listed in Albany as an "artist" at 343 State Street.[15] Recorded in the New York State census of 1855, along with his wife, Harriet.

1858

Listed in New York as an "artist" at 148 Spring Street.[16]

1859

No directory listing (but likely living at the same address in New York).

1860

No listing, but recorded on July 2 in the federal census as living in New York's Eighth Ward (which included Spring Street), along with Harriet, Margaret (age fourteen), and Samuel (age twelve).

1861

Listed in New York as an "artist" at 150 Spring Street.[17]

1862–64

Listed in New York as an "artist" at 47 White Street.[18]

His last datable subject, the capture of the *Harriet Lane* in Galveston, Texas, a Civil War action, took place in January 1863.

Harriet Chambers dies at St. Luke's Hospital on July 28, 1864, age fifty-five, and is buried in Green-Wood Cemetery in Brooklyn.[19]

1865

Listed in New York as an "artist" at 3 Mott Street.[20]

1866–68

His whereabouts are unknown.

1869

Thomas Chambers, "artist," age sixty-one, dies on November 24 at the Union Workhouse in Whitby and is buried in the Larpool Cemetery, Whitby.

NOTES

1. Russett 1996 lists the family members, perhaps derived from an annotated copy of Watkins 1837 in the library of the Whitby Literary and Philosophical Society, where I also consulted an index to the parish register of baptisms.
2. Howard S. Merritt, in *The Genesee Country*, by Henry W. Clune and Howard S. Merritt, exh. cat. (Rochester, N.Y.: Memorial Art Gallery, University of Rochester, 1975), p. 85, cat. no. 18. No city directory was published in New Orleans in 1832.
3. Ibid.
4. *Longworth's American Almanac, New York Register and City Directory* (New York, July 1834); his New York addresses were first recorded in Little 1948, p. 195.
5. In the New York State census of 1855, Harriet stated that she emigrated from London twenty-one years earlier; Merritt 1956, p. 215.
6. *Longworth's* (New York, July 1835).
7. *Longworth's* (New York, July 1836).
8. *Longworth's* (New York, July 1837).
9. *Longworth's* (New York, July 1838).
10. Kenneth Scott, *Early New York Naturalizations, 1792–1840* (Baltimore: Genealogical Publishing, 1987), p. 112, no. 108.
11. *Longworth's* (New York, July 1839).
12. *Matchett's Baltimore Directory for 1842* (Baltimore, 1841).
13. *Stimpson's Boston Directory* (Boston, 1843, 1844, 1845); *Adams's New Directory of the City of Boston* (Boston, July 1846 and succeeding years through 1851); Little 1948, p. 196.
14. *Hoffman's Albany Directory and City Register . . . 1851–52*; Merritt 1956, p. 214.
15. *Munsell's Albany Directory and City Register . . . 1852–53*, and succeeding years through 1857–58.
16. *Trow's New York City Directory* (New York, May 1858).
17. *Trow's* (New York, May 1861).
18. *Trow's* (New York, May 1862, 1863, 1864).
19. Merritt 1956, p. 215.
20. *Trow's* (New York, May 1865).

APPENDIX

Broadside of the Newport Auction of July 11, 1845

Chambers listed seven marine paintings under his own name in this sale. Additional artists were also credited, although their names (Corbin, Nesbit, Miller, and Roberts) do not appear in surviving records of other exhibitions or sales in this period, and the subjects they depicted appear in work attributed to Chambers today. Likewise, many of the paintings in this auction were sold anonymously but with titles that correspond to subjects frequently seen in work now identified with Chambers. Such evidence suggests that Chambers shared his style with a workshop or painted under different names.

Broadside advertising an auction in Newport, R.I., July 11, 1845. Private collection.

CATALOGUE
OF ELEGANT
OIL PAINTINGS,
BY LONDON AND NEW-YORK ARTISTS,
Never before seen in the U. States.
IN SPLENDID GILT FRAMES,
Now Exhibiting, Free, at
MASONIC HALL,
And to be sold at
AUCTION,
On FRIDAY, July 11, at 10 o'clock.

The Paintings consist of Landscape and Marine Pieces; Lake, Mountain and River Scenery; Naval Battle Pieces; Paintings of Steam Ships; Views of Shipping; English, Irish and American Coast Scenery; Scotch and Swiss Mountain Scenery, &c., &c., comprising a very choice collection, all ready for immediate removal to the Parlor. ☞ **THE FRAMES WILL BE SOLD WITH THE PICTURES.**

☞ **Notice.** *Visitors are requested to mark on their Catalogues, previous to the day of sale, the Pictures which they may be desirous of purchasing, as on that day the Pictures will be taken down for the convenience of selling.*

1. Corsica, the birthplace of Napoleon, with a view of the town and road of Bastia, —the victory of 100 guns, Lord Nelson's ship at anchor. This beautiful and highly finished Picture was painted by Mr. Nesbit, of London.
2. Birthplace of Robert Burns, (Scotland)
3. Lake Windermere, (Eng.) a handsome original picture by Mr. Corbin of London.
4. Natural Bridge, Virginia.
5. Tarry town, where Major Andre was captured.
6. Alloway Kirk, with Burns' Monument, moon rising.
7. Washington's birthplace, with a view of the Potomac River, and the Maryland shore; the stone in the foreground denotes where the house stood; the old vine, which is still growing, was planted by the Washington family.—A very fine and highly interesting Painting, by Mr. Corbin.
8. West Point, with a general view of the Military School. A splendid picture, the view taken from Cold Spring Mountains.

9. Lake George and the village of Caldwell, a picture of great distance and beauty.
10. The celebrated Lake of Killarney, Innsfallen, (Ireland) a most delightful Painting, and one of the best landscapes in the collection.
11. New York bay, with a fine view of Staten, Governor's and Bedlow's Islands, the George Washington, Liverpool packet ship, homeward bound, taking in sail to anchor,—one of the finest pictures in the collection, painted by Mr. Chambers of New York.
12. Weehawken, opposite New York, looking up the North River.
13. Delaware Water gap, (companion to No. 12,) on the Delaware, Pa.
14. The Great Western steamship leaving Sandy Hook, Bay of New York—a very delightful picture and perfect portrait of the ship, companion to No. 11.
15. Village of Cedars, River St. Lawrence, (Candia. [Canada])
16. Outlet of Lake Memphremagog, do. do [ditto].
17. George Washington, New York and Liverpool Packet ship, outward bound, leaving Sandy Hook, outer Bay of New York,—a very lovely sea piece, and perfect likeness of the ship (companion to No. 11)
18. Lake of Albano, Rome, in the distance, (also Mount Vesuvius,) are a splendid pair of landscapes, by Mr. Corbin of London
19. Cork Harbor, (Ireland,) New York packet ship Shakspeare, hove to for a pilot, one of the finest pictures in the sale, Original by Mr. Chambers.
20. Hampshire Water Mills, (England,) a handsome original Painting by Mr. Corbin.
21. ⎧Niagara Falls from the American side.
22. ⎩ do. Horse Shoe Falls from the Canada bank.
23. Ross Castle, Lake of Killarney, (Ireland) a rich sunset piece.
24. ⎧Environs of Rome, nothing can exceed the picturesque beauty of this fine pair of
[25.] ⎩ Landscapes, by Roberts.
26. Abbey of Clare Galway, (Ireland,) moon rising, by J Miller
27. Franklin Water Mills, Kent, England, (companion to 20.)
28. Mulgrave Lake & Bridge do. do.
29. Glengowen Castle, Wales, a very fine Painting.
30. Valley St. Martin's, Winter & moonlight, Switzerland, J. Miller.
31. Mount Vesuvius, from the Environs of Naples, this splendid landscape should not be separated from No. 18, its companion.
32. Gennesee Falls, state of New York; a very fine picture.
33. Stratford on Avon, with the burial place of Shakspeare, a very noble and interesting English landscape.
34. Bothwell Castle, on the Clyde Lanarkshire, (Scotland,)—a very splendid painting and companion to 61.
35. The Red Rover, making sail after taking on board, Gertrude, Mrs. Wyllys, Wilder and

Cassandra, from the launch of the foundered Bristol trader Royal Caroline, (from Cooper's Novel of the Red Rover.)

36. The Red Rover passing the Bristol trader in the night. Companion to 35, a pair of very spirited original sea pieces.

37. Indiaman saluting, at the Island of St. Helena, where Napoleon was exiled, Companion to No. 1.

38. Keswick Lake, England, a pretty landscape Companion to 20.

39. Goodrich Castle, Do.

40. Road across the Plain of Waterloo, the distance in this picture is wonderful when viewed through a Magnifying glass.

41. Rob Roy's Castle, Loch awe (Scotland,)

42. Companion to 41, with a view near the Caledonian Canal.

43. Hole in the Wall, (Florida Gulph) Pirate Avenger at anchor under the rocks,---a very romantic Picture,

44. Northumberland, on the Susquehanna river, (very fine)

45. Hudson, on the Hudson River N. York.

46. Eton, Buckinghamshire, England,

47. ⎰ Bay of New York, Governor's, Staten Islands and Shipping.
48. ⎱ Castle Garden and Battery New York—a pleasing and also very beautiful pair of Paintings.

49. Maderia [Madeira], view of the East end, Original by Mr. Nesbit.

50. The Burning Ship, from Capt. Marryats Pirate.

51. East-port and Passamaquoddy Bay, and Pick Nick Party (a very beautiful landscape)

⎰52. Eu, in France, the country residence of the King of the French, (a fine pair of paintings.
⎱53. Cain [Caen?],—Do.—Do.

54. Annapolis Roads, with the U. S. Ship Delaware, 74 Guns, at Anchor, Com. Morris, Commander, from the original sketch taken in 1841.

55. Companion to 54, Bodkin light house and Point Chesapeake Bay, near Baltimore city, (two handsome Marine views,)

56. Ruins of Castledormot, Kildare, (Ireland.)

57. Do. of the Franciscan Abbey; Kilkenny, (Ireland.)

58. Seguin light-house and Island; entrance to the Kennebeck River, Fishing schooners and Shipping.—a splendid original marine Sunset piece of great merit.

59. Boston Bay and Harbor, with a quarter view of the U. S. Ship Ohio, 74 guns, at anchor; the Royal Mail Steamer Hibernia, leaving port for Liverpool,—a splendid original picture, and matches New York Bay, No. 11.

60. Lake George; Sabbath Day Point, at sunset. This is the most lovely and transparent painting in the collection.

61. Bridge O'Downe, (Tam O'Shanter, Scotland,) from Burns, and companion to Bothwell Castle, No. 34,)

62. The ship John Quincy Adams, scudding in the Atlantic, after loss of main, mizzen and foretopmasts. A very spirited sea piece.

63. Nahant, from Lynn Beach; the Royal Mail steam ship Britannia, running in for Boston; a very handsome painting.

64. Rockaway Beach, New York, with the wreck of the ship Bristol, where upwards of 60 passengers were drowned, in 1837. From the original sketch taken on the spot, three days after the dreadful catastrophe.

65. The U. S. frigate Constitution's last broadside to the British frigate Guerriere. Nothing can exceed the elaborate finish of this splendid sea piece, (Painted from Coopers Naval History by Mr. Chambers.)

66. The U. S. Frigate United States, capturing the British Frigate Macedonian,—this is decidedly the noblest painting in the collection, (and also from Cooper's History of the American Navy.

Ladies and Gentlemen are respectfully invited to examine this fine collection, and attend the sale.

Newport, July 8th, 1845. *Atkin[s]on's[?] Job Press.* **J. GOODSPEED, Auct'r.**

CONSERVATION NOTES ON THE THOMAS CHAMBERS PAINTINGS FROM THE COLLECTION OF MORTON C. BRADLEY, JR.

Margaret K. Contompasis

Over a period of three decades, the noted conservator Morton C. Bradley, Jr. (1912–2004), gave hundreds of paintings to the Indiana University Art Museum to form the Morton and Marie Bradley Memorial Collection, which includes twenty-nine of the works by Thomas Chambers discussed in this book. Because of their association with Bradley, the Chambers paintings at Indiana display certain characteristics that distinguish them from the larger body of the artist's work. At the same time, they share many elements with his oeuvre as a whole, including technique, materials, and, for the most part, basic conservation treatments. To contextualize the information gleaned from the examination of these paintings, it will be helpful to have some understanding of Bradley and his treatment techniques.

The Conservation Treatments of Morton C. Bradley, Jr.

A multitalented man known as an accomplished classical pianist, sculptor, author, and collector, Bradley made significant contributions to the field of conservation.[1] In the 1940s he worked at Harvard University's Fogg Art Museum in one of the country's first conservation laboratories, and in 1950 he published one of the first—and perhaps the most comprehensive—texts on the conservation of paintings.[2] In the early years of the profession, as more museums established conservation studios, there emerged a new focus on determining and understanding the agents of deterioration that affected the overall structure of paintings and artifacts. Shifts in relative humidity were known to be at the root of damage associated with the expansion, contraction, and subsequent breakdown of materials from which paintings are constructed. To address this problem, Bradley devised a novel system of lining a painting with a sheet of aluminum slightly larger than the original work (see fig. C-1.) Borrowing a technique from the Dutch, a wax-based adhesive was then used to attach the canvas to the aluminum.

The practice of lining paintings by attaching them to solid supports was not new; early European restorers, often artists, had used a technique referred to as *marouflage*, most commonly employing paste-based adhesives to attach paintings to wooden supports, to walls, and later to manufactured materials such as cardboard and Masonite. But Bradley's innovation was in his choice of materials—wax and aluminum—that are not affected by shifts in relative humidity and thus were intended to brace the canvas and paint layers against the expansion and contraction brought about by environmental changes.

There are several reasons for attaching a painting to a solid support. Initially, this was done to reduce the repeated curling of edges along a repaired tear or to eliminate persistent bulges within an original canvas. Subsequently, lining was seen as a preventive measure, applied to undamaged supports to reduce the chance of cracking caused by changing environmental conditions. Linings also were applied to paintings in preparation for travel to minimize damage from vibration during shipment. In Bradley's generation the shift in conservation philosophy, from a focus on restoration to an emphasis on prevention, had a significant impact on the paintings in his collection and in American collections at large.

Bradley may have lined many of the Chambers paintings in his collection for these general reasons, or to consolidate a crackled or flaking paint surface, often found on paintings stored in fluctuating environments.[3] The moisture inherent in the glue-based adhesives that he, like others at the time, initially used in lining aided in the reduction of cupped paint, a condition in which islands of cracked paint curl upward, pulling away from the support. However, lining a painting with a glue-based adhesive generally subjected the face of the work to considerable heat and pressure, which could flatten the texture of the paint, altering the overall appearance of the image. Glue-based adhesives also could cause a painting to be more reactive to changes in relative humidity. As a result, many paintings lined with this method developed a distinctive crackle as the adhesive and ultimately the paint layer itself expanded and contracted.

While Bradley discussed the use of glue-based adhesives in his textbook, he clearly favored the wax method when treating paintings in his own collection, noting that this meant less heat was needed to attach the painting to the lining, thus limiting physical alterations to the paint layer, such as flattening of impasto.

FIG. C-1 Bradley's lining support consisted of a five-part system: (A) a wooden stretcher; (B) wax-infused linen canvas; (C) an aluminum sheet, sandblasted on one side; (D) lightweight cotton duck fabric; and (E) the painting to be lined.

In the mid-1950s, in an effort to address such physical changes caused by the lining process, conservators developed the vacuum hot table, which enabled them to introduce heat and pressure more consistently over the entire painting surface during the procedure. The placement of a soft membrane over the painting to apply the necessary pressure, coupled with the lower melting point of the wax adhesive, helped to lessen the undesirable effects of the older methods (see fig. C-1).[4] However, the use of the vacuum hot table and wax adhesive gave rise to other problems, including weave enhancement, a condition in which the texture of the original and lining canvases becomes more pronounced as the heat-softened paint layer is pulled into closer contact with individual canvas threads. The penetration of wax into the canvas fibers and small air pockets within the paint layer can also produce an overall darkening of the image and increased transparency of the paint layer. Both the impact of wax darkening and the effect of weave enhancement can be seen in Chambers' painting *Landscape with a Walled Town* (fig. 3-30; see fig. C-2).

In addition to the obvious loss of information from the back of the painting as a result of lining, the tendency to trim the original tacking margins from the edges of a painting before attaching the supplementary support also destroyed documentation from the sides of the work. In the worst-case scenario, the original stretcher was replaced or discarded, leading to the loss of data about the artist's techniques and materials along with clues to provenance. For this reason, as well as in response to the other problems created by wax lining outlined above, the treatments pioneered by Bradley and others of his generation have largely been replaced by less invasive strategies.

A few of the Chambers paintings in Bradley's collection also have undergone extensive cleaning, sometimes resulting in abrasion of the uppermost layers of paint and glazing. In many cases the paintings were selectively cleaned, typically in the lightest areas, leaving dark sections undisturbed and the overall tonal and spatial balances altered. No records about the pretreatment conditions of these paintings are available, but reports from other institutions mention intractable varnishes on some of their paintings by Chambers.[5] However, as Bradley was in the habit of purchasing damaged paintings, it would not be fair to attribute all abraded surfaces to his treatments. In addition to selective cleaning, several paintings appear to have large areas of repainting, but these parts of the works were not considered during the conservation survey undertaken at the Indiana University Art Museum, which focused instead on gathering information about Chambers' own techniques.

A Conservation Survey of the Chambers Paintings in the Indiana University Art Museum

Twenty-four of the twenty-nine Chambers paintings in this survey are oil on canvas; five are oil on millboard. All twenty-four of the canvases have been lined, twenty-three using Bradley's aluminum and wax-adhesive method. One (*Ships Meeting at Sea*, fig. 2-9) was lined with canvas using a glue-based adhesive. Nineteen of the twenty-four canvas paintings retain their original tacking margins. At least five of the original stretchers have been replaced with modern mitered strainers. There is some question about whether Bradley always paired lined paintings with their original stretchers after treatment, but no attempt was made to verify the accuracy of the current pairings. When present, the older stretchers have a homemade quality and are generally four-member, simple-mortise wooden stretchers with keys or half-lap stretchers (fig. C-3); the stretcher face on both types features a low to medium bevel,

FIG. C-2 Detail of the upper right margin of Chambers' *Landscape with a Walled Town* (see fig. 3-30), highlighting two changes to the structure of the painting attributed to the wax-infused lining attached to the canvas using the vacuum hot table: (1) the darkening of the canvas support caused by the penetration of wax into the canvas threads; and (2) the more pronounced texture of the canvas due to weave enhancement. Cusping—a scalloped distortion of the canvas edges due to Chambers' stretching technique—can also be seen along the right margin.

FIG. C-3 The stretchers used in the Chambers paintings at Indiana University are divided between two types, the simple mortise with keys (left) and the half-lap (right).

which is intended to hold the canvas off the surface of the stretcher members. The canvas is invariably a fine, plain-weave fabric, with a warp of forty to fifty threads per inch and a weft of forty to fifty-six. Because none of the paintings is on commercially prepared canvas or stretchers, it appears that all grounds were applied by the artist. The way in which Chambers assembled the materials—including stretcher, canvas, and ground—is the single most unifying element of these twenty-four paintings.

While Chambers appears to have always selected materials manufactured for use in the fine arts, the economy with which he used them speaks to his limited means. The tacking margins are consistently meager, with barely enough fabric to cover the face of the stretcher bar, while the fabric that is folded over the edges of the bar is greatly distorted into a point, hardly wider than the head of the tack used to fasten it to the side. This distortion of the fabric edges is often visible through the finished paint layers. Similarly, the ground is applied to the canvas only to the edges of the stretcher, never onto the tacking margins (fig. C-4).

Several variations in the application of ground were noted. The majority of the paintings have a gesso ground, ranging from white to off-white. In paintings with an overall light palette, there is an additional warm-toned imprimatura, most often described as pink or ocher in color. In some cases a pink imprimatura is applied to the upper portions of an image, usually the sky, and ocher is applied to the lower areas, of landscape or water.

Sketchy underdrawing in pencil was observed in eleven of the paintings. Chambers constructed his images using layers of opaque colors in a range of

FIG. C-4 Detail of Chambers' *Landscape with a Walled Town* (see fig. 3-30), showing the original lower tacking margins intact. The distorted fabric associated with his technique is folded over the edge of the stretcher bar and the lining support. The white material seen below the original, pointed tacking margins is excess wax adhesive. The darkened lining canvas that attaches the new support system to the stretcher is visible below the wax adhesive.

consistency from paste-like to more fluid. The paint becomes less medium-rich in the middle ground, and the details in the middle and foreground are more paste-like, often with areas of low to medium impasto. The larger elements of the images are blocked out in bands of color. Once this initial design layer had dried, Chambers often added the details of the composition without waiting for subsequent layers to dry, slightly blending the wet colors together. The application of light over dark and heavily over thinly applied paint varies from painting to painting.

Details such as rigging and small figures on ships in Chambers' marine paintings in the Bradley collection, as well as details in the foliage in his landscapes, are often found above the varnish layer (fig. C-5). The rigging and figures were applied with very fluid, transparent brown glazes, and the figures were further defined by discrete dabs of opaque color. The glaze-like consistency of the paint used in these details has made them more vulnerable to abrasion during cleaning. Chambers used techniques such as pouncing and, perhaps most often, stippling to render details in the foliage with brushes trimmed to specific patterns. The brushstrokes used to construct the figures that populate Chambers' landscapes are usually single strokes of one color with graduated tone used to define the form, in a fashion that is reminiscent of the decorative painting Chambers advertised (see pages 8–9 in this volume). Drying cracks are consistently found in the wash-like applications of paint in the background, sky, and foliage, a common problem caused by layers of paint with incompatible drying rates. As discussed, in many cases details are found above the varnish and appear more recently painted or better preserved than other areas of the same composition (see fig. C-5); chemical analysis of these features will be performed in an effort to determine their authenticity. While quirky (compared to that of his contemporaries), Chambers' use of color is often quite simple, with raw colors mixed with white in many paintings, with little regard for a realistic rendering of nature. This technique may account for the consistency in color within groups of paintings that seem to have been done at the same time or in series. In her essay in this volume, Kathleen Foster discusses Chambers' notable shift toward a warmer, more monochromatic—and, I would add—more blended palette. This change might be explained by the alterations in color perception and detail that come with age, as the eyes become less able to perceive and distinguish the cooler colors in the spectrum, as well as by Chambers' development of a more sophisticated sense of color over the years.[6]

As discussed, all the Chambers paintings from the Bradley collection had been cleaned, sometimes selectively, at an undetermined time. Observation of the remaining varnishes under ultraviolet light suggests the presence of at least three varnishing systems. The first and most common is natural resin; the second, seen less often, appears to be a combination of oil and natural resin; and the third—found on two paintings overall and in small areas of others—seems to be a combination of materials that might include shellac. Eventually, chemical analysis of the varnishes will help clarify this issue.

Before I began the general examination of Indiana University's Bradley collection, Foster and I discussed her theories on the mysterious identity of Thomas

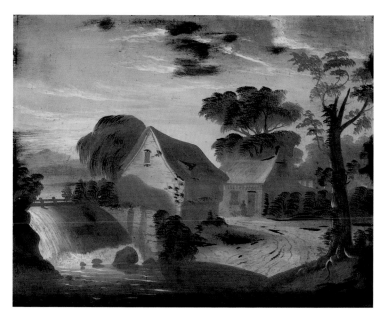

FIG. C-5 Ultraviolet visible fluorescence of Chambers' *Mill and Cottages by a Waterfall* (see fig. 3-23). As a natural varnish ages, chemical changes cause the formation of double bonds that fluoresce when exposed to ultraviolet light. Paint added to an image after it has been varnished will not fluoresce and appears black against the fluorescing varnish. Here we see that foliage details have been added after the varnish and that areas in the upper central sky have been repainted.

Chambers. She suggested various possibilities: The works may have been produced by one person, painting under the name Thomas Chambers for years; by a small group of painters working together over decades, all of whom have been identified as Thomas Chambers; by several artists working individually, all of whom, again, have been identified as Chambers; or—a somewhat less conventional proposal—by one person who painted under more than one name.

Perhaps the conservation survey of the Bradley collection can help reveal more about this elusive figure. The twenty-nine paintings attributed to Chambers all exhibit characteristics associated with his signed work, including a pictorial vocabulary that consists of several variations on the major elements of mountains, clouds, water, and foliage. The imagery has an eerie, fantastic feeling that, while naive, makes for generally credible but slightly unsettling compositions. The light falls unrealistically across the stylized elements, forming long shadows at the base

of objects, while the objects themselves tend to rest on top of the ground. Clues to movement are often mixed with the inconsistent depiction of sails and waves. The images are usually rendered in a slightly exaggerated palette. Water is generally depicted as reflective rather than transparent. The rhythmic curves of the pictorial elements and the highly patterned surfaces combine with outlined forms to lend an overall flatness to the image in spite of the presence of modeling. In individual cases, what appears to be the uncharacteristic treatment of a specific element nevertheless finds a parallel in at least one other painting in the collection. (There is one exception, related to technique: *Flooded Town* [fig. 3-24; see fig. c-6] is the only painting in this group with sgrafitto, a method whereby material [in this case paint] is applied to the surface and then selectively removed. The artist probably used the handle of his brush to remove paint to create the detail in the large tree trunks on the island near the center of the image.[7]) The more highly decorated pictures also appear to have been painted on a compositional base consistent with those of the simpler works, as Chambers layered detail over detail, giving a sense of animation to the surfaces. The undeniable differences in the skill level among the paintings

FIG. C-6 This detail of Chambers' *Flooded Town* (see fig. 3-24) shows that the artist apparently used the handle of his brush to remove paint in order to create lined details in the central tree trunks.

could be attributed to the natural development of the artist's abilities over time, and as Foster discusses, changes in color, pictorial style, and the level of finish may have been in response to the shifting tastes and status of his clients. It is hoped that further examination and microchemical analysis of the paintings will help to support the hypothesis that they are the work of one artist.

Notes

Special thanks go to Rachel Radom for offering invaluable keen observations and initial examinations; to Preston Smith for coordinating the photography of over thirty-five paintings for this catalogue; to Linda Baden for doing the initial editing and to Mary Cason and Sherry Babbitt for giving additional assistance; to Michael Cavanagh and Kevin Montague for photographically capturing the subtle surface conditions of the paintings; to Brian Garvey for supplying the illustrations of the stretcher types and the lining support system; to Joyce Hill Stoner for providing her help and her contributions to the FAIC Oral History Archive, Winterthur Museum and Library, Winterthur, Del.; to Rachel Huizinga for providing background information on Morton Bradley, Jr., ; to William Georgenes for sharing details of Bradley's system for lining the paintings discussed in this essay; and to Kathleen Foster and Adelheid Gealt for creating a forum in which to share our observations. I am grateful as well to Dr. Arthur Bradley from the Indiana University School of Optometry, and to Helene O'Leary, Andrea Gash, and Eileen Savage from the Indiana University Foundation.

1. Kathleen Foster previously presented a comprehensive essay on Bradley and his ties to Indiana University in *An American Picture-Gallery: Recent Gifts from Morton C. Bradley, Jr.* (Bloomington: Indiana University Art Museum, 1992), an exhibition catalogue of some of the paintings in Bradley's earlier gifts to the museum.

2. *The Treatment of Pictures* (Cambridge, Mass.: Art Technology, 1950).

3. No condition or treatment reports for Bradley's collection exist, so it is not possible to know the particular reasons for his treatments. By 1950, when he published his text on conservation, Bradley was advocating the use of aluminum panels as one among several lining choices. He seems to have preferred using aluminum panels to line his own collection, as seen in the many examples in Indiana.

4. William Georgenes worked for Bradley from 1960 to 1967 and treated, under Bradley's direction, most of Indiana's Chambers paintings. In a conversation with the author in April 2008, Georgenes outlined Bradley's technique as follows:
 - In preparation for lining, the aluminum sheet was sandblasted on one side to facilitate the bond between the aluminum panel and the rest of the lining support.
 - The aluminum was cut to a size slightly larger than the original image.
 - A lightweight cotton duck fabric was attached to the aluminum support using Weldwood glue.

- The painted image was faced, a process in which a resin-coated paper used in the manufacture of teabags was attached with wallpaper paste to the front of the painting. The purpose of the facing was to minimize losses in the paint layer that can occur during the lining process.
- A section of linen canvas, cut slightly larger than the stretcher, was infused with the wax-based adhesive. The linen canvas served two purposes: (1) to reattach the lining support to the stretcher, essentially replacing the original tacking margins that may have been trimmed or were too fragile to support the weight of the newly lined painting; and (2) to retain the original appearance of a canvas painting by covering the back of the aluminum panel.
- The back of the original canvas was infused with a mixture of wax and damar resin.

Once all of these elements were prepared, the large, wax-infused linen was placed on the vacuum hot table. The aluminum sheet, with the cotton duck facing upward, was centered on the linen. The purpose of the cotton duck was to accommodate imperfections in the weave of the original canvas and to aid in the future removal of the aluminum support, should that prove necessary. The wax-infused, faced painting was then placed face up, on the cotton duck attached to the aluminum panel. Next, the painting and the lining support were covered with a pliable membrane and heated to a temperature of 135°F. Once this temperature had been reached, the air was pumped out from between the table surface and the soft membrane, providing the pressure needed to confirm the bond between the original painting and the lining support. The painting and lining were then allowed to cool under pressure. After the painting had cooled, paint thinner was used to remove the excess wax. Water and cotton balls were used to remove the paper facing. After the painting was lined and reattached to the stretcher, Bradley would start the cleaning process with relatively mild solvents and continue with increasingly stronger solvents until he had removed the discolored layers. Once cleaned, the paintings were varnished, and areas of lost paint were reconstructed. Bradley often used silkscreen inks to repaint areas of loss in the original image.

5. Examination reports from the National Gallery of Art in Washington, D.C., the Brooklyn Museum, and the Fenimore Art Museum in Cooperstown were compared and found to be consistent with the examinations conducted at Indiana.

6. See John S. Werner, "Aging Through the Eyes of Monet," in *Color Vision: Perspectives from Different Disciplines*, ed. Werner G. K. Backhaus, Reinhold Kliegl, and John S. Werner (Berlin: Walter de Gruyter, 1998), pp. 3–41.

7. This element is unique among these paintings, and the author has not found any references to the technique in other descriptions of the artist's work, although there are several examples of Chambers using paint to achieve similar effects in other images.

BIBLIOGRAPHY

Abbreviations and Frequently Cited Sources

APS Online
American Periodical Series Online

Caldwell and Rodriguez Roque 1994
Caldwell, John, Oswaldo Rodriguez Roque, et al. *American Paintings in the Metropolitan Museum of Art*. Vol. 1, *A Catalogue of Works by Artists Born by 1815*. New York: Metropolitan Museum of Art with Princeton University Press, 1994.

Chotner 1992
Chotner, Deborah. *American Naive Paintings*. Exh. cat. Washington, D.C.: National Gallery of Art; Cambridge: Cambridge University Press, 1992.

Lewis 1994
Lewis, Richard Anthony. "Interesting Particulars and Melancholy Occurrences: Thomas Birch's Representations of the Shipping Trade, 1799–1850." PhD diss., Northwestern University, 1994; UMI Dissertation Publishing, 1994.

Little 1948
Little, Nina Fletcher. "T. Chambers: Man or Myth?" *Antiques*, vol. 53 (March 1948), pp. 194–96.

Merritt 1956
Merritt, Howard S. "Thomas Chambers—Artist." *New York History*, vol. 37, no. 2 (April 9, 1956), pp. 212–22.

New York 1942
T. Chambers, Active 1820–1840: First American Modern. Sales cat. New York: Macbeth Gallery, 1942.

Russett 1996
Russett, Alan. *George Chambers, 1803–1840: His Life and Work; The Sailor's Eye and the Artist's Hand*. Woodbridge, U.K.: Antique Collectors' Club, 1996.

Watkins 1837
Watkins, John. *Memoir of George Chambers, Marine Artist*. Whitby, U.K.: Privately printed, 1837.

Watkins 1841
Watkins, John. *Life and Career of George Chambers*. London: Author, 1841.

Print Sources for Chambers' Work

The American Landscape, No. 1. New York: E. Bliss, 1830.

The Atlantic Souvenir, A Christmas and New Year's Token for 1828. Philadelphia: Carey, Lea and Carey, 1827.

Beattie, William. *Scotland Illustrated; in a series of views taken expressly for this work by Messrs. T. Allom, W. H. Bartlett and H. M'Culloch*. 2 vols. London: George Virtue, 1838.

Cooper, James Fenimore. *The History of the Navy of the United States of America*. 2 vols. Philadelphia: 1839; abridged one-volume ed., 1841. Facsimile ed. of the illustrated 1841 abridged ed. Delmar, N.Y.: Scholar's Facsimiles and Reprints, 1988.

Cunningham, Allan. *Pictures and Portraits of the Life and Land of Burns*. London: George Virtue, 1834.

Frost, John. *Life of Major General Zachary Taylor; with Notices of the War in New Mexico*. Philadelphia: G. S. Appleton, 1847.

_____. *Pictorial History of Mexico and the Mexican War*. Philadelphia: Thomas, Cowperthwait, 1848.

Harper's Weekly, March 22, 1862.

Jenkins, James. *The Naval Achievements of Great Britain, from the Year 1793 to 1817*. London: Author, 1817.

Kampen, N. G. van, with W. H. Bartlett. *The History and Topography of Holland and Belgium*. London: George Virtue, 1837.

Mayer, Brantz. *Mexico, Aztec, Spanish and Republican: A Historical, Geographical, Political, Statistical and Social Account of that Country. . . .* Hartford: Drake, [1850].

Milbert, Jacques Gérard. *Itinéraire pittoresque du fleuve Hudson et des parties latérales [de] l'Amérique du Nord d'après les dessins originaux prix sur les lieux*. 2 vols. Paris: H. Gaugain, 1828–29. Translated by Constance D. Sherman, as *Picturesque Itinerary of the Hudson River*. Ridgewood, N.J.: Gregg Press, 1968.

Naval Chronicle. London: J. Gold, 1799–1818.

New-York Mirror, June 7, 1834.

Olds, Irving. *Bits and Pieces of American History*. New York: Author, 1951.

_____. *The Irving S. Olds Collection of American Naval Prints and Paintings*. Salem, Mass.: Peabody Museum, 1959.

Petersen, C. J. *The Military Heroes of the War of 1812; with a Narrative of the War with Mexico*. Philadelphia: W. A. Leary, 1848.

Ross, Alexander M. *William Henry Bartlett: Artist, Author and Traveller*. Toronto: University of Toronto Press, 1973.

Sandweiss, Martha, Rick Stewart, and Ben Huseman. *Eyewitness to War: Prints and Daguerreotypes of the Mexican War, 1846–1848*. Fort Worth, Tex.: Amon Carter Museum; Washington, D.C.: Smithsonian Institution Press, 1989.

Smith, Edgar Newbold. *American Naval Broadsides: A Collection of Early Naval Prints (1745–1815)*. Philadelphia: Philadelphia Maritime Museum, 1974.

The Token and Atlantic Souvenir: A Christmas and New Year's Present. Boston: Charles Bowen, 1833.

Willis, Nathaniel Parker, and W. H. Bartlett. *American Scenery; or, Land, Lake, and River Illustrations of Transatlantic Nature*. 2 vols. London: George Virtue, 1837–1840.

_____, and J. Stirling Coyne. *Scenery and Antiquities of Ireland*. London: George Virtue, 1842.

SELECTED BIBLIOGRAPHY

Adams, Caroline P., ed. *Great Explorations: Research into American Folk Art Conducted by Students in the Museum Seminar*. Northampton, Mass.: Smith College Museum of Art, 1980.

Ames, Kenneth L. *Beyond Necessity: Art in the Folk Tradition; An Exhibition from the Collections of Winterthur Museum at the Brandywine River Museum, Chadds Ford, Pa*. Exh. cat. Winterthur, Del.: H. F. du Pont Winterthur Museum, 1977.

Anbinder, Tyler. *Five Points: The 19th-Century New York City Neighborhood that Invented Tap Dance, Stole Elections, and Became the World's Most Notorious Slum*. New York: Free Press, 2001.

Anderson, Nancy K., Linda S. Ferber, and Helena Wright. *Albert Bierstadt: Art and Enterprise*. Exh. cat. New York: Hudson Hills with the Brooklyn Museum, 1990.

Anderson, Patricia A. *American Folk Art from Western New York Collections*. Exh. cat. Rochester, N.Y.: Memorial Art Gallery, University of Rochester, 1986.

Andrews, Carol Damon. "John Ritton Penniman (1782–1841): An Ingenious New England Artist." *Antiques*, vol. 120, no. 1 (July 1981), pp. 147–70.

Appadurai, Arjun, ed. *The Social Life of Things: Commodities in Cultural Perspective*. Cambridge: Cambridge University Press, 1986.

Archibald, Edward H. H. *Dictionary of Sea Painters*. Woodbridge, U.K.: Antique Collectors' Club, 1980.

Art Out of the Attic: An Exhibition of Nineteenth-Century American Paintings from Vermont Homes. Exh. cat. Middlebury, Vt.: Christian A. Johnson Art Center, Middlebury College; Montpelier: Vermont Council on the Arts, 1970.

Ayres, James. *English Naive Painting, 1750–1900*. London: Thames and Hudson, 1980.

_____. *Two Hundred Years of English Naive Art, 1700–1900*. Exh. cat. Alexandria, Va.: Art Services International, 1996.

Baigell, Matthew. *Dictionary of American Art*. New York: Harper and Row, 1979.

Banks, William Nathaniel. "The French Painter Victor de Grailly and the Production of Nineteenth-Century American Views." *Antiques*, vol. 106, (July 1974), pp. 84–103.

Barker, Virgil. *American Painting: History and Interpretation*. New York: Macmillan, 1950.

Barrett, Walter [pseud.]. *The Old Merchants of New York City*. New York: Carlton, 1864.

Barry, William David, and Thomas W. Leavitt. *George Loring Brown: Landscapes of Europe and America, 1834–1880*. Exh. cat. Burlington, Vt.: Robert Hull Fleming Museum, 1973.

Bauer, Karl Jack, and Stephen S. Roberts. *Register of Ships of the U.S. Navy, 1775–1990: Major Combatants*. New York: Greenwood Press, 1991.

Bayliss, Anne, and Paul Bayliss. *Scarborough Artists of the Nineteenth Century: A Biographical Dictionary*. Scarborough, U.K.: Anne Bayliss, 1997.

Benes, Peter, ed. *Itinerancy in New England and New York*. Boston: Dublin Seminar for New England Folklife, 1984.

Bergengren, Charles. "'Finished to the Utmost Nicety': Plain Portraits in America, 1760–1860." In *Folk Art and Art Worlds*, edited by John Michael Vlach and Simon J. Bronner, pp. 85–120. Logan: Utah State University Press, 1992.

Bishop, Robert C. H. *The Borden Limner and His Contemporaries*. Exh. cat. Ann Arbor: University of Michigan Museum of Art, 1976.

_____. *Folk Painters of America*. New York: E. P. Dutton, 1979.

_____, and Jacqueline M. Atkins. *Folk Art in American Life*. New York: Viking Studio Books, 1995.

Black, Mary. *Erastus Salisbury Field, 1805–1900*. Exh. cat. Springfield, Mass.: Museum of Fine Arts, 1984.

_____, with Barbara C. Holdridge and Lawrence B. Holdridge. *Ammi Phillips: Portrait Painter, 1788–1865*. Exh. cat. New York: C. N. Potter for the Museum of American Folk Art, 1969.

_____, and Jean Lipman. *American Folk Painting*. New York: C. N. Potter, 1966.

Born, Wolfgang. *American Landscape Painting: An Interpretation*. New Haven: Yale University Press, 1948.

Bourdieu, Pierre. *Distinction: A Social Critique of the Judgement of Taste*. Translated by Richard Nice. Cambridge, Mass.: Harvard University Press, 1984. Originally published as *La distinction*. Paris, 1979.

Bowen, Frank C. *A Century of Atlantic Travel, 1830–1930*. New York: Little, Brown, 1930.

Brooklyn before the Bridge: American Paintings from the Long Island Historical Society. Exh. cat. Brooklyn: Brooklyn Museum, 1982.

Bushman, Richard L. *The Refinement of America: Persons, Houses, Cities*. New York: Alfred Knopf, 1992.

Byard, John K. *A Group of Paintings from the American Heritage Collection of Edith Kemper Jetté and Ellerton Marcel Jetté*. Exh. cat. Waterville, Maine: Colby College Press, 1956.

Cahill, Holger. *American Folk Art: The Art of the Common Man in America, 1750–1900*. Exh. cat. New York: Museum of Modern Art, 1932.

_____, and Maximilien Gauthier. *Masters of Popular Painting: Modern Primitives of Europe and America*. Exh. cat. New York: Museum of Modern Art, 1938.

Campbell, Catherine H. *New Hampshire Scenery: A Dictionary of Nineteenth-Century Artists of New Hampshire Mountain Landscapes*. Canaan, N.H.: Phoenix Publishers, 1985.

Carbone, Teresa A. *At Home with Art: Paintings in American Interiors, 1780–1920*. Exh. cat. Katonah, N.Y.: Katonah Museum of Art, 1995.

Child, Deborah M. "Coming of Age on the Piscataqua: The Marine Paintings of John Samuel Blunt." *Antiques and Fine Art* (August–September 2006), pp. 180–85.

Clapper, Michael. "Thomas Kinkade's Romantic Landscape." *American Art*, vol. 20, no. 2 (Summer 2006), pp. 76–99.

Clayton, Virginia Tuttle. *Drawing on America's Past: Folk Art, Modernism, and the Index of American Design*. Chapel Hill: University of North Carolina Press, 2003.

Clune, Henry W., and Howard S. Merritt. *The Genesee Country*. Exh. cat. Rochester, N.Y.: Memorial Art Gallery, University of Rochester, 1975.

Collins, Jane. "Thomas Chambers: A Romantic Primitive." Unpublished manuscript, 1975, Library, National Gallery of Art, Washington, D.C.

Colwill, Stiles Tuttle. *Francis S. Guy, 1760–1820*. Baltimore: Maryland Historical Society, 1981.

Cowdrey, Mary Bartlett. *William Henry Bartlett and the American Scene*. Cooperstown: New York State Historical Association, 1941. Reprinted from *New York History*, vol. 22 (October 1941), pp. 398–413.

Cutler, Carl C. *Queens of the Western Ocean: The Story of America's Mail and Passenger Sailing Lines*. Annapolis, Md.: U.S. Naval Institute, 1961.

Czestochowski, Joseph S. *The American Landscape Tradition: A Study and Gallery of Paintings*. New York: E. P. Dutton, 1982.

D'Ambrosio, Paul S., and Charlotte Eman, eds. *Folk Art's Many Faces: Portraits in the New York State Historical Association*. Cooperstown: New York State Historical Association, 1987.

Déak, Gloria-Gilda. *Picturing America: Prints, Maps, and Drawings Bearing on the New World Discoveries and on the Development of the Territory that Is Now the United States*. 2 vols. Princeton, N.J.: Princeton University Press, 1988.

Dearinger, David, and Avis Berman, eds. *Rave Reviews: American Art and Its Critics, 1826–1925*. Exh. cat. New York: National Academy of Design, 2000.

Drepperd, Carl William. *American Pioneer Arts and Artists*. Springfield, Mass.: Pond-Ekberg, 1942.

Dunlap, William. *History of the Rise and Progress of the Arts of Design in the United States*. 2 vols. New York: G. P. Scott, 1834.

Earl, Mary Ellen. "Imitators of Bartlett." Master's thesis, New York College at Oneonta, Cooperstown Program, 1965.

_____. *William H. Bartlett and His Imitators*. Exh. cat. Elmira, N.Y.: Arnot Art Gallery and W. F. Humphrey, 1966.

Early American Paintings. Exh. cat. Montclair, N.J.: Montclair Art Museum, 1944.

Ebert, John, and Katherine Ebert. *American Folk Painters*. New York: Scribner, 1975.

Effmann, Elise. "Thomas Cole's View of Fort Putnam." *Antiques*, vol. 166, no. 5 (November 2004), pp. 155–59.

Falk, Peter Hastings. *Who Was Who in American Art*. Madison, Conn.: Sound View, 1985.

Fawcett, Trevor. *The Rise of English Provincial Art: Artists, Patrons, and Institutions outside London, 1800–1830*. Oxford: Clarendon Press, 1974.

Feld, Stuart P. *Plain and Fancy: A Survey of American Folk Art*. Sales cat. New York: Hirschl and Adler Galleries, 1970.

Ferber, Linda, ed. *Kindred Spirits: Asher B. Durand and the American Landscape*. Exh. cat. Brooklyn: Brooklyn Museum with D. Giles, 2007.

Fielding, Mantle. *Mantle Fielding's Dictionary of American Painters, Sculptors, and Engravers*. Poughkeepsie, N.Y.: Apollo, 1986.

Finamore, Daniel. *Across the Western Ocean: American Ships by Liverpool Artists*. Salem, Mass.: Peabody Essex Museum, 1995.

Finch, Roger. *The Pierhead Painters: Naive Ship Portrait Painters, 1750–1950*. London: Barrie and Jenkins, 1983.

Ford, Alice. *Pictorial Folk Art: New England to California*. New York: Studio, 1949.

Foshay, Ellen, Wayne Craven, and Timothy Anglin Burgard. *Mr. Luman Reed's Picture Gallery: A Pioneering Collection of Art*. New York: Harry N. Abrams with the New-York Historical Society, 1990.

Foster, Kathleen A., and Nanette Esseck Brewer. *An American Picture-Gallery: Recent Gifts from Morton C. Bradley, Jr.* Exh. cat. Bloomington: Indiana University Art Museum, 1992.

Fry, Henry. *The History of North Atlantic Steam Navigation, with Some Accounts of Early Ships and Shipowners*. London: S. Low, Marston, 1896.

Gardner, Albert Ten Eyck, and Stuart Feld. *American Paintings: A Catalogue of the Collection of the Metropolitan Museum of Art*. Vol. 1, *Painters Born by 1815*. New York: Metropolitan Museum of Art, 1965.

Garrett, Elisabeth Donaghy. *At Home: The American Family, 1750–1870*. New York: Harry N. Abrams, 1990.

Gerdts, William H., et al. *American Art at the Flint Institute of Arts*. Exh. cat. New York: Flint Institute of Arts with Hudson Hills, 2003.

Glassie, Henry. "Folk Art." In *Material Culture Studies in America*, edited by Thomas J. Schlereth, pp. 124–40. Nashville, Tenn.: American Association for State and Local History, 1982. Originally published in *Folklore and Folklife*, by Richard M. Dorson. Chicago: University of Chicago Press, 1972.

_____. *Material Culture*. Bloomington: Indiana University Press, 1999.

_____. *Pattern in the Material Folk Culture of the Eastern United States*. Philadelphia: University of Pennsylvania Press, 1968.

_____. *The Spirit of Folk Art: The Girard Collection at the Museum of International Folk Art*. Exh. cat. New York: Harry N. Abrams with the Museum of New Mexico, Santa Fe, 1989.

Goldstein, Rosalie, ed. *American Folk Art: The Herbert Waide Hemphill, Jr., Collection*. Exh. cat. Milwaukee: Milwaukee Art Museum, 1981.

Goodyear, Frank H. *American Paintings in the Rhode Island Historical Society*. Providence: Rhode Island Historical Society, 1974.

_____. *Thomas Doughty, 1793–1856: An American Pioneer in Landscape Painting*. Exh. cat. Philadelphia: Pennsylvania Academy of the Fine Arts, 1974.

Greenberg, Clement. *Art and Culture: Critical Essays*. Boston: Beacon Press, 1961.

Groce, George C., and David H. Wallace. *The New-York Historical Society's Dictionary of Artists in America, 1564–1860*. New Haven: Yale University Press, 1957.

Groft, Tammis K., and Mary Alice Mackay, eds. *Albany Institute of History and Art: 200 Years of Collecting*. With an introduction by Christine M. Miles. New York: Hudson Hills with the Albany Institute of History and Art, 1998.

Hall, Michael D., Eugene W. Metcalf, Jr., and Roger Cardinal, eds. *The Artist Outsider: Creativity and the Boundaries of Culture*. Washington, D.C.: Smithsonian Institution Press, 1994.

Harris, Neil. *The Artist in American Society: The Formative Years, 1790–1860*. Chicago: University of Chicago Press, Phoenix Books, 1982. Originally published New York, 1966.

Hartigan, Linda Roscoe. *Made with Passion: The Hemphill Folk Art Collection in the National Museum of American Art*. Washington, D.C.: Smithsonian Institution Press, 1990.

Hayes, Jeffrey R., Lucy R. Lippard, and Kenneth L. Ames. *Common Ground/Uncommon Vision: The Michael and Julie Hall Collection of American Folk Art*. Exh. cat. Milwaukee: Milwaukee Art Museum, 1993.

Hemingway, Andrew, and William Vaughan, eds. *Art in Bourgeois Society, 1790–1850*. Cambridge: Cambridge University Press, 1998.

Heslip, Colleen Cowles. *Mrs. Susan C. Waters, Nineteenth-Century Itinerant Painter*. Exh. cat. Farmville, Va.: Bedford Gallery, Longwood Fine Arts Center, Longwood College, 1979.

_____, and Charlotte Emans Moore. *A Window into Collecting American Folk Art: The Edward Duff Balken Collection at Princeton*. Exh. cat. Princeton, N.J.: Art Museum, Princeton University, 1999.

Hollander, Stacy C. *American Radiance: The Ralph Esmerian Gift to the American Folk Art Museum*. Exh. cat. New York: American Folk Art Museum with Harry N. Abrams, 2001.

_____, and Brooke Davis Anderson. *American Anthem: Masterworks from the American Folk Art Museum*. Exh. cat. New York: American Folk Art Museum with Harry N. Abrams, 2001.

_____, and Howard P. Fertig. *Revisiting Ammi Phillips: Fifty Years of American Portraiture*. Exh. cat. New York: American Folk Art Museum, 1994.

Holton, Randall, and Tanya Holton. "Sandpaper Paintings of American Scenes." *Antiques*, vol. 150, no. 3 (September 1996), pp. 356–65.

Hoppin, Martha. *Arcadian Vales: Views of the Connecticut River Valley*. Exh. cat. Springfield, Mass.: Springfield Library and Museums Association for the George Walter Vincent Smith Museum, 1981.

Howat, John K. *American Paradise: The World of the Hudson River School*. Exh. cat. New York: Metropolitan Museum of Art, 1987.

_____. *The Hudson River and Its Painters*. New York: Viking, 1972.

Howell, George R., and Jonathan Tenney. *Bi-Centennial History of Albany: History of the County of Albany, New York, from 1609 to 1886*. New York: Munsell, 1886.

Huntington, David Carew. *Art and the Excited Spirit: America in the Romantic Period*. Exh. cat. Ann Arbor: University of Michigan Museum of Art, 1972.

Hyde, Ralph. *Panoramania! The Art and Entertainment of "All-embracing" View*. Exh. cat. London: Trefoil Publications with Barbican Art Gallery, 1988.

_____. *Regent's Park Colosseum, or, "Without hyperbole, the wonder of the world": Being an Account of a Forgotten Pleasure Dome and Its Creators*. London: Ackermann, 1982.

Jackson, C. H. Ward. *Ship Portrait Painters, Mainly in Nineteenth-Century Britain*. Greenwich, U.K.: National Maritime Museum, 1978.

Jeffers, Wendy. "Holger Cahill and American Art." *Archives of American Art Journal*, vol. 31, no. 4 (1991), pp. 2–11.

Jones, Agnes Halsey. *Hudson River School*. Exh. cat. Genesee: Fine Arts Center, State University College of New York, 1968.

_____. *Rediscovered Painters of Upstate New York, 1700–1875*. Exh. cat., New York State Historical Association, Cooperstown. Utica, N.Y.: Munson-Williams-Proctor Institute, 1958.

_____, and Louis C. Jones, *New-found Folk Art of the Young Republic*. Exh. cat. Cooperstown: New York State Historical Association, 1960.

Kallir, Jane. *The Folk Art Tradition: Naïve Painting in Europe and the United States.* Exh. cat. New York: Gallerie St. Etienne and Viking, 1982.

Katcher, Jane, David A. Schorsch, and Ruth Wolfe, eds. *Expressions of Innocence and Eloquence: Selections from the Jane Katcher Collection of Americana.* Exh. cat., Yale University Art Gallery. Seattle: Marquand Books; New Haven: Yale University Press, 2006.

Kelly, Franklin, and Robert Wilson Torchia. *American Paintings of the Nineteenth Century.* Part 1. Washington, D.C.: National Gallery of Art; New York: Oxford University Press, 1996.

Klein, Rachel N. "Art and Authority in Antebellum New York City: The Rise and Fall of the American Art Union." *Journal of American History,* vol. 81, no. 4 (March 1995), pp. 1534–61.

Koke, Richard J., et al. *American Landscape and Genre Paintings in the New-York Historical Society.* 3 vols. New York: G. K. Hall for the New-York Historical Society, 1982.

_____. *A Checklist of the American Engravings of John Hill (1770–1850): Master of Aquatint.* New York: New-York Historical Society, 1961.

Kornhauser, Elizabeth Mankin, et al. *Ralph Earl: The Face of the Young Republic.* Exh. cat. Hartford: Wadsworth Atheneum; New Haven: Yale University Press, 1991.

_____, and Amy Ellis, with Maureen Miesmer. *Hudson River School: Masterworks from the Wadsworth Atheneum Museum of Art.* Exh. cat. Hartford: Wadsworth Atheneum; New Haven: Yale University Press, 2003.

_____, Elizabeth R. McClintock, and Amy Ellis. *American Paintings before 1945 in the Wadsworth Atheneum.* 2 vols. Hartford: Wadsworth Atheneum; New Haven: Yale University Press, 1996.

Lancour, Harold. *American Art Auction Catalogues, 1785–1942: A Union List.* New York: New York Public Library, 1942.

Langdale, Shelley R. "The Enchantment of *The Magic Lake*: The Origin and Iconography of a Nineteenth-Century Sandpaper Drawing." *Folk Art,* vol. 23, no. 4 (Winter 1998/99), pp. 52–62.

Larson, Neil G. "The Politics of Style: Rural Portraiture in the Hudson Valley during the Second Quarter of the Nineteenth Century." Master's thesis, University of Delaware, 1980.

Levine, Lawrence W. *Highbrow/Lowbrow: The Emergence of Cultural Hierarchy in America.* Cambridge, Mass.: Harvard University Press, 1988.

Lipman, Jean. *American Primitive Painting.* New York: Oxford University Press, 1942.

_____, and Tom Armstrong, eds. *American Folk Painters of Three Centuries.* Exh. cat. New York: Hudson Hills with the Whitney Museum of American Art, 1980.

_____, and Alice Winchester. *The Flowering of American Folk Art, 1776–1876.* Exh. cat. New York: Viking with the Whitney Museum of American Art, 1974.

_____, and Alice Winchester, eds. *Primitive Painters in America, 1750–1950.* New York: Dodd, Mead, 1950.

Lipton, Leah. "The Boston Art Association, 1841–1851." *American Art Journal,* vol. 15, no. 4 (Autumn 1983), pp. 45–57.

Little, Nina Fletcher. *American Decorative Wall Painting.* Sturbridge, Mass.: Old Sturbridge Village with Studio Publications, 1952.

_____. *Country Art in New England, 1790–1840.* Sturbridge, Mass.: Old Sturbridge Village, 1960.

_____. "Earliest Signed Picture by T. Chambers." *Antiques,* vol. 53 (April 1948), p. 285.

_____. *Little by Little: Six Decades of Collecting American Decorative Arts.* New York: Dutton, 1984.

_____. "More about T. Chambers." *Antiques,* vol. 60 (November 1951), p. 469.

_____. "William M. Prior, Traveling Artist, and His In-Laws, the Painting Hamblens." *Antiques,* vol. 53 (January 1948), pp. 44–48. Reprinted in *Portrait Painting in America: The Nineteenth Century,* ed. Ellen Gross Miles, pp. 120–24. New York: Main Street/Universe Books, 1977.

Lynes, Russell. *The Tastemakers: The Shaping of American Popular Taste.* New York: Harper and Brothers, 1949.

McEneny, John J. *Albany, Capital on the Hudson: An Illustrated History.* Sun Valley, Calif.: American Historical Press, 1998.

McKendry, Blake. *Folk Art: Primitive and Naive Art in Canada.* Toronto: Methuen, 1983.

Mandel, Patricia C. F. "Selection VII: American Paintings from the Museum's Collection, c. 1800–1930." *Museum Notes: Bulletin of Rhode Island School of Design,* vol. 63, no. 5 (April 1977), 24–26.

Mayhew, Edgar de N., and Minor Myers, Jr. *A Documentary History of American Interiors from the Colonial Era to 1915.* New York: Charles Scribner's Sons, 1980.

Mellow, James R. "Art: Primitive Landscapes; American Paintings that Capture the Topography of Yesteryear." *Architectural Digest,* vol. 46, no. 12 (December 1989), pp. 187–91.

Merwe, Pieter van der, et al. *The Spectacular Career of Clarkson Stanfield, 1793–1867: Seaman, Scene-Painter, Royal Academician.* Newcastle, U.K.: Tyne and Wear County Council Museums, 1979.

Miller, Angela. *The Empire of the Eye: Landscape Representation and American Cultural Politics, 1825–1875.* Ithaca, N.Y.: Cornell University Press, 1993.

Miller, Lillian. *Patrons and Patriotism: The Encouragement of the Fine Arts in the United States, 1790–1860.* Chicago: University of Chicago Press, 1966.

Mills, Sally. *American Folk Art: A Sampling from Northern California Collections.* Exh. cat. San Francisco: Fine Arts Museums of San Francisco, 1986.

Muehlig, Linda D., ed. *Masterworks of American Painting from the Smith College Museum of*

Art. Exh. cat. New York: Hudson Hills; Northampton, Mass.: Smith College Museum of Art, 1999.

Muller, Nancy C. *Paintings and Drawings at the Shelburne Museum.* Shelburne, Vt.: Shelburne Museum, 1976.

Museum of American Folk Art. *An Eye on America: Folk Art from the Stewart E. Gregory Collection.* Exh. cat. New York: Museum of American Folk Art, 1972.

Myers, Kenneth John. "Art and Commerce in Jacksonian America: The Steamboat Albany Collection." *Art Bulletin,* vol. 82, no. 3 (September 2000), pp. 503–28.

_____. "The Public Display of Art in New York City, 1664–1914." In *Rave Reviews: American Art and Its Critics,* edited by David B. Dearinger, pp. 32–43. Exh. cat. New York: National Academy of Design, 2000.

Nicoll, Jessica. "Charles Codman: From Limner to Landscape Painter." *Antiques,* vol. 162 (November 2002), pp. 130–39.

_____, et al. *Meet Your Neighbors: New England Portraits, Painters, and Society, 1790–1850.* Exh. cat. Sturbridge, Mass.: Old Sturbridge Village, 1992.

Nygren, Edward, ed. *Views and Visions: American Landscape before 1830.* Exh. cat. Washington, D.C.: Corcoran Gallery of Art, 1986.

Oak, Jacqueline. "Face to Face: M. W. Hopkins and Noah North." In *Face to Face: M. W. Hopkins and Noah North,* pp. 23–28. Edited by Jacqueline Oak. Exh. cat. Lexington, Mass.: Scottish Rite Masonic Museum of Our National Heritage, 1988.

Owens, Gwendolyn. *Visions of Nature: Artists and the Environment.* Exh. cat. Albany: Albany Institute of History and Art, 1992.

_____, and John Peters-Campbell. *Golden Day, Silver Night: Perceptions of Nature in American Art, 1850–1910.* Ithaca, N.Y.: H. F. Johnson Museum of Art, Cornell University, 1982.

Payne, Michael R., and Suzanne Rudnick Payne. "The Business of an American Folk Portrait Painter: Isaac Augustus Wetherby." *Folk Art,* vol. 32, no. 1 (Winter 2007), pp. 58–67.

Peluso, Anthony J. *The Bard Brothers: Painting America under Steam and Sail.* Exh. cat. New York: Harry N. Abrams with the Mariner's Museum, 1997.

Philadelphia Maritime Museum. *Thomas Birch, 1779–1851: Paintings and Drawings.* With an essay by William H. Gerdts. Exh. cat. Philadelphia: Philadelphia Maritime Museum, 1966.

Polley, Robert L., ed. *America's Folk Art: Treasures of American Folk Arts and Crafts in Distinguished Museums and Collections.* New York: Putman, 1968.

Powell, Earl A. *Thomas Cole.* New York: Harry N. Abrams, 1990.

Priddy, Sumpter T. *American Fancy: Exuberance in the Arts, 1790–1840.* Exh. cat. Milwaukee: Chipstone Foundation, 2004.

Quimby, Ian M. G., and Scott T. Swank, eds. *Perspectives on American Folk Art.* New York: W. W. Norton for the H. F. du Pont Winterthur Museum, 1980.

Reynolds, Cuyler. *Albany Chronicles: A History of the City Arranged Chronologically.* Albany: J. B. Lyon, 1906.

Richardson, Edgar Preston. *Painting in America: The Story of 450 Years.* New York: Crowell, 1956.

_____, and Robert Freund. *American Romantic Painting.* New York: E. Weyhe, 1944.

Robey, Ethan. "The Utility of Art: Mechanics' Institute Fairs in New York City, 1828–1876." PhD diss., Columbia University, 2000; UMI Dissertation Publishing, 2000.

Rorimer, James J., et al. *101 Masterpieces of American Primitive Painting, from the Collection of Edgar William and Bernice Chrysler Garbisch.* Exh. cat. Chicago: American Federation of Arts, 1962.

Rosenfield, Sybil. *Georgian Scene Painters and Scene Painting.* Cambridge: Cambridge University Press, 1981.

Ross, Alexander M. *William Henry Bartlett: Artist, Author and Traveller.* Toronto: University of Toronto Press, 1973.

Rumford, Beatrix T., ed. *American Folk Paintings: Paintings and Drawings Other than Portraits from the Abby Aldrich Rockefeller Folk Art Center.* Boston: Little, Brown for the Colonial Williamsburg Foundation, 1988.

_____, ed. *American Folk Portraits: Paintings and Drawings from the Abby Aldrich Rockefeller Folk Art Center.* Boston: New York Graphic Society for the Colonial Williamsburg Foundation, 1981.

Russell, Thomas, ed. *American Naive Painting of the Eighteenth and Nineteenth Centuries: 111 Masterpieces from the Collection of Edgar William and Bernice Chrysler Garbisch.* Exh. cat. West Point, N.Y.: United States Military Academy, 1970.

Schoelwer, Susan P., ed. *Lions and Eagles and Bulls: Early American Tavern and Inn Signs from the Connecticut Historical Society.* Exh. cat. Hartford: Connecticut Historical Society with Princeton University Press, 2000.

Schwartz, Gary. "Ars Moriendi: The Mortality of Art." *Art in America,* vol. 84 (November 1996), pp. 72–75.

Sears, Clara Endicott. *Highlights among the Hudson River Artists.* Boston: Houghton Mifflin, 1947.

Sewell, Darrel, et al. *Philadelphia: Three Centuries of American Art.* Exh. cat. Philadelphia: Philadelphia Museum of Art, 1976.

Shepard, Lewis A., and David Paley. *A Summary Catalogue of the Collection at the Mead Art Gallery, Amherst College.* Middletown, Conn.: Wesleyan University Press, 1978.

Siegel, Nancy. *Along the Juniata: Thomas Cole and the Dissemination of American Landscape Imagery.* Exh. cat. Huntingdon, Pa.: Juniata College Museum of Art with University of Washington Press, 2003.

Spassky, Natalie, et al. *American Paintings in the Metropolitan Museum of Art.* Vol. 2, *A*

Catalogue of Works by Artists Born between 1815 and 1845. New York: Metropolitan Museum of Art with Princeton University Press, 1985.

Stebbins, Theodore E., Jr. *The Hudson River School: Nineteenth-Century American Landscapes in the Wadsworth Atheneum.* Exh. cat. Hartford: Wadsworth Atheneum, 1976.

_____. *The Lure of Italy: American Artists and the Italian Experience, 1760–1914.* Exh. cat. Boston: Museum of Fine Arts; New York: Harry N. Abrams, 1992.

Stein, Roger B. *Susquehanna: Images of the Settled Landscape.* Exh. cat. Binghamton, N.Y.: Roberson Center for the Arts and Sciences, 1981.

Strazdes, Diana. *American Paintings and Sculpture to 1945 in the Carnegie Museum of Art.* New York: Hudson Hills with the Carnegie Museum of Art, 1992.

Sweet, Frederick A. *The Hudson River School and the Early American Landscape Tradition.* Exh. cat., Whitney Museum of American Art, New York. Chicago: Art Institute of Chicago, 1945.

Tillou, Peter. *Nineteenth-Century Folk Painting: Our Spirited National Heritage; Works of Art from the Collection of Mr. and Mrs. Peter Tillou.* Exh. cat. Storrs, Conn.: William Benton Museum of Art, 1973.

_____. *Portraits of New England Places.* Waterville, Maine: Colby College Museum of Art, 1984.

_____. *Where Liberty Dwells: 19th-century Art by the American People; Works of Art from the Collection of Mr. and Mrs. Peter Tillou.* Exh. cat. Buffalo: Albright-Knox Art Gallery, 1976.

Tomlinson, Juliette, ed., with Kate Steinway. *The Paintings and the Journal of Joseph Whiting Stock.* Middletown, Conn.: Wesleyan University Press, 1976.

Troyen, Carol. *American Art from the Currier Gallery of Art.* Exh. cat. New York: American Federation of Arts, 1995.

_____. *The Boston Tradition: American Paintings from the Museum of Fine Arts, Boston.* Exh. cat. Boston: Museum of Fine Arts and American Federation of Arts, 1980.

Truettner, William H., and Alan Wallach, eds. *Thomas Cole: Landscape into History.* Exh. cat. New Haven: Yale University Press; Washington, D.C.: National Museum of American Art, Smithsonian Institution, 1994.

Varnedoe, Kirk, and Adam Gopnik. *Modern Art and Popular Culture: Readings in High and Low.* New York: Museum of Modern Art and Harry N. Abrams, 1990.

Vlach, John Michael. "Holger Cahill as Folklorist." *Journal of American Folklore,* vol. 98, no. 388 (April–June 1985), pp. 148–62.

_____. *Plain Painters: Making Sense of American Folk Art.* Washington, D.C.: Smithsonian Institution Press, 1988.

_____, and Simon J. Bronner, eds. *Folk Art and Art Worlds.* Logan: Utah State University Press, 1992.

Voorsanger, Catherine Hoover, and John K. Howat, eds. *Art and the Empire City: New York,* 1825–1861. Exh. cat. New York: Metropolitan Museum of Art; New Haven: Yale University Press, 2000.

Wallach, Alan. "Thomas Cole and the Aristocracy." *Arts Magazine,* vol. 56 (November 1981), pp. 94–106.

Wattenmaker, Richard J., and Alain G. Joyaux. *American Naive Paintings: The Edgar William and Bernice Chrysler Garbisch Collection.* Exh. cat. Flint, Mich.: Flint Institute of Arts, 1981.

Weekly, Carolyn. *The Kingdoms of Edward Hicks.* New York: Harry N. Abrams with the Abby Aldrich Rockefeller Folk Art Center, 1999.

Wheeler, Robert G. *Folk Art and the Street of Shops.* Dearborn, Mich.: Greenfield Village and the Henry Ford Museum, 1971.

Wickman, Richard Carl. "An Evaluation of the Employment of Panoramic Scenery in the Nineteenth-Century Theatre." PhD diss., Ohio State University, 1961; UMI Dissertation Publishing, 1961.

Wilmerding, John. *American Art.* New York: Penguin, 1976.

_____. *American Marine Painting.* 2nd ed. New York: Harry N. Abrams, 1987.

_____. *American Masterpieces from the National Gallery of Art.* Rev. and enl. ed. New York: Hudson Hills, 1988.

_____. *American Naive Paintings from the National Gallery of Art.* Exh. cat. Evanston, Ill.: Terra Museum of American Art, 1982.

_____. *American Views: Essays on American Art.* Princeton, N.J.: Princeton University Press, 1991.

_____. *A History of American Marine Painting.* Exh. cat. Salem, Mass.: Peabody Museum of Salem; Boston: Little, Brown, 1968.

_____. *Robert Salmon, Painter of Ship and Shore.* Salem, Mass.: Peabody Museum of Salem, 1971.

_____, et al. *Paintings by Fitz Hugh Lane.* New York: Harry N. Abrams; Washington, D.C.: National Gallery of Art, 1988.

Wilson, Arnold. *A Dictionary of British Marine Painters.* Leigh-on-Sea, U.K.: F. Lewis, 1967.

Wilson, James Grant, ed. *The Memorial History of the City of New York, from Its First Settlement to the Year 1892.* New York, 1892.

Zellman, Michael D., ed. *American Art Analog.* 3 vols. New York: Chelsea House, 1986.

Zug, Charles G., III. "Folk Art and Outsider Art: A Folklorist's Perspective." In *The Artist Outsider: Creativity and the Boundaries of Culture,* edited by Michael D. Hall et al., pp. 144–70. Washington, D.C.: Smithsonian Institution Press, 1994.

INDEX

THOMAS CHAMBERS

American Marine and Landscape Painter, 1808–1869

Composed in Monotype Bulmer and Monotype Bell by
Dean Bornstein at The Perpetua Press, Peacham, Vermont

Printed on 150gsm Leykam Matte by
CS Graphics, PTE, Ltd., Singapore